artWorks

For as long as there has been art, there has been discussion about art. Over the past two centuries, as ideas and movements have succeeded each other with dizzying speed and the debate between various aesthetics has turned increasingly vivid, art criticism and theory have taken on an unprecedented relevance to the development of art itself.

ARTWORKS restores to print the most significant writings about art — whether letters and essays by the artists themselves, memoirs and polemics by those who lived with them in the thick of creation, or illuminating studies by some of our most prominent scholars and critics. Many of these works have long been unavailable in English, but they merit republication because the truths they convey remain valid and important. The list is eclectic because art is eclectic; taken as a whole, these titles reflect the history of art in all its color and variation, but they are bound together by a concern for their importance as primary documents.

These are writings that address art as being of both the eye and the mind, that recognize and celebrate the constant flux in which creation has occurred. And as such, they are crucial to any understanding or criticism of art today.

Apollinaire on Art: Essays and Reviews, 1902–1918
edited and introduced by LeRoy C. Breunig
with a new foreword by Roger Shattuck

Futurist Manifestos
edited by Umbro Apollonio
with a new afterword by Richard Humphreys

Surrealism and Painting
André Breton
with a new introduction by Mark Polizzotti

Selected Letters, 1813–1863
Eugène Delacroix
edited and translated by Jean Stewart
with an introduction by John Russell

Stieglitz: A Memoir / Biography
Sue Davidson Lowe
with a new foreword by the author
and a new preface by Anne E. Havinga

CAMILLE PISSARRO

LETTERS

TO HIS SON LUCIEN

꒰◖ ◗꒱

Edited with the assistance of Lucien Pissarro by
JOHN REWALD

Translated from the French manuscript by
LIONEL ABEL

With a foreword by
BARBARA STERN SHAPIRO

artWorks

MFA PUBLICATIONS
a division of the
Museum of Fine Arts, Boston

MFA PUBLICATIONS
a division of the Museum of Fine Arts, Boston
465 Huntington Avenue
Boston, Massachusetts 02115
www.mfa-publications.org

*For a complete listing of MFA Publications, please contact the publisher
at the above address, or call 617 369 3438.*

Originally published in 1943 by Pantheon Books, Inc., New York.
This edition reprinted by kind permission of Sabine Rewald

ISBN 0-87846-648-7
Library of Congress Catalogue Card Number: 94-49368

Available through D.A.P. / Distributed Art Publishers
155 Sixth Avenue, 2nd floor
New York, New York 10013
Tel.: 212 627 1999 · Fax: 212 627 9484

FIRST ARTWORKS EDITION, 2002
Printed and bound in the United States of America

CONTENTS

FOREWORD: *PÈRE* PISSARRO *by Barbara Shapiro* 7

INTRODUCTION 11

THE LETTERS 21

INDEX 361

ACKNOWLEDGMENT

I owe much to Alfred H. Barr, Jr., Henri Focillon, Gerstle Mack, Ludovic Rodolphe Pissarro, Meyer Schapiro, Lionello Venturi and Georges Wildenstein for the interest they have shown in this publication and for the encouragement and help they have offered me.

J. R.

Pissarro's letters to his son Lucien serve as a primer for French art in the second half of the nineteenth century. As the senior member of the Impressionist group, Pissarro acted as mentor to, among others, Van Gogh, Gauguin, and Cézanne, as well as the young Seurat and Signac. Though mainly a landscape painter, he also depicted a selection of powerful cityscapes and harbor scenes. And, unlike other Impressionist artists, Pissarro was a prolific printmaker, as evidenced by the hundreds of etchings, lithographs, and monotypes he produced during his lifetime. In his letters to Lucien, he repeatedly discusses his efforts to create these works, even as he airs his open and often challenging political thoughts – not for a public reaction (as was the case with some of his comrades, such as Emile Zola) but for himself and his family, as a diary of his own aspirations, insecurities, and eventual successes.

When the teacher, writer, and art historian John Rewald (1912–1994) gathered together hundreds of letters and saw to their posthumous publication in 1943, he offered a profound gift to art connoisseurs, general history buffs, parents of distant children, and to a general public who would be interested in French painting and culture in the age of Impressionism. Alongside Eugène Delacroix's extensive correspondence and Vincent van Gogh's numerous letters to his brother, Theo, Pissarro's letters to Lucien are widely valued for their breadth of social and political content and their acute knowledge of art methodology that took place the second half of the nineteenth century.

Camille Pissarro and his wife, Julie, were the parents of six surviving children: five sons and one daughter. Lucien, their eldest, began to travel at the age of twenty; in 1883, he moved to England, ostensibly to become more fluent in the language. Prey to constant fears of poverty, Julie hoped that he would develop an interest in the commercial world and abandon a latent desire to become an artist. Pissarro, however, felt compelled to

7

share with his far-off son his views on politics, literature, his colleagues' ventures, and above all his steadfast artistic expertise. He wrote almost weekly for twenty years until his death in 1903 and, despite Julie's real concerns about financial stability, he made sure that his son never abandoned his pursuit of a career in art.

With the assistance of Lucien Pissarro, who died in England in 1944, and Lucien's wife, Esther, Rewald assembled and edited Camille's letters to his oldest son, most of which were presented to the Ashmolean Museum, Oxford, beginning in 1950 (there are now some 770 letters from Camille to Lucien in the archive). Another brother, Ludovic-Rodolphe Pissarro, also an artist but primarily a cataloguer of his father's paintings, participated in reading and editing the letters. Owing to World War II publication difficulties, when the letters first appeared in 1943 it was not in their native French but in an English translation by the writer Lionel Abel:[1] it is this version that has been reproduced for the present edition. In preparing it, Rewald (as he clearly states) made certain editorial choices, such as combining passages that might be repetitive and avoiding redundant closing expressions. More important, a number of omissions (including Julie's admonitory addenda) were decided upon by Rewald and members of the family, which were restored in a subsequent edition.

As a group, the letters reflect the father's strong ideas and opinions; many included small sketches to illustrate a suggestion that Camille wanted to share with Lucien. His handwriting varied little over the thirty-seven years represented in the Ashmolean collection, and was only affected by the nib of the pen he was using.[2]

The first printing in French, which finally displayed the letters as they were originally written, was published by the firm of Albin Michel in 1950.[3] The introduction, composed by Rewald in New York the previous year, concludes with gracious thanks to "Lucien's widow, who was so solicitous in the preparation of the different editions of Camille Pissarro's letters to her husband." The French edition contains some eighty-five illustrations of family, friends, and works of art, along with a selection of letters from Lucien to his father that had been found too late to be included in the first English printing. Additional information gleaned from documents and periodicals that had not been available during the

[1] Camille Pissarro, Letters to His Son Lucien, ed. John Rewald, trans. from the French manuscript by Lionel Abel (New York: Pantheon Books, 1943).

[2] See Anne Thorold and Kristen Erickson, Camille Pissarro and His Family (Oxford: Ashmolean Museum, 1993).

[3] Camille Pissarro, Lettres à son fils Lucien, présentées, avec l'assistance de Lucien Pissarro, par John Rewald (Paris: Albin Michel, 1950).

war years was also inserted. Rewald's footnotes elaborate upon Pissarro's citations of historic facts, such as difficulties with the legacy of Gustave Caillebotte, the artist colleague who had willed his collection of Impressionist paintings to the Musée du Luxembourg. Rewald makes reference as well to the Dreyfus Affair, in which the artist witnessed the break-up of many of his old friendships.

Since these two collations, issued some six years apart, there have been several more publications of Letters to His Son Lucien. For the second English edition (published in 1972 by Paul P. Appel)[1], Rewald included an appendix comprised of Lucien's letters to his father from the earlier French volume (now translated into English), along with a number of additional footnotes. And in 1981, the publisher Peregrine Smith issued a third English edition to coincide with a major Pissarro exhibition in London, Paris, and Boston. The retrospective celebrated the 150th anniversary of Pissarro's birth, and examined every medium and style that the artist had explored. It revealed the same breadth of interests, the same trials and surveys that were so apparent, and so brilliantly conveyed, in the letters that the artist sent to his son in England.

In turn, Lucien's hundreds of responses demonstrate his dependence on his father's knowledge and advice, with particular emphasis on a joint book illustration project that the two artists had devised. Known as Travaux des champs (Labor in the fields), it was to comprise drawings by Camille that were engraved on woodblocks and then printed in colored inks by Lucien. Although the project was frequently discussed and experimented with for many years, even up to the father's death, the only published phase was a portfolio of six color woodcuts that appeared in 1895. (A full account of the project can be found in the recent collation of The Letters of Lucien to Camille Pissarro: 1883–1903.)[2] In homage to Hokusai's "rough sketches," they codenamed their collaborative effort Mangwa— which in itself was only part of the larger project that the two worked on starting as early as 1886.

Undoubtedly, the most complete and in-depth exploration of Camille Pissarro's correspondence are the five volumes in French that have documented all of the artist's known missives.[3] More than two thousand letters are credited to Camille during his lifetime, which were located and verified

[1] Camille Pissarro, Letters to His Son Lucien, ed. with the assistance of Lucien Pissarro by John Rewald, third edition revised and enlarged (Mamaroneck, NY: Paul P. Appel, 1972).

[2] The Letters of Lucien to Camille Pissarro, 1883–1903, ed. Anne Thorold (London and New York: Cambridge University Press, 1993).

[3] Janine Bailly-Herzberg, ed., Correspondance de Camille Pissarro, 5 vols. (Paris: Editions du Valhermeil, 1980–91).

by the historian and art critic Janine Bailly-Herzberg, including those written to Lucien's surviving brothers (Ludovic-Rodolphe, Georges, and Paul Emile; a fourth brother, Félix, died in 1897) and to his sister, Jeanne. To complete the picture, Bailly-Herzberg also included the numerous passages that Rewald had eliminated from the letters to Lucien. These many letters, and the copious documentation and various corrections, bring together the family life, social functions, and painting campaigns that are melded into the daily activities of a father, friend, and teacher — "the humble and colossal Pissarro" as Cézanne defined him. It is an heroic work, and we can only hope that these volumes will in the future be translated into English.

In 1995, the fifth English-language edition of the letters to Lucien was published.[1] Like the present book, this is an unabridged republication of the volume issued in 1943, and so once again takes a more novelistic approach to the story of Impressionism. The breadth of Pissarro's interests, his constant curiosity, his teaching abilities for his sons and colleagues is laid out for the reader who can study a period in art history that continues to draw an exceedingly interested audience.

Given that all these editions are now out-of-print, as well as the fact that the Museum of Fine Arts, Boston, has long been the proud repository of numerous works by Pissarro and his close colleagues, it is only fitting that MFA Publications should restore to the English-speaking public one of the most engaging documents of the last half of the nineteenth century. As the "Father of Impressionism," Pissarro shared his new theories and methods with his many colleagues, dealers, and friends and, most important, with his son Lucien. The breadth of his interests, his constant curiosity, his abilities as a teacher, and his insights into the artistic and social developments of his day are laid out in these editions with a skill that rivals the best art history.

In 1891 Pissarro wrote to the critic and writer Octave Mirbeau: "Every day I rest by reading. I find that my eyesight is all the better after having gone through a book that I enjoyed."[2] The artist's passion for books and information, and his remarkable talent for expressing what he saw and heard, can once again be enjoyed by readers of his letters who wish to learn more about one of the most significant artists of his time.

Barbara Stern Shapiro
May 2002

[1] *Camille Pissarro*, Letters to His Son Lucien, *ed. John Rewald (New York: Da Capo, 1995).*
[2] *Cited in Joachim Pissarro,* Camille Pissarro *(New York: Harry N. Abrams, 1994), p. 290.*

Lucien Pissarro was twenty years old when he left his parents' home to try his luck in England. Never before had a son of Camille Pissarro been separated from him, and the father was concerned that his eldest should not lack for affectionate advice. In his almost daily letters the impressionist painter drew on his vast experience in life and art to encourage, chide and solace the young Lucien.

It was no easy matter for Lucien, shy and given to dreaming as he was, to leave the house of his parents at Osny near Pontoise, where his brothers and his sister spent their carefree youth in the fields and meadows while their father noted with unconcealed joy the capacities for observation and expression which he found in each of them. Lucien himself had begun to draw at a very early age and, when sent to work in Paris for a firm merchandising English fabrics, he spent the evenings with his friend Louis Hayet making drawings in the cafés and music halls. His mother, who knew only too well the sufferings artists have to endure, had wanted at all costs to prevent her eldest son from choosing his father's "profession." However, the young man's employer soon informed the parents that their boy, although in other respects a fine fellow, would never make good in business. After this, Lucien got a job working with hand-made plates for color impressions. His parents finally decided, by the end of 1882, to send him to England to learn the language. In London he found a position with a music publisher, but continued to paint and draw. First he lived at the home of his uncle, Phineas Isaacson, whose wife was the half-sister of Camille Pissarro. Later he took a studio, gave drawing lessons and devoted himself mostly to the art of wood engraving.

11

Lucien Pissarro often came to France to spend months at a time with his family, which meanwhile had settled in Eragny. But even during these sojourns in France his correspondence with his father was not interrupted. For almost every month Camille Pissarro went to Paris for a few days to see dealers and collectors, to take in the new exhibitions, to make purchases and to visit his friends. At such times he wrote his son to inform him about everything. There were also occasions when Lucien himself undertook to go to the capital. His father, thus enabled to continue his work, discussed with him by mail the paintings he was working on at Eragny and sent him news of the children and their mother. This correspondence, which began in 1883 and stopped only with the death of Camille Pissarro twenty years later, was religiously preserved by Lucien.

In permitting the letters he received from his father to appear, Lucien Pissarro is faithful to his feeling for the man who put so much of his wisdom and knowledge of art into these communications. What Camille Pissarro wrote his eldest son about art should be invaluable to all those who care to be instructed by a great master, and what he reported about his friends and associates can hardly fail to interest whoever delights in seeing an epoch come to life again in the account of one of its principal figures.

In fact, as Adolphe Tabarant has said, Camille Pissarro was the *letter writer of the impressionist group*, for none of the painters who made the movement great could write as Pissarro could, perhaps because none of them loved to write as he. With Eugène Delacroix and Vincent van Gogh, Camille Pissarro will take first rank among those writer-painters who added to their marvels on canvas pages which speak to us of their ideas, their struggles, their daily life and their contemporaries. His lively expressions, his just and subtly qualified observations, his good humor and gift for precise description, make us understand how his intimate friend, Octave Mirbeau, could say that in Camille Pissarro lived a hidden poet.

Nothing could bring us closer to Camille Pissarro than the reading of his letters; to add a single word to these writings would only disturb the purity of his thought. *The greatest kindness to the dead*, François Mauriac has said, *would be not to kill them a second time by lending them lofty attitudes. The greatest kindness would be to bring them so close to us that they drop their pose.*

12

If these documents reveal a man without any pose, they at the same time give us a precise account of his situation in life, his artistic development and the part he played among his friends from the time the impressionist movement finally broke up—the time at which this correspondence begins. This is the period in which the old comrades who had fought together for so long, and had by no means won their fight, wavered and become irresolute; wanting to progress, each one strove to renew his art independently from the others. Doubt and discouragement seem to have seized these audacious innovators. Some, like Cézanne, sought refuge in total solitude, others, like Renoir and Monet, abandoning their comrades, tried to exhibit at the official Salon, still others like Gauguin, hoped to find new inspiration in far off countries, while Pissarro turned to the new generation, anxious to guide it and ready to accept in exchange a share of its ideas. To this new generation belonged his eldest son, and it was through his father that Lucien came to be linked with van Gogh, Seurat, Signac, etc. Camille Pissarro conquered these newcomers by his knowledge of art, by his character and kindness. His counsels, dictated by a complete disinterestedness, showed the young men around him that he was not one of those who jealously keep to themselves the fruit of their researches. On the contrary, Pissarro was anxious to help others profit by his experience, convinced as he was that any truth won by human effort should belong to all. This generous sentiment explains the role he played among the young painters. No one would advise, help, encourage as he could; though his criticism was just, it was tempered by indulgence. In acting thus he endeavored to transmit to the new generation the warmth with which his first efforts had been welcomed, and doubtless he recalled many a time the kindness with which he had been received by the old Corot when, having just arrived from his native isle of St. Thomas in the West Indies, he sought the advice of the master whose influence is evident in Pissarro's early work.

Since the period when he began to paint, at first timidly, then boldly, life had been hard for Camille Pissarro. After difficult years of well sustained effort, the German invasion in 1870 chased him from Louveciennes and forced him to flee to England with his family. (Lucien was seven years old when he first crossed the Channel.) Everything Pissarro owned and almost all of his paintings were destroyed by the invaders. In London he joined Claude

13

Monet, and the two painters began to study the English landscapists, being particularly attracted by the art of Turner. The young art dealer Paul Durand-Ruel, who, too, had sought refuge in the British capital, was introduced to them by Charles Daubigny and encouraged them by buying some of their works. These purchases were multiplied and regularized when Durand-Ruel and the two painters returned to France. The dealer then began to be interested in the work of their friends, Sisley, Degas, Renoir, and Manet, but it was difficult to sell their pictures, and Durand-Ruel was often obliged to suspend his purchases, thus exposing the artists to the torments of uncertainty.[1]

Camille Pissarro's material situation was much more difficult than that of his friends. His wife, a sturdy Frenchwoman of peasant stock, bore him several children, who filled the house with their boisterous play and innocent quarrels. In the midst of much turmoil and burdened with cares, often misunderstood by his wife —for the interminable succession of problems embittered her character—Camille Pissarro, who so seldom experienced the joy of knowing his family secure, accomplished the miracle of creating works distinguished by their calm and beauty.

On his return from England, Pissarro had settled down at Pontoise, where Cézanne soon joined him to work by his side and profit by his advice. Cézanne, in order to study the clear, rich *matière* of his friend, faithfully copied a large canvas by Pissarro presenting a view of Louveciennes. *Perhaps we all come from Pissarro*—Cézanne said later—*as early as 1865 he eliminated black, dark brown and ochres, this is a fact. Paint only with the three primary colors and their immediate derivatives, he told me . . .*

In 1874 the series of impressionist exhibitions began. This was the heroic period in which Renoir and Monet, Sisley and Degas, Cézanne and Pissarro, encountered the ridicule of the public, the disdain of the collectors, the grossness of the art critics, in which they all endured insult and injury and continued to work, braving laughter and misfortune. One can never praise enough the courage of Camille Pissarro and his comrades, who never strayed from the path they had taken and stoically accepted a situation which literally obliged them to create in the void.

[1] *The story of the Durand-Ruel Gallery can be found in the* Archives de l'Impressionnisme *published by Lionello Venturi. However, this work contains only a few of the letters Camille Pissarro wrote to his dealer.*

If a degree of selflessness is needed to undertake a work involving severe sufferings, how much more is required to continue for many years an unbelievable effort which does not awaken the slightest echo! To renounce praise one must have the strength to overcome one's own doubts and to progress with no other guide than oneself.

But in compensation Pissarro had the happiness of being visited by Gauguin, who, after Cézanne, came to ask his advice and to paint at his side. The traces of his apprenticeship as an impressionist were soon to disappear from Gauguin's works, but many years later, shortly before he died, he did justice to Pissarro, noting in his *Racontars d'un Rapin: If we observe the totality of Pissarro's works, we find there, despite the fluctuations, not only an extreme artistic will which never lies, but what is more, an essentially intuitive pure-bred art . . . He looked at everybody, you say! Why not? Everyone looked at him, too, but denied him. He was one of my masters and I do not deny him.*

By those who were "looked at" by Camille Pissarro, Gauguin meant particularly Seurat and Signac. It was precisely at the moment Pissarro came in contact with neo-impressionism, that his correspondence with Lucien began. Confronted with a new truth, Pissarro did not hesitate to change his mode of execution at the risk of losing the few collectors who admired his former style. But while he followed for a time, with characteristic naïveté, the new path broken by Seurat, while he fervently supported the younger man's scientific theories, he nevertheless began in 1887 to modify the rigid execution required by pointillist divisionism, although he was not yet ready to abandon divisionism itself. But soon afterwards he admitted with his customary frankness that he had erred in following the young innovators since the paintings he had made in accordance with their methods no longer satisfied him. His letters reveal his sucessive enthusiasms, hesitations, self-deceptions and new ardors.

Lucien Pissarro adopted neo-impressionism with his father and was closely linked with the originators of the movement. He worked at his father's side and was the first of Camille Pissarro's sons to exhibit with him. When Lucien finally settled in London and set up the press on which he published superb works illustrated with his own woodcuts or engravings of his father's drawings, he called it the *Eragny-Press* in honor of the village where

15

his parents lived, Eragny being for him a symbol of sincere and careful workmanship. Thus Lucien went his own way, painting, drawing, working on his books in close collaboration with his wife, introducing in his turn his only child to the delights of art.

Uninterruptedly the letters passed with their freight of ideas between father and son. It is clear on reading these letters that, even in London, Lucien was closer to Camille Pissarro than was any other of the painter's children.

* * *

Camille Pissarro's letters to his son were not written with an eye to publication. The selection which is presented here was directed by Lucien Pissarro and the first part was scrupulously checked by his brother Ludovic Rodolphe Pissarro, author of the complete catalogue of his father's work. Thanks to their constant collaboration it has been possible to avoid—despite inevitable cuts —any distortion of their father's thought.

Compiled in France, the manuscript was put into final shape in the United States, a circumstance on which may be blamed certain omissions in the notes, for example, those concerning articles from the newspapers and reviews mentioned by Camille Pissarro. These items are not always available in American libraries. But despite difficulties, detailed notes are presented to complete the manuscript by filling out the author's allusions with the necessary facts.

In order not to weaken the documentary value of these letters, the real names of the persons mentioned by Pissarro are not withheld. Is it not indispensable to know those he approved, those whom he disliked? One may accept or reject his judgments, his prejudices, as one will, but no one could accuse him of maliciousness. His frankness and talent authorized him to say openly what his opinions were, even when they were unfavorable to some of his contemporaries. In speech and in act the artist tended to assert the very same convictions that are expressed in his letters.

To give more unity to the text, closing expressions have been suppressed.[1] For the same reason, the suppression of paragraphs, sentences or whole letters has not been indicated by the marks of omission customary in this kind of publication. The truth is that if this course had not been followed, the multiplicity of necessary dashes etc. would have become confused with the many punctua-

[1] *In order to avoid repetition, passages from different letters have sometimes been united.*

16

tion marks in Pissarro's letters which often set off perfectly the painter's phrases.

The reproductions accompanying these letters were chosen with a view to filling out the text and to enlarging on certain of Pissarro's remarks. Here are certain of the works of Camille Pissarro or of his son which are referred to in the correspondence, portraits of Pissarro's children, photographs of the artist and of his friends and other documents likely to familiarize the reader with the world in which the painter moved.

Wherever it has been possible to identify those of the artist's works to which he refers in the letters, the numbers corresponding to these works in the catalogues of his paintings or engravings have been indicated between brackets after the titles. For paintings, these numbers refer to the *Catalogue de l'oeuvre de Camille Pissarro*, published in 1939 by one of the painter's sons, Ludovic Rodolphe Pissarro, and by Lionello Venturi; for engravings, the numbers preceded by a D refer to the third volume of the Peintre-Graveur, *Catalogue des gravures de Pissarro, Sisley, Renoir*, published by Loys Delteil in 1923.

Circumstances have prevented this book from appearing first in French, the language in which the letters were written. In presenting this book after many difficulties, I cannot but think of how much I owe to Lucien and Esther Pissarro for their constant help, and also to my wife for her untiring collaboration, especially in assisting me in the supervision of the translation.

<div align="right">

John Rewald

</div>

CAMILLE PISSARRO'S CHILDREN:

Lucien was born on February 20th, 1863.

A daughter Jeanne, called *Minette*, born in 1865, died at the age of nine.

Georges was born on November 22nd, 1871. He paints under the pseudonym of *Manzana*.

Félix, born on July 24th, 1874, died in England in 1897. At home he was called *Titi*. He signed his pictures: Jean Roch.

Ludovic Rodolphe was born on November 21st, 1878. He was sometimes called *Piton-fleuri* by his father. As a painter he is known as Ludovic-Rodo.

Jeanne, born on August 27th, 1881, is always referred to in these letters as *Cocotte*.

Paul-Emile was born on August 22nd, 1884. He was nicknamed *Guingasse*. His paintings are signed Paulémile.

THE LETTERS

If you speak of things without loving partiality what you say is not worth repeating.

GOETHE

OSNY NEAR PONTOISE
JANUARY, 1883

My dear Lucien,

First we got your telegram, the next day your letter came, and with the following mail your post card. Useless to mention that we had been waiting impatiently for a word from you announcing your arrival. We are very happy to learn that everything went well. I hope that you will continue to communicate with us regularly. Try to keep constantly in mind the fact that you have been presented with an excellent opportunity to learn the English language; for my part, despite the difficulties, I shall do all I can to help you in this task.

What you observed, and mentioned in your letter, interests me much, though I know the route well, having taken it before. I recall perfectly those multicolored houses, and the desire I had at the time to interrupt my journey and make some interesting studies. But it would be a long trip indeed if one stopped at every attractive town or village, at every beautiful motif—although a painter could want nothing better than to be able to stop and then go on his way and always go on and stop.

We are all quite well, including the children; your mother is very busy and I continue to jog along surrounded with my unfinished paintings and drawings, seeking the rare bird whose plumage is resplendent with all the colors of the rainbow, whose song is musical and pure; perfection, as Degas would say, why not!—

Don't forget to draw.

21

My dear son,

You and Esther[1] have been to the National Gallery, you have seen the Turners,[2] yet you don't mention them. Can it be that the famous painting *The Railway*, *The Burial of the Painter Wilkie*, the astonishing *Seascape*, at the Kensington Museum, the *View of Saint Mark in Venice*, the little sketches retouched with watercolors of fish and fishing equipment, etc., did not impress you? I do not budge from here, I work as much as I can on the landscapes. I already began and am at work on my picture of *The Market* [615] which I have changed completely. I work now and then on sketches for my exhibition, although I can hardly count on having it, for the political situation is so bad that we have to be prepared for the worst eventualities. The future is not rosy. In any case one hardly has leisure for painting when one feels the nation fighting to safeguard the republican government which it cost so much blood to establish.

My dear son,

So now you are going to wear tails for the first time. It is a good thing you have the clothes. You will have embarrassments enough in an entirely new milieu, with strange customs and ways of behavior. What wonderful things to observe!

How I regret not to have seen the Whistler show; I would have liked to have been there as much for the fine drypoints as for the setting, which for Whistler has so much importance; he is even a bit too *pretentious* for me, aside from this I should say that for the room white and yellow is a charming combination. The fact is that we ourselves made the first experiments with colors: the room in which I showed was lilac, bordered with canary yellow. But we poor little rejected painters lack the means to carry out our con-

[1] *Esther Isaacson, like her sisters Alice and Amélie and her brother Alfred, were cousins of Lucien, who when in London, lived for a time with their parents, Phineas Isaacson and his wife. The latter was Camille Pissarro's half-sister. Amélie Isaacson lived in Paris with her grandmother, the painter's mother.*

[2] *Pissarro, who greatly admired Turner, had made a careful study of his paintings while in England during the war of 1870.*

cepts of decoration. As for urging Durand-Ruel [1] to hold an exhibition in a hall decorated by us, it would, I think, be wasted breath. You saw how I fought with him for white frames, and finally I had to abandon the idea. No! I do not think that Durand can be won over.—

white frames

Whistler makes drypoints mostly, and sometimes regular etchings, but the suppleness you find in them, the pithiness and delicacy which charm you derive from the inking which is done by Whistler himself; no professional printer could substitute for him, for inking is an art in itself and completes the etched line. Now we would like to achieve suppleness *before* the printing. I saw two prints exhibited in Paris a year or two ago; they were rather delicate, meager and thin-looking, one would have to see a whole collection in order to judge them, for doubtless he has done some that are first rate.

I reread your postscript on aesthetics. I wouldn't want to be an aesthete, at least like those across the Channel. *Aestheticism* is a kind of romanticism more or less combined with trickery, it means breaking for oneself a crooked road. They would have liked to make something like that out of impressionism, which really should be nothing more than a theory of observation, without entailing the loss of fantasy, freedom, grandeur, all that makes for great art. But not *eccentricity* to make sensitive people swoon.

<div align="right">PARIS, MARCH 3, 1883</div>

My dear Lucien,

Monet has opened his show first [2]—a great artistic success, very well organized, not too many canvases, forty at most, and well spaced. It is a well deserved success, for Monet has shown some marvelous things. We shall see if the public will acclaim his show; if not, it will not be because he lacks talent.[3]

Durand tells me that it will be my turn in May, the very month

[1] Since 1871 Durand-Ruel had regularly purchased works of Degas, Monet, Pissarro, Renoir and Sisley.

[2] Durand-Ruel had organized for the first time a series of one-man shows of impressionist painters; in March, Monet, in April, Renoir, in May, Pissarro, and Sisley in June.

[3] Very discontented with his exhibition, Monet, five days after the opening, referred to the show as a "flop" in a letter to Durand-Ruel.

in which he will open the show in London. The young clerk M. Mariotte will be charged with this task, and I do not have much confidence in him.

I set out again for Osny tomorrow, Sunday, without a penny, for Durand was only able to give me the sum I sent you. I do not have to warn you to be discreet in speaking of Durand-Ruel to Dechamps [1] or anybody else, for people are rather envious of him; so be prudent. Monet says this is just a bad moment which must pass. Well, we shall see.

<div align="right">PARIS, SATURDAY, MARCH, 1883</div>

My dear Lucien,

I have been in Paris for several days.

Durand-Ruel has confided to me something which I cannot say I found surprising. You know the young clerk Mariotte who was to give me letters of introduction for you and organize our show in London. The young man has just skipped abroad with 300,000 francs' worth of jewelry which a jeweler had entrusted to him. I do not have to tell you not to recognize him if you encounter him. Careful.—

Duret [2] is here. I have not seen him yet but I hope to meet him at Monet's show. I will speak of you to him.

<div align="right">OSNY, MARCH 15, 1883</div>

My dear Lucien,

You do indeed show strength of will in harnessing yourself to English, nothing but English, and then we shall see. . . . Good, but for your enjoyment—and your future, too, who knows?—do not give up drawing, draw often, always from nature, and whenever possible consult the primitives.—If you could only be persuaded that no other activity is so intelligent and agreeable. What

[1] *An art dealer in New Bond Street, London.*

[2] *Théodore Duret, friend and ardent admirer of Manet was, like Zola, one of the first to be interested in the impressionist painters and to defend them in the press. Later he published a* Histoire de l'Impressionnisme, *the only one written by an intimate friend of the painters.*

would be perfect would be for you to become quite mad about art; Sundays and holidays would then become days of real happiness—you would await them with impatience,—this will not come of itself, you have to feel it.

Gauguin came to spend last Sunday with us, he made two sketches.[1] He is completely taken with your still life, as well as with the landscapes you began, they were on the right track. Guillaumin also found your works really fine; they are superior to much that is done by many a painter with pretentions. . . .

Monet's show, which is marvelous, has not made a penny. A poor idea to have one-man shows. The newspapers, knowing that a dealer is behind it, do not breathe a word, they speak of the frightful canvases on the rue Vivienne, the Cercle St. Arnaud,[2] etc. It is very discouraging. The fact is that Delacroix, Millet, Corot, Tassaert, were only accepted after struggles and combats. People love only the mediocre.

PARIS, MARCH 29, 1883

My dear Lucien,

Tomorrow I leave for Osny to return Saturday for the opening of Renoir's show. I saw Duret who brought me news of you. I am much pleased by the good impression you made on Duret. We talked a good deal about the etchings. It was decided, in principle, to do something in England. As I remarked to Duret, the whole problem is to have what will interest his English public of collectors. I went through the engravings I have ready with the exception of three or four things; these will not be sufficient. I should like to get busy; as soon as I can buy some coppers, I will begin a series of drypoints from nature. Certain corners of Pontoise and Osny ought to be done.

Our poor friend Manet is terribly sick. He has been completely poisoned by allopathic medecine.[3] He has a gangrenous leg; this

[1] *Paul Gauguin, then still a Parisian stockbroker, had entered art as a collector of impressionist paintings and thus came in contact with Camille Pissarro. When Gauguin began to paint, it was Pissarro who got his works admitted to the exhibitions of the impressionist group. During his stay at Osny in 1883 Gauguin painted the entrance to the village at Pissarro's side. See figs. 6 and 7.*

[2] *Galleries where official or commercial art works were exhibited.*

[3] *Pissarro was an ardent believer in the virtues of homeopathic medicine.*

condition results from his having taken tremendous doses of spurred rye. We are losing a great painter and a man of charm.

My dear son,

Renoir opened his exhibition on the first; on the evening before, the press and the *Friends of the Arts* held a reception. I had dispatched a special letter to your uncle Alfred who was very flattered. The next day he took me to hear the Concert Colonne at the Châtelet. First we lunched and then went to the hall. There was a fine program! Schumann, Bizet (new to me), Berlioz (ditto).—I can scarcely express how I marveled at the *Hamlet* and *Roméo et Juliette* of Berlioz.—He belongs with Delacroix, with Shakespeare, he is of the same family, he has the mark of these men of genius. He is prodigious in movement, imagination, strangeness, vigor, delicacy, sense of contrast, he is terrible and suave.

I have been invited to dine with Duret, de Bellio,[1] Monet and Renoir.

OSNY, APRIL 10, 1883

My dear Lucien,

The weather is superb except for a very keen wind which causes me to lose much time.—I am doing a portrait of your mother in pastel [1565], it seems it is not adequate as a likeness, it is too old, too red, not fine enough, in short, it won't do. This surprises me not at all. You know that everyone accepts the one I made pretty obvious, but that is not much good either.

I am almost ready for my show. It is going to be a lot of trouble getting my pictures from the collectors, and it will involve some expense. Renoir has a superb show, a great artistic success, of course, for here you can't count on more than that. I shall appear sad, tame and lusterless next to such *éclat*. Well, I have done my best.

I believe our exhibition in London has gone with the wind, the

[1] *The Rumanian doctor, de Bellio, was intimate with the impressionists and owned an important collection of their works.*

disappearance of Durand's clerk changes everything. . . . I am making drypoints to be ready for a future show in England.

The children are in pretty good health. . . . All of them draw, and the drawings always are to be sent to Lucien. But I deceive them about this, for otherwise my letters would be enormous and costly. However there are times when I am tempted to send you their fantastic landscapes, terrible horsemen, frightful massacres, in which warriors continue to battle even when they have lost their heads; here is bravura pushed to the limit, people running like Hop-o'-my-thumb, here is an incredible Hoffmanesque world of fantasy! I should be happy if these youngsters gave as much attention to their studies as they do to their drawings.

<div align="right">OSNY, APRIL 18, 1883</div>

My dear Lucien,

I am ready [for the Durand-Ruel show], and I am discontented. I will not exhibit my ink drawings, I shall only show important works. I shall follow the example of Monet and Renoir who did not show more than fifty well chosen canvases, which thus were well spaced; it was a good idea, and, incidentally, brought success. I am sad enough in my pictures, there is no point in wearying still more with a lot of little knick-knacks which can have little interest to strangers.—My doubts increase as the moment nears. I saw the etchings Whistler sent the Salon, they are splendid, correctly drawn, strong.

<div align="right">OSNY, APRIL 22, 1883</div>

My dear Lucien,

I finally received your long letter of eight pages. It is stamped "London" and dated the 13th, and yet only got here on the 18th, second delivery. Unquestionably it was opened by the postal authorities, for the envelope is smudged. One has only to read such or such a newspaper to be suspected and put on the index. I would not be surprised if something like that were responsible for the lateness of your letter.

I expected to leave today for Paris, my canvases are packed, and

<div align="center">27</div>

I wanted to spend from the 20th to the 24th seeing my collectors, owners of my works, to choose the most interesting pictures, but our hopes are often thwarted. I see that I shall not be able to leave until Sunday, thus I shall have only two days in which to make my selection, and this will not suffice. I also counted on printing during my stay in Paris a series of drypoints done here from nature.[1] But our maid quit, and that upset everything.

Yesterday I got your last letter. It arrived on time. I suppose that the postal authorities are reassured about our intentions and see that they were on the wrong track.

P.S. I am in Paris. Renoir told me that Durand-Ruel is showing our works in London; the show is supposed to have opened yesterday. It must be on Bond Street; find out.

PARIS, APRIL 24, 1883

My dear Lucien,

I find it curious that Durand should have used [in London] white frames for my pictures, when here he won't permit it under any circumstances.—I should have liked to see the exhibition myself. What you report about the way the pictures were crowded together is terrible. We are not guilty of such lapses here. It is true that if the tapestries are that frightful official red, there is no remedy. Yes, Whistler is right, here is another convention which must be demolished.

Duret, Gonse (of the *Gazette des Beaux-Arts*), Burty, Hirsch, the painter, etc., have opened an exhibition of Japanese prints at Petit's; it is simply marvelous. I find in the art of this astonishing people nothing strained, a calm, a grandeur, an extraordinary unity, a rather subdued radiance which is nevertheless brilliant; what astounding balance, and what taste!

[1] *So far Pissarro had no printing press of his own. It was only during his visits to Paris that he could occasionally get a few proofs of his plates printed at the studios of Degas or Jacque or at the establishments of Salmon or Delâtre, the etching printers. The impressions of this period are therefore rather scarce; some of them, in fact, bear in the artist's handwriting a memorandum,* imprimé par Degas *or* imprimé par Jacque.

My dear Lucien,

I am sending you *Le Figaro*, you will read M. Wolff's stupid piece on our poor friend Manet.[1] I do not have to tell you how indignant I am at the manner in which this gentleman treats the pure-bred artist who shed such glory on this country in an epoch dominated by commercialism. The article in *L'Intransigeant* is very fine, very just, and worthy of its subject, but the artist's works tell us more about him than anything the journalists can write.

My show opened Monday evening; many visitors, despite the fatigue everyone felt who had spent the day at the opening of the official Salon.

Am I happy? Gracious, no, my pictures don't get across.—I have been paid many compliments; but I do not compliment myself. Aside from two or three things, the show is weak. Enough said on this subject.

I shall leave Paris on Friday, in the afternoon.—Thursday, I am going to Manet's funeral.

My dear Lucien,

I am leaving for Pontoise this afternoon, and am bringing a maid with me. When I arrive there your mother will leave to see my show. I hope it will please her.

You will see in *L'Intransigeant* the account of the burial of our lamented Manet. Antonin Proust[2] said some words full of emotion; the newspaper, which is biased, called his speech undistinguished, but everybody said it perfectly expressed their feelings.

Duret left today for London. He promised to look you up; he will tell you about my exhibition. It goes without saying that I

[1] *Albert Wolff, famous art critic of* Le Figaro, *was completely hostile to the impressionists whom he referred to as "madmen." It may be noted, however, that Manet began his portrait, but did not finish it. In his obituary piece on the painter, A. Wolff granted that he had left "several superior works," and summed up Manet's importance as follows: "Manet in the future will be valued more for what he attempted than for what he achieved."*

[2] *An intimate friend of Manet, then Minister of Fine Arts, who had obtained the Legion of Honor for the painter.*

29

received not a few compliments. The ones I value most came from Degas who said he was happy to see my work becoming more and more pure. The etcher Bracquemond, a pupil of Ingres, said—possibly he meant what he said—that my work shows increasing strength. I will calmly tread the path I have taken, and try to do my best. At bottom, I have only a vague sense of its rightness or wrongness. I am much disturbed by my unpolished and rough execution; I should like to develop a smoother technique which, while retaining the old fierceness, would be rid of those jarring notes which make it difficult to see my canvases clearly except when the light falls in front. There lies the difficulty—not to speak of drawing.

M. Tassin of Pontoise, who works for the railroad, asked [Durand-Ruel] the price of two still-lifes. He was shown the price list: 1,200 francs each. He jumped! He met me as I was leaving the exhibition, showed great surprise, gave a few criticisms of my work, and then made several observations which showed him to be a man skillful at handling figures. He said to me:

"But do you know that you have 300,000 francs' worth of paintings in there?"

"Really! I never computed their value, I didn't know! And how do you know?"

"Simple! they gave me the book of prices, I instantly added up the first column, that was so much; there were five pages, I computed the average, that gave the result."

Isn't that wonderful? And what respect!

OSNY, MAY 9, 1883

My dear Lucien,

I see from your letter that your mother is influenced by the art criticism of the newspapers, but if we were to listen to the ideas of all those gentlemen who express their feelings about us, we would have our hands full. I stoically ignore all that.—I well remember that around 1874, Duret, who is above reproach, Duret himself said to me with all sorts of circumlocutions that I was on the wrong track, that everyone thought so, including my best friends, those

30

most interested in me.[1] I admit that when alone, with nobody to prompt me, I reproached myself similarly,—I plumbed myself,—decision was terribly hard.—Should I, yes or no, persevere [or seek] another way? I concluded in the affirmative, I took into account the risks of the unknown, and I was right to stick.

Huysmans, the naturalist author, has just sent me his book *L'Art Moderne*,—it is a collection of his pieces on the Salon and our exhibitions between 1879 and 1882. I read his book with extreme interest. He has a real feeling for our approach. Except for a few points of disagreement, which I mentioned to him in a letter, I share his view. For a while he considered us sick, touched with the disease that attacks painters, "Daltonism." Little by little he has come to take the position that we are cured, and he calls us the only painters of the moment, convinced that we represent the regeneration of French art which had reached its last gasp.—M. Huysmans is exceedingly kind to me in particular. Such encouragement is an incentive to do better work. I will send you the book as soon as I go to Paris, for I will ask Gauguin to buy a copy and mail it to you. You will also be very pleased to find in reading the book that you are not alone in your enthusiasm for Degas who is without a doubt the greatest artist of the period.

My dear Lucien,

Your mother is not back yet, I have not heard from her, and I don't know when she will return. I cannot tell you whether or not my exhibition has made a noise in Paris; here in Osny, I devote myself exclusively to painting, and besides I feel little desire to read those eternal criticisms. If in London we are reproached for showing unfinished work—here we are accused of having sick eyes, *"the sickness of painters who see blue."* Even Huysmans deplores in his book this disease of the visual organ, however on the

[1] *These letters of Duret, found in Pissarro's papers, urge the painter to abandon the impressionist group and to try to be admitted to the official Salon where his work would be seen by forty thousand people. Duret advises him to choose for the Salon "paintings which have a subject, something resembling composition, pictures not too freshly painted . . ." Pissarro did not heed this advice, but Monet, Sisley and Renoir were to follow it after 1880 and show at the official Salon.*

31

other hand he declares that now we are cured. You will see, alas, that like all the critics, under the pretext of naturalism he makes literary judgments and most of the time sees only the subject of the picture. He puts Caillebotte [1] above Monet. Why? because he painted carpenters, boatmen, etc. But then Delacroix is nothing, the ceiling of Apollo nothing!

We can only have a good exhibition if we ourselves arrange it. The Paris exhibition is pretty good though the hall is poor. I placed the pictures quite far apart.—I am fairly well satisfied with my arrangements, Durand gave me complete freedom. I have two rooms of white frames, the effect is good. My *Market* [1361], on which I worked so much since last year, is splendid in a white frame. Today's *L'Intransigeant* mentions it. It is taken for a pastel.[2] I haven't a single pastel, oh yes, one, a tiny one in a dark corner. They confuse everything, gouache, tempera, oil. What connoisseurs!

OSNY, MAY 21, 1883

I recognize fully that you do not draw well, my dear Lucien. I told you any number of times that it is essential to have known forms in the eye and in the hand. It is only by drawing often, drawing everything, drawing incessantly, that one fine day you discover to your surprise that you have rendered something in its true character. Don't despair. If you could work evenings in the free art schools where there are nude models you would make progress. There must be low-priced schools in London; here there would be no difficulty. You ought to find out from Duret. I do not know if I can go to London this year. This would require money and things are always pretty tight.

[1] *A painter who showed with the impressionists. His wealth enabled him to buy many pictures from them. His important collection was to be left to the state.*

[2] *The article, written by Edmond Jacques, says of the exhibition: "There are many pastels which are marvels. First I must mention* The Harvest *[1358] whose perspective is so deep and harmony so warm, the* Market at Pontoise *[1361] full of life and movement, and the* Girl Tending a Cow *[1362] a woman so naive and a cow so admirably drawn. This is a rare collection."*

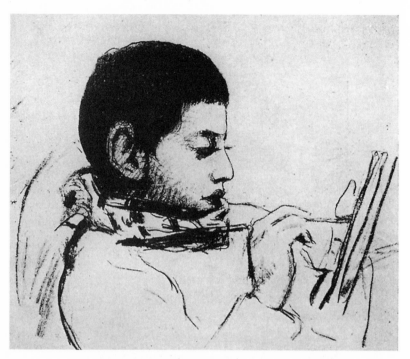

1.—C. Pissarro: Portrait of the Artist's son Lucien, 1874.

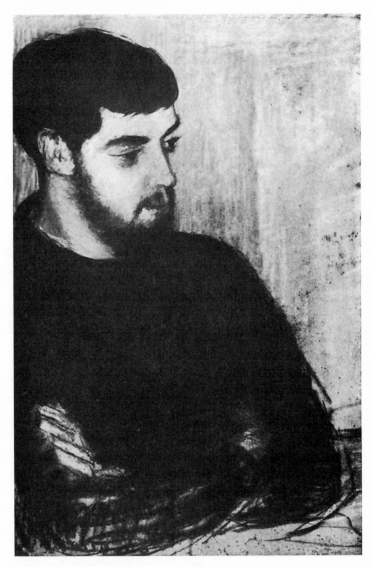

2.—C. Pissarro: Portrait of the Artist's son Lucien, 1883.

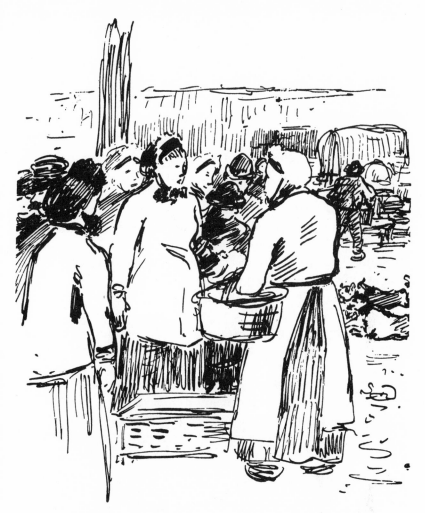

3.—C. Pissarro: Marketscene. Pen and ink sketch, about 1883.

My dear Lucien,

My show is over.[1] Sisley's opens next. I am helping him prepare
for it.

I am going to look at houses at Meaux. Sisley told me that the
country is marvelous.

[1] *While his show was still on, Pissarro had received a letter from Durand-Ruel say-
ing: "I intend to send three of your pictures to an exhibition which opens on July 1st
in Boston. We should try to revolutionize the new world simultaneously with the old."*

My dear Lucien,

I have not been able to write you, for during the last five or six days I have been seeking what appears to be unfindable—a maid. At last I caught one on the wing, I sent her off to Osny, she is nothing remarkable, a simple lass just arrived from the country. Apparently she won't do—worse luck; for to find her cost me all my time, time which I might have employed looking for a town to replace Pontoise.

Yesterday I went to Meaux, spent the day there, and returned to Paris in the evening.—It was terribly hot, so I looked over only one section of the town, which is quite large. But I did visit the outskirts. The city itself, at first glance, has little character: the market is frightful, an immense modern shed, built like a railway station, less interesting than the Halles in Paris, whose proportions give it character. True, there were no tradesmen, from whom it, of course, derives its qualities: in short it did not impress me. The cathedral is superb. Some parts of the outskirts are attractive, with very interesting views of the cathedral, but in regard to types I fear it doesn't come up to Pontoise.—One would have to return two or three times. As for the houses, I found only two, and neither is any good. It is very difficult to get all the details on the spot.— Your mother insists that I am staying too long in Paris, and I agree with her, but two things are requisite for conducting a proper search: going from one place to another and time to waste.—I went to Ecouen, Villiers-le-Bel, it doesn't suit me.—We did consider Versailles, but I am much afraid of that false capital, no types to interest me, I should much prefer Meaux.

I can see no harm in drawing the nude, the figure, if you are permeated with the idea of not following Legros [1] in the field of Greek theory, and are resolved not to seek formulas, not to be influenced by *apt pupils*, not to *fix the proportions in advance*, in a word if you can learn to see for yourself and to draw without relying on a ready made system.

Tell Legros who you are. He knows me. If need be, I can write to him or get someone else to recommend you. You could get Duret, who must be in London, to introduce you.

[1] *Alphonse Legros, a French painter who became a British subject, taught in London in a painting academy, the Slade School, which Lucien was about to enter.*

34

My dear Lucien,

I mentioned to Degas that you are thinking of taking Legros'
course in drawing. Degas says that there is one way of escaping
Legros' influence, the method is simply this: it is to reproduce, in
your own place, from memory, the drawing you make in class. I
suppose that you begin by making a sketch of the whole figure;
when you get home you prepare your sketch and try to do again
from memory what you did from nature. The next day, in class,
you finish a part of your figure; at home you go on with the work
from memory. Little by little you finish both studies simultane-
ously, then you compare them. You will have your difficulties, but
a moment will come when you will be astonished by the ease with
which you retain forms, and, curiously enough, the observations
you make from memory will have far more power and be much
more original than those you owe to direct contact with nature.
The drawing will have art—it will be your own—this is a good
way of escaping slavish imitation.

You speak with some severity of the Academy exhibition. It is
very likely that you are right, but one must not make the mistake
of judging English art in the way French art is sometimes judged
here, as if it were represented by Bastien Lepage and Gervex. Re-
member, England has Keene,[1] he does not exhibit, he is not fash-
ionable, and that is everything. England, like France, is rotten to
the core, she knows only one art, the art of throwing sand in your
eyes.

My dear Lucien,

Yesterday Gauguin came to spend the holidays and make some
studies. He told me that he was working on a project which may
materialize some time, the project is to make models for *impres-
sionist* tapestries. He asked me to try my hand at this, and do some-
thing revolutionary. Naturally I accepted, mostly with the idea of

[1] *Charles Keene, watercolorist, draftsman, caricaturist and engraver, held in England
a position comparable to Daumier's in France.*

35

opening up a field for you. Evidently this is an easily exploited field of industrial art, only one must draw, and draw often. When something develops I shall let you know.

My dear Lucien,

Today I go to Paris with Gauguin whose leave is up; I shall try to sell a few canvases, for Durand leaves us to our fate. At the same time I shall on the 12th remove my things from the rue des Trois Frères. I think I shall much regret no longer having one foot in Paris.—This was very useful for me, since it enabled me to keep up with everything that concerns painting. But we must do the best we can.

In your last letter you asked me to inform you about the views of Clemenceau,[1] and thus clear up a discussion you had. My dear boy, it is naive to bet on any man in the Chamber, if you have ever done that.—You were both right. This would seem to be a joke, but no, it is the plain fact.—You were right in a way since Clemenceau did indeed come before the electorate with a very advanced, even a socialist program, but this does not make Alfred wrong in characterizing Clemenceau as a *Jacobin*, a "deep-dyed" —to quote *Le Figaro*—radical, but nevertheless no socialist. That is to say he is a politician who wants to come to power on the basis of a progressive program. Don't trust even his radicalism, he is a sort of Gladstone,—he isn't worth much. Moreover, if you read the article "Revision" in the copy of *Le Proletaire* which I am sending you, you will see what we think of him and of all the celebrated republicans who promised so much; but don't worry, they give little.—The gentlemen who resigned from their club on account of Clemenceau are extremely naive, for he is a bourgeois deputy. You will think that I have changed and indeed I did, the moment I saw that what I had considered pure gold was dross. Right now all the radical deputies are campaigning for revision [2]

[1] *Clemenceau, then socialist deputy from Montmartre, had just delivered a speech in the Chamber of Deputies in "defense of the Republic against the old regime, advocating the emancipation of the worker, which would lead to his education and development, supply him with tools for work, and give him in his turn a place in the sun."*

[2] *This might be an allusion to a revision of the mode of electing municipal councils which was then being discussed in the Chamber of Deputies.*

although they know it will come to nothing, since the Senate will not permit it. They have one method of attack which the socialists urge them to employ, this is to resign en masse; there would be new elections, and convinced socialists would get in—but there's no danger that they will take this step, they are too afraid of not being re-elected. The whole affair is not serious.

Are you drawing?—Don't waste time, try to improve your work, remember the drawings of Holbein you copied, he is the real master. Don't strive for skillful line, strive for simplicity, for the essential lines which give the physiognomy. Rather incline towards caricature than towards prettiness.

I think it would be better for you to make pastels than to make gouaches for a bit, since you have made much progress with pastel. I looked again at the head you did of a peasant, it is not bad.

PARIS, JULY, 1883

My dear Lucien,

You will receive a check, probably on Tuesday or Wednesday, from Durand; he now is a little less pinched for cash; he seems to be very satisfied with the way the exhibition of our works now being held in Rotterdam is going. He claims that the worst is over. Unhappily the political future is not rosy, as you can see for yourself. From England you are able to see the totality of facts in a better perspective. Clearly it is not the socialists who are dominating events, but the Orléanists and Bonapartists with their usual intrigues—and hence, the capitalists. This winter there will probably be a clash, they may attempt a coup d'état; since Chambord's death the army has been split into two camps. What will result from all this we do not know. I think that these developments will favor the republicans, let us hope so in any case. In the meantime artists will have to endure these circumstances; perhaps the best thing to do is to find a place in industry while waiting for better times.

While you have the time—time should not be wasted—make drawings; it will do you more good than you can imagine. If you just made copies of bas reliefs or Egyptian statues, but did them with scrupulous care, you would make progress. It is best to select simple things like a sphinx, some oxen, etc., there must be some good things of this type at the Kensington Museum, not photo-

37

graphs, the originals themselves. Thus you will get the most perfect insight into the problem of simplification. The primitives aren't bad for this either, on the contrary: Holbein, *and do not neglect nature.*

You need only assert your will. Here they complain that France no longer occupies the position it held in industrial art, and they try to retrieve the lost superiority, but the measures they take to achieve this end are self-contradicting, for they make talentless, timid, humdrum artists professors of drawing.

My dear Lucien,

I haven't done much work outdoors this season, the weather was unfavorable, and I am obsessed with a desire to paint figures which are difficult to compose with. I have made some small sketches; when I have revolved the problem in my mind, I shall get to work. I had Nini [1] pose as a butcher's girl at the Place du Grand Martoy [615]; the painting will have, I hope, a certain naive freshness. The background, that's the difficulty. We shall see. As for my large canvases, I have two which you know, pictures I meditated on for two years. My *Apple-Eaters* [695] I worked on a good deal, I should like to finish it by April! [2]

I don't have a copy of *Abbé Mouret's Transgression* [Zola's novel], I shall pick one up and send it on to Esther, but she will not like the book, she has lived too long in England to appreciate a work of this sort. It is too strongly naturalistic.

My dear Lucien,

What you tell me about your activities in Regent Park is all very well, but you have to understand that little bits of drawings are not enough. These must be made, of course, for you must accustom yourself to seeing the ensemble in a flash and to rendering

[1] *Lucien's cousin, daughter of his mother's sister.*
[2] *This large canvas, 50 x 50 inches, was actually finished in 1886.*

its character at once, but you also have to grow in strength and attack in a serious way bigger things with firm contours, like what you began here.—It is good to draw everything, anything.— When you have trained yourself to see a tree truly, you know how to look at the human figure. Specialization is not necessary, it is the death of art, whose requirements are exactly opposed to those of industry.—Once again I say, you can't waste time drawing landscapes conscientiously. The classroom is good only when you are strong enough not to be influenced.

I know Legros quite well, Monet and I had lunch with him when we were in London [in 1870], he may remember me, he may have totally forgotten me. I could get you introduced to him, but I fear his influence. You must follow Degas' advice to the letter, and with an iron will; it is much more important than you imagine; all the more so since I want you to be protected against Legros, he has lost sight of much that he once did here, or so I am told. How much does he want? Write me.

You wrote that there is a rather simple old fellow who has an Academy but is rather lax in running it. This would be just right, for, let me repeat, I fear Legros has a *preconceived method.*

Watercolor is not especially difficult, but I must warn you to steer clear of those pretty English watercolorists, so skillful and alas so weak, and so often *too truthful.* Look at the little wash drawings of Turner. But the trick cannot be learned, you can do it when you know how to draw. Oil is much more difficult, but when you master it, you can do with it what you want to do. Think of the watercolors of Delacroix, Jongkind. Who else? Degas, Manet —with the rest it is a technique, though there are some who bring talent to it. When you have occasion to, look at the Persians, the Chinese, the Japanese. Derive your taste from those who are truly strong, for you must always go to the source: in painting to the primitives, in sculpture to the Egyptians, in miniature to the Persians, etc., etc.

Please read the defense of Louise Michel.[1]—It is really remark-

[1] *Louise Michel, a famous revolutionary, sentenced to lifelong exile in New Caledonia after the Commune, pardoned in 1880, had just been arraigned for having incited unemployed workers to pillage. In court she declared: "If there is guilt from your point of view, then I am guilty, and I alone. I incited all my friends. It is I who should be punished, I alone. I live only for the revolution. I will always work for it. It is the revolution that I salute. May it rise on the shoulders of men and not on a world in ruins."*

able. This woman is extraordinary. She renders ridicule harmless by the force of her feeling and humanity.

* * *

During the summer of 1883, Lucien Pissarro visited his family in France, and, before returning to London, spent several days in Rouen where his father was working. The correspondence was continued in the fall, after he returned to England.

* * *

ROUEN, OCTOBER 11, 1883

My dear Lucien,

I am hard at work, at least I work as much as the weather permits.—I began a work the motif of which is the river bank in the direction of St. Paul's Church [606]. Looking towards Rouen I have before me all the houses on the quays lighted by the morning sun, in the background the stone bridge, to the left the island with its houses, factories, boats, launches, to the right a mass of pinnaces of all colors.

In the evening I work at Le Cours-la-Reine on the motif you know about [602]. Yesterday, not having the sun, I began another work on the same motif in grey weather, only I looked more to the right [603].

I must leave you for my motif. I have a room on the street. I shall start on a view of the street in fog for it has been foggy every morning until eleven o'clock—noon. It should be interesting, the square in the fog, the tramways, the goings and comings [608, 609].

Until next time, then, and work with ardor. You know that to succeed one must work hard. It is a good idea, while you are *at leisure* in London, *to keep this in mind,* for do we know how long this freedom will last?——Draw more and more often,—remember Degas.—If you want to make copies of the primitives, there are plenty of paintings in the National Gallery, there are the *Egyptians,* the *Holbeins.* Paint the figure; and don't excuse weakness by the fear of drawing freely in public.

Yesterday, while I was working, a little rentier pestered me to

40

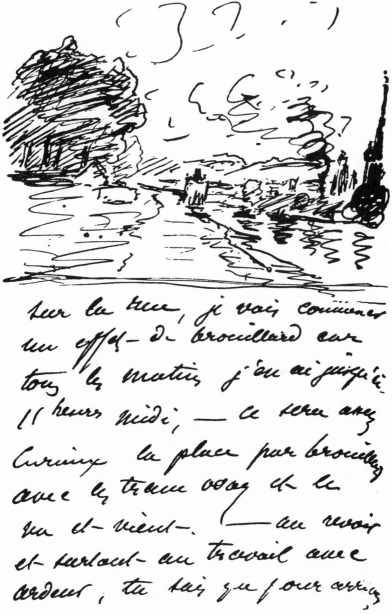

4.—Page from Camille Pissarro's letter, Rouen, October 11, 1883.

death. This poor fellow spoke to me about a young man of nineteen, from this neighborhood, whom he wants to help. This young man is full of ardor and has invincible faith, he has only a hundred francs a month, and he is going to Paris for three or four months.

So I was asked to go and look at a portrait done by this young man. Another painter who will be swallowed up in Paris, or is he strong enough to resist? has he talent? Pardon me, talent is not what is required, everybody has talent nowadays. Well, we shall see. Here comes the sun, I must leave you until next time.

My dear Lucien,

Yesterday I received your letter in which you mention the various works you have begun. Let me urge you to complete whatever you begin. However I know myself the difficulty or rather the difficulties that beset one unexpectedly when working outdoors. Here the weather is always changing, it is very discouraging. I am working on nine canvases, all of which are more or less well advanced. The day after your departure I started a new painting at Le Cours-la-Reine, in the afternoon in a glow of sun [602], and another in the morning by the water below St. Paul's Church. These two canvases are fairly well advanced, but I still need one session in fine weather without too much mist to give them a little firmness. Until now I have not been able to find the effect I want, I have even been forced to change the effect a bit, which is always dangerous. I have also an effect of fog, another, same effect, from my window, the same motif in the rain [608], several sketches in oils, done on the quays near the boats [610, 611]; the next day it was impossible to go on, everything was confused, the motifs no longer existed; one has to realize them in a single session. Yesterday I began to work on a charming motif, a view from the balcony of a café facing Le Cours-la-Reine, unfortunately it is only a canvas of about 21 x 18 inches. I shall do it over again, at least I can finish it.

We shall see what Durand will say, I am expecting him Sunday. The Murers [1] left yesterday, they were very kind to me. Since

[1] *Eugène Murer and his sister Marie. An ex-pastry cook, a novelist and painter in his leisure time, Murer was a friend from childhood of the painter Armand Guillaumin through whom he became acquainted with the group of impressionists. He acquired a very important collection of their works, sometimes obtaining a canvas in return for a certain number of meals. Managing with his sister the Hôtel du Dauphin et d'Espagne in Rouen, he advertised a "Magnificent collection of impressionist paintings, which can be seen any day without charge between ten and six." Renoir painted portraits of Murer and his sister, as did Pissarro [469, 1537, 1538].*

they are part owners of the hotel they arranged to let me have a magnificent room on the street and all my meals for one hundred and fifty a month. I work at my window on rainy days, I think the paintings I do then are my best work; not easy to sell, however. It is raining now, I run to my window.

P.S. I bought *Piping Hot* and *The Ladies' Paradise* [by Zola], which I am about to read. I don't see any point in sending them to London where they will not be enjoyed.

I dined with Monet's brother at Deville. He showed me some Monets and some small but superb Renoirs . . .

I showed my studies to Morel.[1] He responded by exclaiming: "Ah! ah!"—"Look at that!"—"Strange!"—"Interesting!", etc. I don't believe he likes my pictures, however he told me that when he saw my *Peasant Girl Taking Her Coffee* [549], he thought it so fine that he wanted to write and tell me so, but he did not know my address. He called it flawless. However I don't believe my work changed much.[2]

ROUEN, OCTOBER 22, 1883

My dear Lucien,

Yesterday I was visited by Monet, his brother and son, Durand and his son. We spent the day together at Deville. The day was beautiful and we went to Canteleu, a village on the outskirts of Deville, on a high hill. We beheld the most wonderful landscape a painter could hope to see. The view of Rouen in the distance with the Seine spread out as calm as glass, sunny slopes, splendid foregrounds, was magical. I will decidedly go to this village to paint next year, it is marvelous.

Durand found my pictures very fine.—But the weather keeps me from finishing them, and a bad cold keeps me in my room.

[1] *A young painter whom Pissarro met in Rouen and advised; possibly the artist mentioned in the previous letter.*

[2] *The picture dates from 1881.*

My dear Lucien,

M. [Morel] finally left.—The poor boy kept deferring his trip. However I never let him see how bored I was with his absurd conceptions which if not wholly wrong are certainly depressing. I did not want to hurt him, but such reasonings could never lead to anything strong.—He was fated by his very logic to get nowhere.

"Why make studies from nature, nobody appreciates them? I dropped that, I made myself a jack-of-all-trades, I used every trick . . ."

"And", I replied, "you are a success? . . ."

"You see they didn't want good work, very well, I'll give them something for their money . . ."

Ideas stemming from impotence, for an artist should have only his ideal in mind.—He lives poorly, yes, but in his misery one hope sustains him, the hope of finding someone who can understand him; in three out of four cases he finds his man.—I know perfectly well that tricksters, tricksters with real energy, heap up fortunes, but either they pass by like clouds, or they know they are inferior, and feel degraded. Of course this is a question of temperament.—Anyhow, M. told me before he left that he would try color division, soft tones, etc., but he would add "beautiful" motifs. We have heard all that before, it makes me think of V., [1] they are all the same, they want to run with the hare and hunt with the hounds.

Yesterday I received a letter from Gauguin, who probably had heard from Durand that I did some good work here. He is going to look me up and study the place's possibilities from the point of view of art and practicality. He is naive enough to think that since the people in Rouen are very wealthy, they can easily be induced to buy some paintings. . . . Gauguin disturbs me very much, he is so deeply commercial, at least he gives that impression. I haven't the heart to point out to him how false and unpromising is his attitude; true, his needs are great, his family being used to luxury, just the same his attitude can only hurt him. Not that I think we ought not try to sell, but I regard it a waste of time to think *only* of selling, one forgets one's art and exaggerates one's value. It is better to

[1] *Probably an allusion to the landscape painter Victor Vignon.*

get low prices for a while, and even easier, particularly when your work is strong and original, and to go ahead bit by bit, as we do.

What will Gauguin think when I tell him about my talk with Monet who is completely opposed to another exhibition in Paris? [1] This is also Renoir's position.—The people of Paris are fed up: let's not start anything. And truly, I think we have had enough exhibitions. But what will Gauguin not say!—The fact is he has his reputation to make!—I really don't know what to say to him, yet I think it absurd to weary everyone with our affairs, and then I have made up my mind to bide my time.

I will probably leave Rouen in five or six days, for since yesterday the weather has been tame.—I finished six of eleven paintings, of the five unfinished two are passable.—I did not waste my time.

ROUEN, NOVEMBER 10, 1883

My dear son,

I told you that Gauguin was looking for a house in Rouen. He has found a place and is coming to take Rouen by storm, at any rate to try it for a year. He is half-dropping finance for art.

I sent you *Le Figaro*, you will read in it that the impressionists were a sensation in Berlin. Menzel found the paintings poor. And now *Le Figaro* out of patriotism defends us, a strange reversal! [2] But I've seen many strange things! As for Menzel's views, they did not surprise me; he is evidently a man of talent, but heavy and bourgeois as the deuce. Degas was at one time enthusiastic about him and sent us to Goupil's to see his canvas *The Ball Room*. I went, of course, hoping to find and admire a masterpiece, I went quite unprejudiced, with Miss Cassatt. We found a muddy canvas, carefully executed, yes, but without art or finesse. We both found it mediocre. Later I saw some of his watercolors that had the same

[1] *The previous impressionist exhibitions had been very incomplete, for Monet, Renoir and Sisley had elected to send their works to the official Salon. Pissarro and his friends were opposed to holding a group exhibition in 1884. Thus Gauguin, who had participated in the group's exhibitions in 1880, 1881 and 1882, was unable to show his work again.*

[2] *In fact Le Figaro, which in Albert Wolff's reviews had always belittled the impressionists, unexpectedly took this view of the exhibition in Berlin: "These painters, some of whom are masters, are so well known in Paris that there is little point in again evaluating them . . . No doubt the great Menzel is completely wrong about some of the canvases that were exhibited."*

defects, most particularly the same clumsiness and bourgeois spirit. We were then able to make an interesting comparison of this insignificant painter and Degas. Degas, after he had seen the exhibition at Goupil's, did a rough copy of Menzel's *Ball*. Returning, we were astonished by the superiority of Degas' sketch.[1] It is true that a sketch has more charm; just the same Degas' work was there before our eyes and invited comparison with Menzel's. It is absurd to compare Monet with this lubberly German, or even Renoir.— After a while people will get the point.

Degas in examining the canvases of this painter saw in them careful studies of particular types, drawn not without art; but the work is uninspired.

ROUEN, NOVEMBER 20, 1883

My dear Lucien,

Turner's drawing [of Le Cours-la-Reine] looks quite good, it seems to me that you must have copied it from memory, for you left out the trees. I would have liked to have a faithful copy, you can make one. No carelessness at the start, carelessness so easily becomes habitual! It is strange that Turner chose just this motif. That's the way it is in Rouen, you are always struck by the same places. Yesterday I made a drawing of the rue de la Grosse Horloge. I had scarcely finished it when I saw a lithograph of the same street done in 1829 or 1830 by Bonington. But the street has changed: in the foreground there is a house with wood carving which is no longer to be found.—I have also made some drawings from wood sculptures, pure Gothic, with little ornamentation, they are simply marvelous. This is the way to understand the realism of that period. The nudes are admirable.—If you have time, you should copy them; there must be some things of this sort in the London museums.

You tell me that if I have a show in London I should send my best works. That sounds simple enough, but when I reflect and ask myself: which are my best things? I am in all honesty greatly perplexed. Didn't I send to London my *Peasant Girl Taking Her Coffee* [549], and my *Peasant Girl with Branch* [540]? Alas, I

[1] *Degas made a copy of Menzel's painting which was listed No. 30 in the catalogue of the third sale of his atelier. See fig. 11.*

shall never do more careful, more finished work: however these paintings were regarded as uncouth in London. So it is not improper selection which explains why my works offend English taste.—Remember that I have the temperament of a peasant, I am melancholy, harsh and savage in my works, it is only in the long run that I can expect to please, and then only those who have a grain of indulgence; but the eye of the passerby is too hasty and sees only the surface. Whoever is in a hurry will not stop for me. As for the young misses touched, alas, with the modern neuroticism, they are even worse, the romantics were much less ferocious! If they looked into the past they would see to how slight a degree the old masters were—how shall I say?—precious, for they were indeed elegant, in the artistic sense of the word.

I have just concluded my series of paintings, I look at them constantly. I who made them often find them horrible. I understand them only at rare moments, when I have forgotten all about them, on days when I feel kindly disposed and indulgent to their poor maker. Sometimes I am horribly afraid to turn round canvases which I have piled against the wall; I am constantly afraid of finding monsters where I believed there were precious gems! . . . Thus it does not astonish me that the critics in London relegate me to the lowest rank. Alas! I fear that they are only too justified! —However, at times I come across works of mine which are soundly done and really in my style, and at such moments I find great solace. But no more of that. Painting, art in general, enchants me. It is my life. What else matters? When you put all your soul into a work, all that is noble in you, you cannot fail to find a kindred soul who understands you, and you do not need a host of such spirits. Is not that all an artist should wish for?

Goodness! What a tirade! I have not been able to send you the newspapers; I couldn't find them. You will see in one of the last issues of *La France* a very clear article on the Tongking incident.[1] That crazy Gauguin has been praising our foreign minister's policy to the skies. I listened to him for a long time.—He slaughtered the opposition for its stupidity and senselessness just as he did during the Tunis incident and on other occasions. I listened quietly, I am always intimidated, I don't know enough about these matters.

[1] *Henri Rivière, who took Hanoï, had just been killed in a surprise attack, and the event had caused the French government to send troops and Admiral Courbet. The latter, in August 1883, forced the Annamite emperor to accept a French protectorate over Annam and Tongking.*

But at last I begin to realize that my poor friend Gauguin does not always see clearly.—He is always on the side of the bastards!— he is more naive than I thought. . . .

My dear Lucien,

I have just come from the seashore [Petites Dalles], from which, despite the constant rain, I was able to bring back two large studies [599, 600].

It is splendid, the country is superb, there are farms, cliffs, forests, subjects enough to keep one always busy. It is quite far, close to Fécamp, but what of that? I hope that next year we will all be able to spend the summer here, and that you will join us. I dream of taking the sea air with my little Tiolo.

My dear Lucien,

I have been home since Wednesday. I unpacked my studies and paintings. They all seem very clear except perhaps the two versions of Le Cours-la-Reine [602, 603] and perhaps another with Le Bon-Secours in the background [601]. The subjects of these paintings are not more beautiful than what I see here. The beautiful motifs in Rouen are the ships and slopes. The outskirts of Rouen, which are in the country, should be admirable.

As for Petites Dalles, the heights with their farms and apple trees are admirable. The sea, than which nothing is more variable, forms the other motifs, which are everywhere interesting. Results of my trip: I am glad to be back in my studio, I look at my studies more indulgently, I feel more sure about what is to be done.

My dear Lucien,

You must *harness* yourself to drawing. For the present draw just for the sake of drawing, later, when you are more skilled, if you

5.—C. Pissarro: Portrait of Paul Gauguin—P. Gauguin: Portrait of Camille Pissarro, 1883.

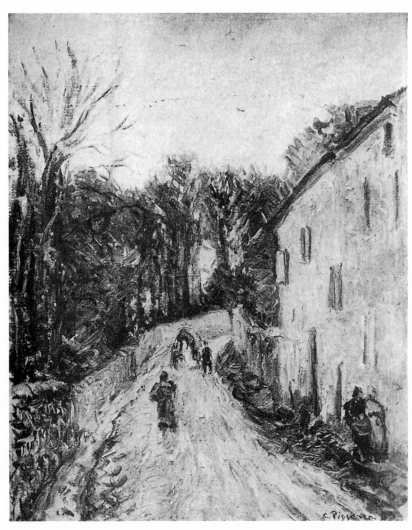

6.—C. Pissarro: Road from Pontoise to Osny, 1883.

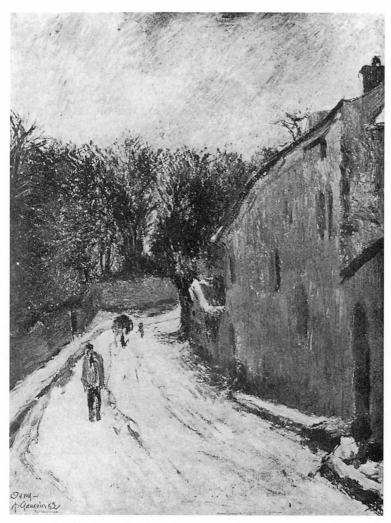

7.—P. Gauguin: Road from Pontoise to Osny, 1883.

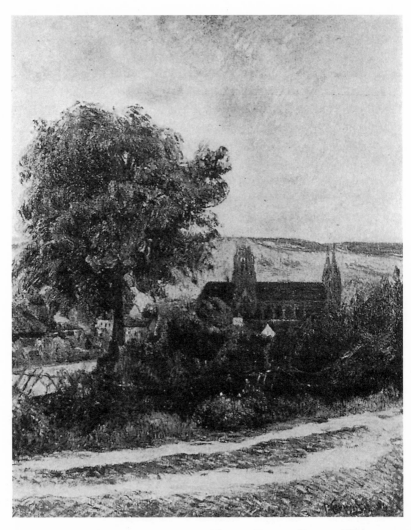

8.—P. Gauguin: Landscape in Normandy, near Rouen, 1884.

have what it takes, you will find your own style. But steer clear of Caldecotte and Kate Greenaway! Remember that the primitives are our masters because they are naive and knowing.

My dear son,

I went to L'Isle-Adam to look at the house with the big garden. I find the country frightful, a vast plain with little slopes in the distance, long, long streets, sad, sad walls, stupid, stupid bourgeois houses. Can a painter live here? I should have constantly to go off on trips. Imagine! No! I require a spot that has beauty! I shall scour the towns and the country, if I find nothing and the house is for rent, we will see!

My dear Lucien,

I am sending you *Les Fleurs du Mal* and the book of Verlaine. I do not believe these works can be appreciated by anyone who comes to them with the prejudices of English, or what is more, bourgeois traditions. Not that I am completely in favor of the contents of these books; I am no more for them than for Zola, whom I find a bit too photographic, but I recognize their superiority as works of art, and from the standpoint of certain ideas of modern criticism, they have value to me. Besides it is clear that from now on the novel must be critical, sentiment, or rather sentimentality, cannot be tolerated without danger in a rotten society ready to fall apart.

The discussion you had about naturalism is going on everywhere. Both sides exaggerate. It is clear that it is necessary to generalize and not lean on trivial details.—But as I see it, the most corrupt art is the sentimental, the art of orange blossoms which makes pale women swoon.

I will look for one or two works of Proudhon on the literary and social question, perhaps Alfred will learn something. But once again, what is the good!!

Of course I can understand someone blushing at coarse jests or

49

erotic passages, but that only proves one is no longer innocent!—
Boule de Suif by Guy de Maupassant may have such an effect, but
Paul et Virginie also gives one definite sensations, even more pro-
found though quite different, one does not blush, for instance!

Why doesn't Alfred read the two little books on socialism which
I lent him?—They are easy reading and should give him a general
idea of the movement which points to the new road our society
must take. I believe that for an Englishman Alfred lacks persist-
ence. Let him read John Stuart Mill, the last works especially; look
what Mill acknowledged before he died! Since Mill was an Eng-
lishman, Alfred will not dispute the accuracy of his judgment. And
he will begin to understand the movement which will change
everything. There is no more time for amusements, you are right,
education is what is necessary. See, then, how stupid the bour-
geoisie, the real bourgeoisie have become, step by step they go
lower and lower, in a word they are losing all notion of beauty,
they are mistaken about everything. Where there is something to
admire they shout it down, they disapprove! Where there are
stupid sentimentalities from which you want to turn with disgust,
they jump with joy or swoon.—Everything they have *admired
for the last fifty years* is now forgotten, old-fashioned, ridiculous.
For years they had to be forcibly prodded from behind, shouted
at: This is Delacroix! That's Berlioz! Here is Ingres! etc., etc. And
the same thing has held true in literature, in architecture, in sci-
ence, in medicine, in every branch of human knowledge. They are
Zulus with straw-yellow gloves, top hat and tails. They are like
the falling, rolling rock which we must ceaselessly roll back in
order to escape being crushed. Hence the sarcasms of Daumier,
Gavarni, etc., etc. You are indeed young to want to convince a
bourgeois!—English or other!

Nini is here. I began a portrait of her, a canvas of about 28 x 23
inches. I set her somewhat sulky face under her curly blond hair
with a great cherry-colored bow on a background of dark blue!
[654]. You can see that from London!—I had a hellish time get-
ting it right. I will be satisfied if I can achieve as good a resem-
blance as appears in that puckered pastel of Alfred [1564]. You
can count on my getting the proper harmony.

Manet's exhibition opens on January 5th.—Manet, great painter
that he was, had a petty side, he was crazy to be recognized by
the constituted authorities, he believed in success, he longed for
honors . . . He died without achieving his desire. Duret, Proust

(Antonin), have been selected to carry out his last wishes and to give a touch of solemnity to the exhibition, they could think of nothing better than to ask the worst officials, Manet's inveterate enemies, to join the organizing committee, and give an official stamp to the ceremony. All the bourgeois gentlemen will be there . . . all those who loved and defended the great artist: shocking! away with them!—Even Fantin-Latour, who, it appears, claims that Manet in his last years had degenerated to such a point that he hoped to change his style through contact with those dilettantes [the impressionists] who produce more noise than art! That's pretty strong, but not surprising!

OSNY, JANUARY 14, 1884

My dear Lucien,

I had a long conversation with Alice, we talked of you.[1] I told her to remind you to go to the academy and seriously devote yourself to drawing the nude. To draw the figure, you have to know anatomy. You need four or five months of work at the academy as a start; the thing to do is to discontinue when the weather gets better and then to go back in the winter. If you could go just in the morning, that wouldn't be bad. When I went I did so only at night so that I could paint during the day. But that is too much to expect of young Englishmen who go out in the evening, isn't it? But calculate that you have little time ahead. Soon you will have to support yourself, and then, beset by other needs, you will have to neglect certain studies. And besides, one must arm oneself at the start with everything necessary for the future fight.

I just received a letter from Gauguin, he has moved to Rouen.

OSNY, JANUARY 22, 1884

My dear Lucien,

I am sending you, with M. Bensusan, a portfolio containing ten lithographs by Daumier and one lithograph of old coins by Delacroix. These are rare by now and I prize them much. I often used

[1] *Lucien's cousins, Esther and Alice Isaacson, were then staying in France.*

to look at them but I am sending them to you in order to give you an opportunity to fill your mind with the real artistry of these two great masters. I am entrusting them to you in the expectation that you will take good care of them, and bring them with you on your next trip. There is nothing better in lithography.

I keenly regret the bad turn Esther has taken, it is a pity, for she has intelligence. . . . Once at a concert we were admiring the splendid unity of the Lamoureux orchestra; she said to me, and with deep conviction: just as an orchestra needs a conductor, humanity needs a leader, a chief. I only had time to make this reply: but not without the consent of his collaborators for otherwise everything would go to pot; thus there is a kind of contract between the musicians of an orchestra and its conductor, who is there simply because he is best able to direct the artists, but is not free to do whatever he pleases,—from this it is a long way to authoritarianism! . . . She would have done better to follow the great concepts of Justice instead of withdrawing into a stupid, absurd and narrow pietism.

Do not be taken in by the facility of beginners, it is often an obstacle later on. So much the better if it is painful for you to take even the first step, the more toilsome the work the stronger you will emerge from it.—Those who have more facility make less progress because they do well right away, with ease and without reflection; they are like the students with good memories. Of course, if one is strict with one's self, facility in execution can be an advantage. I repeat, guard against facility.

It is not surprising that you do not find your forms again with ease, you have been working for so short a time, and it is very difficult. Recommence twenty times if necessary, a moment will come in which you will discover to your astonishment that you know how to draw.—I recall that in the *Académie Suisse* there were students who were remarkably skillful and could draw with surprising sureness. Later on, I saw these same artists at work, they were still skillful, but no more than that. Just think of Bastien Lepage! and Carolus Duran!!! No, no, no, that is not art!

OSNY, JANUARY 29, 1884

My dear Lucien,

Perhaps you would have more success with landscape, you do not draw the figure well enough, not having yet made enough

53

sketches from models. In fact, the best solution for all difficulties is to become a first rate draftsman, and to draw in your own style, but that will come later.

You should give some thought to the problem of how you are to sign your works: my name would be risky, since I have been in disfavor for so long, and then also, people are only too ready to bracket you with someone else. For the present it might not be bad to sign yourself "Vellay," [1] later you may be able to think of something better.

I am not very much surprised about the Henrys, all the feminine readers of Zola open his books with the single purpose of finding gross passages; but the truth is that *The Ladies' Paradise* is really very mild. It offers nothing to those who are not concerned with the enjoyment that art gives.

The children are much better, I am going to devote myself to looking for a house, people tell me that Compiègne is very beautiful.

<div style="text-align: right;">OSNY, FEBRUARY 7, 1884</div>

My dear Lucien,

I am sending you some newspapers. You will read about the sale of Manet's works. Poor results! [2] The bourgeois are always stupid.

As for the troubles the British are having in Egypt, they deserved it! [3] At last *right triumphs over might*. What will the bourgeois say to that! It is all the fault of the so-called "liberal" Gladstone's cabinet of hypocrites and quakers, with their politics of cotton merchants. We were right enough about the arguments of Gauguin and the others!

[1] *Vellay was Madame Pissarro's maiden name.*

[2] *According to the memoirs of Durand-Ruel who with Georges Petit organized the sale of Manet's atelier the results, while modest, exceeded expectations. The total bid for 159 pictures, pastels and drawings was 116,637 francs.*

[3] *In 1881, following the revolt of Arabi Pasha, the British occupied the valley of the Nile. These events led to friction between the British and the French, who had been their partners in the control of Egypt. In 1884 there was a bloody revolt in the Sudan.*

My dear Lucien,

I got back from Compiègne yesterday evening, and I shall not return there. A very level, bourgeois and solemn place, a smaller Versailles and very dull. But there is a Town Hall, and a beautiful Gothic and Roman church. The general view, from the vantage point of a neighboring hill, is rather cold and monotonous. No, it's not for me. Tomorrow I will probably go to Gisors to see Eragny again.

The weather has been almost continuously bad, impossible to do anything. It is too bad you cannot work on the figure during this season. If you want to do some serious work, I think you will have to come back to France, for it seems to me that you have not yet been able to find your way in England. If you can make some drawings that deal with English life send me one of them, perhaps I can do something with it.

Renoir's brother edits *La Vie Moderne*. Renoir does drawings for the paper. It is not very good. Someone told me that I was expected to collaborate, but I have not done so, for I have a horror of *gillotage*.[1]—From a financial point of view it is hardly worth while, I even believe the paper pays only its well-known artists! But one can always try!

To return to the drawings, it is clear that France has little to offer, unless you are a charlatan. If you had a talent for satire, like Forain, but in *your own style, of course*, it would be possible to succeed, that is if you had pull. Send me something I can show to Portier.[2]

This is idle talk. I actually do not know what your capacities are.

~~~~~~~~~~~~~~~~~~~

[1] Gillotage *is a special technique of making drawings for reproduction. These drawings have to be executed on paper with a special grain on which white is obtained by scraping. This technique was very popular at that period.*

[2] *A modest dealer in paints and paintings at the corner of rue Fontaine and rue La Rochefoucauld in Paris.*

*My dear son,*

To give you an idea of what I mean by *done*, I sent you those Daumier lithographs. You received them, of course, but could not have felt them deeply. You have not said a single word about them, but they are "marvels" from any point of view. For myself, I cannot look at them without admiring this great artist. But clearly understand, that if it is *done* that's mainly because it is *constructed*. The junctures of the arms, legs and ankles are as wonderful as in the greatest masters, and these are caricatures! Notice the ties, the collars, the trousers, the folds which reveal so well the forms underneath; the shoes, notice them, and the hands!

My dear Lucien, do not vex yourself about doing something *new*. Novelty lies not in the subject but in the manner of expressing it. When you cite what was *done between Nittis and Whistler*, I must reply again that you exaggerate. Nittis, my dear Lucien, is of little account, he is not dangerous; as for Whistler, he found a formula; very well! but what you must understand is this, you have all the latitude you want to seek a formula. After much study, you will get there, but don't take it into your head that there is nothing to be done; that's what Guillemet used to say: "After Corot, Daubigny, Jongkind, there is nothing left to be done!" Absurd!———What, will art stop just because it produced a Keene, a Whistler? What can have gotten into you? Art went on after the Clouets, the Holbeins, the primitives—other things were done, that's all. No, it is dangerous to occupy one's mind with such notions, it is so much better to strengthen oneself and not give way to the arguments of discouragement which remind me, in a way, of Morel.—If you were here with me, I would have you make *lithographs* and *etchings*, particularly the latter, *and it is always necessary to draw.*

I have been running from one place to another looking for a house. I stayed at Gisors for three days.—We didn't look the place over when we went there together, we didn't see the whole wooded section of the public park, the superb forests with extraordinarily irregular terrain, the ruins of the castle of La Reine Blanche. The park with great trees and towers covered with vegetation, and a view of the church spires in the distance, is superb. Old streets,

three little streams, filled with picturesque motifs; and the country-side is superb, too. I hastily made some watercolors. I promised myself that I would go there to paint, for I haven't found a satisfactory house. I believe I am finally going to take the house in L'Isle-Adam, unhappily it is right next to the cemetery, but the garden is six or seven times bigger than ours, we shall even be able to play cricket. The owner is going to build me a studio in the garden; as far as motifs are concerned they are rather poor; but in summer I can easily go by train to Valmondois, Compiègne, or Auvers. You leave your equipment where you work. As for Rouen, I don't dare go that far away.

Forain, from what I have been told, is not doing the things he used to do. This is a great pity, for he has a fine sense of criticism and is a keen observer. I saw in yesterday's newspaper some drawings by Robida which Gauguin puts above Forain's, how wrong!—skill, an infernal ease, the gift of fantasy, but no style.—What a gap between Degas and all the others!

In Rouen, I bought a copy of Champfleury's *Histoire de la Caricature*, an invaluable book with illustrations by Daumier. In it the whole story of Daumier is told. Looking through this book you see at once that Daumier was the man his drawings show him to be, a convinced, a true republican. And you feel in his drawings the sweep of a great artist who marched towards his goal but did not cease to be an artist in the most profound sense, so that even without legends and explanations his drawings are beautiful.

Your mother is upset because of my letter. She claims I encourage you to concern yourself with art, whereas you should think of earning a livelihood. I do not know whether my advice is good, but in any case, for the present, I urge you only to draw often, and to acquire strength by drawing the nude. When you are strong you can do as you like. But perhaps I am wrong.

PARIS, MARCH 1, 1884

*My dear Lucien,*

I am writing you a short letter. Since morning, I had to run for the lease, for rugs, for money, and I'm fagged out.

I am glad to hear that you are drawing the nude. I wish you

had told me so before; I was thinking of asking you to come home and work here, and help us move. But it's no great matter, continue, we shall delay calling on you as long as possible.

I think you will find attractive things to paint in Gisors, subjects, moreover, which should interest the English: churches, markets, farms, stations, coachmen, shopkeepers, and the landscape itself. We can make lithographs in four tones.—I ought to talk with John Lewis Brown [1] about this. Then we can occupy ourselves with etchings, only the nude will give us trouble.

Yes, we have decided for Eragny on the Epte [near Gisors]. The house is wonderful and not too dear: a thousand francs with garden and fields. It is about two hours from Paris. I found the country much more beautiful than Compiègne, although that day it was still pouring torrents. But here comes the spring, the fields are green, outlines are delicate in the distance. Gisors is superb, we hadn't seen anything.

I am at the moment reading about the terrible explosion in Victoria Station,[2] and I am beginning to think there is no security for anyone in London now, it would be wiser, my boy, to come home and work with me,—don't you think so?

PARIS [MARCH], 1884

*My dear Lucien,*

I hope you can come and help me. I thought it would do you no harm to work with me for a while at Eragny, and indeed in a period of troubles and exploding stations, it cannot be very comfortable to stay in a country where events seem to be shaping up along lines similar to those in Russia.

Send me word about the family and about the catastrophe in London.—From far off, one often gets an entirely different idea of things. But likewise when one is too close one sees nothing; you can't see a Cézanne by holding it against your nose. On the subject

---

[1] *The painter John Lewis Brown was a Frenchman. While not an impressionist, he was intimate with the artists who exhibited at Durand-Ruel's, where his own paintings were often shown.*

[2] *There was an explosion in Victoria Station on the night of February 26, 1884. Afterwards it was discovered that time bombs had also been planted in the stations at Charing Cross, Ludgate Hill and Paddington, by Fenians, Irish terrorists.*

of Cézanne, let me inform you that I treated myself to four extremely interesting studies by him.[1]

*My dear Lucien,*

I am sorry that you cannot go on with English lessons and drawing the nude, which last you should have embarked on long ago. Well, we will try to do some serious work here, we will discuss the matter when you come.

You are right to regard this terrorism as futile and base, but what political party is not base? I beg you to believe that neither side is ever able to be dispassionate in dealing with such political questions, and it is difficult to get at the truth. It is impossible to judge properly if you look only at the facts. I agree that the Irish terrorists are fanatical Catholics and will not be able to get anywhere, but this does not mean that the English are without their own brand of secular iniquity! In all this I see two things: the egotism and waywardness of men!

\* \* \*

*Returning to France in the spring of 1884, Lucien had to go to work once more in Paris where he was employed for some time in the publishing firm of the art dealer Manzi. It was here that he became acquainted with the technique of color printing which he was to use for his woodcuts and books. During this time his father wrote him occasionally from Eragny where the family had finally settled. Later Lucien rejoined his father there to work at his side.*

*The years 1883 and 1884 had been particularly difficult for Camille Pissarro since Durand-Ruel was unable to give him the help he needed. Hard pressed himself, Durand-Ruel could do little for his painters. The letters Pissarro received from him were anything but encouraging:*

*"You cannot conceive what difficulties I have had for about*

---

[1] *Since Cézanne would unquestionably have given his friend Pissarro canvases for which the latter showed enthusiasm, the studies must have been purchased from père Tanguy, the only dealer who handled Cézanne at that time.*

*a month now. I waste my time running after people who make promises and never keep them." (June 1883)*

*"I am terribly sorry to leave you without a penny, but I have nothing at all at the present moment. I must even greet misfortune with a smile and I have to give the appearance of being almost rich." (November 1883)*

*"I am still very annoyed with the way business is going. All those whom I ask for help tell me to wait. That's easy to say." (June 1884)*

*"If we fight just a little more, we shall finally dominate our enemies." (October 1884)*

*"The Gallery still keeps me extremely busy but all I earn is trouble. I wish I were free to go live in the desert." (June 1885)*

Although he could hardly have expected Pissarro to live on these complaints, Durand-Ruel became very angry when the painter finally sold some paintings to second-rate dealers. And he reproached Pissarro because, as he put it, "one of these dealers, Heymann, showed his pictures without frames in dirty shops just to render them ridiculous." On the other hand Pissarro would gladly have abandoned Durand if he had been able to find a dealer ready to give him a regular even if small income.

\*     \*     \*

ERAGNY ON THE EPTE, NEAR GISORS (EURE)
[AUGUST 21, 1885]

*My dear Lucien,*

You mentioned a sketch on which you have begun to work, *Les Graves,* a motif which Guillemet and the Daubignys, father and son, as well as many others have painted.—It is very fine, but alas, how it has been interpreted! I doubt whether you will be able to do much work.—Calm, and reflection coupled with a passion for one's subject, are necessary for good work.

I brought Durand eight pictures, among them my *Sunset* and the motif done from my window. They have been praised, but I find them poor,—tame, grey, monotonous,—I am not at all satisfied.—I am working with fury and I have finally discovered the right execution, the search for which has tormented me for a year. I am pretty sure I have it now, all I need is to spend this coming autumn in Rouen or in some other place where I can find striking motifs.

ERAGNY ON THE EPTE NEAR GISORS
[AUGUST 25, 1885]

*My dear Lucien,*

I am awaiting your arrival, after which, if Durand's kindness permits, I may set out myself. I expect to do a number of pictures in Bouille, on the outskirts of Rouen. I have often heard it de-

61

scribed as marvelous. The time I went to Rouen, I was not able even to visit this place. . . .

No luck, the weather is changing, I cannot finish anything. I received a letter from Monet, who is in despair because he has not succeeded with the canvases on which he worked most furiously, as happened with those I did at Gisors.—My work is going better, but I am only beginning, I still have to put in my final sessions. . . .

You, who are an artist, ought to be able to make Esther understand that Gisors has art treasures that should delight a tourist with taste; tell her about the diversified style of the church, about the wooden doors of Jean Goujon, about the stairways, the genealogical tree, the *French frescoes* (rare), and the basin which I almost omitted from my list. This basin is a whole world!——and then there are the park, the carvings on the town hall, the museum with its extraordinary stuffed birds, in short, you should unroll the list of attractions, and get her to decide to stay here as long as possible.

*good explanation of beginning of Pointillism and relationships between Impressionists and Pointillists*

*1886 was a critical year in the history of modern painting. To follow more closely the events referred to in Pissarro's letters, events in which he played so prominent a role, it might be well to recall these facts:*

For some time now the relations between the impressionists had been compromised by all sorts of disagreements. Cézanne had kept aloof since 1877. Monet and Renoir, wishing to be represented at the official Salons of 1880 and 1881, had not shown their work in the group exhibitions organized by their comrades. Degas had wanted to break with them, whereupon Caillebotte had suggested to Pissarro that they break with Degas. Pissarro had refused. Despite these difficulties, a group exhibition had been held in 1882. In 1883, there had been only a series of one-man shows at Durand-Ruel's. In 1884 and 1885, there had been no exhibitions at all. What would be decided for 1886? From the letters that are to follow it is clear that this question greatly preoccupied Pissarro.

It was in 1885, in the studio of their mutual friend Guillaumin, that Camille Pissarro and Paul Signac met for the first time. Signac, in turn, introduced Georges Seurat. Much attracted by the theories of these young painters who both belonged to Lucien's generation, Pissarro soon became a partisan of "divisionism," which meant radically changing his palette and technique. These changes did not fail to create serious difficulties for Pissarro. His dealers and collectors, for the most part, found his new works unacceptable. On the other hand his old comrades in the impressionist group showed an often open hostility to the new tendency. Thus Pissarro found himself almost completely isolated.

On December 7, 1885, Pissarro wrote to Monet: "For some

*time there has been much talk about a show, it is discussed on every side. I paid a visit to Miss Cassatt. From the very first we spoke about the show. Can't we come to an understanding about it? All of us, Degas, Caillebotte, Guillaumin, Berthe Morisot, Miss Cassatt and two or three others would make an excellent nucleus for a show. The difficulty is in coming to an agreement."*

*It was only by dint of much arguing that Pissarro got some of the old impressionists to consent to an eighth general exhibition in 1886. He got Seurat, Signac and Lucien invited to participate, but this resulted in the withdrawal of Monet, Renoir, Sisley and Caillebotte. How this exhibition was organized—it brought together Mary Cassatt, Degas, Forain, Gauguin, Guillaumin, Berthe Morisot, Camille and Lucien Pissarro, Odilon Redon, Seurat, Signac and some others—will appear in the letters. The show was at once the last joint exhibition of the impressionists and the first public appearance of the painters grouped around Seurat who were to call themselves "neo-impressionists."*

*From then on the split between Pissarro and his former comrades deepened. The latter reproached him for having resorted to "chemical" techniques, and Pissarro replied by dubbing them "romantic impressionists," or even plain "romantics," thus emphasizing the differences in principle which separated them from the new group of "scientific impressionists" to which he adhered. A brochure by Félix Fénéon, which appeared that very year, clarified the theoretical and technical questions about which the two groups disagreed.*

*In a letter to Durand-Ruel, Camille Pissarro explained the theory of the neo-impressionists (crediting Seurat with having first applied it), saying that the aim of the new movement was:*

*"To seek a modern synthesis of methods based on science, that is based on M. Chevreul's theory of color and on the experiments of Maxwell and the measurements of N.O. Rood.*

*"To substitute optical mixture for mixture of pigments. In other words: the breaking up of tones into their constituents. For optical mixture stirs up more intense luminosities than does mixture of pigments.*

*"As far as execution is concerned, we regard it as of little importance: art, as we see it, does not reside in the execution: originality depends only on the character of the drawing and the vision peculiar to each artist."*

64

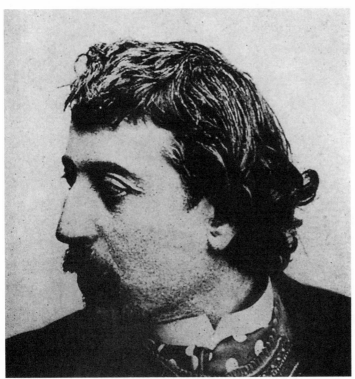

9.—Paul Gauguin, Photograph.

10.—A. Menzel: The Ballroom.

11.—E. Degas: Copy after
Menzel's "Ballroom."

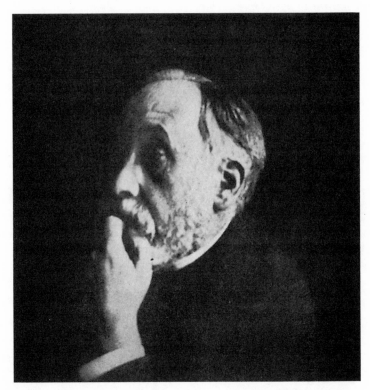

12.—Edgar Degas, Photograph taken by the Artist himself.

*It was as a convinced and enthusiastic adherent of "divisionism" that Camille Pissarro wrote the letters dated 1886.*

\* \* \*

*My dear Lucien,*

Durand is having difficulties with his landlord, he has a lawsuit on his hands and he is looking everywhere for funds to finance the exhibition in America, which he is more than ever determined to hold. Pictures are being selected, today they are making a selection from my works. There will be just our group [the impressionists], in all 250 canvases. These will all have to be sent before next month. I can't understand what is going on, Renoir and Sisley are penniless. Monet came in and left the same day.—Durand asked me if I didn't have some recent canvases which he could take to New York, he wanted to know whether your mother would lend him some of the paintings I gave her. I replied that after the trick he had played in keeping my canvas of Rouen, I would not have anything to do with it, but that he could ask your mother himself. As for my latest paintings, I am keeping them for the Paris exhibition.

I am always waiting, cooling my heels. I left some watercolors with Clauzet,[1] but nothing brings quick results. However I got some promises. Borrowing would be useless, Nunès had not even been able to pay poor Guillaumin the 200 francs he was expecting. I shall have to keep waiting, impatience is of no avail. As to leaving, with what? . . .

PARIS [JANUARY], 1886

*My dear Lucien,*

I went to Paulin's [2] this morning in frightful weather, in a pouring rain, the streets are like lakes. It is two o'clock and it is still

---

[1] *Pissarro sometimes writes Clozet, sometimes Clauzet. The contemporary reviews mention only one dealer, rue de Châteaudun, named Clauzet.*

[2] *Paul Paulin, a dentist and also a sculptor, was one of Pissarro's friends. He did busts of many of the impressionists, including one of Pissarro. However this was done after the painter's death.*

raining. I am streaming wet, my feet are soaked. I went out in vain, Paulin was not in. I will try him again at six o'clock, after going to Durand's to see if anything has turned up.—Yesterday evening he had nothing to give me, not even twenty francs, it's very embarrassing! Things must be very bad. Everything is at a standstill.

I know that Monet, Sisley and Renoir get no more than I do. Monet particularly must be up against it, for Petit, too, is in dire straits, much worse off even than Durand, from what I hear from people who understand business matters: he is reduced to his last devices.

On every side I hear the bourgeois, the professors, the artists and the merchants saying that France is finished, decadent, that Germany holds the field, that artistic France must succumb to mathematics, that the future belongs to the mechanics and engineers, to the big German and American bankers.—As if we could foresee all the surprising things to come! Damn it, yes, France *is* sick, but what is the cause of her sickness?—that's the question! She is sick from constant change, she may die, that is true, her fate depends on the other countries of Europe. If they are moving, even if ever so little, in the same direction, we shall see something new. Evidently things cannot remain as they are!

The gentleman who noticed my watercolor at Cluzel's [1] asked the price, but only because he was interested to know the amount. How characteristic!

PARIS [JANUARY, 1886]

*My dear Lucien,*

Yesterday Durand went to Signac's to ask for some canvases for the exhibition in America. He also expects to see Seurat and Guillaumin.

You must have received 150 francs.—Durand will let me have a little more, I have a gouache to do for 200 francs. Mother is wrong to complain so much and make herself ill, this crisis will pass. It is general. If Durand decides to go to America, it must be that he expects to have some money. It is to his interest to help us.—All is not lost.

---

[1] *Pissarro's frame-maker, who occasionally exhibited some of his canvases.*

66

Until next time, my dear Lucien. Embrace everyone and tell your mother that I need all my strength and will to hold my place, modest as it is, in the artistic struggle, that vital fight success in which will finally make us secure. I have the necessary will, but your mother tries me sorely, she accuses me of not doing my duty. She knows perfectly well that the contrary is the case.

PARIS [FEBRUARY 5, 1886]

*My dear Lucien,*

It is easy to talk of returning to Eragny, and not wasting time, but this must be borne in mind: if Durand persists in not giving me what I need, it will be absolutely necessary to obtain money elsewhere. You know very well that this can't be done all of a sudden.

Beugnet [1] saw my fan; he would like to have it, he wants to see it again by daylight, he hesitates, he acts as if he were engaged in an epic combat the outcome of which must either be victory or death. This morning Paulin told me that he had not yet turned up. Unquestionably he will put in an appearance, but if unhappily we are overzealous it is to be feared that all will be lost. Isn't that horrible! The trouble is that we have to deal with an extraordinarily cautious man. In addition Beugnet has enormous vanity: he wants to discover what he should buy on his own initiative, his best friends have no influence on him. Now to leave before concluding the sale might be to lose a regular customer. Once the gouache is sold, I can go to see Beugnet, and come to an understanding with him; if things get difficult I will be able to exhibit some pictures at his place. If Durand completely abandons us, I will perhaps find a little sale for my retouched drawings, in short I think the prospect is good, for me as well as for Beugnet. I do not have grandiose illusions. I will look for other ways of bolstering my position. Portier, for his part, could help me a bit, despite his funereal air. As for Clauzet, that is another matter; as long as that crook, Heymann, is behind the scenes I don't want to have dealings with him.

However I continue to hope that Durand will finally come into the clear . . .

---

[1] *An art dealer.*

Yesterday Sisley was looking for me everywhere. Madame Latouche [1] told me that he wanted some information about the technique of painting fans. Well, this means my fans are spoken of . . . I only fear one thing: that they will finally say that's all I am good for! We shall see . . .

Yesterday I went to see M. Robert Caze with Cézanne. At Caze's I found all the young poets, among them a young man who writes impressionist verses. The young are very enthusiastic about our work. They tore Zola's *His Masterpiece* to pieces, it seems to be completely worthless—they are very severe. I promised to read it when it appears.[2] But they were very enthusiastic about Flaubert—there I agree! They are right!—They consider *Bouvard and Pécuchet* a masterpiece.

Your mother believes that business deals can be carried off in style, but does she think I enjoy running in the rain and mud, from morning till night, without a penny in my pocket, often economizing on bus fare when I am weak with fatigue, counting every penny for lunch or dinner? I assure you all this is most unpleasant—but I want just one thing—I want to find someone who has enough belief in my talent to be willing to help me and mine keep alive. I am happy only when I am at Eragny with you and the others, when I can tranquilly dream of the work at hand —damn it, that is almost too much to hope for!

PARIS [FEBRUARY, 1886]

*My dear Lucien,*

I got the money you sent me for rent. I shall pay it tomorrow during the day. Portier advanced me 50 francs. I will deduct 30 francs from the note. Durand has promised me something by Monday. He is very close-fisted, can hardly meet his own expenses— and yet hopes to come out on top.

Paulin is about to sell a fan to another one of his friends. As for Beugnet, he is a regular rabbit, he has not dared show himself.

---

[1] *An art dealer on the rue Lafayette. Her shop was taken over by Contet in 1887.*

[2] *Zola's L'Oeuvre (published in English under the title* His Masterpiece), *which belongs to the Rougon-Macquart series, had been appearing since the beginning of the year in Gil Blas. This novel, the hero of which is a painter, was severely criticized by all the artists who were friends of the author: Monet, Cézanne, Renoir, Pissarro, etc., as well as by Antoine Guillemet who had supplied Zola with much information about the milieu treated in the novel.*

*My dear Lucien,*

It's simply heartbreaking—enough to drive one mad. Durand sends me nothing. It is hard enough to be forced to leave urgent work in order to keep running to Paris to place some miserable gouaches.—This cannot continue, I am fed up . . . Durand is playing a dangerous game with us, he is lucky that nobody wants our work, mine in particular. We will have to calm down and crawl into our shells.

Don't forget to ask Nunès for a little money for me. I am very worried and the future is not promising!—Explain to him that I have been abandoned by Durand who nevertheless asks me for canvases.

Of course you can stay in Paris until you have seen Guillaumin and company; give them my best and tell Guillaumin that I am much discouraged by Monet's remark that the exhibition may not be held; discouraged above all by the fact that Madame Manet [Berthe Morisot] does not expect it to take place, that is a very bad sign.—You have to stir these people up, and keep after them continually.

*My dear Lucien,*

I can well believe that your mother is completely upset by the fact that the money didn't come on Monday, I am exasperated myself. Lionel [Nunès] has an unconscious cruelty, which in such a sensitive boy is frightening. Knowing all my troubles, he is neither generous nor does he spare me embarrassment. But what enthusiasm! what joy when he received the fan. Which did not prevent him from failing to meet me. He is cruel enough to make me run after him. Too much wordy veneration; I don't know what he arranged with you, but I will not again ask him for money!— I had asked him to give me 100 francs, which was what he owed me for the fan.

Nothing to report about the exhibition. I am afraid it will not be held on account of Degas who insists that it run from May 15 to June 15.—Absurd!

69

I am expecting to hear from Portier about my gouaches. Paulin has met a new collector, I hope something will come of it, but I suppose Portier must proceed slowly. I shall see him shortly and if there is news I will write you tomorrow.

*My dear Lucien,*

I expect to go with Guillaumin to see Madame Manet [Berthe Morisot], and try to come to an understanding about the exhibition. There has been a hitch since nobody agrees.

My plan, in case Durand had nothing for me, was to entrust Heymann with the sale of my oils while permitting Portier to handle the gouaches at his leisure. Besides, I know for a fact that Portier is really doing his best.—If I had two or three canvases of about 24 x 20 inches I would let Heymann handle them. I much regret having given Durand my *Cows in the Field* [701]. But careful! As you say. . . . I have great hopes in Portier.—I got only 50 francs from Lionel [Nunès], and that wasn't easy to get. I shall not ask him for anything ever again, he makes me chase after him, I've had enough of it, I have been made a fool of too often to take him at his word!

Your *Peasant* is really fine; Guillaumin, Signac, Seurat, Gauguin think so too.—My only criticism is that the *apron is just a bit clumsy*, you have to make some changes, just a few, but in the right place. "It's amazing," some said, "that this was done on wood." It had been taken for a pencil drawing. It does indeed render the matière well. But that is not the quality I prize in the work, what pleases me is the drawing which is really fine and simple, and the values which are better than I expected. It would be grand if you could do the interior equally well. Try to vary your cut to avoid monotony, and don't forget the firmness and variety of the outline. Do you follow me?

*My dear Lucien,*

No news yet, I still don't know what is happening with my gouaches. A number of collectors promised to visit Portier; he

must have seen them. I won't get news until about six o'clock this evening. As for Durand, it is impossible to separate him from a single penny.—But now I don't count on him, I am waiting for Portier to sell some things, then I will repair to Eragny and make or finish several small canvases, and have them handled by Gosset or Heymann—although the latter won't commit himself about my work.—I sounded him out and spoke to him of placing my canvases, without actually asking him to handle them. His answer was extremely vague; evidently he understood what I wanted but was waiting for a categorical request. When the time comes, I'll see what is to be done; he often said that he could impose anything he favored on his collectors.

The exhibition is completely blocked. Guillaumin was not able to go with me to M. Eugène Manet's yesterday, it has been put off until Saturday. We shall try to get Degas to agree to showing in April, if not we will show without him. If we do not settle the whole thing in the next four or five days, it will be dropped altogether. Degas doesn't care, he doesn't have to sell, he will always have Miss Cassatt and not a few exhibitors outside our group, artists like Lepic.[1] If they have some success he will be satisfied. But what we need is money, otherwise we could organize an exhibition ourselves. I shall find out what Madame Manet thinks, but I am afraid she will not want to appear with us if Degas does not. In that case the whole thing will be off, there won't be any exhibition, for to spend money exhibiting at the same time as the official Salon is to run the risk of selling nothing. Miss Cassatt and Degas say that this is no objection, but it's easy to talk that way when you don't have to wonder where your next meal will come from!

I just ran into Bracquemond. He talked a good deal about color and about his experiments with warm and cold tones. His conclu-

---

[1] *Since the impressionists had to cover all the expenses for their exhibitions the participation of the wealthy members of the group like Degas, Miss Cassatt, Berthe Morisot (Edouard Manet's sister-in-law), Caillebotte, etc., was essential from a financial as well as from an artistic point of view. Poor artists like Pissarro, Gauguin, Guillaumin and their friends could not raise the necessary funds by their own efforts. On the other hand, Degas was not interested in exhibitions restricted to the group members; he was even opposed to such shows. He believed that it was desirable to appeal to a wider public and consequently wanted to include well known semi-official painters whose works would tone down the audacity of the impressionist canvases. Since the first impressionist exhibitions he had insisted on inviting some of his personal friends like Zandomeneghi, de Nittis, Count Lepic, Rouart, and so on, artists who were not in any sense members of the impressionist group and who also showed at the official Salon.*

sions are very interesting and curiously enough are close to what we spoke of.

*My dear Lucien,*

Portier reports that he has sold a gouache. He will try to let me have the money tonight. I expected to call on Madame Manet today, but I'm afraid I won't be able to make it.

I gave the doctor all the money I had: 10 francs. If I can collect anything at all, I will leave tomorrow, otherwise I will wait.

PARIS [MARCH 8, 1886]

*My dear Lucien,*

I went to Paulin's this morning. I banked on his having seen the collector who was interested in my gouache; unhappily he had not, so I am still here. Luckily at about five o'clock Durand returned and gave me three hundred francs. He announced that he would probably leave for America at the end of this week.[1]

I hope the question of the exhibition will be settled tonight; Degas, I think, is trifling with us. And I hope it can be arranged without the old impressionists. We can always try to found something more permanent.

PARIS [MARCH, 1886]

*My dear Lucien,*

Because of Degas I missed the post last night. We went in a body to meet him to determine the number of paintings each would be allowed to exhibit. As usual, he arrived at an impossible hour. We had to stand in the street discussing the matter. Things are going well.—

---

[1] *Leaving his gallery under the direction of his son Joseph, Paul Durand-Ruel left for New York on March 13, 1886, accompanied by his son Charles, with 300 canvases, works of Millet, Manet, Monet, Renoir, Sisley, Pissarro, Degas, Whistler, Morisot, Boudin, Guillaumin, Forain, Seurat, Signac, and so on.*

I went to dinner with the impressionists. This time a great many came: Duret brought Burty, an influential critic, Moore, the English novelist, the poet Mallarmé, Huysmans, M. Deudon, and M. Bérard; it was a real gathering. Monet had been in Holland,—he arrived from The Hague at eight o'clock, just in time for dinner.— I had a long discussion with Huysmans, he is very conversant with the new art and is anxious to break a lance for us. We spoke of the novel *His Masterpiece*. He is decidedly of my opinion. It seems that he had a quarrel with Zola, who is very worried. Guillemet, who is furious about the book, also wrote to Zola, but only to complain that *Fagerolles* is too easily identifiable. They are telling a charming anecdote in connection with the book: Guillemet, who worships Zola, and with good reason, wanted his name to appear on this work, which he was certain would add to Zola's renown. He wrote Zola, requesting that the book be dedicated to him. Zola, very embarrassed, as you can imagine, by this expression of admiration, replied that he was reserving all dedications until the whole *Rougon-Macquart* series appeared. But since *His Masterpiece* was published, Guillemet's ardor has melted like butter in the sun; he wrote Zola a long letter of complaint. Zola assured him that it was Gervex he had described.[1] Guillemet calmed down, completely content with this explanation.—As for Gervex, he takes a different attitude. He has his friends call him "Fagerolles." At X's marriage he paraded this name.

What I have written you should not be repeated.

Yesterday I had a violent run-in with M. Eugène Manet on the subject of Seurat and Signac. The latter was present, as was Guillaumin. You may be sure I rated Manet roundly.—Which will not please Renoir.—But anyhow, this is the point, I explained to M. Manet, who probably didn't understand anything I said, that Seurat has something new to contribute which these gentlemen, despite their talent, are unable to appreciate, that I am personally convinced of the progressive character of his art and certain that in time it will yield extraordinary results. Besides I am not concerned with the appreciation of artists, no matter whom. I do not accept

---

[1] *As a matter of fact the character of Fagerolles, the worldly and unprincipled painter who adapts the theories of the impressionists to the corrupt taste of the public, was not inspired by Guillemet. Zola's notes about his character establish this beyond doubt; in his notes Zola conceives Fagerolles as "a shrewd rogue who keeps apart and breaks with the group. Maupassant and Gervex. I can make him get his reputation through the support of fashionable women (Bourget)."*

the snobbish judgments of "romantic impressionists" to whose interest it is to combat new tendencies. I accept the challenge, that's all.

But before anything is done they want to stack the cards and ruin the exhibition.—Monsieur Manet was beside himself! I didn't calm down.—They are all underhanded, but I won't give in.

Degas is a hundred times more loyal.—I told Degas that Seurat's painting was very interesting. "I would have noted that myself, Pissarro, except that the painting is so big!" [1] Very well—if Degas sees nothing in it so much the worse for him. This simply means there is something precious that escapes him. We shall see. Monsieur Manet would also have liked to prevent Seurat from showing his figure painting. I protested against this, telling Manet that in such a case we would make no concessions, that we were willing, if space were lacking, to *limit our paintings* ourselves, but that we would fight anyone who tried to impose his choice on us.

But things will arrange themselves somehow!

Schuffenecker [2] has been to see Monsieur and Madame Manet. The latter went to see his work and *accepted it*. What do you think of that? After his letter which was so dignified!—I have just seen a still life of his, and it's truly terrible.

*My dear Lucien,*

I wrote you this morning and explained the difficulties we must surmount to hold this eternal exhibition. But I hope for the best, there is smoother sailing now.—We shall show our work together in the same room, you, Seurat, Signac and I; in this way we can arrange the hanging of our works together.

They are beginning to decry our paintings, even those who before hailed us most warmly; it is so absurd.

---

[1] *Seurat intended to show his large canvas* A Sunday Afternoon on the Island of la Grande Jatte.

[2] *Emile Schuffenecker, one of Gauguin's closest friends who had been influenced by everybody and thus did not develop his own style. In 1886 he showed with the impressionists.*

*My dear Lucien,*

I agree with Guillaumin and his friends, the Petit gallery is a grandiose place for an exhibition [1] that is true, but I think that a modest show of works by Degas, Miss Cassatt, Madame Morisot, etc., etc., will not lose by comparison. So much the better, I like it better that way. Isn't Renoir curious? he gives out that he will exhibit but vacillates. I don't know whether Madame Morisot will keep to her word. It is my view that in such circumstances there are not two courses of action. As for Degas, he would be delighted by a fight; after all a fight provides the occasion for determining who is on your side.—All in all they are four; we can at best count on Degas, Madame Morisot, Miss Cassatt and Guillaumin, by right of seniority myself perhaps!—That makes five against four [2]— without counting the newcomers who will show their mettle under fire! Now that should be interesting.—It is true the others will consider themselves the *pure impressionists. I think Petit is behind them.*

*My dear Lucien,*

They have found a place [for the exhibition]! Good news at last, and there's no question of a slip-up. It is probably the same place, above the Maison Doré.

\* \* \*

*The exhibition was finally held above the Restaurant Doré at the corner of rue Laffitte and the boulevard des Italiens. The show ran from May 15 to June 15, which was what Degas had demanded. On Degas' insistence the word "impressionist" was omitted from the announcement and the exhibition was called "Eighth Exhibition of Paintings." The list of exhibitors included: Madame*

---

[1] *Georges Petit, possessed of a great fortune and with a magnificent hall in which to hold exhibitions, was the most formidable rival of Durand-Ruel. Zola, taking a hint from Guillemet, termed the Petit Gallery: "the department store of painting."*

[2] *That is to say the five exhibitors, Degas, Morisot, Cassatt, Guillaumin and Pissarro, against those of the old group who would not be represented in this exhibition: Renoir, Monet, Sisley and Caillebotte.*

*Marie Bracquemond, Miss Mary Cassatt, MM. Degas, Forain, Gauguin, Guillaumin, Madame Berthe Morisot, MM. C. Pissarro, Lucien Pissarro, Odilon Redon, Rouart, Schuffenecker, Seurat, Signac, Tillot, Vignon, Zandomeneghi.*

*Degas exhibited 15 pastels, mostly of women at their toilette. Gauguin showed 19 paintings, including several views of Rouen and a landscape done in Denmark where he had gone after total failure in Rouen. He left his family in Denmark when he returned to France.*

*Camille Pissarro was represented by the following paintings (all executed with little dots in the divisionist manner), pastels, gouaches, and etchings: View from My Window on a Grey Day [696]; Fields of Bazincourt, Morning; Slopes of Bazincourt, Afternoon [698]; Pear Trees in Bloom, Morning [697]; Autumn, Picking Apples [695]; Marshes of Bazincourt, in Autumn; Full Sun, Peasant in the Fields; Mother and Child [691]; Cows and Peasants, gouache belonging to M. G. Berend; Peasants in the Sun, gouache; Girl Tending Geese, gouache belonging to M. Samson [1467]; Peasants, fan, gouache; six studies of peasants, pastels; Potato Harvesting, etching [D. 63]; Rue de l'Epicerie in Rouen, [D. 64]; and rue Malpalue, in Rouen, [D. 53], etchings; Cows and Landscape, etching [D. 59]; Harbor of Rouen in the Rain [D. 44] and Landscape, etchings; Landscape in Rouen [D. 50] and Landscape in Osny [D. 62], etchings.*

*Seurat exhibited three drawings and six paintings including "A Sunday Afternoon on the Island of la Grande Jatte," which was most laughed at of all the paintings exhibited.*

\* \* \*

PARIS [JUNE, 1886]

*My dear Lucien,*

Signac leaves today for Les Andelys. Durand-Ruel will arrive at the end of the month only to leave again; he will stay only for a fortnight. He is very satisfied with his exhibition [in America], he hasn't sold anything,[1] but he has great hopes, his expenses

---

[1] *This may apply to Pissarro's works, but as a whole the exhibition in New York was more than just a moral success. Within two weeks after its opening The New York Daily Tribune announced that seven to eight pictures had been sold. And the show lasted two months.*

were enormous, still he has his hopes, but this will not help us. The exhibition goes very slowly, no visitors.

Portier told me that he is practically certain to sell *my little canvas in dots.* That would be perfect, that would be 400 francs which would keep us until better times.—And now I am going to try harder to sell. This is a bad moment for an exhibition.

I forgot to tell you that Seurat, Signac, Gauguin, Guillaumin expect to show with the *Independent Artists* and advise you to show too.[1] Seurat will keep your things in his studio. I will probably leave some of my things with him until Durand arrives.

*My dear Lucien,*

I had a long talk with Durand-Ruel about his American venture.[2] What he said seems reasonable enough: there are two opposite versions of what befell in America, both are equally exaggerated: he did not make a fortune with miraculous luck nor did he engage in sharp practice and have to decamp. He is very glad that he went to New York himself, and he has great hopes in possible developments there. All this is quite vague, but proves, at any rate, that everything is not lost. If we are not saved by Durand, someone will take us up, since our work is sure to sell in the end. For the present, I am trying to find some means of support until my paintings sell. Durand promised me some money this week, he expects to have some, he said, but he has made so many promises, that I can't depend on him; if I can sell something, I will.—But to whom?

Monet and Renoir knew in advance that Durand was to arrive. They were here from the 18th, but I know that both of them think as I do, and are waiting to see what will happen. They received no more money than I did.—

---

[1] *That year the exhibition of the* Independent Artists *was to have run from August 20 to September 17. The Society of Independent Artists had been founded in 1884 by Redon, Seurat, Signac, Cross, Angrand, etc. The organization proposed to hold exhibitions in which all the artists could participate without having to submit work before a jury.*

[2] *Durand-Ruel returned from New York on the 18th of July. He remarks in his memoirs that without the American show he would very likely have been unable to emerge from the financial difficulties which beset him in 1885–86. His success in New York restored his optimism. He was planning to return there for a second exhibition.*

This morning I went to see Legrand, naturally we discussed the American venture. Legrand confided to me that he had been asked by Knoedler, the Goupil of New York and hostile to Durand, for some impressionist paintings. Durand had better be careful, or he will lose the game. We cannot go on in such poverty, willy-nilly we shall have to break with Durand. Legrand also said that he would probably leave for New York in September, and that he would be willing to represent us and place our paintings with Knoedler. He even hopes eventually to supplant Durand.—But what's holding them up? We are a good investment, yet nobody seems to have a few thousand francs for some half a dozen canvases on which they can make a profit!—Strange! And when the paintings begin to sell they will come at once—how make paintings to order? But now not a single friend with enough confidence in me to lend me enough to keep alive.

PARIS [JULY, 1886]

*My dear Lucien,*

I daily expect that cursed telegram from New York which is to deliver me and enable me to work. But it has not come.

Durand tells me that his affairs promise well, that we should not give up the game. As a matter of fact he is more determined than ever to persevere. I must wait—since nothing has turned up.

This morning I showed my drawings and etchings to a little dealer, also your woodcuts and watercolors.—He does not think my drawings are salable, they are too "made" and not interesting enough; however he wanted the pastel portrait of Titi [1553]; he offered 60 francs for it, including the frame. I refused, for I can't go that low, having received 200 francs from a collector. I asked 150 or at least 100 francs, if he would take four; he turned the offer down. All the same I know that he wants some impressionist works, there is no doubt about that but he wants to get them for nothing.

Try to get a little money from Dumas,[1] so that I won't have to lower my prices too much. I must be able to hold out until Durand can help me.—Since it isn't easy, as you can see, to place anything

---

1 *The publisher of* La Revue Illustrée, *in which drawings by Lucien appeared occasionally.*

with dealers, I would still like Durand to handle my works; the others are too hesitant! Your mother must be exasperated with me, but the truth is that I constantly run after the dealers and do not waste a single opportunity. I am obliged to dance attendance on them, for a single rendezvous I lose five or six days. They don't show up, they forget, etc., etc., she doesn't know the embarrassment I feel, the explanations I must make, the absurd discussions I must endure.—And if all this led to something: but no, nothing! It is heartbreaking.—

Tell your mother not to be too impatient, if she can wait just a bit longer the moment must come when we will be out of this mess.

PARIS [JULY, 1886]

*My dear Lucien,*

To my great regret I still cannot leave Paris. In the course of a long talk Durand gave the same old explanation: payment had been delayed. He told me that he had made up his mind to keep us going, that he would devote himself to this end, that he was certain to succeed, that I should not be discouraged, etc., etc., in short he said everything one would expect him to say—which might prove that he is not going to give up the game.—But in the meantime, I discussed our affairs with Legrand. The latter is trying to push us, I think.—He told me he would speak of me to Knoedler, I ought to drop in and see him Tuesday.—If Durand doesn't watch out, the grass will be cut under his feet.—He suspects us much. I warned him that I was determined to sell my work. But he need not fear, no exploiters have presented themselves! They are so anxious not to make a mistake, they are so gingerly, it is farcical. Just the same, something is brewing.

PARIS [JULY 27, 1886]

*My dear Lucien,*

Still nothing! Durand told me yesterday that he is expecting a check from New York any day now. I hope it will not be long delayed.—The weather is very unfavorable, I can stay here for a while, particularly since I caught cold Sunday.

**79**

Durand has been to Petit's, he has seen the Renoirs; he does not like Renoir's recent style, not at all. As for Monet, he has withdrawn his landscapes of Holland.

Yesterday I saw Portier, always the same, desperate, discouraged. I have not yet seen Heymann.

Talk to your mother and try to keep her from worrying too much; urge her to be patient for just a little longer.

PARIS, JULY 30, 1886

*My dear Lucien,*

I received the case of paintings.

Durand likes my paintings, but not the style of execution. His son, the one who went to New York with him, saw them but has not said a word to me.—Durand prefers the old execution, however he grants that my recent paintings have more light—in short, he isn't very keen. My *Grey Weather* [1] doesn't please him; his son and Caseburne [2] also dislike it. What kills art in France is that they only appreciate works that are easy to sell. It appears that the subject is unpopular. They object to the red roof and backyard [721] just what gave character to the painting which has the stamp of a *modern primitive,* and they dislike the brick houses [679], precisely what inspired me. You should all see how calm and simple is this painting next to the romantic extravagance of my canvas of *Cows* [701]. Curiously enough, Durand is not bothered by the passionate style of execution in this work.

I very much fear that Durand will again let me go for a long time. And I won't kill myself to sell to the first comer! This is a bad moment, for nobody is in Paris.

I am really furious about having to waste my time here, but I don't understand how this world of tradesmen operates.—Those who buy don't pay, Durand assured me that Petit didn't give Monet a cent, and that neither did Clapisson who bought the landscapes of Holland, Clapisson being a stooge of Durand himself.—I take all that with a grain of salt. In the meantime we must hope for a solution for *all* of us through Durand, but as always, don't say a word.

---

[1] *See fig. 25.*
[2] *Durand-Ruel's cashier.*

80

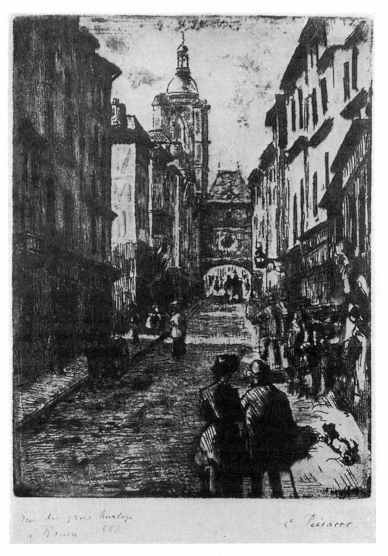

13.—C. Pissarro: La rue de la Grosse Horloge à Rouen, 1883.

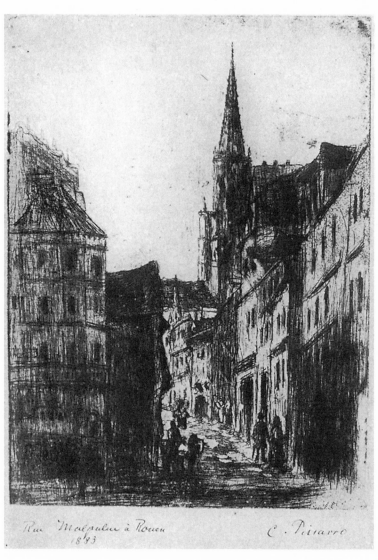

14.—C. Pissarro: La rue Malpalue à Rouen, 1883.

I saw John Lewis Brown yesterday, he is no better off than I am, and doesn't know what to think.—And many others are in the same straits, it is maddening.

*My dear Lucien,*

M. Fénéon sent me the draft of his article; he wanted me to look over certain passages dealing with the question of technique.[1] I am afraid that these questions are only too well explained and that the painters will take advantage of us. I would have liked him to discuss this with Seurat, but this is impossible.

*My dear Lucien,*

I have just visited Dumas. He kept the two drawings, but he will probably use only *The Wagon.* "Well, well," he said, "that's really fine." He seemed very satisfied. As usual, we talked for a long time about the stupidity of subscribers, publishers, and investors. I spoke to him about money; he directed me to the cashier who replied that bills always had to be presented before the 10th, and that yours had come in too late.

Send me a list of the paintings your mother has in her room, and send me the *dates,* I am about to make a selection for the show in Brussels.[2] I will include the two last paintings I did. Durand just received them from London. That's strange!

The hostility of the romantic impressionists is more and more marked. They meet regularly, Degas himself comes to the café, Gauguin has become intimate with Degas once more, and goes to see him all the time—isn't this seesaw of interests strange? For-

---

1 *Félix Fénéon, a friend of Seurat and Signac, was from the very beginning an ardent defender of their work. In 1886 he had published in* La Vogue, *the review edited by Gustave Kahn, a series of articles on the impressionists. The reference here is doubtless to an article on the neo-impressionist technique which was to appear in September in the Belgian review* L'Art Moderne.

2 *The paintings were to be sent to the exhibition organized by* Les Vingt. *This Belgian group, led by Octave Maus, each year invited a number of foreign artists to its exhibitions. In 1887 it was the neo-impressionists' turn. Pissarro, Seurat, Signac, etc. were invited.*

gotten are the difficulties of last year at the seashore, forgotten the sarcasms the Master hurled at the sectarian, forgotten all that he [Gauguin] told me about the egotism and common side of Guillaumin. I was naive, I defended him [Gauguin] to the limit, and I argued against everybody. It is all so human and so sad.— They are angry with us, and will not pardon me for being sincere enough to want to be faithful to my deepest convictions.

<div align="right">PARIS, DECEMBER 3, 1886</div>

*My dear Lucien,*

I forgot whether I mentioned in my last letter that M. Pillet was delighted with my fans; he told me that my work was in no way unclear, and that many people up till now opposed to impressionism have been struck by the clarity and strength of the drawing, and he felt that I had conquered the monotony which the desire to be sober and harmonious often brings.—Goodness! He was somewhat hurt by the two little Signacs and a little also by the strange rectilinear drawing of Seurat, but his criticism was not severe, their pictures are so clear, so fair, and have such sincerity.

I might mention that I have been invited to the opening of Chinese shadow-plays. I asked for permission to transfer the invitation to you. The show will take place in the "Chat Noir" in about a week. You have heard of the author: Caran d'Ache. I was at John Lewis Brown's and I was introduced to M. Caran. He is a very elegant young man, quite unusual, with a somewhat Russian manner, full of that wit which brings such speedy and complete success in Paris. If you are interested, Brown will introduce you to him; this would be just a formality for he knows all about you and has great admiration for your engravings which appeared in *La Revue Illustrée.*

Lately I have been going with Seurat, Signac and Dubois-Pillet to *La Nouvelle-Athènes;* entering one evening, we saw Guillaumin, Gauguin, Zandomeneghi.—Guillaumin refused to shake hands with Signac, so did Gauguin; there was some explanation; impossible to understand a word of it; it appears that the cause was that affair in Signac's studio, a misunderstanding. Nevertheless Gauguin left abruptly without saying goodbye to me or to Signac.—Guillaumin came over to shake hands and asked whether

<div align="center">82</div>

I was going to dine with the impressionists on Thursday. Much surprised, I replied that this was the first time I had heard of the dinner. You can be sure that I won't spend thirteen to fifteen francs for dinner; I have three francs in my pocket, and besides we no longer understand each other. It seems that the old group will close ranks; as for me, I insist on the right to go my own way. —So much the worse for the narrow-minded!—That Seurat was invited to Brussels must have surprised them. At Petit's, Monet and Renoir have recommended John Lewis Brown for the exhibition of the *French* Vingtistes (Petit Exhibition). What do you say to that? . . . they who cannot endure his work!—The impressionists are done for, no matter what the sectarian Gauguin says, I do not believe Degas will succeed in rallying them.—Degas will look for new elements among the opportunists of the Salon, the Scotts, on this score I even told Daumoulin who asked me to exhibit to address himself to Degas! As far as we are concerned, from the way these gentlemen treat us, it is clear that I alone will be invited [to the Petit Exhibition].—I await them without wavering! Please understand that our role is very simple; we must stand alone! We have the stuff to be strong.—

I am running to Pillet's. Until next time. I was invited to Dubois-Pillet's [1] Sunday, Fénéon will be there as well as Seurat-Signac.

PARIS [DECEMBER 6, 1886]

*My dear Lucien,*

It seems that Rochefort is greatly taken with the charm of this new art; he remarked that the color is very delicate and the design is as precise as with the primitives. I do not believe, my dear Lucien, that to be understood, I shall have to wait again as long as I did when I made my début; since I already have something of a reputation a good part of the ground has already been covered, one complete exhibition—and we will have arrived.—This is why I am so concerned with the Brussels show.—Monsieur Pillet advises me to send only new works, his argument being that the public will be confused by two different techniques. M. Pillet,

---

[1] *The painter Dubois-Pillet was an ardent adherent of neo-impressionism. It was he who drafted the constitution of the Society of Independent Artists in 1884.*

83

who is very intelligent, is enchanted with the movement, and claims that Monet will have no recourse but to join it, since he must feel the need to achieve what the impressionists lacked—great purity of design.

I saw Guillaumin. We went to look at my two latest paintings which were bought by Durand. All he said was "there's no firmness in the foreground." It was evening, we were seeing the paintings by gas light, which neutralized the orange tones. As Seurat says, what they look for is thick impasto; but at Clauzet's I saw a Guillaumin, also in the evening, and it looked made of tar, so much shellac was used at the base of this painting, which in my view is really old stuff; it must be admitted that he made an effort to tighten the design but then the harmonies are insignificant and lack logic, there is no drawing, there is a flurry of colors, but no modeling; it is one step from Jules Dupré—modernized.

I am calmly confident, we have before us a superb art and admirable research—which should interest anyone who is sincere.

I am here without a cent, I shall be hard put to find a solution. —Even if I wanted to leave I would not be able to do so without borrowing. I would rather lose time now, when the days are short and my paintings are drying, but this is a difficult moment, New Year's day is terrible for selling expensive objects, people only give sweets as gifts nowadays, this costs only a few francs and is better received.

Zandomeneghi looks at me with compassion and seems even mournful. It is very curious. . . .

PARIS, DECEMBER 10, 1886

*My dear Lucien,*

Great news, which I am sure will please you. I expected to leave today, having achieved nothing from my two agents, but Ajalbert insisted that I remain for a while so as to meet Monsieur Gustave Kahn and discuss with him some illustrations for *La Vogue, this is not to be repeated.* It seems that Kahn is thinking of changing the character of this publication, he may propose that we, the scientific impressionists, and none others, do all the illustrations. There is a *catch,* he would not be able to pay at first, the point would be to set things going and if the sheet becomes known and sells then we will be paid.—It seems to me that in any case it

84

will be good publicity for you, *La Vogue* will have a new format and will be elegantly printed on very fine paper.

You must have received a signed copy of Fénéon's brochure.[1] At the same time *La Revue Indépendante* appeared, but everything in this journal is decadent, verging on the decadent or academic. The publisher, as pusillanimous as ever, tries to conciliate the hare and the hounds.—A colorless review. Kahn wants *La Vogue* to maintain its clear character, and as I see it, that is the only way to achieve something permanent.

Dumas [of *La Revue Illustrée*] pleases neither those with taste nor those without. He wants to have a publication which will last and flatter neither the good nor the bad. Either the one or the other. All this portends a new idea of illustration, we must light the fire and let the wind blow on the flame.

Did I inform you that Martinet took the shop on the boulevard and at the corner of the rue du Helder and has put his show window at our disposal? I discussed this offer with Seurat and Signac: accepted. It opens next week. We expect to exhibit there. However passersby will not purchase anything, that is understood! . . .

P.S. Doing drawings for *La Vogue* means entering pictorial journalism and getting acquainted with agents who may eventually help us publish our folder *Travaux des Champs*.[2] It is so difficult when you are not known, it is imperative that we make you known, in fact make all of us known to the publishers, thus by helping each other we will all get work. What do you think?

ERAGNY [DECEMBER 24, 1886]

*My dear Lucien,*

Of course it is something to be able to appear in a newspaper, but you must protect yourself against those damned businessmen who lie in wait at the press, and only want artists who will agree to work for nothing. . . . I agree with Paul Alexis that one must always demand payment, even if only the tiniest sum is involved,

---

[1] *The reference is to the brochure,* Les Impressionnistes en 1886, *a collection of the articles analyzing and defending Neo-impressionism.*

[2] *Camille and Lucien Pissarro had conceived the following project: drawings by Camille, representing the seasons of the year and the types of work done in the fields, were to be cut on wood by his son. The project was later abandoned and only a few engravings in the series remain.*

simply to safeguard the principle. Otherwise these gentlemen will get accustomed to not paying, and if they can easily find compliant artists, the time will come when they will discharge anyone who asks to be paid! . . .

I have finished my picture for the Brussels' show. That is to say the picture belonging to Durand and the one of the *Fields of Bazincourt*. I will take them to Paris on my next trip there.

ERAGNY [DECEMBER 27, 1886]

*My dear Lucien,*

I will have to leave for Paris as soon as you return.

I did two drawings with pen and in little dots a *Little Market* and a *St. Martin* (pig dealers), it would be a good thing if I could sell them to some newspaper, that would bring us a few pennies. . . . I still don't know what I am going to do, for Heymann seems completely indifferent. He probably knows my position and naturally is waiting for me to reduce my prices, just as Durand did last time. . . .

ERAGNY [DECEMBER 30, 1886]

*My dear Lucien,*

Your letter, which we got this morning, is not at all reassuring. We are more and more anxious about the non-arrival of the sixty francs. . . . We just needed this!

It is always like that, as soon as a painting leaves your possession, a client comes along who wants it; the next time I go to Paris I will try to get Durand to surrender the canvas I am asked for. . . . I will bring the two canvases for the exhibit in Brussels, I worked hard on the one belonging to Durand—I was yoked to this one for fifteen days; I believe it is much improved, more luminous; there is something strange about working with points of color. . . . If you are patient, after a while, bit by bit, you achieve a surprising grace. . . . If I had the time, I could work on it much more, I am sure that it could be refined even further.

I don't understand at all what is said on both sides about Durand. If he has made so much money through us, then what

86

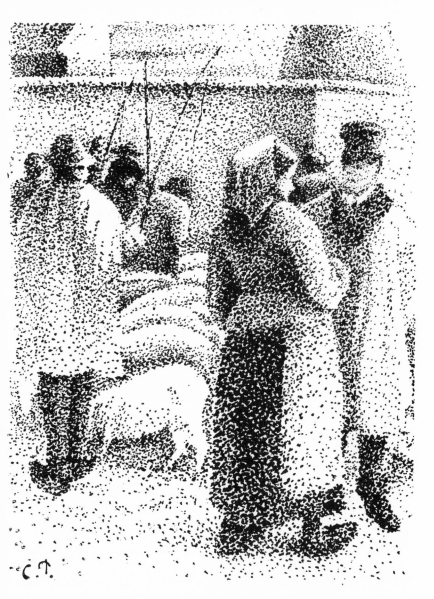

15.—C. Pissarro: St. Martin—Pig dealers. Pen and ink drawing, 1886.

advantage would it be to him to drop us? I believe that the truth is that Durand did make money but that he had to make payments and that is why there is not a penny for the painters. . . . The proof is that Durand is still here for lack of money. I am very pleased that Raffaëlli gave you an introduction for the *Courrier*

*Français,* it was very kind of him. Who the devil told him that I was angry with the old group? It seems to me that they are the ones who are offended, and all because I have the cheek to have an idea which they don't share. These authoritarians are intractable and incorrigible, but they are men of genius!

I told you that I made two drawings in dots. I have done another in the same manner: *The Wheat Market at Gisors, A Lace Merchant at Pontoise,* an ordinary pen drawing, and a *Shepherd and Sheep* in the same style. If we could place these we could get a few cents while waiting for this terrible month of January to pass. ... These drawings matted look very well.

PARIS [JANUARY 7, 1887]

*My dear Lucien,*

I wasn't able to write you, for I had to husband my last few cents; the weather has been so bad that I couldn't do any of the things I had in mind.

Durand was not able to open the exhibition in New York, it seems that the Paris dealers have leagued with those in New York to create difficulties for him.[1] They schemed so well that they were able to conjure away all the show-rooms in New York, so that Durand will not be able to hold his exhibit until April.

And now we shall have to fight for our position on *La Vogue.* Lèbre[2] has such influence with the review that we may well be relegated to last place. I think it would be wise not to appear in the first issue; have they not given the cover to our worst enemy, to him who robs us, who is regarded as our leader if only because he uses our ideas, accommodating them to the taste of the vulgar,

[1] *According to Durand-Ruel's memoirs the American dealers and not the French created these difficulties. Taking it for granted that he would fail completely, they did not oppose the organization of his first exhibition in New York. But when this was successful, they got Washington to institute new customs rules which delayed Durand-Ruel's second show. Thus it was unable to open at the end of 1886 and had to be put off until 1887, opening late in May of that year, a time very unfavorable for business. And Durand-Ruel was confronted with this almost unsurmountable obstacle: each painting he sold first had to be shipped back to France and imported a second time to America. It was these complications which made Durand-Ruel finally decide to open a branch in New York.*

[2] *Lèbre was the chief editor of the illustrated weekly* La Vie Moderne, *in which drawings by Lucien Pissarro and other neo-impressionists often appeared. Renoir too collaborated, at least in 1879, when his brother Edmond was the editor. But in general, the drawings which appeared in the weekly were on a very low level.*

I mean, of course, Besnard.[1] It seems that they are counting on Puvis de Chavannes, and hence all the Puvisites! We shall be drowned, rubbed out once again,—but no, I say, let's not be such innocents!—This evening we shall be able to discuss the matter, there is to be a meeting, I will speak to Kahn and criticize the choice they made without consulting us.—Besides I do not wish to be subject to these gentlemen and I particularly object to having M. Lèbre pass judgments on my drawings, for this does not fall within his competence. . . . Seurat and Signac completely support my view that we must not be passed over. Even Puvis de Chavannes should not be supported. Why? because he is our antithesis in art, whatever his talent. He will necessarily use his influence to get everything for his followers, to favor backward art and retard our development as impressionists. In any case we must not expose ourselves to enemies disguised as innovators.—But you are in a different category, you can risk appearing anywhere, with you it is entirely different. If we give drawings to *La Vogue* without being paid, the least the review could do would be to make our work known, it would be foolish to work for the aggrandizement of others. When I am paid it is another story, it is simply a question of the terms offered!

Seurat sent two canvases to Martinet, the latter, after having gone into raptures at Seurat's studio, began to stammer when directly asked to exhibit the paintings: the gas light, the white frame, the painter's own interest, etc., etc. I went to see him, and since he had asked me to give him something to sell, he gave the most threadbare excuses; passing by with Seurat that evening we saw the two canvases, they were shown not on the boulevard, but on the rue de Helder. Again our secret enemies, the Boulards and their consorts have been up to their old tricks.—I will send him nothing.

I saw your painting at Pillet's, but he hasn't hung it. There are two Monets, a *Cliff* and a *Landscape of Vétheuil*, I must say they are inferior, they are rank, and the execution recalls certain Gudins. . . .—Monet has too much talent not to recognize some day that we are right.

Your painting is on the whole good, but I am sure that eventually you will see that it needs more development, that you can

---

[1] *Of Albert Besnard, a pseudo-impressionist, and a winner of the Grand Prix de Rome, Degas said: "He flies with our wings."*

give it more suppleness, and bring its colors to interpenetrate.

Tell your mother that I am enormously concerned about the rent, etc., and that I am splitting my head to find a way out. Today I am going to track down Heymann. Who will get me out of this?

I shall not go to de Bellio's tomorrow. Being unable to afford the dinner [of the impressionists] and not wanting to accept an invitation, I have put off my visit until Saturday.

PARIS [JANUARY 9, 1887]

*My dear Lucien,*

We have come to an agreement with *La Vogue:* no Puvisites.— The cover will be changed every three issues. . . . We shall be the only illustrators. . . . Kahn was astonished by our rejection of Besnard. . . .

Monet has been to Durand's, he brought the paintings he did this year; he has one in bright sunlight, it is an incomprehensible fantasy; M. Caseburne himself admitted to me that it is absolutely incoherent, blobs of white mixed with Veronese greens and yellows, and the drawing is completely lost. The other canvases are more carefully done, better, but dark grey. My *Eragny* has more calm, and you can see in this painting the advantage of unmixed colors and clear and solid draftsmanship. I assure you I would not be afraid to show my work with Monet's. Durand says that Monet pities me because of the course I have taken. So! . . . Perhaps he does, now . . . but wait. M. Robertson being insensitive to Monet's qualities, Durand asked me to explain to him, in English, the good points of Monet's work. I did my best, loyally and without hesitation, for despite his mistakes I know how gifted is this artist, but M. Robertson can't stand his work. "And who painted this horror?" It is true that he doesn't know anything, but this simple man must be offended by the disorder which results from a type of romantic fantasy which despite the talent of the artist, is not in accord with the spirit of our time. M. Robertson said several times: "I like your fans a hundred times better." "Why didn't you buy them?" I replied. You must realize that eventually we shall have all those who are not haunted by romanticism, who feel simple, naive nature, which does not exclude character and science, like the primitives. Caseburne also pointed out: "But

91

your *Eragny* has more air and draftsmanship, I don't understand the boss." I say this: Monet plays his salesman's game, and it serves him; but it is not in my character to do likewise, nor is it to my interest, and it would be in contradiction above all to my conception of art. I am not a romantic! I would really have no *raison d'être*, if I did not pursue a considered technique which yet leaves me free to express myself, and does not inhibit an artist who has the gift.

PARIS, JANUARY 12, 1887

*My dear Lucien,*

Dubois-Pillet, knowing my difficult position, proposed to lend me fifty francs. This was very kind of him for he is not rich. Compelled by need, I wrote him that I would be glad to accept; I will send you the money as soon as I get it.—Dubois-Pillet, incidentally, won me over to dining with the "Independents," it was after the dinner that he made his kind offer.

Descend from your glorious dreams of publishing in *La Vogue:* yesterday afternoon Kahn dropped in at Signac's with the unexpected news that everything was disrupted, and that *La Vogue* would be suspended for two or three months. . . . I suppose the printer or Lèbre put a spoke in the wheel. By the way, do you think your symbolist drawing is of interest? . . . People are interested in New Year's, the ills of the season, moving, snow, the Tarrasque, the war, etc.

PARIS, JANUARY 13, 1887

*My dear Lucien,*

Yesterday I saw Heymann, he seemed to think that Bismarck's peace proclamation had and will continue to have great weight with the collectors. Are these foxes so simple minded as to credit that ruffian's treacherous words? So much the better then, perhaps I can sell something, in any case I will strike while the iron is hot and before this horrible chancellor changes his mind.

*My dear Lucien,*

Nothing new since yesterday, except our meeting at Asnières, attended by Fénéon, Seurat and Signac. . . . I paid a visit to Paulin who was most friendly. He asked for my Paris address without my proposing anything, for I had not expected him to be sympathetic; he asked me if my new technique had yielded good results. I told him—it is no more than the truth—that my last fans are clearer, more delicate and better drawn than the ones he has; I hope an occasion will arise when I can prove this to him. He is not more limited than anyone else, he will see that I am right, but if I am too precipitous I may lose everything. . . . We have to be patient, our detractors have either not really seen our work, or seen it under adverse conditions. Once our paintings are hung somewhere they will have an effect like our early canvases had on official art. Proof: the canvases of Monet at Pillet's are sloppy and completely incoherent even to M. Pillet, who said as much to me.

What annoys me most of all is being unable to settle anything so that I can go back and finish what I began. I have a small order —it will amount to a hundred francs—for a little canvas representing my new technique; unfortunately I have nothing except my little *Sunset;* the foreground will have to be finished and I need it to make the larger which I began—but if I must I'll do without it. Look at it and write me your opinion, it is for Seurat's mother who ordered it, and I don't want to give it in an unfinished state.

*My dear Lucien,*

Don't neglect to *send me the little sunset painting, Autumn,* of which I am making a larger version; it is the small one I want, the canvas of about sixteen inches, I believe. As soon as I receive it I will receive a hundred francs; I will send you eighty francs, for I need a few cents myself, having nothing left . . . Let your mother not worry so much, this period will come to an end. I hope the trembling collectors will be reassured by that Bismarck bunkum and think of paintings.

*My dear Lucien,*

I brought the painting to Seurat, he told me that it was just what was wanted. The problem now is to get the money and send it to you without delay, but since nothing comes without trouble, here I am with a cold, feverish, unable to leave my room so foul is the weather. I didn't sleep all night, how can I go and see Seurat? I was to dine with them; impossible today, perhaps to-morrow. . . .

Let's talk about your drawings: you are quickly discouraged; how do you know whether they are good or bad?—You cannot see objectively what you have made yourself.—It is incredible that, having done a drawing, you find it impossible to re-work it. This is because you insist on copying—and you should not copy, you should change, even the arrangement, as it suits you. When you do a work over again you should get new sensations; you should not copy slavishly but freely make use of your original without *arrière-pensée.*

Durand-Ruel has not answered my letter. . . . Strange. . . . I wanted him to buy everything in my studio, except my pastels and drawings. I am going to see M. Pillet, perhaps I can make a deal. If I could, even at a sacrifice, get a few thousand francs, I would be able to work tranquilly for a while.—And I would be willing to sell everything except the ones belonging to your mother and the ones hanging in the dining room.—Among these there are several canvases that would appeal to those who like my former style. Perhaps Murer could be persuaded? or perhaps he knows someone who would be interested. Ask him.

*My dear Lucien,*

I managed to send you the eighty francs yesterday. Luckily I felt a little better, and I was able to go out in the afternoon; I hurried to Seurat's. Returning, I met Portier at Clauzet's. He informed me that Bracquemond wants to discuss some important matter with me . . . What can he have to say to me? . . . Mysterious! . . . According to Portier he has some scheme up his sleeve.

. . . Has Gauguin something to do with it? . . . We shall see. . . . Portier assured me that the only dealer anxious to buy my work is Petit. He or another, that's all I want. It seems he is dreaming of showing all the impressionists at his exhibitions. But this is just gossip. Where the devil did Portier hear all that? . . . He told me that business is miserable, and naturally has no collectors for me. I saw Pillet who said that something might be arranged with Petit. It would be a good sign if he bought some of my new canvases. . . . We must not dream too much.

*My dear Lucien,*

I am anxious to find a collector of good will. . . . It is useless to look, there aren't any. . . . Heymann has accomplished nothing, indeed, he doesn't even seem to care, I do my best to prod him, he does nothing; the problem seems to be very difficult, for it is to his advantage to find a solution.—I went to M. Pillet's as I wrote you in my last letter; together we examined the problem from every angle, our conclusion: nothing. He agreed to show some of my recent canvases to Petit. But I am sure that Monet and Renoir worked against me with Petit; perhaps I am exaggerating. . . . At the moment the only thing left for me to do is to sell my Degas pastel, it will be painful to let it go, but it can't be helped. . . . What do you think? If I could get from five to eight hundred francs it would certainly lighten our burden.

Tomorrow Bracquemond will visit me at your grandmother's; he wrote me that what he had in mind will no longer interest me but that he will come just the same, that he will be glad to see my painting. I have nothing new here to show him . . .

I like your little fairy tale, only it is a bit long.[1] The only writers I know of who could re-write it are Fénéon and Ajalbert. . . . I shall speak to Fénéon. He is very kind and I believe he is interested in us.—But the real problem is with the

---

[1] *Lucien was then thinking of doing some albums for children, and had conceived a story of a doll who sneezed which he wanted to illustrate. This project was not realized. At this period Lucien did a watercolor of* The Queen of the Fishes, *which was not successful either. It was used in his book of the same title, published in 1894 at Epping.*

publishers: *they are all thieves*. They put the knife to your throat even if you are famous; isn't it like that in every brand of industry, isn't fraud the rule? And they carry it off with an appearance of childlike candor that completely disarms you! I am waiting for your drawings which I shall bring to Lèbre, and I shall speak to Fénéon.

*My dear Lucien,*

Despite the fog and cold, I went last evening to "La Taverne Anglaise," where the young collaborators to *La Vogue* hold forth; I was hoping to see Fénéon, and he was there.—I asked him to re-work your fairy tale; delighted to be of service to you he took the manuscript remarking, "the title is quite perfect." I will have his emendations in two or three days.

I went to the Toché show. He is a second Henri Regnault. . . . Watercolors about eight to ten feet in size very skillfully done, blazing with color, but not interesting. . . . This gentleman has had an article written about him by Albert Wolff which must have cost him plenty; the shameless, insolent, and yet influential critic certainly gave him his money's worth. His laudation of this shady character is enough to make one give up. Seurat knew Toché. He is in no sense a Giotto, a primitive inventing his own style. He is a shameless crook. He takes from everybody, he is in no sense naive . . . besides he must be rich, he has had articles about him in all the newspapers.

I am just about fed up with Paris . . . and I am making no progress! The fact is that I can sell neither my new paintings nor the other ones, so it is not the new technique which is responsible. . . . Business is simply terrible! . . . But when will there be a change!

I expect Bracquemond here at three o'clock. . . . What the devil is he up to? What I want is to sell something, if only a very small painting. But Bracquemond is a good fellow and has always befriended me, and if I can help him in any way, I shall.

No news of Guillaumin; he has not appeared at Clauzet's since he made his contract. Gauguin is gone . . . completely disappeared . . . but I did hear that this summer at the sea shore he laid down the law to a group of young disciples, who hung on the words

96

of the master, that austere sectarian.[1] At any rate it must be admitted that he has finally acquired great influence. This comes of course from years of hard and meritorious work—as a sectarian! P.S. Bracquemond just left. He knows a dealer who wants something of mine. He is a regular dealer, it seems . . . a sharp trader, but at least a dealer. "Good," I said to Bracquemond, "let's try." Exploited on every side, one cannot be too discriminating. To myself I say: what luck if something comes of it. I am waiting for his answer.

PARIS, JANUARY 23, 1887

*My dear Lucien,*

Bracquemond told me that he took some of Gauguin's pictures with him, hoping to sell them; he considered them good paintings but . . . strange. . . . A little confused, but after all interesting. . . . Alas! All those to whom he showed the pictures became literally angry, conceiving that they were being taken in. . . . He told me that he strongly urged Gauguin not to show his paintings to the dealer in question. . . . Bracquemond found him a job in a pottery works. Bracquemond said that some of his things were good, others not. All in all he seemed to imply that it was the art of a sailor, a little taken from everywhere. . . . Aha, what do you think? I was always discreet, but I am not surprised, I made up my mind about him a long time ago, and while I won't say that he may not change for the better, at bottom his character is anti-artistic, he is a maker of odds and ends.

Bracquemond tells me that he looked attentively at my works at our exhibition. Far from objecting to them, as I expected, he said they were compactly drawn, and modeled, but he is shocked by the dots; he enjoined me to stick to divisionism but not to use the dot.—I said nothing to him of our experiments. He told me that of all the impressionist painters he liked my work best; this was not the first time he had said this; to each one his own taste. He does completely accept my view that the old disorderly method of execution has become impossible.

Before making up my mind about the Degas, I shall see whether

---

1 *Paul Gauguin had spent the year of 1886 at Pont-Aven in Brittany. He became the leader of the painters at the pension of "La mère Gloannec."*

I can do business with Bracquemond's dealer. Just the same I shall look for a buyer. I'll sell the pastel but not the drawing which is a gift from Degas, or an exchange for something of mine. It would be indelicate.

*My dear Lucien,*

The more I think of it, the more mortified I feel about parting with the Degas, and the more convinced I am that our only course is to sell it. It is painful to do so, it means losing one of our purest joys. . . . Signac says it is worth at least a thousand francs. Arrange somehow *to get it to me undamaged;* I am going to see Portier about it. I have not heard from Bracquemond.

*My dear Lucien,*

I shall have to leave for Eragny. I left a painting about 21 by 18 inches at Enot's, rue des Pyramides, and I expect him to get my canvas which will come from Brussels. Signac promised to make an effort to get my work sold in Brussels. I received a note from him yesterday announcing his arrival and Seurat's. I am expecting a letter with all the facts about the exhibition [of the Vingt].

I also left with Paulin a fan which he is going to try to place for me; by leaving things everywhere I am trying to arrive at a solution, but the holy chants of war sounding all around us cry halt to everything, the collectors no longer dare to buy, although paintings are the best investment—and that's exactly what they want.

I also have much to tell you about our group of scientific impressionists. I learned much while staying in Paris and I shall tell you what good Signac had to endure, and I too through him. This is not to be repeated.

I met Sisley; as ever, and like the others, he is secretive. He'll show at Petit's this year. He told me that Durand may have sold all his impressionist paintings to Mr. Robertson. That's why this gentleman doesn't buy any more—he has enough.

98

*My dear Lucien,*

I would gladly exhibit in Paris with the "Vingt," for they are very sympathetic to us, but one has to be ready for a show, one has to have a respectable quantity of canvases. Despite my hard work, I haven't accomplished much. I would consider myself lucky if I managed to have three canvases ready—even that figure is problematical because I must sell no matter what. And to sell I must remain in Paris, for when I leave my agents forget me, having no one to prod them.

In any case to show would be a good thing and above all would involve little expense. Is it not unfortunate that Seurat should be so—how shall I say—so sick! [1] I cannot understand such extraordinary behavior. If not due to illness, it must have been planned, but in any event it was simply stupid, for it will not prevent the art of Signac and the others from developing on the basis of our theory.

Nor can I understand what is in Renoir's mind—but who can fathom that most variable of men? Who the devil got him to go to Dubois-Pillet's—he would not take the trouble to visit Monet, Sisley, or me? . . . There's something behind this! . . . Perhaps those gentlemen who found it so hard to accept Guillaumin when I defended him have changed their minds and now plan to present him to Petit. . . .

This morning I received a letter from de Bellio. He writes that he does not believe scientific research into the nature of color and light can help the artist, neither can anatomy nor the laws of optics. He wants to discuss these questions with me and find out my views.

Now everything depends on how this knowledge is to be used. But surely it is clear that we could not pursue our studies of light with much assurance if we did not have as a guide the discoveries of Chevreul and other scientists. I would not have distinguished between local color and light if science had not given us the hint; the same holds true for complementary colors, contrasting colors, etc. "Yes," he will tell me, "but these have always been taken into account, look at Monet." It is at this point that the question becomes serious!

---

[1] *This is doubtless an allusion to the fear Seurat had expressed at the time that other painters might borrow his technique if his work were shown.*

*My dear Lucien,*

This morning I received a letter from Signac who wants my opinion about showing with the "Vingt." I shall write him that I think it would be very good for us to exhibit with them; Seurat is no doubt the only one who will have objections. His prudence is so extreme. But we—or I, at least—have nothing to lose, since I recognize no *secret* in painting other than that of the artist's own sentiment, which is not easily swiped!

Tell Tanguy to send me some paints. What I need most are ten tubes of white, two of chrome yellow, one bright red, one brown lac, one ultramarine, five Veronese green, one cobalt; I have on hand only one tube of white . . . I expect to begin to paint again from nature, and I need the colors.

*My dear Lucien,*

Here we are again in a hopeless mess . . . Just imagine! the relative with whom the new maid had left her two children, suddenly, without warning, arrived yesterday with the two little ones and left them on our hands! You can conceive what followed and how gloomy your mother became. The poor maid was to be pitied, and your mother pitied her. But how will all this end? The maid leaves tomorrow for Auvers to find a place for the children. . . . While this was what we desired, it took money, and your mother has —she told me—nothing left! And you know how she is in such circumstances! Here is the rock which must be raised again and again, without stop,—and I was hoping to complete a new study I just began from nature. But I shall have to go to Paris to raise a few cents. . . . I have no luck, the only one of my paintings which was liked in Brussels belongs to Durand,—and he is not at all satisfied with it, this very canvas had the knack of displeasing Guillaumin, too . . . how luck favors me! . . . Of the eleven hundred francs sent us—nothing remains! . . . You will have to get busy, my dear, for we both cannot stay [in Paris] at grandmother's, and eat and sleep there, unless you find a way to succeed in business. . . .

Verhaeren's article is first rate.[1] Ask Signac to give you the address of this critic, I will send him my card.—Van Rysselberghe's drawing is very good, it has character; I like Meunier's less, however it is not bad but out of proportion, and it is a bit too much like Michelangelo!

All this does not bring us bread. . . . This epoch is certainly full of stupidities; one has a reputation gained by many years of effort, one has drudged, despite your mother's constant remarks to the contrary, one has done the work of four to attain a true and proper renown, the kind won in fair fight. Bah! It is as if one had been singing to himself all the time, your bourgeois, when it is a question of rewarding such efforts, turns his back on you. Even people like Nunès, to whom I have made concessions, seem to take me for an old idiot! . . . As a final humiliation, I am forced to beg people to buy one poor picture which cost me so much in toil. . . . It is all very discouraging.

But after all, complaints and groans are of no avail: I will have to return to Paris—and to my miseries of the last few months.

ERAGNY, MARCH 1, 1887

*My dear Lucien,*

I received your letter with the sixty francs. Really, if Heymann would take the trouble, I believe he could sell my paintings; one thing is certain, they must have *some* value, I have not yet been able to determine how much despite all my inquiries; all that I have been able to find out is that Durand has sold almost all our works; Sisley has confirmed this. Now Durand doesn't give them away, and we can be sure that he has not lost money on them. If I could track down the unknown buyer perhaps I could sell him something more important than watercolors at twenty francs. But whom shall I ask to help me? Monet and Renoir are uncommunicative, they know some collectors but are cool to me, and Duret himself is playing possum. So I shall have to return to Paris, dropping the studies from nature which I just began.

---

[1] *During the Brussels exhibition of the "Vingt," the Belgian poet published a long article in* La Vie Moderne *(February 26, 1887) on the neo-impressionists, particularly stressing the work of Seurat and Pissarro.* La Vie Moderne *published between January and April of 1887, a number of drawings by Lucien Pissarro, Signac, Cross, Dubois-Pillet, Seurat, Van Rysselberghe, etc.*

*My dear Lucien,*

I sent my three paintings to Petit, tomorrow I will go to discover their fate. I brought Heymann my four watercolors, he is expecting to hear any moment about my large gouache *Le Marché des Fossés* [1346]; if it has been sold I will leave. It will bring, I hope, three hundred francs.—I saw Paulin who told me that one of his friends wants something of mine for about three hundred francs, he spoke of this to Portier, but I shall be there myself, it would be devilish bad luck if I did not conclude a deal which would enable me to take advantage of the good weather and sunlight.

Paulin has gone to Brussels to the "Vingt," everybody has been there, he told me that the Lebourgs were all *black*, and that my things showed up very well, and were clear and colorful. It seems that Durand-Ruel was there, too. I think that there is a veering to the new technique, if they dislike the large Seurat [1] at least they admire the small canvases.

At this moment I am planning my exhibition,[2] I think I will show only new paintings and one frame enclosing four or five panels. I will ask permission to show in the corridor downstairs the two fans I sold to Paulin, the one Portier has, the last three I did, and some gouaches that are already sold.

I believe that my last landscape will be quite good, I shall frame it thus: a one and a quarter inch white margin around the painting, a flat oak surface of three and one half inches and a gilt laurel border of one and one quarter inches: this will look proper, I think, and I may do the same for the other canvases; I have to show my works to best advantage, for you know how the other artists present theirs. So framed, my painting will lose nothing, I hope, and the frame, while severe, will not be too ill-matched with the others nearby.

I will be very lucky if I can just hold my own; I have no illusions, I do not expect them to be carried away with enthusiasm, but if I am not blotted out by the others, it will mean victory and much sooner than some believe. Already the most assured convictions seem more hesitant, smiles have given way to discussions, and

[1] A Sunday Afternoon on the Island of La Grande Jatte, *sent by Seurat, created a scandal in Brussels.*

[2] *Pissarro was intending to participate in the* International Show *which was to open at Georges Petit's on May 7, 1887.*

I sometimes even sense approbation. They are waiting—well! that's something in itself.—What a pity I haven't a large canvas finished!

*My dear Lucien,*

M. Petit told me that the three canvases are salable, that he has not yet been able to attend to this but that he will do his best. He told me that the international committee met, and after some deliberation, decided not to permit white frames. I mentioned that having foreseen such difficulties I had resolved to have oak frames with white margins on the paintings, and that in this way I proposed to reconcile the harmony of the other frames with mine without disturbing the harmony of my pictures. He found this satisfactory, but I asked myself if they would not find something else to object to, damn it! If so, I will at once withdraw. As a matter of fact, I don't regret not having white frames, which would not be rich enough in these surroundings.

Yesterday I met Duret, he said to me, "Ah! you are going to exhibit, but you know you should regard this as a purely commercial affair. It is a most stupid milieu! stupid! Compromise I say, don't hesitate." I answered, "Well, well." After a while your name came up, I mentioned what Dumas has decided to do, and what everybody is saying at the publishers,—and then my Duret became an anarchist again. "But that is absurd, nothing can be done any more, look, even Zola lowers himself to collaborate with Busnach, to earn a few cents; my dear friend, I withdraw, I write for nobody any longer, I never shall again, the newspapers have a horrible fear of whatever is not banal or stupid. I am content," he said, "to work quietly, far from Paris, at Cognac." "Then goodbye, my dear Duret, and be of good courage," I said and hurried to Petit's.

I forgot to mention: Portier said to me: "It is decided, no more exhibitions [with] Degas will be held?"

"Why?"

"Because you exhibit at Petit's."

"But, Portier, do you think Degas would be willing to show with Seurat, Signac, Dubois-Pillet?"

"Oh no! you can't expect that."

"Well then," I replied, "why the devil should I care about Degas?" [1]

*My dear Lucien,*

I am always hoping that things will go a little better than they have in the past, but how long one must wait; luckily the cold and the snow make me regret less my stay in Paris. And now I must resign myself to not showing my *Apple Eaters* [695], the frame for a canvas that size would cost too much, and it is not certain that the committee will accept a frame with a white border . . .

*My dear Lucien,*

I finally had the luck to run into Mirbeau at the exhibition [of the *Indépendants*]. We had a long talk, and he remarked that you ought to go to see him, that he had been intending to write to you but did not wish to do so until after he had seen [the publisher] Ollendorf, which he has now done. He recommended you warmly, he cannot have his book illustrated, for that matter he does not agree that books *ought* to be illustrated; it is just as well, he thinks, if not far better, to publish drawings without any text.[2] Nevertheless he recommended you. It seems that Ollendorf is very kind, though rather weak. Mirbeau told me a lot of gossip; it seems that the coming of the impressionists created great confusion at Petit's.

Apparently Renoir has destroyed all the work he did last summer . . . He is exhibiting only a very few things, but they are extremely interesting; Whistler, too, is showing with us as well as Puvis de Chavannes.

Heymann has just this moment brought me two hundred and fifty francs from Portier; I shall send the money on to you. It is for a canvas I left at Paulin's; Portier is about to sell the other one.

---

[1] *Degas did not participate in Petit's International Exhibition. Of the impressionist painters, only Monet, Renoir, Sisley, Morisot and Pissarro were represented.*

[2] *Mirbeau did not stick to this principle and later published with Bonnard* **La 628 E8.**

*My dear Lucien,*

My little panel is quite perfect in its frame, it has great unity, it is bathed in a very harmonious and delicate pearl-grey tone; the execution is absolutely superior to large strokes, and I believe the work cannot fail to please whoever looks at it without prejudice.

*My dear Lucien,*

*Le Figaro* has just published two letters of the great Millet; these letters show the painter in a very peculiar light and clearly indicate the petty side of this talented man.[1] It is very discouraging. I have not yet read the letters, but Signac told me the substance of them. The great Millet indignantly protests against the Commune [and the communards], whom he characterizes as barbarians and vandals; he concludes with a dig at good Courbet, who, as I see it, can only be aggrandized by this attempt at belittlement. Because of his painting *The Man with the Hoe*, the socialists thought Millet was on their side, assuming that this artist who had undergone so much suffering, this peasant of genius who had expressed the sadness of peasant life, would necessarily have to be in agreement with their ideas. Not at all. More and more indignant disavowals from the great painter! What do you think of that? I was not much surprised. He was just a bit too biblical. Another one of those blind men, leaders or followers, who unconscious of the march of modern ideas defend the idea without knowing it, despite themselves! . . . Isn't this a strange phenomenon? For a long time now I have been struck by the unconsciousness of the intellectuals.

Gustave Kahn's book is to appear soon.[2] Signac told me that Kahn expects it to be a great success and will be very discouraged

---

[1] *Millet had refused to join the* Fédération des Artistes Français *which had been formed during the Paris Commune under the leadership of Courbet. In a letter dated May, 1871, Millet expressed his view of the communards: "Isn't it frightful what these wretches have done to Paris? Such unprecedented monstrosities make those of the vandals look conservative."*

[2] *The reference is to a volume of poetry,* Les Palais nomades.

if his work is not received with enthusiasm. I don't understand how a man as well balanced as Kahn can for one moment count on success; which is so rare and surprising when it comes. . . . No, he can be sure that if his book is really superior, if it embodies some new idea, it will be greeted with silence. . . .

PARIS, MAY 8, 1887

*My dear Lucien,*

I went to Asnières with Signac, still exhausted from the hanging . . . I had all I could stand from that confounded exhibition which smells to heaven of bourgeois values. But just the same I wanted the experience of seeing my pictures hanging with those of the leaders and followers of triumphant impressionism.

Evidently, for the test to be decisive, I would have needed at least fifteen canvases to be in harmony with the other exhibitors, and also my works should not have been scattered about as they were. The Monets, Renoirs, Sisleys, Cazins, Raffaëllis, Whistlers were shown in groups. Just the same it is clear, it is very evident that we have more luminosity and more design; still a bit too much stiffness; badly framed and the tapestries are in contradiction with our harmonies. I am not too dissatisfied; what enraged me, though, was the offhand way I was treated. M. Petit, to please a foreign painter who was blinded by my luminosity, withdrew my *Plain of Eragny*, withdrew it altogether and hung in its place a dark Monet. I was so angered that I was simply incapable of being polite to my guests. I was furious and complained bitterly, if it had not been for John Lewis Brown I should have made a furore. I reflected that after all it was better to calm down and take it up later. But you cannot conceive to what degree this milieu enslaves one, and how easy it is for the powerful to restrict the liberty of others. Even my poor little panel was put aside, I protested once again this morning and was promised that space for my work would be found. De Bellio seems to like my pictures, he called me a magician. . . . I am afraid this is just flattery. As for M. Chocquet,[1] it would be an exaggeration to say that he was

---

[1] *Victor Chocquet, who had collected works by Delacroix, became interested in Renoir, and then a really passionate worshipper of Cézanne. He acquired a large number of Cézanne's paintings and was the latter's faithful friend.*

106

flattering, he cannot abide my work, I sense his dislike, but it means nothing to me.

Finally I am completely exhausted, for we spent from nine o'clock last night until seven in the morning hanging paintings.

I am off to the exhibition, I will write you later about certain ideas expressed by Monet which are most extraordinary coming from such an artist. . . . They can only be explained by the fact that he is in opposition. . . .

*My dear Lucien,*

I have been wanting to write you for three days, but I lacked the three cents for postage.

I was finally permitted to replace the painting of the *Plain*, as to the little panel, I could not obtain the space for it. Every day they make promises, every day I press them: they seem to be trifling with me.

I am very glad that I decided in favor of exhibiting; it was an experience I needed. Who knows, I may never again be able to show with the old group of impressionists, and I have every reason to be satisfied. You will see for yourself how wide is the divergence. It is an altogether different art, it is of course not understood, but it is seen, for it is so different, so clearly distinct; at a great distance this is recognized, and you would be amazed at the luminosity and simplicity of my works.

Your mother came to the exhibition. I am very sorry that I did not know she was coming, for then I would not have been dining with Signac and I should have been so pleased to show her around. But perhaps she wouldn't have liked that? She must have heard a lot of nonsense about the paintings.—Tell me whether she did not find Monet's things a little too dark? I do not know whether I am correct in this, but these works seem to me to lack luminosity, by which I mean the light that bathes bodies in the shade as well as those in the sun. The effect is certainly decorative, but there is little finesse and crudities are prominent; I do not know if it belongs to our vision which aspires to harmony and demands an art which while not decoration is yet decorative.

As for Renoir, again the same hiatus. I do understand what he is trying to do, it is proper not to want to stand still, but he chose

to concentrate on the line, his figures are all separate entities, detached from one another without regard for color; the result is something unintelligible. Renoir, without the gift for drawing, and without his former instinctive feeling for beautiful colors, becomes incoherent. As for Sisley, he has not changed, he is adroit, delicate enough, but absolutely false. . . . Whistler has some very fine bits of sketches in paint, forty-two!! He was honored with the best places, he also has a large portrait of a lady, the painting is completely black. Nor is there any luminosity either. Whistler, by the way, does not care for luminosity. His little sketches show fine draftsmanship. In the corridor he has some very good, in fact, quite superior etchings, they are even luminous, which is strange for an artist who does not aim at this in his color.

Madame Berthe Morisot has some excellent things. The sculptor Rodin is a great artist. Degas finds him a little mannered; I think so too, or rather I should like to see a bit more synthesis instead of simplification. As to the foreign painters, they are inconceivably bad! Montenard had several paintings hung but withdrew them all, finding them out of place with the others. Besnard has no cause for satisfaction. His paintings [by comparison] are white! . . .

At Petit's they are waiting impatiently for Wolff's article. You cannot imagine how much the painters and dealers tremble before this gentleman. When Wolff came in everyone rushed over to hear the pronouncements of the oracle, those who enjoyed his favor or who had the honor to be acquainted with him pressed around him; a word he dropped was repeated like an echo in the mountains. How the poor artists have fallen! It is horrible.— At one time I felt a sudden push; John Lewis Brown, always enthusiastic, was shouting at me, "Pissarro, my friend, Wolff likes your paintings very much!" "Really, my dear fellow, that is just claptrap, I don't believe it, if true it would be very peculiar indeed!" What do you think of that? But have no fear, I know to my cost what this milieu is worth. Let us not excite ourselves, he who laughs last laughs best!

I went to the dinner of the *Indépendants* yesterday. It went off very well! Hochedé made a little speech and drank to the honor of the old impressionism. He seemed to be criticizing Monet, Sisley and Renoir; there is something besides art in his criticism, I fear, for he is generally eclectic. . . .

*My dear Lucien,*

I shall do my best to leave by the beginning of the week. I would have liked to see you here in Paris, to get your reaction to the Millet show, to ours, and to mine especially. I wanted to send you a little money, I made every effort to, I have only been able to borrow forty francs from Heymann; I must carefully husband part of this money so as to be able to return to Paris if need be. Heymann's collectors lost heavily during the recent crises, some time will have to elapse before they regain confidence. You must remember that Heymann recruits his collectors from the small capitalists.—This is very distressing since I can count only on people of that sort.

Petit has undertaken to push Monet and Sisley, hence it hardly matters to him whether or not I get anywhere; he has his faithful collectors who recruit buyers here and there. I observed these gentlemen several times propagandizing exclusively for Monet and Sisley. The placement of paintings was done in advance, the grouping was calculated, I know that; talking with Sisley I got what practically amounts to an admission. So you see my canvases were scattered to give them less importance. I let them get away with it this year, I didn't want to say anything; besides I was afraid that my canvases would not show well with the others. This was unnecessary modesty on my part, grouped around my *Apple Eaters* [695], my show would have been much superior.

Yesterday I saw Bracquemond. He likes my large painting [695] less than my new things, he finds these last very excellently drawn and more pure and delicate in color; he did not even notice from where we were sitting, that they are *pointillist* works. I called this to his attention, he replied that this could not affect his judgment, that he would not take sides for or against.—On the other hand he finds the Sisleys first rate and the Monets beautiful. However he was rather critical of Renoir, though he thought some parts of the large painting very well drawn—I am of his opinion as to the parts.—It is the ensemble, the synthesis which is faulty, and this they refuse to understand!—He also noted the crude execution in some of the Monets, particularly in one of the Holland canvases, in which the impasto is so thick that an unnatural light is added to the canvas, you can hardly conceive how objectionable it is to me,—even worse is the swept and meager

109

sky—no, I cannot accept this approach to art.—But the walls in the picture seem to me very well treated. As for Sisley, I just can't enjoy his work, it is commonplace, forced, disordered; Sisley has a good eye, and his work will certainly charm all those whose artistic sense is not very refined.—Madame Morisot is doing good work, she has neither advanced nor fallen back, she is a fine artist. Whistler is very artistic; he is a showman, but nevertheless an artist.

These are my impressions. As for myself I have some doubts about my work—that is inevitable, but I feel that I have certainly made progress. I want to know how I can put this progress to account in figure compositions done in the studio. This is what I shall attempt next year. I need to do two large canvases and several landscapes. Will I have the peace of mind to carry out this venture successfully? I will do my best. Seurat, Signac, Fénéon, all our young friends, like only my works and Madame Morisot's a little; naturally they are motivated by our common struggle. But Seurat, who is colder, more logical and more moderate, does not hesitate for a moment to declare that we have the right position, and that the impressionists are even more retarded than before.

PARIS [MAY 16, 1887]

*My dear Lucien,*

I went to the Millet exhibition yesterday with Amelia. . . . A dense crowd.—There I ran into Hyacinthe Pozier,[1] he greeted me with the announcement that he had just received a great shock, he was all in tears, we thought someone in his family had died.— Not at all, it was *The Angelus*, Millet's painting which had provoked his emotion. This canvas, one of the painter's poorest, a canvas for which in these times 500,000 francs were refused, has just this moral effect on the vulgarians who crowd around it: they trample one another before it! This is literally true—and makes one take a sad view of humanity; idiotic sentimentality which recalls the effect Greuze had in the eighteenth century: *The Bible Reading, The Broken Jar*. These people see only the trivial side in art. They do not realize that certain of Millet's drawings are a hundred times better than his paintings which are now dated.

---

[1] *A painter who lived in Eragny.*

They were not so dazzled when they looked at the admirable Delacroix decorations in St. Sulpice! What animals! it is heartbreaking!

A great change is taking place in art at this moment; it gives me pleasure to note the symptoms of this change. I have met a number of painters and critics who seem to understand that the old impressionists have fallen behind. Then, for example, I saw Astruc yesterday, he fulminated against the backsliding of Renoir and Monet, and Sisley's lack of progress. I am not disappointed with the results of my exhibition. It even seemed to me that Astruc understood our experiments, without perhaps being able to illuminate them further. He grants that Millet's work has become dated, he agrees with me that Millet's whole value is in his drawings, which however are infected with a sentimentality that one day will embarrass all true artists! [1] An article in *L'Estafette* appeared which it seems is very favorable to me and very unfavorable to Monet, Renoir, etc.; my brother mentioned this to me but could not find the issue.[2] The article is by M. Desclozeau, a young critic, he will have read Fénéon, I have heard that they are acquainted— Fénéon scored a bull's-eye. Hyacinthe [Pozier], the sensitive landscapist, told me about a very flattering article in some art review. I don't know which, but I will find out. I don't attach much importance to all these writings which are generally inspired by the interested parties, but they can serve as a thermometer, indicating one's value and influence at the moment.

It is absolutely necessary to work with a view to a good exhibition next year: I need as many figure paintings as possible.

*My dear Lucien,*

I saw M. Schuffenecker at the exhibition. Naturally the Gauguin-Guillaumin incidents came up.[3] Very malicious, M.

---

[1] *The same ideas were expressed by J. K. Huysmans in his article on the Millet show which appeared in* La Revue Indépendante *in July 1887.*

[2] *In a review of the* International Exhibition Jules Desclozeau *wrote on May 15:* "M. Camille Pissarro *has painted a field bathed in sunlight, whose forms, colors and reflections are admirably synthesized. It is more* field *than any field we have ever seen. We cannot understand what interest the brutal paintings of M. Claude Monet and the* simplicist *works of M. Renoir can have. Both these artists have taken the wrong path.*"

[3] *See with regard to these happenings Pissarro's letter of December 3, 1886.*

111

Schuffenecker, and very malicious, M. Gauguin, who according to M. Schuffenecker was ill advised in giving free rein to his wounded vanity!! Believe me, I told him frankly what I thought of the conduct of the two friends, Gauguin-Guillaumin, on that occasion. But what was most wonderful, the real climax, was to hear M. Schuffenecker speak in the most glowing terms of the new technique, praising Seurat not only for his scientific approach, but even for his talent!

"Well, then," I told him, "you are no longer in agreement with Gauguin-Guillaumin."

"I beg your pardon; you will see for yourself what enormous progress Gauguin has made. I have just come from the country, Gauguin is absolutely taking this direction, he is a proud painter and he has an iron will. He will be talked about."

"We shall see, M. Schuffenecker. In any case," I said, "Gauguin was wrong to rail against Seurat, Signac,—and, consequently against me. There is now little possibility of our coming to an agreement. Besides, we have taken our stand, we shall exhibit alone, struggle alone, for I do not believe those gentlemen will adhere very firmly to the position of scientific impressionism.—We shall see."

Vehement protests from Schuffenecker.

You see, my dear Lucien, all these people who twist and turn, begin to realize that they have blundered, and they will try anything again and again—particularly Gauguin—to steal our place. —This was to be expected.—We are going to see strange things; for we who understand what difficulties must be surmounted and what delicacy of vision one must have can be prepared for some wonderful things from these people! Didn't Schuffenecker, too, throw himself into the fray? How right Fénéon was to lay down categories. Besides I explained this to Schuffenecker and in quite harsh terms, I even told him that in the future we would certainly break our way for ourselves and not let ourselves be pillaged by the "Fagerolles." Isn't that the final comic touch? Schuffenecker begged me to visit him. I really want to go, if only to see for myself what is being done. . . . I can't get over it.

I met Anquetin; he also wants to follow us. This is getting to be a real steeplechase.

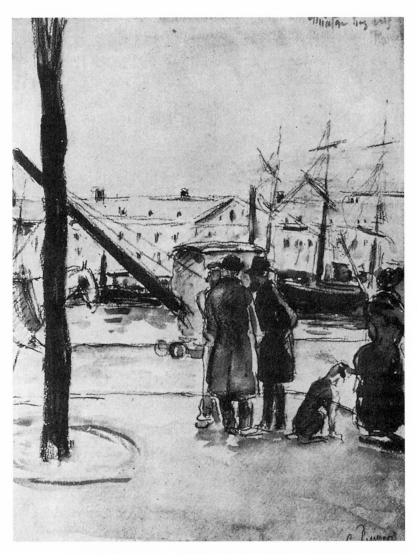

16.—C. Pissarro: Le Théâtre des Arts à Rouen, 1883.

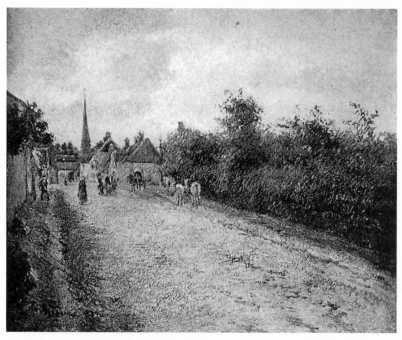

17.—C. Pissarro: The Village of Eragny on the Epte near Gisors, 1884.

*My dear Lucien,*

I have only a vague recollection of the gouache of mine which you tell me is to be sold at auction. Let's hope it is not sold for some miserable sum—that would be the last straw! I have no one to bid and push up the price.

Has Wolff done an article? . . . Certainly not.[1] With the reappearance of the new impressionists he has suppressed his review, he doesn't dare breathe a word either in praise or blame. Petit has nothing to rejoice about, this reflects on the show. This Wolff is too old for our time, what we need is a Félix Fénéon, but of course the tricksters won't like him!

*My dear Lucien,*

I'm damn lucky that that gouache brought 300 francs. Where the devil is she now, Dame Misfortune? Can it be that she's forgotten me?

*My dear Lucien,*

The fact that I can't sell my own works does not at all prove that I would have been a successful businessman; damn it all, I know how I would have made out: I would have gone bankrupt two or three times; in this I would even have been blameless; bankruptcy would have resulted, perhaps, from too great trust in my dear competitors, and hence be come by honestly. Into the bargain, I would not even have had the satisfaction of living by my ideas; what regrets! Besides, it was not possible. I would much rather be a worker than a businessman who is actually nothing but a middleman or intermediary, and should properly conduct his business for the worker's profit. It is simply for being my agent that he takes the lion's share of the returns for my work!— No, it is too idiotic.

---

[1] *In fact no article by Albert Wolff on the Petit exhibition appeared in* Le Figaro.

113

I began a canvas about 21 x 18 inches; I began it in grey weather, impossible to go on with it in the sun. I am going to have plenty of trouble and if Heymann doesn't sell anything what shall I do then? I have done four gouaches and I am about to work on my 36 x 28 canvas. I am working hard. If I didn't have so many worries the picture would paint itself.

P.S. If you happen to see Seurat or if you write to Signac, tell them that I have tried the mixture of cadmium (well recommended by Contet), with red, white and Veronese green. It becomes black in four or five days from the Veronese green. Even blacker than the chrome yellow mixture. *Tell this to Contet.*

ERAGNY [JUNE 1, 1887]

*My dear Lucien,*

I finished four gouaches of which two are pretty good, *Market of Pontoise* [1413] and *Cow-girl of Eragny* [1426–27]. The two others are so-so. I have my *Gathering Sweet Peas* [1408] which I shall finish, it is about twenty-five by twenty-one inches; perhaps Portier will prefer it to the others, in any case I will send him the four small gouaches pretty soon.

Heymann is sleeping; he has no collectors any more. It is beyond me how Sisley and Renoir get along. Monet of course has people interested in him.

Try to find out whether Fénéon wrote a piece on the Petit exhibition. I hope the show doesn't get much attention. The *Indépendants* got many more reviews—it is true this isn't much help.

Impossible to work outdoors; continued thunder storms. I am working hard at gouaches. I am beginning my large canvas, and continuing my landscape with the hare.

ERAGNY [JUNE 4, 1887]

*My dear Lucien,*

I am really pleased to find that Huysmans is more or less sympathetic to me; he understood what we were getting at, you will

114

see, in a few years he will adore the dot![1] There are now three artists, Huysmans, Mirbeau and Bracquemond, who accept us.

My dear Lucien,

I see that even my last gouaches are not going to be understood, it's enough to make one quit. . . . Portier takes to my most mediocre work, precisely this *Market of Gisors* has been a great bother to me. The work being a failure, I went over it with a few pen strokes, I thought of not sending it. The only good thing I have is the *Market of Pontoise* [1413]. I have almost finished another gouache: *Two Peasants Near a Well* [1410]; this was done in bright sun, I believe it is as good as the *Market of Pontoise*. If you go to Théo van Gogh's, see if he was the blond young man who bought my gouache [at the auction].[2]

What a joke! It's a wonderful business being a bourgeois—without a cent. But one can hardly conceive of a bourgeois without unearned increment. All those who work with their hands or brains, who create, become proletarians when they depend on middlemen—proletarians with or without overalls.

My dear Lucien,

My painting *The Cleft* [715] is hardly advancing even though I work on it every day. It is really taking much too long. I'm going to make more gouaches than ever for I see no way of selling figure paintings. Perhaps, I will be compelled to return to my old style? That would be very embarrassing! We shall see. Anyway, I will have learned to be more precise.

Nothing particular to tell you except that I am still waiting

---

[1] *Huysmans in his "Art Chronicle" in* La Revue Indépendante *had just written of Pissarro's works shown at the Petit exhibition: "Besides his Apple-Pickers, which calls to mind his ample and delicious canvases of former years, M. Pissarro this time brings to the booty of the hall only a few pointillist landscapes less resolute in emphasis and less clear, in my view."*

[2] *Théo van Gogh, the brother of the painter, was director of the Boussod & Valadon Gallery on the Boulevard Montmartre. Prompted by him, this gallery, which had replaced that of Goupil, became interested in the impressionists and their friends.*

for a letter from Théo van Gogh. Nothing yet from that quarter. And now my only hope is in Durand-Ruel; that gone there is nothing left. Things are becoming very serious. I have done several watercolors, one of which is about 25 x 21, *Shepherdess* [1417] which has a certain style. One sitting with a model and I could finish it; I am going to Paris to sound out Durand. Maybe he can place it in New York.

*My dear Lucien,*

You ask me if I am working; in the morning I have a session in the sun, the rest of the day I work on gouaches and on figure paintings, I make sketches and studies in grey weather for my *Reapers* [713],—it is beginning to make progress. . . . I am preparing some gouaches to be ready in case Durand, by some lucky chance, can sell them, as I see that I must count no more on Théo van Gogh than on the others; I don't know what to do. . . . I have just five francs for train fare; as soon as I have a supply of gouaches I shall leave, I can't afford to miss any chance that comes along.

Dubourg [the framer] sent me his bill, it runs up to 995 francs! . . . His account is pretty steep, he charges me very high prices.— That's all I earn, bills! . . . The Petit exhibition costs me plenty!!— and I don't know if I shall show next year; besides, with all these worries, these comings and goings, I am not producing, I can proceed with my gouaches but I have no model for the figure paintings, you see what I am limited to.

Your mother worries a great deal and that doesn't help matters.

*My dear Lucien,*

I shall go to Paris, I can't remain here any longer without news. —I shall bring a large gouache, which I consider quite successful and very salable, also several small watercolors. I would be happy if chance would help me discover a generous collector like Néla-

ton's grandson,[1] such a man is rare, he is an artist with taste. The collector today regards a painting only as a share of stock, it is disgusting to be a part of such a degenerate business. . . .

The weather has changed, we are having rain. I am working on my *Harvest* [713], it is taking a very long time and I am not getting the effects I want, I return to the gouache and I do a lot! . . . We are celebrating the holiday [July 14th] in Eragny. Wind, rain and not a penny . . . very sad this year.

ERAGNY [AUGUST 25, 1887]

*My dear Lucien,*

As was agreed upon, I was to go to Paris to bring my group of paintings in order to look for collectors or for a loan, at any rate for whatever financial arrangement could get us out of our predicament. But everything has changed, your mother assured me that she would do better, and as I have hardly been very happy in my various ventures up till now, I let myself be persuaded. In any case, while your mother is taking these steps, I shall find time to do two gouaches, to finish the two paintings I am now working on, and to begin my fall campaign, so as to have some extra canvases in case business picks up when the collectors return.

I can't give you any further details about the means your mother expects to use to succeed better than I; she doesn't know herself, I suppose. I have a vague idea that she is counting on Murer [in Auvers], but I'm afraid she's deluding herself. For my part, I confess that I would expect nothing from this quarter. Well, she left yesterday with Cocotte for Pontoise to go from there to the Murers! Next she intends, I think, to go to Paris. If she accomplishes nothing at Auvers, whom will she see in Paris? Well, I couldn't discuss the matter with your mother and dissuade her, it would only have resulted in quarrels which simply irritate us and keep us from solving the problem. This is the state we are in: darkness, doubt, quarrels, and with all that one must produce works that will stand up to those of one's contemporaries. One must create art, without which all is lost. So, my dear Lucien, I stiffen myself against the storm and try not to founder. Your

---

[1] *Doubtless it was M. Nélaton who was responsible for Pissarro's gouache getting 300 francs at the auction.*

mother accuses me of egoism, indifference, nonchalance. I make heroic efforts to preserve my calm so as not to lose the fruit of so much thought and labor.

I just finished a gouache of 25 x 21 inches, *Harvesters at Rest* in the shade of great poplars [1411]. I am quite satisfied with it although I have not been able to get the effects I would have liked with this stubborn medium. I have also nearly finished *The Cleft in the Road* [715] and my *Sunset* [712] in our field. I am fairly well satisfied with them. I still have to develop my new technique [1] while respecting as much as possible the laws of color. I have begun a *Washwoman* in gouache, about 21 x 18 inches, and I am about to begin my fall campaign. If your mother can handle the paintings successfully, we'll solve our difficulties—but there's the rub!

*My dear Lucien,*

I got your letter of the 25th on the 26th. The next day your mother returned from Paris. She has already told you [in Paris] the outcome of her venture. As you must have remarked, it was quite barren.

Murer, it seems, takes the view that I am lost. He even told your mother that when my name comes up in a conversation people smile! . . . He is willing to give me any kind of help except money. He is in financial straits himself, he receives nothing but promissory notes which cannot easily be converted into cash. He suggested that I hold a kind of fake auction, and if I so desire, he will introduce me to Tual, the auctioneer. De Bellio is also of the opinion that I am either lost already or falling behind, and that I am making a great mistake in trying to develop my art.—He, too, would like to help me, if possible.—So these are the results of her venture; exactly what I anticipated, which is why I would not turn to these people. As for Murer's proposition, I thought of it long ago and even spoke of it to Théo van Gogh who considered it too risky. The fact is an auction, if it failed, would be a complete disaster, unless Murer were prepared to bid,

---

[1] *Because it slowed up his production and for other reasons which are explained later in his letters, Camille Pissarro at that time began to soften the rigid execution of pointillist divisionism, without however wishing to abandon divisionism itself. For Seurat and Signac divisionism was not necessarily bound up with the little dot.*

118

and if necessary, to buy three or four thousand francs' worth of paintings, which I am certain he is not—nor is de Bellio, either. So the whole thing would be dangerous. As for introducing me to Tual, so as to interest him in my affairs, that is another mirage. . . . I know Tual, Boussaton's successor, who knew me very well.— Tual has often expressed a desire to help me; but, of course, in a safe way. If he had confidence in my work and were ready to put up the money himself, that would suit me perfectly, but no danger! Millet himself would not have found an auctioneer willing to invest money in his paintings. Only Murer, the man of facts, could entertain such romantic ideas. No, it is obvious that Tual, who stands to lose nothing, and may even gain, would like nothing better than to hold an auction of some so-called private collection of my work. Then, the auction failing—which is inevitable —I would lose the paintings and I would have incurred new expenses. Who will believe that any owner of Pissarros would sell his collection at such an unfavorable time? The only thing which could bring a collector to take such a risk would be the desire to be rid at any cost of bad paintings, in order to buy "real" impressionists' works. . . . And then the four or five collectors in Paris can't be taken in, everyone will realize that it is not a legitimate sale. Besides, an auction, particularly under such circumstances, would have to be prepared well in advance. I would do better to sell the whole lot at a low price to some speculator.

The more I think of it, the more dangerous it appears, much more dangerous in fact than to have tried to progress so as not to paint grey, lustreless pictures.—Nevertheless I will go to see Murer, I will see what he says man to man. But I think Théo van Gogh, who is very subtle, will be able to give me good advice. . . . But what I need is money, and now.

I have to get out of this mess without resorting to a public auction, that was my idea when your mother left, that is what I must do. Besides, an auction could not be held until November, and we cannot wait till then.

I finished a gouache about 21 by 18 inches. I will leave for Paris.

*My dear Lucien,*

I have decided that it would be better to see Alexis [1] than to write to him. I composed two or three letters, all were inadequate, and so I decided to go and see him. I was right to do so. At first I couldn't find Alexis. He was in Paris. Then I learned at *Le Cri du Peuple* that he had fought a duel with M. Bernhardt and been wounded in the right arm.—The wound is not very serious.—I presented myself to Madame Alexis who, a very subtle woman, grasped the situation thoroughly and understood my position. Alexis will be glad to give a more positive tone to his article, and is ready to serve me if need be. Then I went to the Murers; I had lunch, and then we had a talk. As if by plan, though we did not meet, Renoir and his family came by the same train to the Murers. A tremendous discussion of the dot! At one point Murer said to me: "But you know perfectly well that the dot is impossible!" Renoir added: "You have abandoned the dot, but you won't admit you were wrong!"

Nettled, I replied to Murer that he no doubt took me for a cheat, and to Renoir I said, "My dear fellow, I am not that senile. Besides, you Murer know nothing about it; and as for you Renoir, you follow your caprice, but I know where I am going!" Then there was much abuse of our young friends: Seurat discovered nothing; he takes himself for a genius, etc. You may be sure that I did not let these remarks pass unchallenged.—I had imagined that they knew something—if ever so little—of our movement, but no, they knew nothing about it.

*My dear Lucien,*

Things are picking up. . . . I received a letter along with eight hundred francs from Théo van Gogh; he sold de Bellio my large painting, the one in grey light [711]. Five hundred francs for a canvas this size is very little. De Bellio finally picked this one. Although it was not a brilliant transaction, I am quite pleased, perhaps later on prices will be better. The other picture which was

[1] *Paul Alexis was preparing an article on the Murer collection.*

sold is a gouache—*Gathering Sweet Peas* [1408]. Van Gogh wrote me that he had to accept as part payment a painting which it will be difficult to place. The collectors are really extraordinary, they just won't pay cash. All the same it was very kind of van Gogh to make the deal and get me out of hot water. And your mother is a little calmer, so I will be able to work on some canvases. I have six or seven canvases going, while some are drying I work on the others, thus I lose less time.

ERAGNY [OCTOBER 13, 1887]

*My dear Lucien,*

This morning your mother received a letter from Mlle. Murer announcing that Trublot's [1] piece will appear any day now and that Renoir has been living [at Auvers] in the same hotel as Trublot ever since I last saw him. For all I know Trublot may get everything wrong in his article! As I foresaw, Murer is going to cry up the importance of the period in painting represented in his collection! Another romantic! [2]

I work a great deal, but how long it takes! I don't know whether I will be able to bring my two autumn canvases; it has been raining for more than a week, the days are cold and grey. What a nuisance!

~~~~~~~~~~~~~~~~~~~~~~~~~~

[1] *The pseudonym of Paul Alexis.*

[2] *The article, which appeared in* Le Cri du Peuple *on October 21, did not favor certain of the painters while deprecating the others, which was what Pissarro feared. The article discussed the Murer collection as a whole and listed the various works represented in it, often under completely fantastic titles. It seems that at that time Murer's collection included eight Cézannes, twenty-five Pissarros, sixteen Renoirs, ten Monets, twenty-eight Sisleys, twenty-two Guillaumins, etc.*

ERAGNY [JANUARY 30, 1888]

My dear Lucien,

At the end of the week I shall have to go to Paris; we are with-
out a penny. I have to hasten my departure, though I would like
to do a little more work on my canvases.

I may actually not have enough to make the trip, I expected
something for the fan, through Nunès, but nothing, no reply.
When I am away from Paris nothing I count on happens. If you
can scrape together a few francs for me, send us the money, I will
repay you when I collect some money in Paris. I don't see how
I can get away, I had put some money aside for the trip, but your
mother needed it.

ERAGNY, FEBRUARY 2, 1888

My dear Lucien,

I have still not received anything from you. I suppose you were
unable to get the money I begged you to send me for train fare.
—I hoped to leave on Saturday, but I was penniless. Nunès, as
usual, didn't answer my letter, so I suppose the fan wasn't sold
after all. But at any cost I must get to Paris. Next week I will send
my three paintings by messenger to Théo van Gogh; I hope he
likes them and that something will materialize. I see that after
so many hardships, I shall as ever have to give my things away!
what bad luck! Van Gogh writes that he is expecting the pictures
and that he hopes to make a deal. But he doesn't sell anything, he

complains that the collectors show no interest in even the most beautiful works. It is heartbreaking! All the same one must not despair, on the contrary, one must outface misfortune and do the impossible.

My dear Lucien,

I was very happy to receive your letter announcing that Théo van Gogh had finally sold my landscape. But you did not mention the price. . . .

I have finished my two gouaches and am ready to leave.

I am troubled by the fact that my gouache was bought [at auction] for almost nothing by Meyer. If only this doesn't prove an obstacle to selling my new ones! Why the devil didn't somebody, Durand's son, or Théo van Gogh, or some collector, bid more than that? This is completely discouraging.

My dear Lucien,

I got the money from Théo van Gogh, it was three hundred francs. The picture sold was *Peasant Houses* [710] which belonged to the Boussod & Valadon Gallery, and van Gogh has taken another canvas of the same size, the one with the motif of the *field with a white wall* [709], done in bright sun, to replace the one he disposed of. At least this is what I understand [from his letter]. My gouache was sold for sixty francs at the auction.

My dear Lucien,

I hope to send Théo van Gogh three small paintings and a gouache in about a week. Your mother wanted me to do a painting for her, but, as ever, not in my new manner. It would be impossible for me to do one in my old manner. . . .

A letter has come from Portier with the news that the etchings

123

I gave him in payment for the one hundred francs I owed him, have been sold to a museum in New York which specializes in engravings. Portier wrote that to complete the sale I would have to do a self-portrait in pen and ink and send it along with the proofs to the said museum.[1] I am supposed to get fifty francs for the self-portrait. I made the portrait and dispatched it, but I have heard nothing since.

Tell me about our friends, write me whatever you think I ought to know. When I send my paintings to Théo van Gogh, go and see them. Try to find out whether the sale of my works has had a good or bad effect, for they always find reasons for lowering prices, and only when compelled do they give you what you are entitled to. I hope that with the help of van Gogh and Durand we will be able to emerge from this situation. It seems to me that I deserve no less, since I have worked conscientiously. I do not believe that anyone could devote—if not more talent— more care and good will to the service of his art; it takes me hours of reflection to decide on the slightest detail; is this impatience? . . . I think not! For I do not wish to make a brush stroke when I do not feel complete mastery of my subject, there's the rub—that is the great difficulty; without sensation, nothing, absolutely nothing valid . . . I believe I have hit my stride. I have begun a series of things which will really be in my style. What I have written is of course not in accord with business policy, evidently it is not a recipe for getting rich.

My dear Lucien,

I would very much like to see the exhibition of caricatures, the Daumiers, particularly. What a wealth of sensations he had! But I am working on my picture of *Gleaners*, it is giving me plenty of trouble. . . . I lack data, that's always the great difficulty. I need models, I no longer know where to find them. Only at Pontoise could I find what I need, but I am not free to go there, and besides I can't afford it. I have to rely constantly on figures I have already

[1] *There is no such museum in New York. However, the buyer of Pissarro's etchings and of the self-portrait (see fig. 30), Mr. S. P. Avery, planned to leave his collection to the print department of the New York Public Library, where it is today.*

made—I really need to renew my sensation of the figure . . .
but what can I do?

My dear Lucien,

I saw in the *Cri du Peuple* that the exhibition [of the *Indépend-ants*] ended gloriously. You ought to be able to move your things without too much trouble. If you see Signac, remember me to him and tell him to visit me at Eragny. He's been so friendly to us that I really owe him an invitation, and it would be better if he came while you are staying with us.

Try to find out from Théo van Gogh or Portier how things are progressing in America and if *anything has been heard* about Durand.[1]

My dear Lucien,

I think you would do best to come here, for if you wait indef-initely for your money you will miss the good weather; come now while we have some money and prepare for your exhibition for next year and also do some illustrations. It is necessary not to be discouraged, one must get oneself accepted on the strength of incontestable, if not uncontested, gifts. Renouard made his name on the strength of three or four illustrations of scenes backstage and women painters in the Louvre, while these were far from being comparable to the work of Degas they were quite good, they lacked style but had energy, they were not the works of a nonen-tity, and Renouard got somewhere. For my part I think when one has talent one finally breaks through; so don't pass up any opportunity to do some work. . . .

I work mostly in the studio; as I mentioned several times, the leaves are burgeoning and change so rapidly that I have been un-able to prepare a single sketch. I am making little watercolors and pastels, I think they will come out all right; in the studio I am pre-

[1] *Durand-Ruel whose affairs were gradually picking up was about to open a gallery in New York.*

paring five or six canvases, I work on one after another, I am getting used to working that way.

My dear Lucien,

We must find out from Durand when the exhibition opens.[1]
Let me know how many canvases I can show. If you can tell me on what day the exhibition will open, I will know where I stand. Perhaps I will be able to finish my pictures—and that's what matters most. If I don't get news of the opening I will leave on Saturday or Sunday morning—that is if my pictures are in shape.

I lost so much time trying to sell my things in Paris that I have nothing ready in case of need; and I must have five or six new works. If I can obtain from Signac or Seurat or some other neo-impressionist a frame of about 36 x 28 inches for my landscape *The Cleft in the Road* [715], I will show the canvas, but never in a horrible gilt frame.

My dear Lucien,

My pictures have still not been sold. I saw Paindessous, he told me that he was leaving, made me some wonderful promises and expressed great friendship for me. He said something which is perhaps true enough: "You know, of course, that there are quite a few people who are very anxious to buy but won't buy through a dealer. It's only the big collectors who are willing to do so." He added: "You ought to have a place in Paris where you could always have canvases ready to be sold." There is something in that, don't you think?

I saw the Monets, they are beautiful, but Fénéon is right, while good, they do not represent a highly developed art. For my part,

[1] *This exhibition opened at Durand-Ruel's on May 25 and lasted for a month. It included 24 canvases of Sisley, 24 Renoirs, and 26 Pissarros (11 paintings and 15 pastels and gouaches). Monet was not represented for he had broken with Durand-Ruel and signed a contract with Théo van Gogh to have his work handled by the Boussod & Valadon Gallery.*

126

I subscribe to what I have often heard Degas say, his art is that of a skillful but not profound decorator.

Théo van Gogh seems dissatisfied by Fénéon's article;[1] he told me that Monet had said that *it could have been anticipated.* You will see that I will be blamed for the article, and actually I don't try to stir up trouble, I do my best to calm both sides. I cannot be held responsible for the ideas of others, even though correct, particularly when they are expressed in an exaggerated form.

Durand-Ruel is disappointed in his venture in America.

PARIS, JULY 10, 1888

My dear Lucien,

I told you that Monet's recent paintings did not impress me as more advanced than his other works; almost all the painters take this view. Degas is even more severe, he considers these paintings to have been made to sell. Besides he always maintains that Monet made nothing but beautiful decorations. But the recent works are, as Fénéon says, more vulgar than ever. Renoir also finds them retrograde. Durand's son, too, is of this opinion; but of course his attitude is governed by the fact that he is a rival dealer.

I ran into Monet at Durand-Ruel's. For some reason or other he always seems to have a sly look. I happened to be reading an article which criticized his work in the most idiotic way, presenting arguments so stupid that I couldn't help calling them to his attention; the things said in his favor were equally idiotic. Other than this we did not discuss painting—what would be the point?—he cannot understand me. After all, he may be right, for each one of us must be faithful to his own capacities!

I met Bracquemond who expressed great admiration for my *Girl Breaking Wood* [722]. We discussed divisionism, he told me that he thought my new decision was correct, that it was more than chance that had made me take this path. As you see, he is very sympathetic.

[1] *In a review of Monet's show at the Boussod & Valadon Gallery, Fénéon had referred to Monet's "brilliant vulgarity," adding: "His renown increases but his talent does not seem to have developed since the* Etretat *series." This notice appeared in July, 1888 in* La Revue Indépendante.

My dear Lucien,

There is a mystery in this commerce in pictures which I try to unravel from what I see and hear. Thus, yesterday Durand suddenly took me aside and asked me, in a tone almost of accusation, whether I had sent any pictures to Théo van Gogh.

"Yes," I replied.

"You shouldn't send your pictures to a person like that! Why didn't you let me have them?"

"Because you have quite a few and can't sell them immediately."

"Bring them to me, and have nothing more to do with Théo van Gogh, for his having your pictures is bad for my business and keeps me from selling."

"Look here M. Durand, you don't sell my pictures."

"But I do, I sold some in America."

What do you think of this? You realize, of course, that I can't take Durand's suggestions; elementary prudence forbids such a course. If I bring everything to Durand and he drops me, as he did in the past, I will have no way out, I will be tied hand and foot, at Durand's mercy. Good man though he be, he will probably always behave, despite himself, as he has behaved in the past. So I told him very frankly that Théo van Gogh had sold my new canvases, likes them very much and has defended them intelligently, and that I would not take back the pictures I had left with him. This doesn't prevent me, I added, from showing you what I have.

The upshot: Durand is disgruntled to see Monet dealing with Boussod & Valadon [Théo van Gogh], he would have liked to keep Monet, he wants me to stick with him but he gives me no real assurances. The incident gave me an opportunity to tell him that I was absolutely without money, he promised to send me some, we shall see if he keeps his promise. I think he is very anxious not to let me languish, that wouldn't be very clever on his part.

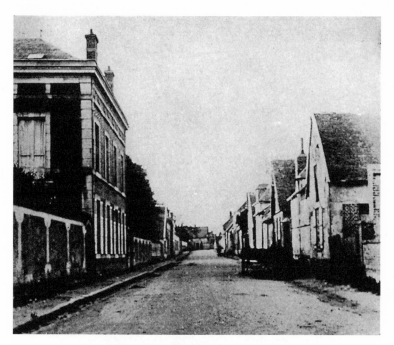

18.—Camille Pissarro's House at Eragny, Photograph.

19.—C. Pissarro: Portrait of the Artist's Wife, about 1883.

20.—M. Luce: Portrait of Camille Pissarro, 1890.

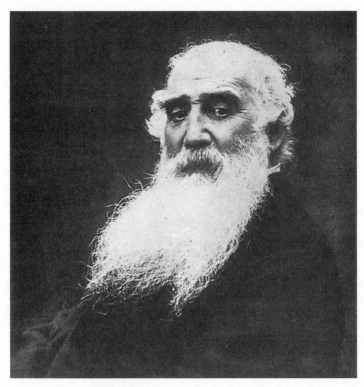

21.—Camille Pissarro, Photograph, about 1893.

My dear Lucien,

I hope you thought of showing my canvases to Seurat for I am very anxious to know his opinion of them. You don't mention your exhibition, I want to know all about it; I don't think exhibiting can be as bad as that, the collectors are simply not interested in painting, good or bad. If we had to hear everything they said we would be fair game for the dealers. . . . Aren't we that already?

I would be very happy if Seurat and Signac came here before they leave. Your mother hasn't said anything but you know that she is gracious to everyone. The weather is as uncertain as ever. I work just the same but not as much as I would like.

PARIS, AUGUST 31, 1888

My dear Lucien,

Nothing concluded yet with Durand-Ruel. Today he looked at the gouaches that Cluzel sent him this afternoon. You couldn't guess which ones he likes, which he dislikes. *The Landscape with Cows* he doesn't care for at all; he says it is too yellow, that nature is not as exaggerated as I represent it to be, in short he sees no poetry in the canvas. *Les Fillettes qui font de l'herbe* he doesn't like either, the girl crouching is not sufficiently articulated, her body isn't felt. In my *Sheep*, the landscape is not sufficiently modeled. The only one he likes is *Two Young Girls Standing*. We the artists, you see, have no understanding of painting. He is behaving, it seems to me, like a tradesman who deliberately disparages the goods he is to buy, so I don't think he'll give me a good price. I'll hear from him Saturday.

That's the way painting is understood, it's incredible! As I remember he said exactly the same things to me about the gouaches and paintings I showed [at the exhibition]; despite Durand they were a great success. That's what everybody told me last night, Bazire of *L'Intransigeant* said so too and praised my work to the skies; I mentioned this to Durand and I recall now that when Renoir, Monet and Sisley brought him sketches, he made a great fuss about them, particularly about Monet; he had no fault to find when, as a matter of fact, despite their talent there

129

was something to be said against them. . . . But I know where I am going.

My dear Lucien,

Will I be able to leave tomorrow? I am waiting for Durand's reply. If he does not sell my gouaches I will turn to Théo van Gogh who has returned [from Holland] and will do his best to place them. He told me again that my *Rouen* is almost sold, his collector is very anxious to have it but is not very rich. It is always the penniless who are well disposed, those with money are hesitant and buy Leloirs (I believe that's the name) at 30,000 francs per *ordure* according to van Gogh's estimate! That's the way it goes.

Théo van Gogh told me that my etchings, Degas' drawings, your woodcuts and the Seurat have created a sensation at The Hague; it seems that some old man with a critic's license, a representative of all that is most bourgeois and official, provoked by the general interest in these works, wrote a long article in a serious bourgeois newspaper, hurling anathema at us and predicting the end of the world; he took particular exception to me and simply cut me to pieces, the old fool! . . . Like a volley of shot came the reply from all the newspapers devoted to the renewal of art, one particularly, very well written and widely read, a paper supported by all the young artists and writers, warmly championed us in a long article on my etchings, your woodcuts, the Degas drawings and the Seurat. The article showed real knowledge of the modern art movement in Paris. Imagine the commotion, a little more and they would have come to fisticuffs. . . . Finally van Gogh wants to know how much you want for a proof of the engraving you made of my drawing for *Les Travaux des Champs* and two others which I don't remember; I told him five francs each.

My dear Lucien,

Durand-Ruel is sick, it is several days now since he has been seen in the rue Laffitte. I wrote to him, he finally replied that he

22.—*Les Travaux des Champs:* The Sower. Drawn by Camille and cut on wood by Lucien Pissarro. Published in 1888 by Théo van Gogh.

was not going to take my gouaches. What I can't understand is why the devil he urged me to let him have them. I am going to bring them this very morning to Théo van Gogh and I hope Durand won't complain if I bring my canvases to anybody. What do you think of that? . . . He has been complaining that Monet dropped him for Boussod & Valadon as though he himself were not responsible. If he wants to have the same relations with us as formerly he will have to take all our work. Unquestionably there is bad blood between Durand and van Gogh; the former is furious about the deal with Monet. Théo van Gogh knows this. But what can we do, aren't we forced to go elsewhere? As for van Gogh he will do everything possible to prove to Durand-Ruel that the gouaches can be sold.

It was a good thing that I didn't bring my oil paintings. I was right to put Durand to the test with my gouaches, but I never imagined that he would hesitate on such slight grounds; it was just a trial and it will leave me more free in the future. It's really strange, he wavers and won't even stick to what he demands of you. His son Charles just left for New York.

I think continually of some way of painting without the dot.

I hope to achieve this but I have not been able to solve the problem of dividing the pure tone without harshness. . . . How can one combine the purity and simplicity of the dot with the fullness, suppleness, liberty, spontaneity and freshness of sensation postulated by our impressionist art? This is the question which preoccupies me, for the dot is meager, lacking in body, diaphanous, more monotonous than simple, even in the Seurats, particularly in the Seurats. . . . I'm constantly pondering this question, I shall go to the Louvre to look at certain painters who are interesting from this point of view. Isn't it senseless that there are no Turners [here].

PARIS, OCTOBER 1, 1888

My dear Lucien,

I had a long conversation with Renoir. He admitted to me that everybody, Durand and his former collectors attacked him, deploring his attempts to go beyond his romantic period.[1] He seems to be very sensitive to what we think of his show; I told him that for us the search for unity was the end towards which every intelligent artist must bend his efforts, and that even with great faults it was more intelligent and more artistic to do this than to remain enclosed in romanticism. Well, now he doesn't get any more portraits to do.

ERAGNY, DECEMBER 13, 1888

My dear Lucien,

I received your letter yesterday, I think I will participate in this exhibition but only under certain conditions. If I am to show, my prints must be presented properly. You see how much importance Whistler attaches to the mode of presentation, and he is very right to do so. It is not a good idea to have several proofs in the same frame. It is much better to have each proof, even the smallest, in its own frame.

[1] *At about that time, Renoir, absorbed mostly by the problems of linear form, made a great many drawings and painted in a style which has since become known as his "Ingresque" period.*

I've worked all these days on my etchings. I have made two new ones and retouched two old ones which have not yet been exhibited. I'm sending them to you so that you can have Delâtre pull the trial proofs. See to it that he just makes one proof of each and that it's as fine a proof as possible, *let him take particular pains with the sky in the little Port of Rouen* [D. 56] which I reworked; the sky should remain white and luminous as in the proof Jacques fils pulled for me, that is the main thing; I don't want to weaken the plates by pulling, I'll have them steeled. Send them to me immediately so that I can retouch them if necessary.

For a month we have had magnificent weather, I very much regret that I didn't begin a study from nature with the hoar frost and mist; we have this effect all the time, but I have so many things going. I almost finished my sunset, *Briqueterie* [724], I am still working on it, the sky is completed but I am going slowly; the other canvases which are less advanced are also progressing.

$$\boxed{1\ 8\ 8\ 9}$$

My dear Lucien,

Your mother must have told you that I have been offered 1,200 francs for my twelve watercolors; after paying the dealer, 1,020 would remain for me. I have decided to make the sacrifice, I can't afford to hesitate. I will send you the money as soon as possible. I hope that I won't have to let my etchings go for a song, but can realize enough on them to put something aside for the future. The watercolors had great success. I think I will decide to go to Rouen to make some more.

I haven't finished my prints yet, I am having a hard time getting good proofs; it takes so long, so very long. I put everything in order in the evening, and as soon as they are ready have them mounted. Will I have the same luck with them as with the watercolors? The publishers are not used to paying much, they like to wait for auctions at which they can get bargains, the collectors are even more patient. For them the great thing is to find marvelous, rare proofs for three or four francs or even less. Don't the richest collectors have this passion for discovery?

I don't know what to write Fénéon about the theory of "passages".[1] I will write him what seems to me to be the truth of the

[1] *This data was doubtless for an article in preparation. While the question of the "passage," which was to separate Camille Pissarro from pointillism and thus from divisionism, was then the main preoccupation of the artist, he was still unable to express himself with precision on it. Replying to Félix Fénéon in a letter dated Feb. 1, 1889, he wrote: "I received from Eragny your letter asking me to give you some technical information on 'passage.' It would be difficult to say anything about this;*

matter, that I am at this moment looking for some substitute for the dot; so far I have not found what I want, the actual execution does not seem to me to be rapid enough and does not follow sensation with enough inevitability; but it would be best not to speak of this. The fact is I would be hard put to express my meaning clearly, although I am completely aware of what I lack.

ERAGNY, AUGUST 12, 1889

My dear Lucien,

Your mother wants you not to forget to go to the pawnshop to pay what we owe. Since you said nothing about this in your letter she is very much afraid that you will overlook the matter and it is urgent.

I have almost finished my *Gleaners.* I have gone back to my *Haymakers* [729–730] and worked on the little *Goose Girl* [1435] and a *détrempe* for Cluzel. The work is really going well —it's always like that when you begin.

PARIS, SEPTEMBER 9, 1889

My dear Lucien,

I went at once to Théo van Gogh's to see how my paintings look in new surroundings. I am fully satisfied. The *Women with Buckets* in a beautiful new gilt frame is quite perfect; it has height of tone and comforting warmth, it has fullness and power. I like the painting better than the *Gleaners* which ought to be more

I am trying at this very moment to master the technique which ties me down and prevents me from reproducing with spontaneity of sensation. It would be better to say nothing about it, I have not yet really settled the question."

Signac, some years later, in his book: De Delacroix au Néo-impressionnisme, tried to explain Pissarro's desertion thus: "Pissarro wants to achieve delicacy by means of adjustments of nearly like tones; he keeps from juxtaposing two distant tones and does without the vibrant note which such contrast gives, but strives on the contrary to diminish the distance between two tints by introducing into each one of them intermediate elements which he calls 'passage'. But the neo-impressionist technique is based precisely on this type of contrast, for which he feels no need, and on the violent purity of tints which hurts his eye. He has kept of divisionism only the technique, the little dot, whose raison d'être is exactly that it enables the transcription of this contrast and the conservation of this purity. So it is easy to understand why he gave up this means, insufficient as it is by itself."

135

than satisfactory, but it was not framed and this makes it hard to judge. Incidentally van Gogh finds them very beautiful.

I went to the exhibition on the rue de Grenelle [the *Indépendants*]. There I met Fénéon and Régnier. Kahn is serving his twenty-eight days, he was not able to get a leave. I saw Hayet yesterday morning, he was discontented with the hanging.

The hall is beautiful. Entering it, I found the light not too bad, on each side of the main room are little connected rooms in which the light is horribly raw: the dots of color stand out in the most frightful way; but in the main room they impress me favorably. Certainly at first sight the neo-impressionists seem meager, lusterless and white,—particularly Seurat and Signac. But once you become accustomed to them they appear much less so, while, however, having a kind of stiffness which is disagreeable. A new Seurat in the big room seemed to me very beautiful, very clear, a Signac in the same room, done the same year, is also very beautiful and firm but is too dependent on Seurat. A landscape by Hayet painted in oil, very beautiful, well drawn, good in its color values, I found rather admirable, a little lusterless but that comes from the uniformity and stiffness of the dot. Your *Road* hangs between these two painters or rather near them, for all three of you are flanked on each side by black smears. Your *Road* is very good, the only thing I find I object to is the trees which seem to me to be a little weak against the sky or rather not strong enough in their color values. But the painting stands up very well beside the other neo-impressionists. The motif could perhaps have been better composed: the foreground should have been shortened; the dark section in the foreground, for example, is superfluous. *The Portrait of Cocotte*, badly hung in the other room, seems to be technically better. The background is spoiled to some extent by the folds of material, they were unnecessary, if you rework them I think you will do better to decide on a plain background. The hands are not very well done, it's a pity. Hayet's *La Place de la Concorde*, in the same ill-lighted room, didn't please me at all, not at all. It does have a little life, but how vulgar in motif, tone, composition, drawing! The figures in the foreground are very bad. No, it is really very poor; the landscape is a hundred times superior. The Toulouse-Lautrecs are very interesting. Fénéon likes the Anquetins, but they owe too much to the Orientals.

The others have nothing, nothing, nothing at all. Oh yes, there is a frightful Hyacinthe Pozier above Hayet's landscape. It is

136

framed in varnished dark brown wood with large ornaments which I swear to you are made of straw, but of straw like in straw mats! The monstrosity of this ornamentation simply cannot be conceived. It is worthy of the period of the Eiffel Tower. Whoever thought this up is truly a man of genius, he has found something worse than plush, he is really great!

PARIS, SEPTEMBER 13, 1889

My dear Lucien,

Théo van Gogh sold a Monet to an American for 9,000 francs. But in general business is bad.

* * *

Deserted by Monet, the Boussod & Valadon Gallery in February of 1890 held an exhibition of Camille Pissarro. In the spring of that year the artist went to work in London where he painted the Bridge of Charing Cross, views of Hyde Park, Hampton Court Green and Kensington Gardens [744–747]. Lucien Pissarro, who had not revisited England since 1884, and Maximilian Luce accompanied him, and returned to France with him several weeks later.

It was after his return that Camille Pissarro was requested by Théo van Gogh to take in his brother Vincent who was anxious to leave the asylum of Saint-Rémy near Arles where he had been confined since May 1889. Pissarro, who had known Vincent van Gogh from his first appearance in Paris in 1886, and who had often advised the Dutch painter during the period when the latter was abandoning his dark style for the impressionist technique, was ready to put him up at Eragny. But Madame Pissarro was afraid of the effect on her children of an unbalanced man. So Camille Pissarro suggested his friend Dr. Gachet at Auvers on the Oise, who was willing to care for Vincent van Gogh. The latter came to Auvers in May 1890 and there killed himself in July of the same year.

In November 1890, Lucien Pissarro returned to England. He set himself up in London, and helped by his cousins Alice and Esther Isaacson, tried to find pupils for lessons in drawing and engraving. Recommended by Fénéon and Octave Mirbeau, he was able to meet English artists like John Gray, Charles Ricketts

137

and Charles Shannon who in turn introduced him to Whistler. Through Ricketts and Shannon he became interested in the efforts made by William Morris to bring about a renaissance of the woodcut and the illustrated book. Ricketts and Shannon invited Lucien to collaborate with their review The Dial, the first issue of which had appeared in 1889, illustrated with woodcuts "printed from the wood to insure the greater sweetness of the printing." Lucien Pissarro contributed to the second issue which appeared in February 1891.

Lucien naturally kept his father in touch with the studies and researches of his new friends. These were all the more interesting to Camille Pissarro because they had some connection with his own efforts.

Indeed, at this period Camille Pissarro devoted much time to etchings and even resumed working at lithography which he had abandoned since 1874, a year in which he executed a dozen lithographic drawings (see fig. 1). He now bought a press which enabled him to proceed with his graphic work during the long winter evenings in Eragny. From this time almost all his etchings were printed by himself, usually on papier d'Ingres or old Dutch paper, of which he always kept in stock a good supply obtained from old ledger books. He also began to make experiments in color printing, using for this four plates, one for each color, blue, yellow and red, and a keyplate, black, for the outline, as in the typographic process. As for Pissarro's lithographs, they were either drawn directly on the stone or on specially prepared plates of grained zinc, but some drawings were also done on paper, transferred and sometimes retouched on the stone. These lithographs were printed in Paris by M. Tailliardat, a man of great understanding and intelligent patience.[1]

Pissarro also began to work on a series of drawings: Les Travaux des Champs, which were to be cut on wood by Lucien.

At his exhibitions Pissarro showed from time to time a few specimens of his etchings, which never attracted much attention. In 1889 and 1890 he showed with the group Les Peintres-Graveurs at Durand-Ruel's. His etchings were priced from 15 to 140 francs.

<p style="text-align:center">* * *</p>

[1] For more information on Pissarro's graphic work, see the article on his etchings and lithographs in The Print-Collectors Quarterly, October 1922, by the artist's son Ludovic Rodo.

ERAGNY, NOVEMBER 14, 1890

My dear Lucien,

We were awaiting impatiently your letter announcing your arrival in London. You are really lucky to have had a good trip, the weather here has been very unfavorable.

I received a letter from the brother-in-law of Théo van Gogh. He writes that Théo is calmer and that it will be possible to send him to Holland.[1] *The Vingt* are to include van Gogh's works in their exhibition as are the *Indépendants* who will have one room for Dubois-Pillet,[2] and one for Vincent.

ERAGNY, NOVEMBER 17, 1890

My dear Lucien,

Each one of us has several facets. The surface often appears more important than what is inside, hence the errors of those who judge carelessly. How many times has that not happened to me! The surface is often complete in some people from the very beginning, but not the possession of their own sensations. From this come errors. Some natures achieve the surface very slowly; this is the least danger an artist runs. So one should not think

[1] *After the suicide of his brother, Théo van Gogh fell seriously ill and apparently even became insane. Brought to Holland, he died in January 1891. He was buried in the little cemetery of Auvers beside Vincent whose inseparable companion he had been.*

[2] *Dubois-Pillet, one of the founders of the* Salon des Indépendants, *had died that same year.*

159

of the surface or the appearance, but concentrate on what is inner! How many pupils have you, at the moment?

I am very worried about Durand-Ruel, I am terribly afraid that he will let me down. The papers here announce a dreadful crash in New York and London. The famous Barings whom everyone spoke of are in dire straits, the Bank of France has been obliged to lend England 75 millions to prevent a European disaster. Good enough! But the counterstroke! *What will the victims do?*

Since your departure, besides preparing canvases, I have made five fans which I am very satisfied with. I have two *Effects of Fog* which you have not seen and which are interesting; one is on Japanese paper and is magical; another is on onion paper, it is very strange. It is a red sunset like an Aurora Borealis, with a stripe of pearl-grey fog, with cows vague in the fog and a tall girl in the foreground [1644]. I bet Durand won't take it.

My dear Lucien,

I am happy to hear that you have found friends worthy of you, but it is strange that the young English artists are so ignorant of the impressionists. You tell me that these young fellows engrave on wood and that they were taught the craft. You seem to regret that you were not. This is not the first time you have voiced such regrets.—All right, but I continue to believe that it is better to perfect oneself little by little and by one's own efforts. Just think for a moment, had you learned engraving from Lepère or even Florian, would you be able to produce a work you could call your own? Are you so naive as to believe that? By simply continuing with engraving you will achieve something very different but artistic.

My dear Lucien,

This morning I received your letter which, as always, we awaited impatiently. You tell me of the new acquaintances you have made in London and of the negative results of all your

140

efforts. But, my dear Lucien, you shouldn't be surprised that swallows don't fall into your mouth completely roasted. You must redouble your efforts and continue in spite of everything. Nothing comes without great exertions. I told that to you before, I repeat it again for it seems to me that you lack confidence. But that's absurd!

I will probably soon be in Paris for it is going to be necessary to sell something. Soon I will have completed my four or five little canvases of about 21 x 18 inches and 18 x 15 inches. The canvases of 21 x 18 are very good; they have, I think, more liberty, more air than have my previous works. I am completely satisfied with them. All I need to be made happy is for them to please Durand. Eight days ago I sent him my five fans; he has not yet replied. I can't understand why he remains silent, or, to be more exact, I understand that poor Théo van Gogh who bolstered me against him is no longer here.

ERAGNY, DECEMBER 12, 1890

My dear Lucien,

I just this moment received your letter. I'm really astonished by your expressions of discouragement. For you to write in this way means many scenes here at home. After I wrote you just to warn you, you had to put your foot in it! If you are already discouraged you will not accomplish anything in London. You must understand once and for all that one must be sure of success to the very end, for without that there is no hope! It's the same in everything, in business as in art. He who doubts is lost beforehand! How many times haven't I told you that where there's a will there's a way; but nothing comes of itself. You've hardly been gone a month, damn it, and it takes a little time to arrange one's affairs. You have good opportunities, you ought to succeed, *besides it is absolutely necessary that you do so!*

The worst of it is that your discouraging letter comes to cap other troubles, such as our not having a maid, my not having heard from Durand-Ruel about my five fans, my fears that this Durand will play me some dirty trick and the consequences of Théo van Gogh's madness. These things do not discourage me at all, I have been in such predicaments before, but your mother can't keep her grip. She is constantly discouraged, and if you

141

continue to take the tone you have, you can imagine what the moral effect will be! So hold fast!

I am writing this letter without your mother's knowledge for I don't want to add fuel to the fire. I am by no means as pessimistic as you are.

<div align="right">ERAGNY, DECEMBER 20, 1890</div>

My dear Lucien,

I have finished my pictures. If the weather is not too bad I will most probably leave for Paris on Monday.

Durand wrote me that he found the fans very beautiful, and that he would certainly take two or three. If with these he takes my three paintings, I should get quite a little money.

One after the other the children took sick. They have all practically recovered, and the usual racket is beginning again. Your mother found a young Breton maid who should do nicely.

<div align="right">PARIS, DECEMBER 23, 1890</div>

My dear Lucien,

Durand has asked me to contribute some drawings to a review which he supports, in fact, I think he is the publisher. I will send you a copy of it.[1] It has some reproductions of Degas; I persuaded Durand to use an etched reproduction of one of my paintings; Titi will handle it under my supervision, he ought to make a good job of it.—At Durand's there is an exhibition of painting and sculpture. The painting is very ordinary, although there is a picture by Zandomeneghi which is quite remarkable, and there are sculptures by Rodin and Bartholomé.—The figures by Bartholomé are first rate, among these there is a wax bust which is at once extremely modern and very primitive; it has great nobleness, one feels that the artist is a pupil of Degas. Very remarkable, too, is a large piece which seems to be for a tomb : a young man, a young woman and a dead child; it is truly poignant. . . . It is far stronger than anything by Rodin, whose works become petty and facile beside it; there is also a little room filled with Legros' work. Some

[1] *This was* L'Art dans Les Deux Mondes, *a review published by Durand-Ruel from November 1890 to May 1891. In this review important articles on Renoir, Monet, Pissarro, Degas, Sisley, Seurat, etc., appeared.*

very beautiful etchings, skillful as the deuce, but absolutely copped from Rembrandt! Some sepia drawings, landscapes owing a little too much to Claude and Poussin, model drawings for the classroom, admirably done and completely derivative from the antique. There is a profile which scandalously resembles a Leonardo; all in all most of the great masters contribute something to these works. As for the paintings, alas! Sad! Sad!

I went to the Boussod & Valadon Gallery. Nothing has been decided. M. Joyant [1] is still doing all he can; he has informed me that my best collector, M. Dupuy, whom you know, committed suicide. Isn't that extraordinary! What is most sad is that this too honest youth killed himself because he believed he was bankrupt; his friends were heartbroken when they discovered that his affairs were really in good order. Those who have taken over his enterprises find that they are excellent!

Your mother made me take Titi with me so that I could find a job for him; I took him along but I brought him back to Eragny. She accuses me more than ever of having raised you to do nothing; as always I let the storm pass. For after all, what is the point of putting a boy, Titi or Georges, in a factory where he will be exploited and either acquire no skill or if he does learn something learn it badly, like young Murer? That would be idiotic. Wouldn't it be better to have them wait for some good opportunity, and in the meantime have them work with me? But these false notions prevent me from getting them to work to good effect.

PARIS, DECEMBER 26, 1890

My dear Lucien,

I had a long talk with Dumont, who has an amazing shop on the rue Laffitte, about the interest taken in engravings. Nobody ever enters his shop. He is desperate, it seems that from New York to London, from London to Paris there is complete disinterest in all forms of the engraver's art. Reproductions alone are desired. Goupil's sells its garbage in New York and London. Those who call themselves pure art collectors have complete collections of Charles Jacques, of Buhot, and among these things by Seymour Haden, Whistler, and Legros slip in, but that is all.—It is very sad; not at all encouraging.

[1] *Maurice Joyant, an intimate friend of Toulouse-Lautrec, had replaced Théo van Gogh at the Boussod & Valadon Gallery.*

My dear Lucien,

I have a real problem now: my eye has swollen in this intense cold and threatens to abscess. I shall have to go to see Dr. Parenteau, and to stop running around.

I don't believe Durand will publish *Les Travaux des Champs.* His review is just so much self-advertisement and nothing more. Durand cares less for art than ever, he is having some reproductions of my paintings made by the Michalet process.[1] Degas is furious, he says that Durand probably hopes to get the Legion of Honor.

Durand didn't want my small canvases simply because they were in my last style. He says that an artist should only have one style. Example: Ziem! Literally! I mentioned Delacroix, Turner, Corot. Well, he said the dealers have all they can do to make Delacroix understood even now.

My dear Lucien,

My eyes have been so bad that I had to interrupt all that I had in view. You can imagine how distressing this is to me coming directly after my troubles with Durand.

For some time now I have been anticipating this trouble with

[1] *The Michalet process was a method of non-photographic reproduction. The work of art was redrawn for the plates, and this inevitably produced distortions and made the reproductions very mediocre.*

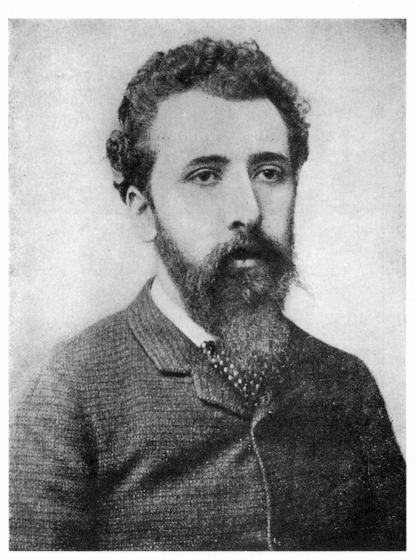

23.—Georges Seurat, Photograph.

24.—G. Seurat: A Sunday
Afternoon on the Island of
La Grande Jatte, 1884–86.

25.—C. Pissarro: View from the Artist's Window in Eragny, Grey Weather, 1886.

26.—C. Pissarro: The Train to Dieppe, 1886.

my eyes. The intense cold to which I was exposed in my runnings around aggravated my condition to such a point that the doctor was afraid of erysipelas, which seems to be a very serious matter. By constant medication we were able to control the swelling but not to prevent an abscess from forming. I have kept to my room since Friday and I probably won't be able to go out before several days.

Gustave Kahn has just asked me for a painting. I have a canvas of 21 x 18 inches which I think is what he wants. I am not unhappy about this, as you may imagine, for truly the collectors are not running after my works.

It seems that an article about me by Mirbeau will soon appear in Durand's review. I don't know whether Durand will be angry if Mirbeau should praise my last productions, but Durand seems more convinced than ever that my last paintings will prevent my early paintings from being sold.

Hayet came to see me. He is always the same, a great dreamer and very practical. He proposed to introduce me to a former dealer, who, it seems, understands painting, knows a great many dealers and is generally a shrewd fellow. According to his brother he is just the man for the neo-impressionists, and on the basis of this personage, Hayet has constructed a complete plan for organizing an exhibition in which I, the most balanced painter of the group, would cut a brilliant figure.

This is what Hayet, good fellow that he is, has in mind: I am to raise the flag of neo-impressionism and step forward as the leader of the movement; but, as I explained to him, I have no desire for the position of chief, I would rather leave the struggle for such honor to Gauguin and his likes. I have trouble enough just trying to sell my work. Besides influence comes only with time and despite one's will. When you have the qualities necessary for leadership, the role will be thrust on you while you are asleep.

PARIS, JANUARY 10, 1891

My dear Lucien,

Hayet was to come yesterday with the young man who aspires to be a dealer. He had begged Luce to come too; we waited until 11:30: no one came. Hayet is really extraordinary! Is it all up with those wonderful projects of his?

145

The group of painter-engravers is going to form an organization which will be known as the *Société des Peintres-Graveurs Français*. It seems that I can't be a member because I am an alien! [1] They intend to invite foreign-born artists, but I will not accept any invitation from them. How officious they are!

My dear Lucien,

I will probably leave for Eragny tomorrow. I feel much better, but I will have to keep my eye bandaged for another eight days. I shall try to work with one eye; Degas does it and gets good results; he has only one good eye!

I am very happy that my things pleased you and I am particularly pleased that your friends liked my print. I was well satisfied with it. The woodcut you sent me is most charming and Ricketts is right: if larger, it would be most effective. It is very good, you are on the right road. You had your share of difficulties, but, as you see yourself, you get nothing except at a price. When will *The Dial* appear? I hope you can send me a copy.[2]

My dear Lucien,

I would be glad to exhibit my etchings in London, however I don't expect anything, no more there than elsewhere, for truly the collectors understand only the engravings of Charles Jacques, Millet, Daubigny, and several others, if even!—It is enough to make one renounce the medium. Fortunately I only regard it as a pastime.

I have had all my watercolors mounted, and I am arranging them in portfolios. If I could exhibit them! But it would cost too much to have them matted. After all, I have 161. Georges likes them better than my paintings.

[1] *The Society of Painter-Engravers, in deciding to admit to membership only French citizens, thus excluded two of the best etchers of the period: Camille Pissarro, whose parents had been French but who, born in the West Indies, was a Danish subject, and Mary Cassatt, the American.*

[2] *The second issue of* The Dial *appeared in February 1891.*

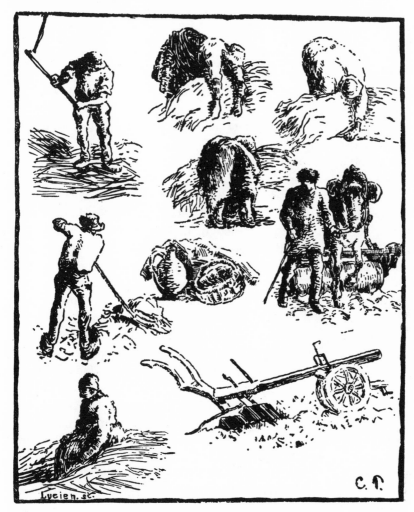

27.—*Les Travaux des Champs:* Peasants in the field. Drawn by Camille and
cut on wood by Lucien Pissarro, about 1890.

<div align="right">PARIS, JANUARY 15, 1891</div>

My dear Lucien,

I am still here. I wrote you that I had decided to leave but the
doctor advised me to wait a bit longer; it seems his previous op-
timism had been short-sighted, an abscess has formed.

The little money I put aside is slipping away fast. I am on pins
and needles. I have two paintings, which have already been sold,
to finish!

<div align="center">147</div>

My dear boy, when I read the excellent articles of Mirbeau and Geffroy, the master critics of Paris who lead the way and whose good opinion is so sought after by the most fashionable, I ask myself: but what is the good of it! The public . . . doesn't care! Durand-Ruel . . . doesn't care! It tickles him a bit, and it will have value later on; but for the present we can rot! . . . The important thing for him is to buy low and sell high. How disgusting! Go on then, devote yourself to pure art! But they point a finger at you, and assume an ironical air . . . treat you like an imbecile. And maybe they are right!

The publisher of E. Jacques, M. Bénézit, as you know, has an engraving shop at 21 rue Chaptal, very well furnished and attractive, not too big but good enough. In order to keep in touch with Bénézit who is an intelligent and active man, I left five framed etchings which were sleeping at Dumont's, rue Laffitte. I will send him my things from time to time, and later perhaps we can organize an exhibition, either alone or with two or three others. If I could get around, I would go to see Miss Cassatt to ask her to participate; I will do something along these lines when the weather is favorable. I would like Bénézit to become our Théo van Gogh for engravings! But so many projects fade the next morning! Alas, everything is like that!

You are right, I believe, to stick to engraving, you are making great progress, and your drawing is more and more masterful. You really have your own note, and that is tremendous. But how relate this art to life. . . . That is the problem, for the fact is that engravings are of interest to nobody except those young monomaniacs who prefer your wonderful simplicity to the engravings of Lepère, Baude, etc. When you make a drawing which is to be engraved on wood, you ought to strive for the proper distribution of *your strong values* in order to master them before engraving.—In drawing, one can foresee the effect.

ERAGNY [JANUARY 22, 1891]

My dear Lucien,

Well here I am home at last, and not without troubles in these evil days. My eye is much better, but I have to keep it bandaged, which irritates me in the extreme.

I was very happy to notice in your letters evidence of new developments in you. You seem to have more self-confidence and will, these are the fruit of strict application and long experience. Result: your work has more assurance and more personality. This is a good sign.

My dear Lucien,

I am sending you the latest number of *L'Art dans les Deux Mondes*, we are discussed throughout its pages. Durand is propagandizing furiously; the whole thing is incomprehensible, for on the other hand he doesn't encourage me to bring him my pictures. Portier has not gotten anywhere with my canvas of 21 x 18 inches, but he is going to try to show my large canvas *Peasant Breaking Wood* [757]. He seems to be aiming at replacing poor Théo van Gogh. Poor lad, he is safe from pain now; it was sad to see him, once so active and intelligent, out of his wits!

My eye has improved. This morning I was able to remove the bandage and finish the canvas for Kahn, but I am quite sure the abscess will form again.

My dear Lucien,

What is always most surprising in your communications is what Crane, Ricketts, Shannon, etc., think of my work, the opinion some have of my etchings, others of my drawings engraved by you. I am all the more astonished since in Paris I hardly found anyone aside from us who understood or liked them. Up till now I have felt around me nothing but indifference for work in black and white. Then, too, I am an extreme skeptic, and I often wonder whether compliments are not paid me out of courtesy; doubt even infects me to such a point that I lose the desire to make any more etchings or lithographs. For seriously, do you believe that those who sung my praise at the [exhibition of] painter-engravers, meant what they said? . . . except for Degas, who told me he loved

149

my *Field and Mill,* but what about the others? . . . As for the collectors, I assure you that what they really like is Charles Jacques, Buhot, Bracquemond, or Legros when he imitates Rembrandt; the same goes for Seymour Haden. But engravings based on vivid sensations, no! And it is this that I try for when I do engravings!

I finished the painting for Kahn. I think (you know the doubts that assail one when one has just finished something), I think it is good; it was done very freely. I divided the tones without waiting for the paint to dry and nevertheless it is quite luminous. It has much more suppleness than my previous paintings and has as much purity and light. So I feel that I am about to make rapid progress with this approach. Ah, well! If Durand had wanted to continue, I would have made a wonderful series of paintings for him! But he doesn't understand. He doesn't care!

I am sending you the latest issue of *L'Art dans les Deux Mondes.* It contains a very remarkable piece on Meissonier by Fourcault; it is very harsh but completely just. But this will not prevent people from hailing Meissonier—they can't help but be affected by the prices his canvases get—"the greatest artist France has had for a century", to quote the stupid remark of our Minister of Fine Arts, Mister Bourgeois (how appropriately named!).

ERAGNY, FEBRUARY 15, 1891

My dear Lucien,

I received your letter and the proof of your lithograph. I am sure that you can exhibit it, I find it excellent. Decidedly you are finding your path.

What you write about your friends' ideas is quite correct. Damn it, one must find one's own conventions! . . . Only a moment ago I saw in *L'Art dans les Deux Mondes* that Shannon has just been made a member of the royal society of painter-engravers, and *Bracquemond* has been made an honorary member. Has Shannon told you about it?—at the moment Bracquemond's star is rising, rising!

This morning I received a letter from a Mr. P. G. Hamerton, editor-in-chief of the London *Portfolio.* He got my address from Durand and asks me for some drawings to accompany an article

150

28.—C. Pissarro: Woman sewing. Drawing, published
in 1891 in *The Portfolio*.

on the impressionists. I shall send him some figure drawings. Do
you know this review, do your friends? What is it like? [1]

Abscessed again! Once again the bandage for eight or ten days!

[1] *In 1891, P. G. Hamerton, editor of* The Portfolio, *published a series of articles on
"The Present State of the Fine Arts in France", the fourth of which was devoted to
"Impressionism" and accompanied by a drawing by Pissarro (see fig. 28). Hamerton's attitude towards impressionism was typical of the critics of the time whose
erroneous conceptions of "the beautiful" and "the ugly" he shared. Hamerton wrote:
"There is M. Camille Pissarro, who has some very ardent admirers, and yet who is
very foreign to me . . . It seems to me that he admits lines and masses that a stricter
taste would alter or avoid, and that he includes objects that a more scrupulous artist
would reject . . . He does not seem to care whether the line of shore is beautiful or
not, and he has so little objection to ugly objects that in one of his pictures [probably
604 or 607] the tower of a distant cathedral is nearly obliterated by a long chimney
and the smoke that issues from it, whilst there are other long chimneys close to the
cathedral, just as they might present themselves in a photograph. By this needless degree of fidelity, M. Pissarro loses one of the great advantages of painting."*

And this is going to continue until the good weather comes. In my fifteen days of grace I worked, now I am resting.

My dear Lucien,

The woodcut you sent me is just beautiful; your personality comes out perfectly, the work is charming in every respect. The movement is original, the values are very precise, the terrain in the foreground is very delicately modeled, the background is well drawn and well cut. You are making progress, you have found yourself and that is immense; you can now go boldly in search of your own conventions.

What, my etching pleased Mr. Ricketts? I am delighted. . . . Nobody noticed it here. Don't you think that I could offer one proof to your friend? Which of the two: *The Market* [D. 97–98] or *The Geese* [D. 76]? I would be delighted if they want to reproduce it [in *The Dial*], you know that I have the steeled plates for them in hand.

I have not yet begun to work on the etching, our little press is so poor that the project is hardly attractive. And I am halted by a lack of the necessary data. A press is something more to own; and I am afraid that once I have all the necessary tools I may neglect my painting. This would be bad business, for an etching, as Bracquemond says, isn't worth twenty centimes.

The exhibition of painter-engravers opens April 1st at Durand's. We are pushed out! Oh, these patriots! But I see that in London they play the same game. When will artists be able to free themselves from these official and retrograde ideas, so shabby and bourgeois!

My dear Lucien,

In accordance with your wish, I chose forty-two proofs of mounted etchings and will send them to you. You will find among these a free proof of *Setting Sun* [D. 96], an artist's proof which I would like you to deliver to M. Ricketts for me. You know that

these proofs are very rare, I have only eight of them, and these are not very good; the plate is difficult to pull.

The proof of *Fields and Mills* is first-rate. There are only three proofs of this sort; the steeling obliterated the suppleness of the background. I have only three proofs left, the third is for the Luxembourg Museum.[1] *Woman Emptying a Wheelbarrow* [D. 31] is rare, you recall that there are only two proofs, only one of which, the one I am sending you, is good; this is the one in grey. As for *The Hovel* [D. 20] you know that only six of this one have been pulled. The steeled proofs are sometimes very beautiful but less rare; if you need some more data, write and ask me.

I suppose you will have difficulty in making people understand that I am not an engraver, that these are simply graven impressions.

ERAGNY, MARCH 9, 1891

My dear Lucien,

Signac, returned from Belgium,[2] wrote me asking for my painting of Dubois-Pillet.[3] Not a word about the exhibition of the *Vingt*, however he offered to take some of my fans and sell or show them for me. I wasn't very interested for I know the Belgian collectors, who, when you come down to it, are simply two or three artists who buy just in order to get information, and since they know all about my work, they have no use for my things. But real collectors, who love works of art, not simply because produced by a definite school, but because they are art, such collectors do not exist!—They are too interested in what is being done at the moment. I do believe they would scorn to buy even a Degas or a Monet, or any other master who is well known. Strange

[1] *Pissarro had decided to leave a complete collection of his engraved work to the Luxembourg Museum although the State never bought any of his prints.*

[2] *Signac had gone to Brussels to appear at a banquet given by the Vingt, in whose exhibition he had participated as a new member of the group; among the others who had been invited were Seurat, Camille Pissarro, Gauguin, Guillaumin, Sisley and also van Gogh, for whom the Vingt had organized a retrospective show. Pissarro exhibited two canvases of London: Kensington Gardens [747] and the Bridge of Charing Cross [745] as well as three fans.*

[3] *The Indépendants were preparing a retrospective show of the work of Dubois-Pillet who had just died.*

indeed! Yet how Belgian! . . . Nothing good can come from this quarter. The truth is I don't know why I sent my work to the *Vingt;* in order not to seem to be breaking with them. But the costs have to be met.

It seems that it was Gauguin and van Gogh who were the subjects of controversy in Brussels this year; naturally there has been much discussion in the newspapers.

I wrote to M. Bénézit who has an attractive place on rue Chaptal, next to Boussod & Valadon, to ask if he would hold an exhibition of my engravings, drawings and gouaches. He had already spoken of this to me. The moment is favorable.—I have just received an invitation to exhibit as a foreign artist with the *Peintres-Graveurs Français.* The exhibition will be held on April 3rd. I refused for a number of reasons; among other things each exhibitor is obliged to leave with the society one proof of each work shown. This is understandable for those who pull three or four hundred proofs but I, who most of the time have only three or four proofs, would lose all my stock! What do you think? I would much rather exhibit alone, if it were possible. All the same I wouldn't have said anything under other conditions, but certain members of this society impress me as ill-intentioned. I am distrustful!

ERAGNY, MARCH 19, 1891

My dear Lucien,

I finally completed three important canvases, two gouaches and several etchings. I will probably leave for Paris Tuesday—if possible, Monday. Monet dropped me a line to inform me that he had been visited by M. Montaignac, who, so it seemed to Monet, indicated that he was disposed to deal with me; I will not lose this chance. If you read the column from America in *L'Art dans les Deux Mondes,* you must have seen that this gentleman is going to America with big enterprises in view. Incidentally I advise you not to fail to read with close attention the articles with news about American affairs. And don't fail to let me know when you have received my trunk of etchings.

154

My dear Lucien,

I leave Tuesday for Paris, it is decided. I shall try to deal with
M. Montaignac. At Petit's, he played a role like that of Théo van
Gogh at Boussod & Valadon's, he was the right arm of the firm.
He impressed me as an intelligent man quite sympathetic to our
art; I learned from Monet last year that he [Montaignac] had a
hand in his [Monet's] affairs; they were in touch for quite a
while, he [Montaignac] has also been in contact with Sisley—as
you see he is not a newcomer. I don't know what may come out
of this, but when one is shipwrecked and comes across a plank,
shouldn't he seize hold of it? But I don't expect extraordinary suc-
cesses, I know only too well that all I do is either badly understood
or displeasing. Evidently my art is not of a kind to please many,
so I am dreaming of quite modest dealings with Montaignac.

I am sending you *L'Art dans les Deux Mondes, L'Echo de Paris,*
in which there is an article by Guy de Maupassant on Swinburne,
the English symbolist poet, and *L'Eclair,* which has an article on
the *Indépendants* in which Ceranda de Belzein is dubbed a great
painter and the neo-impressionists are called idiots. It is astound-
ing how uncultured are these writer-journalists . . . how preten-
tious! Now these animals are beginning to discover that the sym-
bolists are not without talent, but you should see which of them
they single out. It is always the same story . . . and the public
imagines it is kept well-informed!

You are right to distrust those tricksters who are trying to wear
your shoes. If they were trying to exploit the possibilities of the
medium, such practices would be justified, but they take your
ideas, your cuts, your values, your execution, add some charlatanry
to the execution, and become successful!

Seurat's death

My dear Lucien,

Terrible news to report: Seurat died after a very brief illness.
I heard the cruel news only this morning. He had been in bed
for three days with a disturbance of the throat. Improperly
treated, the illness developed with ruinous speed. It is my impres-

sion that the malady was the very one de Bellio told me about some time ago: diphtheria. The funeral takes place tomorrow. You can conceive the grief of all those who followed him or were interested in his artistic researches. It is a great loss for art.

I looked for a long time at your engravings at the exhibition [of the *Indépendants*], they are hung to admiration on a panel which divides the room of the impressionists into two sections.— Your colored engravings are excellent, they are real pearls, the others are very good, your lithograph has delicacy and distinction, which, by the way, are your outstanding qualities. Your prints have attracted a lot of attention, several of the newspapers mentioned them, M. Paul Mantz gave them high praise. I am sending several [press clippings from the] Bonneau [agency]. It is obvious that from the point of view of art you have an important place in this exhibition. . . .

There is a splendid exhibition of that unfortunate Seurat; some marines, as delicate as ever, somewhat white and weak in coloration, but very artistic, and a large canvas, a *Circus*,[1] which is excellently composed; a clown cut on the foreground dissatisfies us, but the work as a whole has the stamp of an original artist, it is *something!* All his pictures are framed in chromatic colors and the ensemble gives the effect of an intense blue and violet stain; I find this disagreeable and discordant, it is not unlike the effect of plush! . . .

Signac has some landscapes of the kind you know, very correct, very well executed, but cold and monotonous; he has a bizarre portrait of Fénéon, standing, holding a lily, against a background of interlaced ribbons of color which do not add to the decorative quality of the work and have no value from the point of view of sensation. Angrand's work is just about what it has been. Van Rysselberghe has some good things, but one feels the academy in his drawing. The pupils of Gauguin: a M. Willumsen is terribly like Bernard, Anquetin has some good things in a classical vein, and some formidable soldiers' wives, but that he is very adroit is evident. Emile Bernard: nothing new. Gauguin didn't exhibit. He is leaving for Tahiti on a government mission obtained through the efforts of Renan, Jr.[2] He will come through. We who were so

[1] *This picture was since given to the Louvre by the American collector, John Quinn.*
[2] *This "mission" amounted to nothing more than an informal promise to buy one of Gauguin's paintings when he returned. The purpose of the "mission" was to give Gauguin "standing" with the authorities in Tahiti.*

close to him know that he has great vitality and is inured to the difficulties of life, and can take a new tack if need be!

I am organizing a modest show at Durand's. One of the small rooms; twelve etchings; drawings, pastels, gouaches; twenty-four things in all. Along with my work, in the other room, Miss Cassatt will show an equal number of things. We want to open simultaneously with the *Peintres-Graveurs;* it is Saturday, so I haven't too much time.

PARIS, APRIL 1, 1891

My dear Lucien,

I am indeed happy to hear that Messrs. Ricketts and Shannon think well of my engravings. There must be some way of coming to an agreement about the two proofs they want; I don't want them sold, no; you might suggest an exchange; it would be for me a charming souvenir, I should like to see it hanging with our collection in the dining room.

With regard to your engraving, *Sister of the Woods,* I am far from finding it a failure, but no! It is the atmosphere of the thing (not in the literal sense), it is the taste of the ensemble. For example, your little engravings that were exhibited also have a somewhat British air which was understood by all those who saw them, but in addition, as I see it, there is in your engraving the savor of *rustic nature, if you will,* something of the unknown which we have here in *Eragny,* and which distinguishes whatever we do. In your work particularly there is a *naive good faith* and a discreet reserve which charms. Your *Sister of the Woods* has just a hint of the rigidity and solemnity reminiscent of the English. It's nothing. I do understand that Ricketts selected the subject, for *The Dial,* and it's not bad, people will like it.

I am much taken up with my little show at Durand-Ruel's. I am having my new prints framed. I will send you several of them soon; there are some market scenes [D. 97–98], a *Breton Peasant Woman at the Well* [D. 101], etc. I am waiting to see them framed, then I will be able to appraise them.

I forgot to mention above when I discussed your engraving that I am prepared to see you changed by England, that is inevitable, but I can assure you that you will never lose your naive and discreet nature. Don't be anxious, then, about the changes taking

157

lace in you. Go forward, resolutely, and if you put your whole ul into perfecting a work it will be original. And persist *obsti-'ely, obstinately* in doing what you did at Eragny, only with greater knowledge and experience.

Yesterday I went to Seurat's funeral. I saw Signac who was deeply moved by this great misfortune. I believe you are right, pointillism is finished, but I think it will have consequences which later on will be of the utmost importance for art. Seurat really added something.

PARIS, APRIL 3, 1891

My dear Lucien,

It is absolutely necessary, while what I saw yesterday at Miss Cassatt's is still fresh in mind, to tell you about the colored engravings she is to show at Durand-Ruel's at the same time as I. We open Saturday, the same day as the patriots, who, between the two of us, are going to be furious when they discover right next to their exhibition a show of rare and exquisite works.[1]

You remember the effects you strove for at Eragny? Well, Miss Cassatt has realized just such effects, and admirably : the tone even, subtle, delicate, without stains on seams : adorable blues, fresh rose, etc. Then what must we have to succeed? . . . money, yes, just a little money. We had to have copper-plates, a *boîte à grain*, this was a bit of a nuisance but it is absolutely necessary to have uniform and imperceptible grains and a good printer. But the result is admirable, as beautiful as Japanese work, and it's done with printer's ink! When I get some prints I will send you some; incidentally I have agreed to do a series with Miss Cassatt; I will do some *Markets, Peasant Women in the Fields*, and—this is really wonderful—I will be able to try to put to the proof some of the principles of neo-impressionism. What do you think? If we could make some beautiful engravings, that would really be something.

I have seen attempts at color engraving which will appear in the exhibition of the patriots, but the work is ugly, heavy, luster-

[1] *While the Society of French Painter-Engravers was holding its exhibition in the main room of the Durand-Ruel Gallery, Pissarro and Mary Cassatt showed their engravings in two small adjoining rooms.*

29.—Lucien Pissarro: Sister of the Woods. Woodcut,
published in 1892 in *The Dial*.

less and commercial. I am certain that Miss Cassatt's effort will be
taken up by all the tricksters who will make empty and pretty
things. We have to act before the idea is seized by people without
aesthetic principle.

This is a bad moment for me, Durand doesn't take my paint-
ings. Miss Cassatt was much surprised to hear that he no longer
buys my work, it seems that he sells a great deal.—But for the
moment people want nothing but Monets, apparently he can't
paint enough pictures to meet the demand. Worst of all they all
want *Sheaves in the Setting Sun!* always the same story, every-
thing he does goes to America at prices of four, five and six thou-
sand francs. All this comes, as Durand remarked to me, from not
shocking the collectors! True enough! What do you want, I re-

plied, one has to be built that way, advice is useless. But while waiting we have to eat and pay our debts. Life is hard!

PARIS, APRIL 8, 1891

My dear Lucien,

Unquestionably my figures are beginning to be noticed. Thus, for instance, the etchings of *Markets* and the projects for fans in my exhibition at Durand-Ruel's have had some success. I went through the room of the Society with Degas, and he observed my things closely, he complimented me again and again on the style of my figures; Zandomeneghi too (who is so difficult), noticed particularly my designs, fans, gouaches, etc. That was very kind and very flattering, but just the same Durand refused to take my canvas of *Mowers in Repose* [773] with which I was very satisfied, a *Sunset with Fog* [767 or 768], and one *Sunset*. But a clear categorical refusal! While telling that Monet had admired them! I brought them to Portier who has become enthusiastic about my latest things. But there is no point in having illusions, there are few who understand. I am often discouraged when I see people so indifferent, indeed in some I sense a repressed hostility. . . . On the other hand I have noticed a sympathetic attitude in people who for years did not understand my work and frankly told me so; this gives me real satisfaction.

What has befallen Miss Cassatt is just what I predicted: great indifference on the part of the visitors and even much opposition. Zandomeneghi was severe, Degas, on the other hand, was flattering, he was charmed by the noble element in her work, although he made minor qualifications which did not touch their substance. . . . As to the practical results which Miss Cassatt anticipated, we must not count on them unduly, the general response is mostly hostile. As you can see, it is no use being astonished by the reticence of one's comrades, the witticism directed at M. Prudhomme: *"Let's ignore that, it is not handmade!"* always holds good for artists and comrades, they do not love what is simple, sincere, or if indeed they notice something which has such a quality, it is only when its simplicity is the result of cunning. People are such terrible gobblers in Paris! They are taken in with such unimaginable facility! In this lies the secret of their coldness.

160

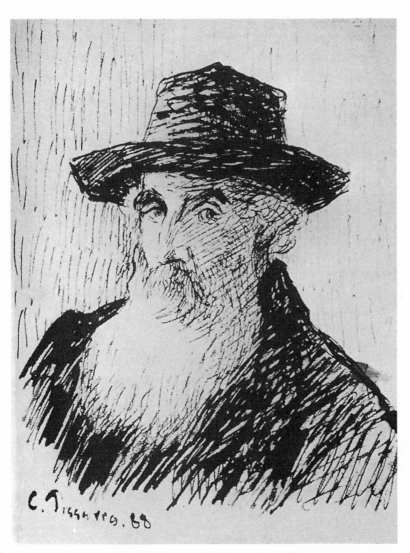

30.—C. Pissarro: Selfportrait. 1888.

31.—C. Pissarro: Portrait of the Artist's daughter Jeanne,
about 1888.

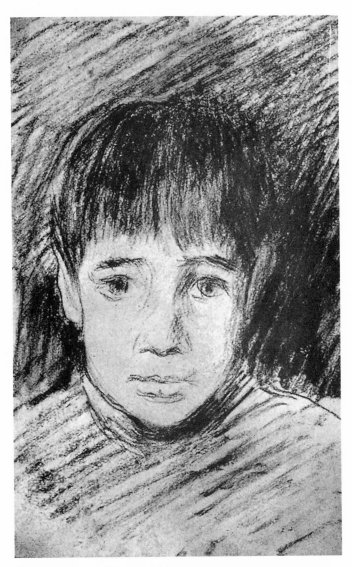

32.—C. Pissarro: Portrait of the Artist's son Félix, about 1885.

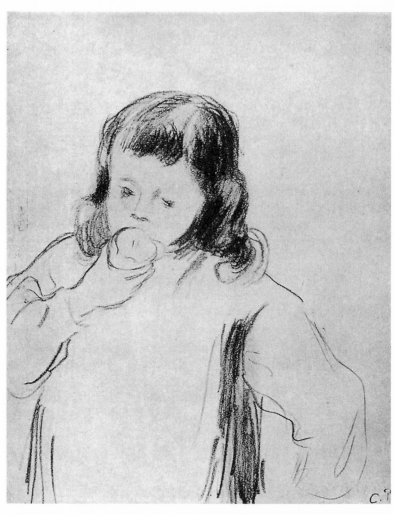

33.—C. Pissarro: Portrait of the Artist's son Rodolphe, about 1884.

You really ought to send me a *Dial* so that I get an idea of it. As soon as I am less preoccupied with questions of money, I will have some prints made of the latest engravings I exhibited and send them to you.

I have found my lost plates: *The Hovel* [D. 20] and *Le Père Melon* [D. 25], a whole parcel was discovered by Degas. He came across them while cleaning up his studio and he has put them aside for me; I still don't know how many of them there are in the lot.

PARIS, APRIL 9, 1891

My dear Lucien,

I have just received a card from the exhibition of the *Indépendants*. The writer wants to know the prices of your three woodcuts. You see, they have been noticed.

I saw de Bellio yesterday; he sends you his best. He mentioned that Monet was going to have a one-man show at Durand-Ruel's, and exhibit *nothing but Sheaves*. The clerk at Boussod & Valadon told me that the collectors want only *Sheaves*. I don't understand how Monet can submit to this demand that he repeat himself— such is the terrible consequence of success! It happens all the time! I am very disturbed by Durand's behavior; he really seems to want to bury me; if I don't take drastic steps to extricate myself from this blind alley, I am done for.

PARIS, APRIL 13, 1891

My dear Lucien,

I am leaving without having made the most modest sale, despite all Portier's efforts. One would say that people feel that I am no longer good for anything. If you only knew what I was offered by a dealer for two canvases of about 21 x 18 inches, paintings which Durand had rejected, on which I had worked long and with which I was most satisfied! I had asked Durand for five hundred francs, the dealer offered two hundred! I was forced to refuse this offer; to accept would mean to be crushed at once.— The collectors understand nothing but Monet's work now, they wrangle with me over the most absurd details. Not one offer at

161

my little exhibition, despite the fact that Zandomeneghi, Degas, etc., complimented me no end. Janniot was delighted with my show, he couldn't get over my watercolors on Japanese paper and my etchings. "How's that?" he asked, "you aren't selling any? That's most extraordinary!" However that's the way it is, and the more I try the more humiliated I am. So I shall leave for Eragny, I don't want to remain here without a penny.

There are moments when I ask myself whether I really have talent . . . in fact I often doubt it. What does my work lack then, or what has it in excess?

I am enclosing a note from the Argus; you will observe in reading it that even Geffroy who is sympathetic to us, has little understanding of engravings. He has looked at your work, which is really remarkable and quite unique in France, most superficially. No, they do not understand us, they do not see the hidden meaning, the mysterious beauty of the thing artistic; it will take twenty years to uncrook the eyes even of those who devote themselves to art! And that applies to all of them, but all! I think this is due to the general trend of the period, it has not yet produced a man capable of imposing his ideas on the masses. It was thus that M. de Mareille was able to convince his epoch of Watteau's greatness.

I have just seen Portier who for a moment really discouraged me. It seems that Duret exchanged an old work of mine, a little painting done in 1873 with the Japanese, Hayashi, a dealer in knick-knacks I know. Portier invited him to come and look at my three new paintings, the Japanese replied that he did not care for my recent work! But Portier, setting the old canvas, which he had cleaned, alongside of my new ones, was completely enthralled by the latter. Incomprehensible! A Japanese! They were all poured into the same mould! decidedly . . . or I am indeed blind!

Yesterday I met Sisley whom I had not seen for at least two years. He is quite happy as long as he is adrift. He said that Durand was our worst enemy; he had tried to beat down Monet, who unhesitatingly turned to Théo van Gogh, and from then on, being able to keep his prices up, and having the support of Madame H.,[1] who has a small income, managed to rise. Durand then became as soft as felt, formerly ferocious he became tender

[1] *Madame Hochedé, widow of the collector and owner of a Paris department store who became Monet's second wife.*

as a lamb. I turned to van Gogh too late, I might have had the same luck!

Since Durand is unable to support all the impressionists, it is entirely to his interest to let them fall by the wayside after he has obtained enough of their work, for he knows their pictures will not sell until much later. The lower the prices, the better for him —he can leave our canvases to his children. He behaves like a modern speculator for all his angelic soft-spokenness. Sisley, who can't forgive his lack of good faith, for we were all naive and believed his promises, is convinced that Durand has lost out with Monet whose exceptional luck and real talent served him in good stead. If I could find some base of support, I would certainly frustrate his hyena-like calculations—but my work is not understood, particularly since the death of Théo van Gogh. Such is the influence of a man who believes! That is the sort of man it is necessary to find. But such men are not ready-to-order. Perhaps I am out of date, or my art may conflict and not be conciliable with the general trend which seems to have gone mystical. It must be that only another generation, free from all religious, mystical, unclear conceptions, a generation which would again turn in the direction of the most modern ideas, could have the qualities necessary to admire this approach. I firmly believe that something of our ideas, born as they are of the anarchist philosophy, passes into our works which are thus antipathetic to the current trend. Certainly I feel that there is sympathy for us among certain free spirits, but the one I can't understand is Degas, for he loves Gauguin and flatters me so. Friendliness and no more? . . . How understand him . . . such an anarchist! in art, of course, and without realizing it!

PARIS, APRIL 20, 1891

My dear Lucien,

I am sending you the review *L'Art dans les Deux Mondes* and a review which contains an article on Gauguin by Aurier.[1] You will observe how tenuous is the logic of this *littérateur*. According to him what in the last instance can be dispensed with in a work

[1] *Albert Aurier, the symbolist writer, had devoted one of his first articles on art in the new Mercure de France to Gauguin.*

163

of art is drawing or painting; only ideas are essential, and these can be indicated by a few symbols.—Now I will grant that art is as he says, except that "the few symbols" have to be drawn, after all; moreover it is also necessary to express ideas in terms of color, hence you have to have sensations in order to have ideas. . . . This gentleman seems to think we are imbeciles!

The Japanese practised this art as did the Chinese, and their symbols are wonderfully natural, but then they were not Catholics, and Gauguin is a Catholic.—I do not criticize Gauguin for having painted a rose background nor do I object to the two struggling fighters and the Breton peasants in the foreground,[1] what I dislike is that he copped these elements from the Japanese, the Byzantine painters and others. I criticize him for not applying his synthesis to our modern philosophy which is absolutely social, anti-authoritarian and anti-mystical.—There is where the problem becomes serious. This is a step backwards; Gauguin is not a seer, he is a schemer who has sensed that the bourgeoisie are moving to the right, recoiling before the great idea of solidarity which sprouts among the people—an instinctive idea, but fecund, the only idea that is permissible!—The symbolists also take this line! What do you think? They must be fought like the pest!

ERAGNY, APRIL 25, 1891

My dear Lucien,

Before leaving Paris I went to see Miss Cassatt. I watched her make color prints of her aquatints. Her method is the same as ours *except* that she does not use pure colors, she mixes her tones and thus is able to get along with only two plates. The drawback is that she cannot obtain pure and luminous tones, however her tones are attractive enough. We will have to make a more definitive trial of our own method to determine which is to be preferred.— We had a long talk about the problem of selling pictures, I told her about my position *vis-à-vis* Durand; she is incensed at Durand on her own account and asked me if I would go along with her if she left Durand. We will probably exhibit with Degas. She will use all the influence she has to push our paintings and engravings in New York, she is very desirous of upsetting Durand. She has a lot of influence and Durand, who suspects that she is irritated

[1] *The reference is to Gauguin's painting* Jacob Wrestling with the Angel, *see fig. 56.*

164

with him, is trying to calm her down with promises and offers which he does not make good. Degas also is very irritated, he too has plans which bode no good for Durand. I am making some lithographs, Meyer would like to have them, the deal will really amount to something. If only I could drift for a while. I hope Miss Cassatt will get something of mine sold, she liked my three canvases very much and wanted to see them in their frames at Portier's.—Will anything come of it? I have had so many disillusionments that I don't dare expect too much. I don't depend on Portier at all, he cannot replace Théo van Gogh. I think some good exhibitions would help us, particularly in New York. I believe Miss Cassatt is beginning to understand my recent work, she never before was as enthusiastic as this last time.

<div align="right">ERAGNY, MAY 2, 1891</div>

My dear Lucien,

I will send you any day now the new etchings I mentioned. I expected to have finished them, but a new abscess broke out and I was forced to suspend all my work. I leave Sunday, that is, tomorrow, for Paris, I will go to see Parenteau who will probably operate on my eye. I was penniless and didn't know how I could leave here. As a last resort I wrote to Monet who promptly sent me a thousand francs. I will be able to give Grancey two hundred francs, pay the rent, put a little aside for the house, and make the trip to Paris. Good, but when will I sell something?

With my prints I will send you *Les Hommes d'Aujourd'hui*, "Paul Cézanne", they have not deigned to send me a copy![1]

<div align="right">PARIS, MAY 5, 1891</div>

My dear Lucien,

My affairs are at a complete standstill, however my reputation, at least with Geffroy, Mirbeau and the painters, has not suffered.

[1] *The painter Emile Bernard, the friend of Gauguin, had just published in the Hommes d'Aujourd'hui series a study of Cézanne, the first work to appear on the painter of Aix. The brochure contained a portrait of Cézanne by Pissarro, see fig. 48. Later numbers of the series were devoted to Seurat, Signac, Redon, Luce, etc.*

There are, of course, certain young intriguers who claim that I spent much of my life being influenced by Manet (the height of absurdity), Monet, Renoir, Sisley (astonishing to say the least), and even the pointillists. These young men speak of "personality" without having thought precisely of what the word can mean. For them personality is expressed only in technique.

Yesterday Monet's show opened at Durand-Ruel's. I saw everybody there. I went with one eye bandaged and had only the other with which to take in Monet's marvelous *Sunsets*. They seemed to me to be very luminous and very masterful, that was evident, but as for our own development we ought to see deeper, I asked myself: what do they lack? Something very difficult to delimit clearly. Certainly in rightness and harmony they leave nothing to be desired; it would rather be in the unity of execution that I would find something to be improved, or rather I should prefer a calmer, less fleeting mode of vision in certain parts. The colors are pretty rather than strong, the drawing is good but wavering —particularly in the backgrounds—just the same, this is the work of a very great artist.

Need I add that the show is a great success? This is not surprising, considering how attractive the works are. These canvases breathe contentment.—

Mirbeau spoke to me of your woodcuts which he finds admirable, as does Monet. I saw not a few friends who inquired about you.

Luce wants to know whether you would collaborate with me in outlining the anarchist conception of the role artists could play and the manner in which they could organize in an anarchist society, indicating how artists could work with absolute freedom once rid of the terrible constraints of Messrs. capitalist collector-speculators and dealers. How the idea of art would be further developed, the love of beauty and purity of sensation, etc., etc. It won't be necessary to elaborate, Georges Lecomte will do the actual writing, it is a question only of ideas. It is to appear in a review which Pouget hopes to launch. I am afraid I will be unable to set down on paper the ideas that came to us so often—it is so difficult to formulate an idea.

166

My dear Lucien,

First of all, news about me: things for the moment are satisfactory enough, however I am not without anxiety about what the future will bring. Right now Parenteau is giving me injections of silver nitrate while waiting for another abscess to form, when that happens, and the eye is sufficiently inflamed, he will perform the slight operation necessary. So the thing is only deferred. I will probably now not suffer from abscesses so constantly, thus I will be able to do a little work. Besides, I am getting used to the idea of working with one eye, which is certainly better than none! I have one hundred and fifty francs to send you for your expenses, this money is the result of my modest show which had a certain amount of success. Isn't that amazing? Monet has opened his show, I wrote to you about it, well, it has just opened, my dear boy, and every painting has already been sold for from 3000 to 4000 francs each! If I could only sell one fourth that many paintings I would be only too happy to help Alice and Esther in my turn, but no, it has been decreed that I am not to have the satisfaction of making happy those near me, even your mother who certainly deserves some rest from care. It breaks my heart!

I sent you with the etchings an issue of *Les Hommes d'Aujourd'hui*, which has a portrait of Cézanne by me and a critical note by Bernard. This ignorant fool claims that Cézanne for a time was under the influence of *Monet*. That is the limit, no? However Gauguin knows all about the Cézanne studies done in Auvers, Pontoise and elsewhere! Zola himself noted and, as I see it, correctly noted, by whom Cézanne was influenced! [1]

But I was wrong to speak of Bernard's ignorance, it is just sharp practice à la Gauguin. Bah! What's the point of this? Aren't we all, including the great Gauguin himself, under the influence of the milieu?

[1] *Pissarro here alludes to the incontestable fact that it was he himself who had influenced Cézanne when the latter worked near him at Pontoise and Auvers-sur-Oise from 1871 to 1874. It was in this period that Cézanne purified his palette and changed his until then fiery execution for one based on impressionistic touches of color. Cézanne always openly admitted what he owed to Pissarro, and in 1904, after the death of his friend, even described himself as "Pissarro's pupil". It seems that the symbolists grouped around Gauguin and Emile Bernard, all ardent admirers of Cézanne, wanted to ignore the fact of his indebtedness in order to aggrandize him.*

167

My dear Lucien,

Tell me if you have received my etchings and whether you like them. The landscape has had some success, Degas liked *The Market* very much. He advised me to leave it as it was, but I have not yet made up my mind whether I want to try to give it more clarity after I have made a few prints. You will notice it is quite strong.

Times are hard, I can't sell anything. I have had five rather old canvases done in 1872–1873 belonging to a banker,[1] who commissioned them from me, on auction, besides four door panels [183–186], (measurements 22 x 52 inches). The five canvases are well preserved, grey and delicate, particularly *Snow Effect* done at Louveciennes which is very good. There is also a small canvas, *Street of Louveciennes* which seemed very fine to me. The lot was sold for a song, eleven hundred francs for the four panels and three hundred and seventy francs for the small canvas of 18 x 15 inches. The latter was bought to be sent to New York. The buyer had seen my new things and had suggested them without being able to get them taken—his backers claim they are done "in dots" and won't hear of them. Only Théo van Gogh was able to have the collectors here accept them. It's hopeless now, they are more stubborn than ever.

Durand was at the auction. He let my paintings go at the most ridiculous prices! However, they were works done long ago! The strangest thing is that this devil of a Durand praised my *Serpentine with Effect of Fog* [744] which belongs to M. Gallimard and a small canvas of 21 x 18 inches done completely in the divisionist technique, a field in a white, setting sun, which had been sold to poor Dupuis who committed suicide. And didn't he say to me yesterday, right in front of Zandomeneghi at the Monet show: "Monsieur Pissarro, it's your turn now to have a good show!"

I have to send you on behalf of Madame Seurat, in memory

[1] *A reference to the auction of the collection of Achille Arosa which took place on May 6, 1891. Arosa had paid in 1871 a hundred francs apiece for the four panels. The banker Arosa was the godfather of Paul Gauguin and had introduced the painter to modern art.*

of her son, a drawing and a small panel. Send your card with a line to 110 Boulevard Magenta.[1]

Anquetin is getting somewhere. Aren't these Normans clever! Consider that he sent some grotesque things to the *Indépendants*, among them a rather good nude figure imitated from the primitives, but carefully done, not badly drawn, rather attractively colored, but also some horrible landscapes and a huge prostitute whose enormous breasts hang outside her bodice. Naturally there was a storm. He was not content with showing at the *Indépendants* and sent eight objects to the *Champ de Mars;* seven were rejected. Tumult in the newspapers, meetings of discontented artists, then a third organization was formed, Anquetin, president. They will soon open a fourth exhibition—what cliques!

<div align="right">PARIS, MAY 13, 1891</div>

My dear Lucien,

I was sure my prints would please you. It was a great pleasure to me to make them. For a long time now I had been wanting to do some things of this character—I had meditated on this for such a long time during my days of inactivity that the actual execution required very little time. If I had had better plates, I would perhaps have gotten better results.

I am overjoyed to hear that you are beginning a painting in your studio. It is by working in the smithy that one becomes a blacksmith. It is incontestable that work in the studio is just as difficult as work outdoors, but it is entirely different from the point of view of the requirements, methods, and results. One should not seek in the studio what cannot be found there, even as outdoors one should strive only for direct and spontaneous sensations. Remember that watercolors help the memory, and enable you to retain the most fugitive effects—watercolors render so well the impalpable, the powerful, the delicate. And drawing is always indispensable. Divide your tones without worrying about the dry-

[1] *Fénéon, Signac and Luce were entrusted with the task of distributing Seurat's works among his heirs: the artist's family and his mistress. They had suggested to Madame Seurat that she present souvenirs of the dead painter to his former friends and comrades. The drawings which Camille Pissarro received in this way he left after his death to the Luxembourg Museum.*

ing of the colors; on the contrary I am sure that you won't dirty the tone if you don't press too much on your brush and work with the point.

I don't know for sure whether Miss Cassatt and Madame Berthe Morisot will join the "Panel Society",[1] but it shouldn't be difficult to find out, I will ask them myself and will do all I can to persuade them. It seems to me it would be an excellent thing. The regulations of the "Panel Society" look good to me, the organization should accomplish something; I see that in London the *young* are not the Barnums they are here.

We are fighting against terribly ambitious "men of genius," who are concerned only to crush whoever stands in their path. It is sickening. If you knew how shamelessly Gauguin behaved in order to get himself elected (that is the word) man of genius, and how skillfully he went about it. We were left no choice except to smooth the way for him. Anyone else would have been ashamed! Knowing that he was in such difficulties, I myself couldn't but write to Mirbeau in his favor. He was in such despair. Mirbeau, at the solicitation of the symbolists, wrote an article in which he went too far, as I see it, and the article made a great noise. I learned from Zandomeneghi that although afraid to go and face Degas, Gauguin nevertheless wrote to him to ask for his support. Degas, who after all is very fine and sympathetic to people who are in trouble, put himself at Gauguin's service and bought a canvas at the sale.[2] De Bellio, who had been obstinately cold to Gauguin, confessed to me that he had changed his view of Gauguin's work, that he now considered him to have great talent, although not in sculpture. Why? . . . It is a sign of the times, my dear. The bourgeoisie frightened, astonished by the immense

<hr />

[1] *Some of Lucien Pissarro's English artist friends planned to found a Society primarily interested in the graphic arts. At the exhibitions to be organized by this Society each member's work was to form a panel of the same size. The project fell through eventually.*

[2] *After his quarrel with Vincent van Gogh in Arles, towards the end of 1888, Gauguin lived in Brittany, working with Emile Bernard, Schuffenecker, Charles Laval, Meyer de Haan, etc. It was during this period that he completed his Jacob Wrestling with the Angel. Completely destitute, Gauguin decided to go to Tahiti, and proposed to raise the funds by holding an auction of his works. On February 16, 1891, Octave Mirbeau published in L'Echo de Paris a long article, the purpose of which was to call attention to this sale which brought in almost 10,000 francs. Degas bought La Belle Angèle (today in the Louvre) for 450 francs, and a landscape of Martinique for 260 francs. Jacob Wrestling with the Angel brought 900 francs. Gauguin left on April 4, 1891. Later Degas acquired still other pictures of Gauguin, including a copy of Manet's Olympia.*

clamor of the disinherited masses, by the insistent demands of the people, feels that it is necessary to restore to the people their superstitious beliefs. Hence the bustling of religious symbolists, religious socialists, idealist art, occultism, Buddhism, etc., etc. Gauguin has sensed the tendency. For some time now I have been expecting the approach of this furious foe of the poor, of the workers—may this movement be only a death rattle, the last. The impressionists have the true position, they stand for a robust art based on sensation, and that is an honest stand.

Another genius! Anquetin. Wanted to play the *Société des Indépendants* a dirty trick. He insisted that a meeting of all members be convoked at which proposals to change the by-laws and regulations could be made. He proposed, first of all, to drop the name *Indépendants!* This defeated his whole enterprise. Afterwards measures were taken to prevent any similar attempt from succeeding. So you see everyone is devoting much more time to intrigue than to art. This is what we have come to—I hope it is different in London. It is necessary to escape from this milieu.

PARIS, MAY 14, 1891

My dear Lucien,

I met Duret at the Monet exhibition at Durand-Ruel's. We talked a good deal about you and about your woodcuts. Duret likes your work so much that he has spoken of it to M. Gallimard. This M. Gallimard is the collector who bought my *Serpentine with Effect of Fog* [744]. Hence Duret thinks that you (or I, for that matter) ought to show him a series of the best woodcuts you have, in black and in color. M. Gallimard will unquestionably appreciate your work. It is not unlikely that he will commission you to do something special. Isn't it your dream to do a rare book? Nothing prevents us from attempting it.

A sign of the times: at the shop of Bernheim-Jeune the dealer on rue Laffitte, a canvas of mine done in 1882, has been hung in the window. It is a landscape with the same motif as a canvas I have in the studio: *Women in the Fields;* you must remember it. This landscape is not as good as the one I have, it isn't bad at all, but in the other, which was done in the studio, there is a calm, a unity, and I do not know what quality that makes it more artistic! The work done in the studio is sometimes much more severe,

171

less pretty in color, but in revenge more artistic and more care-
fully thought out. Just the same it's been a long time since I have
seen a canvas of mine at another dealer than Boussod & Valadon
or Durand-Ruel. Will my things sell at last so that we can ex-
tricate ourselves from poverty?

<div align="right">PARIS, MAY 17, 1891</div>

My dear Lucien,

M. Gallimard has invited me to see his collection. I will take
along my little portfolio and avail myself of this opportunity to
show him your engravings.

The exhibition of the *Champ de Mars* has just opened, Luce and
Paillard, the engraver, told me that there were some very interest-
ing but quite defective furnishings by Carabin. Some beautiful
things by Puvis de Chavannes, some pretty Sisleys. I have not been
able to go there. Perhaps I will be able to take a day to see the
exhibition and then I will write you about it.

<div align="right">MAY 18</div>

I am sending you three parcels of newspapers. I was delayed
in sending them. They consist of a series of newspapers which
contain material on the relation of art to socialism, this can serve
as a point of departure for the article I asked you to do from the
anarchist point of view. I read an article by Bergerat in *Le Figaro*
in which he took the position that art could not exist under social-
ism. Confusing socialism, syndicalism and anarchism, he claims
that the anarchists will be eager to subject art to the direction of
the state which will dictate in all fields! What ignorance and what
bad faith! There is an interesting article on occultism which I
marked off and which I suggest you read, and there are articles
on the play which is going to be given as a benefit for Gauguin
and Verlaine. Tanguy told me that Gauguin arrived in Noumea,
he will have to remain there for five or six months since he hasn't
enough money to get to Tahiti. He will work there while waiting
for funds.

<div align="center">172</div>

My dear Lucien,

M. Gallimard found your prints very beautiful, very personal, he told me that there is a general demand for color prints and that these are much sought after, but that he has seen none to compare with yours, which have a characteristic naïveté which charms. He showed me a volume by Verlaine illustrated with pen drawings by Rodin, and another volume the cover of which has pen drawings and writing on parchment by Raffaëlli. That must cost plenty! He ordered a drawing from Monet for a book, and a gouache on parchment from me.

I really regret that you are not here, you would have been able, you who have some experience in book-making, to open new horizons to him, for I find that his books, unusual as they are, and carefully printed, lack the essence of what is original in the modern conception, lack the grand style. They are unusual and well made, that is obvious, but the disposition of the letters? The *mise-en-page?* There is a lack of ornamentation and when the book is printed simply the French characters are thin.

Thus the book whose cover was made by Raffaëlli does not seem to me to have been conceived in terms of French characters, which are slender and delicate; what was needed was something like large hand-written letters, either in calligraphy, or in a type made from hand-written characters. It is strange that Raffaëlli didn't feel this. Another thing: why a gouache on a cover that has to be handled, why not inside? And instead, a woodcut the color of shellac on the cover?

What do you think of all this? A really fine book must be as much a work of art as a painting is. So there is still much work to be done, a book like that, as far as I am concerned, has not yet been made . . . this is just the beginning.

My dear Lucien,

It's amazing what bad luck we have! Everyone wants my work . . . they press about my canvases from all sides, they know that it is to these that they must turn, but they want to get them for

nothing. The collectors deliberate and do not buy . . . they hesitate! What I need is a good exhibition, but where? At Durand's I get all sorts of propositions, I get offers without even asking—but they don't buy a thing. . . . At Boussod & Valadon's they soft-soap me and talk against Durand. If I go to Durand's they become furious, and if I go to Boussod's, Durand is no more furious; in short: neither will buy my work. If anyone else were available, I would unhesitatingly turn to him, but there is nobody. I am most perplexed. On top of all this I have no pictures and I am by no means satisfied that my eye will give me no further trouble! But I have courage aplenty. I redouble my efforts, but nothing results, I must bide my time. Luck comes sometimes when you are sleeping! —I have in me something which chills the enthusiasm of people— they become frightened! They are, perhaps, instinctively right to pause like mules in the mountains when they come abreast of some obstacle invisible in the blackness. . . . But I am so full of courage that I cannot but be confident; would that your mother shared my confidence!

I regret being unable to send you an article by H. Fouquier on Gauguin, which appeared in *Le Figaro* Sunday. What exaggeration! When one does not lack talent and is young into the bargain how wrong it is to give oneself over to impostures! How empty of conviction are this representation, this décor, this painting!

PARIS, MAY 29, 1891

My dear Lucien,

I went to see M. Gallimard this morning. We had a long talk. He has decided to engage you to do something, and he told me that he is planning to go to London with Duret to discuss the matter with you, on Duret's return from the Caucasus. He added: I have made up my mind to engage your son to do something, but I will have to work on it.—Geffroy strongly urged him to do this book. I hope he will keep his word and not delay too long. M. Gallimard is an indecisive fellow, although a man of good will.

My dear Lucien,

As soon as I got back here I went to work. I began three canvases of about 36 x 28, 31 x 25 and 28 x 23 inches; they are progressing rapidly. One is even almost finished. It is not executed in "dots," which I have completely abandoned in order to accomplish the division of pure tones without having to wait for the paint to dry; this last had the disadvantage of weakening the sensation. I am eminently satisfied, and I assure you the tones are quite as delicate, express my sensations more freely and are more personal; I believe my approach will vindicate itself. I had hoped to do some studies from nature, but the weather is so wretched, so uncertain, that I had to give this project up.

leaving Pointillism

A few days ago I received a letter from Miss Cassatt, asking me if I would like to give lessons to some young American girls. I replied that she should send them to me but that I would take nothing for advice. I still don't know what they have decided. I didn't want to engage myself to give lessons, for I don't want to be tied down. My eye may become aggravated without warning, and I prefer to limit myself to simply giving advice, which, by the way, is just as good.

My dear Lucien,

I shall write to Miss Cassatt and to Mme. Manet [Berthe Morisot] about the matter of the "Panel Society." I wish I could win them over, but I don't dare hope. You can't imagine how much harm the young artists have done themselves by their desire to advertise themselves. Degas spoke of this to me recently with extraordinary vehemence, and he made no exceptions when he expressed his hatred for people advertising themselves. Speaking of Signac he became violent and poured out his spleen on everyone! It must be admitted that at one moment Signac behaved most imprudently and should have held his tongue,—it was the presumptuousness of youth. I am certain that he will never act like that again, but the great pity is that men of real worth now can't be counted on to join organizations. There's too much distrust.

The two engravings you sent me are excellent and in the *right style*. Don't bother your head about those who can't understand your type of drawing, let them put themselves in your shoes. Your drawing is actually quite correct, when you have studied and understood it—one step more and it will not be so! Only keep your personality intact! Each of us has his qualities and faults, the important thing is to have many qualities. Esther's vision is too narrow. She has a certain sentimentality which can influence a young artist to go counter to his own judgment. The pretty is a greater pitfall than the ugly or the grotesque! This is why men of merit are so rarely understood from the start. Everyone knows this, yet commits this error!

We had a lot of trouble with Georges and Titi a few days ago. It was not their fault—this time. They just missed being murdered —literally! at a torchlight parade in Gisors towards midnight, a band of ruffians from *La Société de Gymnastique* which was to meet there the next day, precipitated themselves, drunk and spurred on by a lad from Eragny, on Titi and Georges. Without the intervention of a man of Herculean strength they would have been beaten to death. They managed to escape, losing their hats, but what is more serious, the lad from Eragny went through Georges' pockets while others were holding him by the throat, and stole his pistol. Luckily he took Georges' knife—doubtless because it was attached to a chain—for a watch; except for this circumstance he would have gotten the watch, for he detached the knife and chain. In short the boys returned in a sorry condition. Fortunately they suffered no serious hurt. Titi caught a kick below the knee-cap, on the shin-bone, which is still painful. What can we do? make a complaint? These patriots were all drunk! We would have to get witnesses, go to Evreux, and then what? No, the best thing for them to do is to keep apart, or, if indeed they go to such a celebration, to go in force. Such things are always happening to the two boys. But there is no preventing boys from fighting.

ERAGNY, JUNE 23, 1891

My dear Lucien,

I received your letter of June 21, with the list of the prints which were sold to M. Kennedy. It is 300 francs you can keep. So

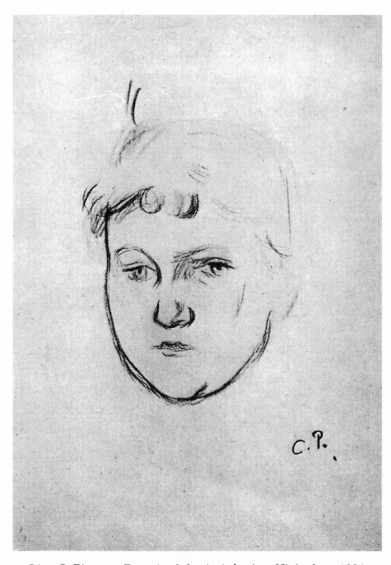

34.—C. Pissarro: Portrait of the Artist's niece Nini, about 1884.

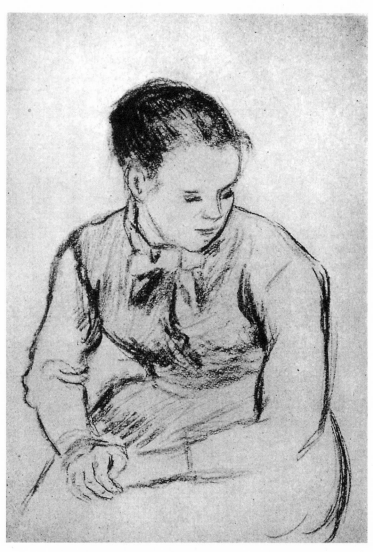

35.—C. Pissarro: Peasant Girl Sitting, about 1885.

then there are three American dealers who have my engravings, the three biggest dealers! Avery, Keppel and Kennedy. Keppel assured me last year that he would not sell any of them, that in America my work was not understood at all. . . . But how comes it that Kennedy wants my things, surely it is not out of his appreciation of them? . . . Mysterious.

When painting tires me, I shall work at watercolors and engraving. I hope to do a series of *Markets*, another of *Troyes* and *Châtillon-sur-Seine*, etc. Legros has made some remarkable etchings, particularly his early ones, but those I saw at his exhibition here are too reminiscent of Rembrandt and others. Just the same they are quite strong. The drawings in silver point, as I see it, lacked originality and were often academic. How I prefer the drawings of Degas!

Titi has painted some rough sketches, not bad, not in "dots," of course; the dot prevents one's seeing the variety in values. I urge you to consider this carefully.

ERAGNY, JUNE 28, 1891

My dear Lucien,

If you can spend the holidays with us—that would be perfect. We all have so much to tell each other.

I am glad to hear that you have seen Bénézit. He is a charming young man, full of good will and very intelligent, but alas! as is so common, he hasn't the shadow of a notion of what distinguishes true from false art. Unfortunately he imbibed the principles of Ch. Jacques, he is impregnated with that art *false for all time*, my dear Lucien, for the art of 1830 is that of Corot, Courbet, Delacroix, Ingres. And it is eternally beautiful! As a matter of fact I execrated Ch. Jacques even in my youth. At that time he was ranked above Millet. Believe me, I broke many a lance on this question, but I must admit that my adversaries were not very formidable, they were quite timid!

I am sure that Bénézit is making an honest attempt to understand this but by certain signs I have come to realize that he is not capable of seeing the art in drawing, in the drawing itself.

177

This morning I received a charming letter from Mme. Manet [Berthe Morisot] informing me that in principle she would be delighted to join the "Panel Society" the moment that I do. Naturally she is waiting for the program, which you are to send her and which will give her complete information about this group. I answered that you and I belong to the society although I have not yet received any official notification. I have not yet received Miss Cassatt's reply; I am not at all certain about her, she has fixed ideas about this.

I will send you *L'Echo de Paris* with an article by Mirbeau and an interview with Charles Henry, who gives his views on literature. Charles Henry has a most curious notion. He thinks that the future will be dominated by mysticism. It is strange that not one of the young men understands that it represents not the future but backwardness . . . for the future that will bring the abolition of capital and property will be so different that it is impossible to imagine what the ideal of that time will be, at least we cannot plumb its depths with our myopic vision.

I have just looked at all your woodcuts. I am sure that you yourself don't suspect how artistic they are!

ERAGNY, JULY 7, 1891

My dear Lucien,

The day before yesterday I received a letter from Miss Cassatt announcing that she and her family had rented a castle near Chaumont-en-Vexin. She wants me to explain about the "Panel Society." She writes that such a society can accomplish nothing in England, where there is no future for engraving, and that she has at the present moment a whole series of colored aquatints at Dowdeswell's—they were sent by Durand—which are having no success, are not even spoken of.—I urge you to go and see them with your friends, I believe you will find them most interesting. I tried, in replying, to make her understand that she could not expect to find appreciation at Dowdeswell's and that what was necessary was to reach the artistic milieu which is to London what the impressionists were [to Paris] in their time. I have done my best to convince her. Will I succeed? I must wait and see. Don't

you think it would be a good idea to speak of this to Degas? But one can hardly count on him . . . he is so utterly disgusted with youth! As I see it, his attitude is—well—somewhat exaggerated!

Miss Cassatt is getting ready to organize a general exhibition of her works in New York. She has surely every chance of being a great success there, for she knows the people and the situation so well.

ERAGNY, JULY 8, 1891

My dear Lucien,

I received your letter this morning.—Yes, my dear Lucien, I recognized at once the sentimental and *Christian* tendency in your crowned figure [*Sister of the Woods*], it was not the drawing, but the attitude, the character, the expression, the general physiognomy. I know that your first plan was conventional as compared with your last. But the figure itself is conventional in relation to your art.—There is not only this jarring note, but also, I insist, a sentimental element characteristically English and quite Christian, an element found in many of the Pre-Raphaelites . . . and elsewhere. As for the idea, my son, there are hundreds of ideas in your other engravings, which belong to you, anarchist and lover of nature, to the Lucien who reserves the great ideal for a better time when man, having achieved another mode of life, will understand the beautiful differently. In short, sentimentalism is a tendency for Gauguin, not as a style, but as an idea. Scorn compliments!

Proudhon says in *La Justice* that love of earth is linked with revolution, and consequently with the artistic ideal.—That is why we do not care for Crane, he is not conscious of what he should admire in art. Contradiction! Yes, one's work is cut out for one in that milieu, but one has to find one's style elsewhere and impose it and make the reasons for it clearly understood. For this, a certain authority is necessary—but haven't we Degas and all the impressionists? We have taken the right path, the logically necessary path, and it will lead us to the ideal, *at least that is how it appears to me.*

I am at this moment reading J. P. Proudhon. He is in complete agreement with our ideas. His book *La Justice dans la Révolution* must be read from beginning to end. If you had an oppor-

179

tunity to study it you would understand that those who follow the new tendency are influenced by bourgeois reaction. Look how the bourgeois woo the workers! Isn't everybody socialist, hasn't even the Pope fallen into line? Reaction! The purpose behind all this, my dear boy, is to check the movement, which is beginning to define itself; so we must be suspicious of those who under the pretext of working for socialism, idealist art, pure art, etc., etc., actually support a false tendency, a tendency a thousand times false, even though, perhaps, it answers the need of certain types of people, but not our needs; we have to form a totally different ideal! Paul Adam, Aurier and all the young writers are in this counter-revolutionary movement, unconsciously, I am almost sure, or per-haps out of weakness . . . and for all that they believe they are doing something new! Fortunately the revolution that raised the problem has seen many other things. I hope a first-rate mind will be discovered. How beautifully Gustave Kahn might have filled this lack; but it is impossible, he does not believe in the Justice inherent in man. So much the worse for them, they too will pass! My dear boy, it is amazing how contemporary this book on *Justice* is. Every young man ought to read it, while disregarding certain passages in which the author argues that the good society can be achieved by means of an almost state organization—but this is no great matter.

My dear Lucien,

Just when I least expected it, just when I was fully at work, this cursed eye trouble came back. I was working in our field in superb weather, there came a sudden wind—or maybe it was a puff of dust—and in two days an abscess had formed and broken. Once again I must spend two wearisome weeks in Paris. I didn't deserve this—I expected to be able to work until autumn at least.

At Durand's, Renoir is exhibiting at this moment his pictures of 1890–91. They do not seem to be creating any great sensation. It is true that the exhibition is being held in the small rooms, the main room is showing the works of Americans.

I am sending you *L'Art dans les Deux Mondes*, the final issue, it is being discontinued. You will see from the article "Causerie" that the review's purpose was to put the impressionists over, and

since this objective has been attained, there is no reason for it to continue. Hum! hum! Does this mean that it is without funds? You never know what's up with that devil of a Durand. I learned lately, in Paris, that Durand had to take back a number of paintings sold for a considerable sum to a collector who went bankrupt. Is this the case? Mysterious! It might explain his attitude towards me. And it seems, at least that is what Miss Cassatt says, that Renoir, all of whose work he takes, is very annoyed and has to make pictures which please!

<div style="text-align: right">PARIS, JULY 17, 1891</div>

My dear Lucien,

Luce came this morning. He had news of our friends: Signac is at Concarneau, Ajalbert is in Auvergne, Paul Adam is leaving for Egypt, on a pleasure trip, I believe, Gustave Kahn arrived in Paris under circumstances as comical as they are extraordinary to anyone who knows Kahn well. It seems (his wife probably had a lot to do with this) that he came to investigate why the friends and associates of Seurat received those little panels and drawings of that ill-starred fellow from Madame Seurat. Suspicions of trickery and swindling have been voiced. Fénéon, Luce and Signac simply wrote him breaking off relations. It is sad to see this poet, poor fellow, making a fool of himself before everyone. The first chance I get, I will try to make him realize how foolish he has been. Naturally I support my friends Luce, Signac, Fénéon. Having been here ever since the distribution [of Seurat's drawings and panels] took place, I can testify that everything was done in a strictly legal and correct manner.

<div style="text-align: right">PARIS, JULY 21, 1891</div>

My dear Lucien,

The affair of the panels is simply idiotic: Seurat's mistress [1] went to Belgium and voiced all sorts of suspicions to Madame

[1] *Even Seurat's most intimate friends, during the painter's life, knew nothing of Madeleine Knobloch and the child she had borne Seurat. (The infant died shortly after his father). Madeleine Knobloch had asked Félix Fénéon to represent her at the formal division of Seurat's works between her and his family and had received part of the painter's works.*

<div style="text-align: center">181</div>

Kahn. The latter sided with her and must have urged Kahn and his *alter ego*, the Belgian painter Lemmen, to come to Paris and make an investigation. Poor Kahn was enmeshed in this stupid intrigue, which has resulted in a rupture with Luce, Signac and Fénéon. It seems that later Lemmen wrote Signac a letter of apology. I must add that the mistress of poor Seurat is if not mischievous, certainly without brains.

PARIS, JULY 28, 1891

My dear Lucien,

Thursday I will see the doctor and if everything goes well I will return to Eragny at the end of the week. I can take off the bandage, stay indoors with the windows closed and work. This is what I am longing to do. Things are not too bad at the moment.

So I will be in Eragny if you come during the first week of August.

*　　*　　*

After spending some time with his family in Eragny, Lucien left for London early in October, taking with him his brother Georges. Octave Mirbeau gave them a letter of introduction to John Singer Sargent.

*　　*　　*

ERAGNY, OCTOBER 4, 1891

My dear sons,

I received your card and your two letters. We were glad to hear that you had such a good crossing. Now you are gone, I hope things will develop to your satisfaction.

Mirbeau sent me the letter that Mr. Sargent wrote to him. He [Sargent] wrote that the description of the two Pissarros had given him a great desire to make your acquaintance. Perhaps Mr. Sargent could get you some pupils, that would be a great help.

I am waiting for mother to finish Maeterlinck's *Les Aveugles;* it is quite short, a fine little book. It is very dramatic, simple, cold,

terrible and very modern, and besides, full of motifs. It has much in common with the etchings you have made. It should be read carefully, scene by scene.

My dear Lucien,

We received this morning your letter announcing that you have found a studio. So you will soon be settled.

What you say about Sargent doesn't surprise me; Monet had told me that he is very kind. As for his painting, that, of course, we can't approve of; he is not an enthusiast but rather an adroit performer, and it was not for his painting that Mirbeau wanted you to meet him. He is a man who can be very useful, and I hope that when the time comes he will put himself at your service. Have you informed him that you are giving drawing and painting lessons?

There is an article in today's *Eclair* which I will send you. Arsène Alexandre berates the directors of the Luxembourg asking by what right they refuse to buy the work of painters whom all the art critics recognize as gifted and who sell their paintings to collectors less stupid than the said directors.—For thirty years now I have heard such complaints! But they remain unmoved, the bureaucratists!

My dear Lucien,

I am not surprised that Kahn now regrets what happened.

Yesterday I went to see M. Cheramy. He was most charming. He showed me around his gallery, which is a jumble of every sort of thing: superb Delacroix sketches, among others an astonishing and strange *Paganini*, some early studies by Corot, some drawings by the same, studies by Ingres, Degas, Manet, Tassaert, Géricault —all these wonders besides a quantity of artistically valueless things. A selection has to be made from all these. M. Cheramy told me that he wanted something of mine and that he would go to Portier's to look at my work.—He went to Durand-Ruel's to look

183

at my paintings, he saw a fan, but it seems Durand asked *so* much for it that he didn't buy it.

Just this moment a letter came from Mirbeau thanking me for *The Goose Girl* [770] and the drawing *Young Peasant Woman Making Up*. Mirbeau, good fellow, is completely enthusiastic, and I am only too delighted to be able to give him pleasure. He says that you have written him. He has again written to Sargent about you. He is convinced that Sargent can be a great help to you. Both of you have the necessary gifts to achieve something.

Forward, and be of good courage, my friends. I believe your début is more promising than mine; I still cannot come to the end of my tether, and I have the sad burden of being unable to make your mother happier . . . No luck!

PARIS, OCTOBER 23, 1891

My dear Lucien,

I expect to make some ten or twelve thousand francs this year. And if the money is forthcoming as speedily as I expect, we can set you up in London. What do you think of that? I should like that better than having to depend on strangers. But I don't believe I can count on Durand-Ruel this year, he will need a lot of capital to buy Jongkinds, the prices of which rise like the tide. They are buying whatever they can find, everyone is buying, so the pictures go to the highest bidder. What I must do is pave the way with my little Parisian buyers who, by purchasing Pissarros, will help me get more for my works; I sense a tendency in that direction. I will increase my price bit by bit while there is still time; the little collectors can be a big help in this. What do you think? So let us be hopeful!

I didn't mention that I am thinking of moving from Eragny next spring. I wrote to Dallemagne about repairs. He has not replied. I will send him a registered letter requesting a cancellation of our lease, but only when I have found just what I want at Pontoise or Lagny, etc.

My dear Lucien,

It's a pity you weren't able to go to Birmingham to see the assembled masters of Pre-Raphaelism. It is indeed surprising that the provinces in England are more sympathetic to innovators—it is just the opposite in France where the provinces are so bourgeois and pusillanimous. But it must be admitted that this is natural, since the provinces here are without any initiative, political or artistic; this is centralization in all its splendor!

The compliments you paid Titi for his etchings have really moved him and renewed his zest for work. He is going to undertake a portrait of Piton-Fleuri in oils.

No more news, except that we are in a state of perfect calm . . . not a cry . . . not a breath . . . other than the autumn breeze or the snort of the stove.[1] And my work is going well; it is with ecstasy that I toil and drudge at my four canvases.—Your mother has informed me that she will be gone for a month or two. I hope she will enjoy her vacation, she really needed it. I know only too well that it is not very gay to be here and never go out or see a living soul except *père* Kimir and *mère* Fieu; that's not very much . . . and not very diverting!

My dear Lucien,

I am working furiously, my canvases seem to be progressing. *Cowherdess* [823] is well advanced, as is *Peasant Woman Dreaming* [824], I am well satisfied with them, but the *last stroke* is the most difficult and takes longest! I have also gone back to my *Two Women in a Farmyard,*[2] one of whom holds a bucket of water; this work should be sensational. . . . I am also at work on three small canvases which are simmering, but for all this work there is still no money.

[1] *Mme. Pissarro had just left for Paris with Jeanne and Paul-Emile, her two youngest children.*

[2] *No doubt a reference to the gouache* Peasant Women Talking *[1410] dated 1887.*

My dear Lucien,

For the moment we are short of money, very short, and I have received from Portier, who was so encouraging, a despairing letter to the effect that he is unable to sell my small canvases, which his collectors don't like at all!

I have received a very charming letter from Mirbeau. He urges me to give him a free hand so that he can persuade M. Roujon, his old friend and the new director of Fine Arts replacing Laroumet, to buy something of mine for the Luxembourg. If this comes off, which do you think I should sell, *Apple-Eaters* [696] or *Woman Breaking Wood* [722]? To tell the truth, I haven't the remotest idea how either of these two paintings, especially the second, will look when hung at the museum.[1] Mirbeau also mentioned that he had seen Rodin in Paris and that they had discussed me; it seems that Rodin is a warm admirer of my work and would like to have something. He wants to purchase something and leaves it to me to select whatever I like best. So I am really perplexed, finding my own work atrocious, understanding, as I do, how right Portier's collectors are, even though I rage against them.

Miss Cassatt writes that she will visit me tomorrow with an American friend who wants to speak to me about taking lessons. I wrote her to come for lunch . . . and your mother has been away for sixteen days . . . never mind, we shall do what we can.

My dear Lucien,

Your mother returned from Paris last night. Guingasse and Cocotte quickly resumed their antics. We can hear them squalling in the garden. . . . Everything was really too peaceful here.

—Not having received a word—or a cent either—from Portier, I wrote him to send my *Setting Sun, Effect of Fog,* to Rodin.

1 *Despite Mirbeau's insistence, M. Roujon did not purchase a canvas of Pissarro for the state. Later he also refused to propose Cézanne for the Legion of Honor, as Mirbeau demanded.*

I have agreed to stop for Mirbeau at Damps and go with him to the performance of *Les Aveugles*. I will dine (it is a matinée) with Geffroy, Rodin and Mirbeau. Which reminds me: I received a charming letter from Rodin mentioning, among other things, that he can meet my price for my *Landscape with Effect of Fog*, which he finds splendid. It is 500 francs for this canvas of about 25 x 21 inches. I will send you a little money as soon as I can.

PARIS, DECEMBER 6, 1891

My dear children,

In a letter to Mirbeau I mentioned that Georges would like to illustrate Maeterlinck's *Princesse Maleine*. Now this is my advice to Georges, I have tried what I recommend, it is worth following: when you feel the impulse to make something, do it no matter what the cost . . . you can be sure of reward. So rare a thing is it to have a desire that it is one's duty to act on it, and at once, for desire evaporates if one delays. Forward, go to it! Be advised, act! *That is the most practical course one can take.*

. . . the more I try, the more they dodge. But I feel I am better than many of the others. It is hard to sell right now: there will be an auction of Jongkind's studio tomorrow, that will be a mad rush! They will fight to get his works! . . . Of course, he is dead now!

PARIS, DECEMBER 8, 1891

My dear Lucien,

I lunched with Rodin yesterday. He has real charm. During our conversation he asked if I would like to see the Goncourt collection; he promised to write me a note of introduction to the eminent novelist. Shall I go? . . . People have such peculiar ideas about me.

Yesterday the auction of Jongkind took place. His watercolors are marvels, and since the artists pronounced them first rate, the collectors came to bid for them more than for the oil paintings.— That's all they talk about. The strange thing is that they could have been gotten quite cheaply. Imagine, little Meyer, "the Ball,"

187

had enough cleverness to buy *one* before the auction . . . not very bold, the Ball, as I told him. Now it is too late.

My dear Lucien,

With my last letter I sent you a word from a dealer on the rue Lepelletier.[1] I just visited his place. He would like to know whether you would be willing to have him handle your canvases. Write me if this is agreeable to you. You can already include in his catalogue what you will have ready later. There will be Anquetin, Lautrec, Sisley, Luce, Gausson; and probably Paillard, Gauguin, Schuffenecker, Bernard, Sérusier, etc. I think it can't be too bad to participate. Write me what you think in this regard.

Monet has been in London since yesterday. He probably went there to work. Everyone is awaiting with impatience his series of London impressions. He lives quite far behind Regent's Park, at the home of M. Harvley, 60 Curzon Street, Mayfair. Most likely he is with friends, and perhaps it would be awkward if you went to see him. Joyant, of Boussod & Valadon, gave me this news.

Joyant asked me for some pictures. He is waiting for me to go to Eragny to visit me there. He said he wanted to buy old and new works, between 1,500 and 2,000 francs' worth. I replied that he couldn't expect to get very much for so little money, that I sold my earlier work at high prices; he said he would take old and new things, that the moment to launch me had arrived, and he begged me to deal with his house. No one could have been friendlier, my dear. There's something behind this. It must be that the auction of Jongkind put an idea in his head. 300,000 francs were taken in on the first day, 100,000 on the second.

Durand is away. I have to see what he will do. Joyant asked me to give him preference if I hold an exhibition, but the gallery is so small.—Finally, I believe our troubles are coming to an end, and then, you won't have to worry. I hope, if everything goes well, to come to London for a watercolor campaign! Well, we shall see!

Your mother will go to the performance Friday. You should see her, she is astonishing, you would not recognize her with her

[1] *A reference to the dealer Le Barc de Boutteville who at that time had begun to push young artists like Vincent van Gogh, Bonnard, Lautrec, Signac, etc.*

black velvet coat, stylish hat, and binoculars . . . it's nothing short of a resurrection! If she knew what I am writing about her she would be angry. And with that she had two great baskets when she came to Montmartre!

My dear Lucien,

I have reason to be a little more confident of the future; several signs indicate this, as you will see.

I went with your mother and the Mirbeaus to the performance of *Les Aveugles* and a little scene by Laforgue; both works were miserably acted. There was quite a crowd, everyone in art was there. During an intermission Carrière came over to shake hands and said bluntly:

"I come to apprise you that you have had much success in New York and that presently you will receive offers. I think I ought to let you know, so that you won't be taken by surprise."

I told him that I had suspected as much since the clerk at Boussod & Valadon had been so insistent that I go to see him. Following this, Joyant asked if he could come to Eragny. Another proof: Bernheim, of the rue Laffitte, bought four panels at auction . . . These works, framed superbly, were shown in the window and made a sensation. Everybody spoke of them to me. Yesterday Bernheim said to me:

"At the first auction including some of your paintings, you will find five or six dealers ready to bid at high prices, and if you want I will organize a show for you. Your moment has come!"

With regard to the exhibition, there has been a change.[1] You must understand that I am on the point of a definitive success. This is understood by everyone interested in my work. It goes without saying that if I have a show, I must exhibit *alone* and under first class conditions. I have been invited to show in three places: Durand's, Boussod & Valadon's and Bernheim-Jeune's. Most likely I will decide for Durand. You realize, of course, that a modest show along with other artists does not correspond to what those

[1] *Camille Pissarro had intended to have his next exhibition with his two eldest sons, Lucien and Félix, but now decided otherwise.*

189

who are interested in me expect. I must make my way. I must get through while the favorable moment lasts.

My dear Lucien,

Joyant told me today that he would come to Eragny on Tuesday. In the course of our conversation he told me—but this is in confidence (if you see Monet, don't speak of this to him)—he told me that he was going to organize a general exhibition of Renoir's work! While Durand was hiding Renoir's light under a bushel, he [Joyant], would show it to the world. Joyant begged me not to breathe a word of this. . . . Can you imagine what a state Durand would be in? Why the devil did Joyant tell me this?

Durand will return from Austria shortly. Today, Joseph Durand remarked to me as we parted, that as soon as his father got back he would come to Eragny.

My dear Lucien,

I believe I will decide to show at Durand's, he has the largest rooms to exhibit in. The Boussod & Valadon Gallery is really too small. And it is to my interest to humor Durand, I am not strong enough to buck him. Boussod & Valadon are going to have a new place on the boulevard des Capucines or around the Madeleine; then we may try to do something for them.—For one thing, you will have to come and help me with my exhibition. I need you to assist me in making a correct choice of paintings and to help me hang them. As for selling my canvases, that will come in due course if the dealer thinks it necessary. We shall see.

I spoke to Mirbeau about *La Princesse Maleine,* he is attending to it. It can be easily arranged with Maeterlinck, who will be only too pleased; unfortunately this splendid fellow has permitted himself to be exploited by a publisher who has him by the throat. The poet never dreamed his work would be so successful when he imprudently undertook to turn over all his output for a bagatelle.

190

I always omit mentioning that Guillaumin has just won 100,-000 francs in the city lottery.[1] Amazing!

My dear Lucien,

Show Mr. Reid my etchings; you have the prices. The fans bring—at least that is what dealers here pay for them—300 francs. Perhaps we should ask 400 francs for them in London in order to get 300. *If you can't get more, 300 francs.* In any case you can let people know that my prices are on the rise, and do the best you can.

Joyant came yesterday, he was enthusiastic about my watercolors and my latest paintings, but they are too revolutionary for his boss. He put six canvases aside, which I am to send him to show his boss. He told me that two or three will be taken for certain. These are the ones:

Blossoming Apple Tree with Hill of Bazincourt	1,000 francs
Setting Sun, seen from my Window	1,000 francs
Sente de la Justice at Pontoise	1,200 francs
Landscape (in heighth) of Pontoise	1,200 francs
Landscape: Delafolie Mansion	600 francs
Hampton Court Green [746]	800 francs

I may lower the prices of the new canvases, I will maintain the prices of the earlier things, or perhaps increase them.

My dear Lucien,

I received your letter this morning, which shows some discouragement since you did not succeed with Reid, of whom, by the way, I did not have any excessive hopes. This is the man who sold Monticellis at such high prices in Glasgow. For four or five years he has appeared to want to take the impressionists in hand; at the time of poor Vincent van Gogh, he was contemplating this

[1] *Thanks to this unexpected fortune, Armand Guillaumin was at last able to quit his administrative post in Paris and devote himself entirely to painting.*

project; it came to nothing. Théo van Gogh did not regard his judgment of art very highly, and finally they had a falling out.

Did I let you know that M. Chéramy has bought a fan from Durand and paid 850 francs? He told me he would have liked to acquire for 2,500 francs one of the panel-friezes at Bernheim's, but it was too large. The said Bernheim told me that the panels were a great success, little Meyer also told me that.[1]

We are having wonderful weather, these days . . . dry cold, hoar-frost and radiant sunlight. I have begun a series of studies from my window, canvases of about 18 x 15, 25 x 21 and 36 x 28 inches. It is extraordinary how certain I am of my execution, which is now much easier. If I finish them I will have a beautiful series of Bazincourt paintings. I was afraid that repetition of the same motif would be tiring, but the effects are so varied that everything is completely transformed, and then the compositions and angles are so different.

ERAGNY, DECEMBER 29, 1891

My dear Lucien,

We were visited yesterday by the three American ladies sent by Miss Cassatt; they wanted to find lodging at Eragny so as to be near me and receive my advice.—Too bad such aerolites don't drop on you from the sky in London. Unfortunately they couldn't find a place either here or in Bazincourt. This makes four, with the one who came last time with Miss Cassatt. You see, there will be a colony, soon!

Thank you for your good wishes; I want to succeed for you all. But what I wish for both of you is first of all good health, courage, confidence in yourselves and love of what is beautiful, good and just!

[1] *See Camille Pissarro's letter of May 9, 1891. These panels had been purchased several months before at the Arosa auction for 275 francs each.*

192

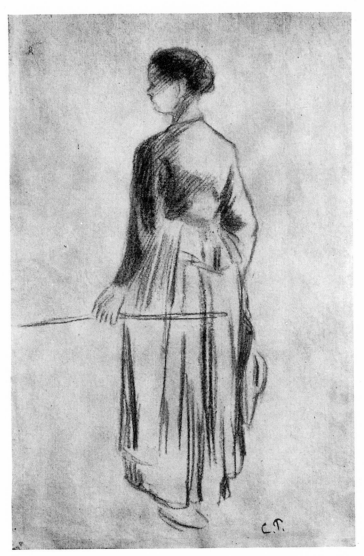

36.—C. Pissarro: Peasant Girl, about 1885.

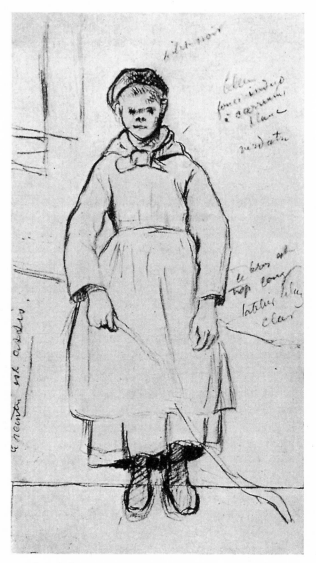

37.—C. Pissarro: Little Peasant Girl, about 1885.

ERAGNY, JANUARY 10, 1892

My dear Lucien,

Yesterday I had Joseph Durand at the house, he came with his friend Mellério, a young art critic. They were delighted with what they saw. The young Durand informed me that his father was expecting to come out here any day to reach an agreement with me about holding a general show of my work; this would have to take place from the 25th of January, before the exhibition organized by the Sàr Péladan,[1] which will cause such a tumult in the press that anything coming after it will be an anti-climax. It has to be the 25th or not at all . . . as you realize, no doubt, I am caught napping; I have only ten days in which to finish from five to six canvases begun from the window, and my figure paintings. If my eye does not betray me, I will be ready. As soon as I see Durand senior, I will write you to come, there will be so much to do and I would like to work until the last moment. And then I'll have to select canvases of different periods and go hunting for them or asking collectors. Let us hope that something will come of this and that we won't be disappointed this time.

[1] *The "Sàr" Péladan, an eccentric figure, an idealist and spiritualist writer, defender of a dead aesthetic borrowed partly from Dante and Leonardo, had founded L'Ordre de la Rose-Croix Catholique with the aim of renewing art through mysticism. The first exhibition of this Ordre opened on March 10, 1892, at Durand-Ruel's. It had considerable success, but none of the painters belonging to the group is remembered in the history of art.*

My dear Lucien,

It is decided, the exhibition is to run from January 23 to February 20. This morning I received a letter from Joseph Durand asking me to get ready, his father is still in London but will return to make all the arrangements. I don't know whether he will have time to come to Eragny—but in any case you must come as soon as you can. I need you to make expeditions to the collectors. Everything else is going well.

I sent Durand the list of my pictures, twenty-five canvases, with the dimensions, so that he can arrange for having them framed.

PARIS, FEBRUARY 7, 1891

My dear Lucien,

Always a crowd at my exhibition. I sold my little *Sunset*, the one I did from my window. With the three other canvases sold, that makes 5,200 francs. The sale is not extraordinary, the collectors seem to be hesitating; I hope the Americans give the whip-hand later.

*　　*　　*

Lucien returned to London at the beginning of April, after the closing of his father's exhibition, which had comprised fifty canvases painted between 1870 and 1892 as well as twenty-one gouaches executed between 1880 and 1890. The foreword to the catalogue had been written by Georges Lecomte.

*　　*　　*

ERAGNY, APRIL 17, 1892

My dear Lucien,

I really have no luck with this weather; I have had to put off my trip to Beauvais till later. I began a series of paintings outdoors and I have still to finish them, but there is rain, wind, snow and

194

frost! I hope I don't make my excursion distasteful by pining for the sun. The day after you left I received a line from Eugène Manet to the effect that if I was still of a mind to take a trip to Touraine he would be happy to accompany me; his doctor had recommended a mild climate, he was looking for a good place. It is nine days since that letter came; the day before yesterday I heard of his death. Now all the Manets are gone!—the poor fellow didn't know his end was so near.

I supposed that this exhibition of Whistler would show his new works. It's strange that he doesn't want to show his new canvases. Perhaps he hasn't any! For years now I have seen the same works again and again, even very early works! . . . Why? . . .

ERAGNY, APRIL 26, 1892

My dear Lucien,

Yes, certainly, I should have lost time by going with you. I have been able to do here several good oil studies of spring and to complete my *Cowherdess* [823] and my *Woman Sitting* [824] and my *London Park, Primrose Hill* [804], I think these represent an advance in unity. How different they are from the studies! I am more than ever for the impression through memory, it renders less of the object—vulgarity disappears, leaving only the undulations of the truth that was glimpsed, felt. No need to say that this is not understood, and my anxiety about the future continues as before, despite the success of the exhibition. I have had no news from Paris about my collectors: can it be they are paralyzed with fear of dynamiters? That is quite possible.[1] . . . As soon as I have finished my studies of spring and the little studio is ready, I will write to my collector the abbé Gauguin to come and see my new things.

Someone sent me—I don't know who—Kropotkin's book. I am sending it to you. I am also sending you *La Révolte*,[2] which will enable you to see the recent events in a new light. Pouget and Grave have been arrested in the general sweep that was made of

[1] *A reference to anarchist activities and to the trial of the anarchist Ravachol which then occupied the attention of the public.*

[2] *An anarchist newspaper edited by Jean Grave, who also published* Le Père Peinard, *in which drawings by Lucien and Félix Pissarro appeared from time to time.*

all the comrades in the name of laws which even the bourgeois newspapers are beginning to regard as ill advised. The Republic, of course, defends its capitalists, that is understandable. It is easy to see that a real revolution is about to break out—it threatens on every side. Ideas don't stop!

About the cream and blue cloth of which you spoke, your mother says that it won't last, I think it would be wiser to get a material better than the kind used in the children's room and to use the oriental cloth for curtains in the little studio. These oriental cloths harmonize very well with my paintings, described as "screaming" by certain critics. The little studio is ready; after it is thoroughly cleaned we will begin hanging. But what is the good of it? Who the devil will see my "shouting" pictures, as a certain Andréi [1] of *La France Nouvelle* calls them? Couldn't that be a pseudonym?

ERAGNY, MAY 8, 1892

My dear Lucien,

Let us talk of things that are essential, and that, considering your character, must be spoken of.—Your engravings are accepted everywhere, that is certain; you have the beginnings of a fame that is not based on mine; that is the point.—When one has succeeded so well with engraving, one is expected to reach the same heights in other branches of art. People do not like change, a *gent* who takes the liberty of operating outside established boundaries has to win his rightful place all over again. You see what is happening around us—note that people have become so intellectually debased that even those who are with us take the same stupid attitude!—They are incapable of discerning the real quality that is equally in your engravings and the other things you do. You are a naive, a rough workmen, you have a style all your own, you have only to follow your bent, to perfect the material, make it beautiful. Useless to ask for adroitness, that will come some day, and besides

[1] *A reference to an article by A. Andréi which appeared on February 23, 1892, during Pissarro's exhibition and which contained this passage: "M. Camille Pissarro has a peculiar vision of nature. He sees blue, red and yellow; with these three colors he plays with the mastership of unconsciousness, the boldness of an apostle, the virtuosity of a man inspired, and sometimes achieves astonishing effects, clamorous symphonies, and even harmonies full of charm."*

beauty does not lie in that. Yes, you answer me, but how earn money? That's a matter of commercial talent, inherent in the individual. . . . To be ingratiating, stealthy, to hold the reins secretly all the time and direct all movements like an expert coach-man—or to have a good fairy watching out for your success . . . luck! Hence you should not despair.—You have to get a grip on yourself and look at things more calmly, without too many anxieties.

You are right, the bulk of the poor do not understand the anarchists; however, there is no use pretending, if people are in a funk it means that they sense that they are faulty. Have you read the interview with Zola? While terming the anarchists ideologists, utopians, he takes a stand for a fight with logical methods, demonstrating the absurdity of the anti-scientific theory. That's running with the hare and hunting with the hounds. So the people must free themselves by means of science. Quite an order, for when men of science rule, it will not be less despotically because in the name of science!

Titi has begun several studies, canvases of about 18 x 15 and 25 x 21 inches. They are going well, he has a really good eye; he will be a painter, for in what he has done already he has shown a personal touch. For my part, I have completed three canvases of about 21 x 18 and 25 x 21 inches, which I shall take to Portier. He asked for them, having sold my *Shepherdess*, a canvas about 21 x 18 inches, for 1,200 francs, and a little canvas about 16 x 13 inches, for 500 francs.

The little studio is all fixed, the canvases have been hung, it looks very attractive. I will write abbé Gauguin that I have some new things to show him.

There's no doubt about it, I haven't time to go to Beauvais, the weather is so changeable, and then, when alone, I lack peripatetic initiative. However, I should welcome a change.

I am going to Paris October 12th. I am bringing Joyant a series of thirty-six etchings.

PARIS, MAY 13, 1892

My dear Lucien,

This morning I ran into the painter Vidal who knows London well. He advised me to exhibit in London, and with this in view he

197

gave me letters to Mr. Demthorne, 5 Vigo Street, Regent Street, and for the painter Lionel Smithe, R.A. They are friends of his. I can't elaborate about this right now, but he is convinced I will meet with success.

Yesterday I saw Renoir's exhibition. There are plenty of beautiful things, but it is far from being as well arranged as mine; too many canvases, much too many.

I think I will bring my painting equipment to London. Do you think I will find it easy to work there?

My dear Lucien,

As I mentioned to you yesterday, there's no sense in concealing that I am going to London, why? All the more so since I have to go anyway; since it is altogether to my interest to go and prepare the ground, I should have liked to go as soon as possible. When I make up my mind, I don't like to let things drag. Joyant requests me to let him be one of the first to see my pictures [of London]. Durand likewise. Joyant wants me to exhibit at Thomson's; I told him I would decide when I was there. Here is something curious and which I didn't anticipate: he told me that contrary to the predictions of the dealers, it is my new works which are most in demand. Isn't that interesting? Needless to say, it is always the same story with the dealers; Durand realizes it fully, and it is a good thing for me! otherwise I would have been buried long ago. So I have decided to do some very free and some very vigorous things in **London.**

And now I would like to know how much equipment I will have to take with me? I am not as strong as formerly—when I carried bag and baggage with ease—I am beginning to fret at burdens. Suppose I sent ahead my paints and canvases of 21 x 18 and 25 x 21 inches? Do you think that a good idea? For it would be a real nuisance to bring these with me. Or do you think it would be better to buy supplies in London? But canvases are not the same sizes there. Write me what you think would be most practical.

I went to the exhibition at the Champ-de-Mars. Whistler has a portrait, a marvel! There is a superb Puvis de Chavannes. For the

198

rest—nothing! Mirbeau right in *Le Figaro* cut Carolus [1] to pieces, this has created a sensation, and *Le Figaro* has broken with Mirbeau—they wouldn't publish his article on Renoir.

My dear Lucien,

I shall do my utmost to leave by Monday the 23rd; the weather, as you point out, is somewhat coldish, but it is not dangerous to my eye. I have been working at Eragny in this sort of weather without painful result.

Things have gone well. If I had sent in my latest paintings I would have sold them, for Durand asked me whether I have been working, and Joyant also. It is not a bad idea to make them wait a little. The niece of old Martin, who is in charge of her late uncle's affairs, asked me for pictures, she says they are in demand. She also asked me whether you would send her something. I sent the picture you gave me to Le Barc de Boutteville, who is holding an exhibition of young artists; it is very fine, very.

Lautrec, too, is leaving for London soon; perhaps we'll come on the same train.

ERAGNY, MAY 20, 1892

My dear Lucien,

Things are going well with Portier. I took him, some days ago, two canvases about 21 x 18 inches in size—he writes that he has just sold them for 1,200 francs each, and asks me for more pictures. I have none, for it is my latest works that are in demand, strangely enough!

It seems that M. Dallemagne [2] is compelled to sell his house. Your mother wants me to *borrow* in order to buy it; I am opposed. The

[1] *Mirbeau had had the courage to write of this portrait painter, then much in vogue: "At bottom, M. Carolus Duran would be excellent as upholsterer. Is not this perhaps the secret of his success? He does not paint women, he upholsters them, he does not dress them, he decks them out. He hangs fabrics on them as on doors, he drapes them like beds. . . . M. Carolus Duran disregards all that constitutes the human face. He is ignorant of painting, for that matter, despite the extreme virtuosity he shows."*

[2] *The owner of the house in which the Pissarros lived at Eragny.*

199

moment we are beginning to sell does not seem to me the right time to burden ourselves with a debt that will cause me anxiety, and all to the end of remaining in Eragny, which I would like to leave, which is too far from Paris, in a badly constructed house which doesn't stand straight, and with a garden far too large for your mother to tend and about which she has not failed to complain often enough. No, it doesn't suit me. If we have to move, you can come and help us.

PARIS, MAY 21, 1892

My dear Lucien,

I leave Monday morning on the 8:22 train. I will arrive at Victoria Station at five o'clock. I hope you will be at the station. The weather is beautiful.

* * *

Contrary to the expressed wishes of her husband, Madame Pissarro, anxious to remain in the house in which they had lived for eight years, decided during Pissarro's absence to visit Claude Monet at Giverny and ask him to advance her the money she needed to buy the house at public auction. When he learned that she had taken this step, Camille Pissarro seconded her request in a letter to Monet from London, dated June 8, 1892. The latter was able to lend them the money they asked for, and the Pissarros became the owners of the house they lived in at Eragny near Gisors.

* * *

1, GLOUCESTER TERRACE, KEW GREEN, KEW
[JUNE, 1892]

My dear Lucien,

I am glad to hear that you arrived safely.

Decidedly we have no luck. How is it, circumstances being as they were, that Lionel didn't have the presence of mind to let the house go to us for 15,000 francs? We will be penniless for some

time now, unless we can find some means of remedying the situation. If I didn't have to stay here to complete the paintings I began, I would bestir myself to raise three or four thousand francs. Just at this moment Portier is away, Luce informs me; he doesn't say for how long. There are two canvases, about 18 x 15 inches in size, which are for sale at 1,000 francs each. If he returns to Paris you must bring him something. Then there is the abbé Gauguin who wants two canvases. I have just about enough to tide me through here, and I don't dare ask Durand. If Monet could send us some Americans, you might do something with them. I have to decide whether to leave Kew (a pity) and I am at a loss.

I have sent Monet a temporary receipt.

I have sent your mother by registered letter the deed notarized and signed by a solicitor. I hope it is in order.

* * *

On August 10, 1892, Lucien Pissarro married a young English woman, Esther Bensusan, whom he had known for many years, and then left with her on a honeymoon trip to Rouen.

* * *

ERAGNY, AUGUST 16, 1892

My dear Lucien,

Here I am at Eragny at last delighted to be with the family and surrounded by my studies. I read the letter you sent your mother announcing your departure for Rouen. I suppose you will have not a few things to show your wife in that beautiful city, although it is fast being ruined by horrible modern constructions. Don't forget to show Esther the splendid view of Rouen from the heights of Canteleu; it is so grand that I still regret not having made a study of it. Naturally you will go to the heights of Bon Secours. I hope that while you are there you remember to visit Monet's brother at Deville. Have you given up traveling afoot? It must be quite hot for Esther. Do enjoy yourselves while you are there. When you are ready to come, drop me a line.

My dear Lucien,

I want to urge you, since you are passing by Pont-de-l'Arche with your wife, to call on Mirbeau. If you think it best, you might let him know you are coming, or take a chance on his being in, in any case you will have paid your respects. And while you are in those parts, don't you think you should see Monet? But it is up to you.

I wrote Monet that I was back and asked when I could see him. I have not yet received his answer.

Mirbeau wrote me that he will visit me with Rodin, who will spend several days with him. Naturally I told him how happy I would be to receive this artist whom we admire. I must also inform Durand when I finish retouching my *Kew Gardens* [793–803]. That will be soon—I am afraid they won't seem very salable to him! I consider my *Flood* [786] much grander and more beautiful from every point of view. And I find my studies of spring first rate! I expect to recoup at Mirbeau's.

Canteleu! how marvelous it is! Yes, I should love to visit it again and I shall. The museum you admired is the one to which I used to go when the weather didn't permit work outdoors. Is your wife pleased with this beautiful city of Rouen, so old and so artistic? But how hideous is the new part, what a slap in the face of the bourgeoisie . . . what's the good, they are not aware of it and so don't care!

LES DAMPS BY PONT-DE-L'ARCHE
SEPTEMBER 9, 1892 [FROM MIRBEAU'S]

My dear Lucien,

You must have read the letter I wrote your mother the day before. I mentioned that I went to work at once; the motifs are superb, as you know, of course. I made progress until yesterday when the strong wind kept me indoors.

Work, seek and don't give way too much to other concerns, and it will come. But persistence, will and *free* sensations are necessary, one must be undetermined by anything but one's own sensation.

I have begun four landscapes which seem to me superb in

motifs and effects, with hills in the background [806–809]. I don't know how they will develop.

P.S. Portier wants to know if he can go to Eragny and select two or three things. I said he could and asked him to let you know in advance. Show him the *Kew Garden* paintings, though, as I wrote him, they are too dear for his clients: 2,000 for the canvases 21 x 18 inches, 3,000 for those 25 x 21 inches.

<div align="center">LES DAMPS BY PONT-DE-L'ARCHE
SEPTEMBER 16, 1892 [FROM MIRBEAU'S]</div>

My dear Lucien,

I don't believe I'll stay here much longer. Mirbeau's father is very insistent that he visit him before the 25th; Mirbeau assures me that he does not care to go, but I think it wise not to hamper him. Unfortunately I didn't finish completely my three canvases, and I don't know what kind of weather we will have. I will be obliged to finished them in the studio.

I expect to ask for the *Kew* canvases (the ones 21 x 18 inches) 2,000 francs each from collectors, 1,500 from dealers; I think that is reasonable. I am hesitating between 2,000 and 2,500 from dealers for the canvases 25 x 21 inches. We shall see.

<div align="center">PARIS, OCTOBER 2, 1892</div>

My dear Lucien,

I saw Joyant who is very interested in our publication.[1] He is coming to Eragny to discuss our project and to see your large woodcut; he asked me how many prints we would make and what it would cost. I told him I didn't know and that for the moment this side of it didn't concern us. He wants to hold an exhibition of my watercolors, I don't see how that will help me. Evidently he wants to attract collectors in order to sell at the same time works by Monet, Degas, or others; so I told him that if he wanted to show my watercolors he would do well to buy my six *Kews*. He asked me to bring them, I replied that I wouldn't let go of them

[1] *No doubt a reference to the portfolio* Travaux des Champs, *prepared by Camille and Lucien Pissarro.*

<div align="center">203</div>

unless he bought them. His answer was that he hadn't sold anything of mine since last year.

I haven't yet gone to Durand-Ruel's. I will go presently. Portier is expecting two collectors, he will do his utmost to sell them something. He complains that the prices are too high for his collectors, and likewise that the pictures are too new; however, he finds them very beautiful.

I hear that poor Tanguy is ill. I shall go to see him. Write me what paints I need or rather the amount remaining. I have just seen Signac, who is to be married Monday, so I shall stay till then.[1] Durand told me that he expects to come to see me. He volunteered this. It is agreed that I will let him set a date.

Degas is having an exhibition of landscapes;[2] rough sketches in pastel that are like impressions in colors, they are very interesting, a little ungainly, though wonderfully delicate in tone. And what astonishes me most is that Manzi and the others like them! No, decidedly they do not understand; these notes so harmoniously related, aren't they what we are seeking? Good enough, if they understand Degas, they ought to understand us. Let me add that the landscapes are very fine.

Speaking about Miss Cassatt's decoration, I wish you could have heard the conversation I had with Degas on what is known as "decoration." I am wholly of his opinion; for him it is an ornament that should be made with a view to its place in an ensemble, it requires the collaboration of architect and painter. The decorative picture is an absurdity, a picture complete in itself is not a decoration. It seems that even the [decorative paintings of] Puvis de Chavannes don't go well in Lyon, etc., etc.

PARIS, DECEMBER 19, 1892

My dear Lucien,

I come from the exhibition [at Le Barc de Boutteville's] ; though the day was overcast the pictures showed up pretty well. I saw Luce there, he told me your picture was sold at the price you gave : 250

[1] *Paul Signac was going to be married to a distant relative of Camille Pissarro.*

[2] *After the exhibition of the impressionists, this was the only one-man show Degas ever had. The artist exhibited studies of landscapes recently executed, supposedly in his studio.*

francs with the frame. Your *Kews* look very well even in the fuzzy light.

The sale of my series [done in England] to Durand has had good results, I think. I believe it is best to sell to Durand for a while. He hasn't said anything about this yet, I am biding my time. A good sign: Prosper [1] said to me: "You surpassed yourself, they are splendid!"

Meyer the Ball, whom I met, said to me: "You are unapproachable!"

Too late, O Ball, you always miss the bus!

[1] *Prosper Garny, handy-man at Durand-Ruel's, had the complete confidence of his employer.*

My dear Lucien,

I have been in Paris since yesterday. I got back from Poissy with Georges, Esther and Titi; we met M. and Mme. Mirbeau at the railroad station in Poissy and in the course of conversation the latter spoke to us with great enthusiasm of the Japanese exhibition (Outamaro and Hiroshigé) organized by Bing at Durand's. We took the train to go to see it; the show is really astonishing and is admirably arranged: little rooms of faded rose and pistachio-green, it is exquisite, and the prints are wonderful. It is an artistic event. Mirbeau and his wife didn't come with us.

I saw Durand. My exhibition is set for March 15. I am sending enclosed the list of canvases.

I saw Monet at the Japanese exhibition. Damn it all, if this show doesn't justify us! There are grey sunsets that are the most striking instances of impressionism.

My dear Lucien,

You must have received the list of paintings which I sent with my letter. We shall see, when I return, what paintings I can show; considering how little time I have left—one month—I can't count on finishing all the pictures on which I am working now.

Went to the impressionists' dinner yesterday with Titi, who

became very annoyed in the company of the old gang. Some nasty remarks passed between Duret and Renoir about the election to the Academy of a certain Thureau-Dangin, an illustrious unknown, and the well deserved defeat of Zola,[1] whose place is not in that bedlam! How stupid!

Admirable, the Japanese exhibition. Hiroshigé is a marvelous impressionist. Monet, Rodin and I are enthusiastic about the show. I am pleased with my effects of snows and floods; these Japanese artists confirm my belief in our vision.

PARIS, FEBRUARY 27, 1893

My dear Lucien,

I unpacked my cases. Durand seems to like the pictures well enough, except for the hand of the *Woman in Yellow Shawl* [854] and the sky of *Hoar-frost* which he claims is too obviously flaked! We shall see when it is framed.

[On the left-hand page is this letter of Camille Pissarro to his wife]:

My dear Julie,

I unpacked my cases at Durand's. I can't tell you anything, I found all abominable and I must wait several days before I shall see Durand again. While waiting I am going to begin a study of *La Place du Hâvre*, it is very beautiful.

I will get some money tomorrow, I will send you a small sum, as you wished.

Until I see you again. Kiss the children for me.

PARIS, MARCH 3, 1893

My dear Lucien,

Although the weather wasn't very promising, I have decided to go to Poissy to take advantage of the days without wind, and I can leave my *Rue St. Lazare*, which is advancing well, to dry.

[1] *Having entered his candidacy for the* Académie Française, *Zola found himself opposed by a certain Thureau-Dangin, who won by twenty-two votes to four.*

Great news! the terrible Duret, the enthusiast of Japanese art, has sold his entire collection of prints and books to Boussod . . . and a good many of his canvases! He won't look at prints any more! He is buying old masters!

I saw Lautrec yesterday, and he introduced me to M. Marty, who publishes a periodical devoted to prints. He asked me to give him something for the second issue and also wants something from you. You should give him something straightforward and well knit. I don't know what I can give, a lithograph, perhaps?

PARIS, APRIL 28, 1893

My dear Lucien,

I went to Durand-Ruel's. Very friendly was Durand, and very busy. I don't agree with Luce, strangely enough I found the Manets extraordinary, certain prints have a surprising savor, so unexpected, the little Spaniards, the sketches, I marveled at them. No, I don't understand friend Luce's judgment. The Whistlers are very beautiful, but unlike Luce I found the Manets more attractive.

PARIS, MAY 9, 1893

My dear Lucien,

The canvas sold for 4,000 francs [at an auction] is about 21 x 18 inches in size. I haven't seen it. From the description and the date—1870--71—I suppose it is a study of *The Road from St. Germain to Louveciennes* [96]. The Ball [Meyer] told me today that it was a great surprise and would have very happy consequences! Damn it, the speculators aren't very shy. Well, let them do as they please. It was Durand who bought it for an American.

PARIS, JUNE 7, 1893

My dear Lucien,

I have just seen Durand-Ruel, who was very friendly. Joseph has arrived from New York, his reports are very alarming. It seems

208

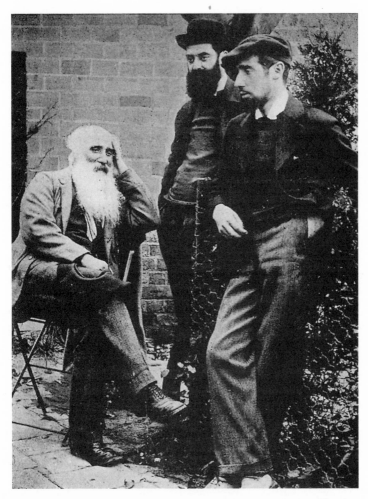

38.—Camille Pissarro with his sons Lucien and Félix in Knocke, Belgium. 1894. Photograph.

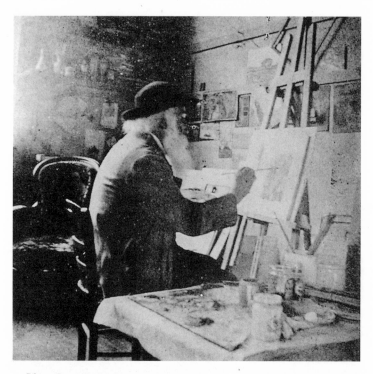

39.—Camille Pissarro in his Studio, about 1897. Photograph.

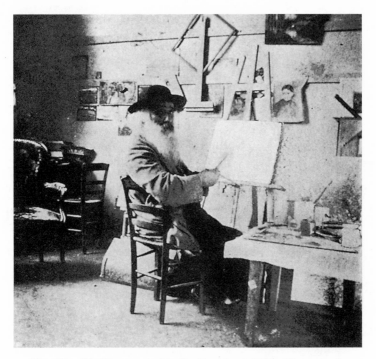

40.—Camille Pissarro in his Studio, about 1897. Photograph.

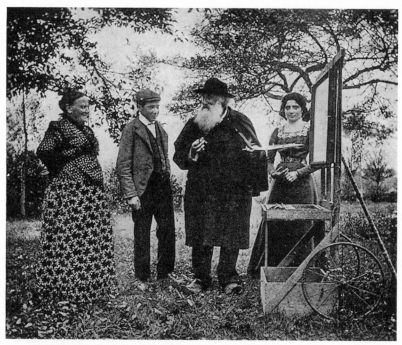

41.—Camille Pissarro with his Wife, his son Paul-Emile and his daughter
Jeanne, working in his garden, about 1897. Photograph.

they expect a real crisis soon as a result of the compromises the Republican Party has made with the big speculators in metals. Although outside these transactions, the art dealers will be affected by them for some time. Look out below! It's always the same story, if business slackens we are going to have trouble.

It is my hope that now that you find yourself back in London, you will concentrate energetically on your studies and be able to give free play to your sensations. I am most anxious to see where you are going, the knowledge you have more than justifies your being self-confident. The superb work you did as an engraver proves this, your problem is to discover an execution appropriate to your spirit. Do not permit yourself to be discouraged. Do not overdevelop a critical sense, and trust your sensations blindly.

PARIS, JULY 3, 1893

My dear Lucien,

Tomorrow Parenteau expects to begin his treatment. While waiting, I am beginning some small canvases which I will continue at Eragny : figures, which is what Durand asks me for. He told me that he saw the *Woman with a Wheelbarrow* [823] at the abbé Gauguin's and found it superb. I hope the things I am working on will satisfy him. I have also prepared several compositions of *Peasant Girls Bathing* in a clear stream under a shade of willows; this tropical heat suggests motifs of shaded spots on river banks. It seems to me that I have the best sense of the great poetry in this. What hampers me is the impossibility of getting a model, otherwise I could do things which would be new and rare. I shall make up my mind to do only small figures, trifles. It's a pity.

Georges and Titi have prepared an album of etchings, very nicely arranged, very much like your own. They intended to bring it to Mirbeau so that he can show it to Roujon, but I think this scheme must be abandoned. Here is why : Saturday, at about four o'clock, the three of us decided to pay Mirbeau a short visit. We entered by the back gate and saw, several paces from us, his wife in a lilac dress with a bonnet fastened under her chin; we were about to salute her, but Madame Mirbeau disappeared into a cabin at the left of the first yard. We opened the gate, a little dismayed; a maid came from the same cabin as if by chance. We asked if Mirbeau was there.

209

"Monsieur is gone," she replied.

"And Madame?"

"She is sick in bed."

A picture! Sheepish, sweating, we left, discoursing on the capriciousness of women and the fragility of the heartiest and most intimate friendships. . . .

I won't go there again, I will not write to Mirbeau.[1] I will wait for a suitable occasion—not even that—I will remain in my savage's retreat, scorning all tricks.

I have no news of art to tell you. It is so hot that we can think of nothing but refreshing drinks, shady places and cold baths—and of the rain for which we wait in vain!

PARIS, JULY 6, 1893

My dear Lucien,

Georges left last night for London.

Parenteau has operated on me, it seems with complete success. I feel fine. I will probably leave on Monday.

PARIS, JULY 7, 1893

My dear Lucien,

Mirbeau just visited me. He was here already at half past one; I was having lunch. He came as a scout, for his wife came also, half an hour later. Before his wife came, I explained what had happened on my visit. He assured me, somewhat embarrassed, that his wife had been sick that day; the last straw, that. The servants in that house have a funny practice: it seems that before showing people to the door, the maid goes to the mistress to ask for directions. No, that sounded false, I could feel Mirbeau's embarrassment. When his wife came, she insisted that it had been her chambermaid; her attitude seemed to be: "Since I say it, it is so!"

[1] *During the same period a similar misadventure befell Jean Grave who, in his book* Le Mouvement Libertaire sous la IIIe République *published Mirbeau's letter of apology:* "It was the fault of that foolish little girl who let you in, and who, out of mischief, often plays such tricks on us. . . . I am ill. Pissarro stayed with us recently. . . . He was heartbroken to see me in such a condition."

I didn't insist, but remained cold, stiff. . . . They ended up by inviting me, as they parted, to spend some time with them when I leave for Eragny. "Oh! I have so much luggage, another time . . . later on!" They insisted, obviously embarrassed by the coldness of my manner. I should be very surprised if Madame didn't understand.

<div align="right">ERAGNY, JULY 15, 1893</div>

My dear Lucien,

What you tell me about Vallotton doesn't surprise me. His work is characterized by a great feeling for the decorative. His black, his correct drawing, while greatly exaggerating, strikes the spectator, in short, is new and valid, and it is not surprising that he has attracted attention.

<div align="right">ERAGNY, JULY 20, 1893</div>

My dear Lucien,

The fourteenth of July has been a most sad day. I would have liked to send you the newspapers, to keep you abreast of developments, it is worth the trouble. It all began with a procession of students in single file against that idiot Bérenger, the old senator who had denounced the *Bal des Quat'zarts.* The cops and troopers slugged, killed, invaded even the hospitals; this coincided with the closing of the *Bourse de Travail,* more sluggings on the Place du Château d'Eau. Behind the whole mess is the fact that the Minister Dupuis was anxious, in view of the coming elections, to give the Right an earnest proof of his support. Long live the Republic! . . . everybody is happy.

<div align="right">ERAGNY, JULY 26, 1893</div>

My dear Lucien,

I have looked for the recipe for painting with cheese. The preparation that John L. Brown uses is the following: a mixture of casein with a borax solution (100 parts of casein to 10-12 parts

<div align="center">211</div>

of borax). You will find it in London. I advise you to have the mixture prepared by a pharmacist. You have to use powdered colors with it and work while the mixture is still lukewarm. I found it preferable not to pulverize certain colors too much—the result is then exactly like pastel.

Georges tells me that Epping is not very beautiful. Bah! one can make such beautiful things with so little. The motifs that are too beautiful sometimes appear even theatrical—just look at Switzerland. Old Corot, didn't he make beautiful little paintings in Gisors, two willows, a little stream, a bridge, like the painting at the Universal Exhibition? What a masterpiece! Happy are those who see beauty in the modest spots where others see nothing. Everything is beautiful, the whole secret lies in knowing how to interpret. And from your description, the place must be very interesting.

I am certain that I will not be able to visit you this year, I have too many things to do and I have to take care of myself. If things are well with us after the winter is over, I may pay you a visit. Yesterday I began the American treatment by means of injections. If I can cure the cartilage there is a good chance that I will be rid of this illness.

Portier came to see me. He took away with him for cleaning eighteen canvases, among them the one that was hung in the hall. He says it will be marvelous [when cleaned]. This excellent Portier is now concerned only with cleaning paintings, and incidentally, he makes an excellent job of it. He cleaned up the painting of Esther G., *View of Louveciennes*, it is a resurrection. Georges had brought it to Durand-Ruel before it was cleaned, what naïveté! Georges expected to sell it; not only did Durand reject, he even denied that it was my work. I laugh to myself, one of these days I will hang this canvas, properly framed, with my other works, and give him a lesson in painting, as bye-the-bye, has happened more than once.

I received from Italy a letter from a lady who wants to know what I charge for lessons and whether she could find lodging near me. I answered that I don't give lessons, but that I have a son living near London who could help her more than I, unable to spare the time and sick as I am.

My dear Lucien,

Here are the ingredients for egg paints: the yellow of an egg beaten, a spoonful of alcohol, a little Arabian gum, very little. I have looked for the formula everywhere and not been able to find it, but this must be close to it. Shannon can experiment with this, and I will try to see Zandomeneghi who gave me the formula once before. I forgot to tell you to use casein in the mixing of borax with warm or lukewarm water.

My dear Lucien,

The weather is very beautiful here except for a few storms and the unbearable heat. I am working outdoors, hard. I have a number of things finished, figures and landscapes, which I shall try to sell, for our funds decrease under our eyes. We will have to pay for masons, carpenters and locksmiths who are rebuilding the loft and my studio in the barn and making repairs all around. What a pity that we can't get together, there is room here for a colony of painters. The woodwork of the window in the studio is partly done, the light will be superb. The one thing that bothers me about the studio is that your mother stores grain and hay in the barn. These are very inflammable, a little fermentation and they can take fire. I am not easy in my mind about this; I realize that I will be insured, no matter! my lost studies will not be restored. I intend to keep my principal things in this studio.

Would you believe that a dealer showed Portier a horrible copy of a work by some painter, claiming it was a picture by me? The picture is signed *Pissarro* but with the initial C. He sent me a traced copy. The gentleman who has it said he got it from me. . . . I finally discovered that it was something made by your uncle Alfred from pictures which he took for rent.

My dear Lucien,

My studio is taking form. They are setting the ceiling to it. Its measurements are 7 x 8½ meters and the ceiling is very high. It will have a large enough window on the west side, which I would have liked to be square-shaped, but I thought of that too late. The door will be right near the entrance to the barn, the stairway in the court and the roofing will be of old tiles. Besnard this morning sent me the drawing for the carpenter, I find it somewhat pretty. I should prefer something more rustic. The real nuisance is how to cover the stairs, some covering, it seems, is imperative. Faith, I will cover the whole of it with new vines, that will save the form.

I forgot the main thing: a bay-window, three meters archwise to the north, which gives a good light. And now, once everything is complete and the bills are paid, the question is: will my paintings not be poorer, am I not too old to paint anything worth all this trouble?

Titi works without much energy; Rodolphe, as a result of our threats to get him a position at a notary's, draws from time to time. No, that won't do! I would like to see them begin to look at nature more attentively and with passion; the moment has not come yet, they prefer to work conceptually. . . . Yes, but knowledge is necessary. However I must say that Titi has done some studies which indicate a certain amount of progress, but he quickly becomes slack when inspiration doesn't come and this is apparent in his work.

My dear Lucien,

Lord, how money slips through one's fingers. I haven't much left. I hope that Durand, who has the knack of recognizing when someone needs him, won't play the hypocrite and make promises he can't keep. I am waiting impatiently for a chance to go to Paris and see what I can do. Chène, the dealer of the rue de la Paix, is very enthusiastic about the idea of having me deal with the jeweler Vever. He [Vever] is a big speculator in works of the

school of 1830 and has made an enormous fortune on them; it seems that he is on the point of taking something. It seems that the Chicago exhibition, at which he had to participate, was a colossal flop. It is to be feared that this may cool his ardor. This Chicago folly is a great pity. Who the devil wants to have any truck with pork-butchers?

I was introduced at Chène's to an American dealer interested exclusively in the painters of 1830. He admitted to me that a great step had been taken forward since then.

"Well then," said Chène, "get something before it is too dear!"

"Oh!" said the dealer, "we are not that confident. Suéton has too many Monets. If he doesn't make a good deal soon, it may turn out to be a poor investment."

Suéton, the big American dealer who has one hundred and twenty Monets, has become Durand's competitor, they fight on our backs. I know of these things only by hints, which worry me no end.

The weather is frightful today, rain and wind. It must be the same at Epping, it's a pity. It has been so beautiful lately and I was beginning to work regularly from nature. It is maddening, for this is the most favorable time, September and October. I can't endure the summer any more, with its thick, monotonous green, its dry distances, where everything is clearly outlined, its torment- ing heat, depression, somnolence. The sensations necessary to art revive in September and October . . . whereupon there is wind and rain!

* * *

In the autumn of 1893, Félix (Titi) joined his brothers, Lucien and Georges, in England. Georges and Félix returned to Eragny by the end of the year.

* * *

My dear boys,

At last! Let us speak of art, my boys. I look at your engravings from time to time and the more I scan them the more I become convinced that you are real chaps! Recently Pozier came to see me,

215

I showed him your woodcuts, he was enthusiastic about them. I expect Titi to do something big and well studied, *based on nature.* One feels great progress in the observation of nature in Georges' engraving. Lucien's has great purity. . . .

I do remember the engraving you [Lucien] had in the *Dial,* but I never said that I disliked it. I simply remarked that it would have been better if the figure had been more clearly articulated against the background. This is just a question of the eye, mine in particular, nothing more than that, and it does not imply that your engraving is not admirable from other points of view. Even among masters like Degas, I sometimes discover *manquements de valeurs;* to point these out is not to judge the substance of the work any more than to note a misspelling is to condemn a book. But scorn my judgments! I have such a longing for you all to be great that I cannot hide my opinions from you. Accept only those that are in accord with your sentiments and mode of understanding. Although we have substantially the same ideas, these are modified in you by youth and a milieu strange to me; and I am thankful for that; what I fear most is for you to resemble me too much. Be bold, then, and to work! . . .

They have just set in the sash of the large bay-window in the studio. The glass has to be put in, I hope Crépin doesn't make me wait! The studio is splendid, but I often say to myself: what is the good of a studio? Once I painted no matter where; in all seasons, in the worst heat, on rainy days, in the most frightful cold, I found it possible to work with enthusiasm. Your mother reproached me for indifference, but it was not this feeling that prompted me, on the contrary, the more irked I was, the more I felt the need to paint. . . . Will I be able to work in these new surroundings? Surely my painting will be affected; my art is going to put on gloves, I will become official, deuce take it! . . . This is a serious moment, I shall have to watch myself and try not to fall!

<div align="right">PARIS, OCTOBER 3, 1893</div>

My dear Lucien,

I have been in Paris for several days, and I am quite satisfied with the results of my visit, not from the point of view of selling my work, but in so far as I learned some things which I must not

42.—Lucien Pissarro: Solitude. Woodcut. Published in 1893 in *The Dial*.

pursue. I thought I could drop Durand, now I am sure it is almost impossible. I went to meet Chène on arriving, we talked about everything. He told me that America is finished as far as pictures are concerned, everyone is bankrupt. A gallery just went bankrupt in New York; Chène lost something in it, you can see how discouraged he must feel. So nothing can be expected from that quarter. He told me that Durand was going to New York and would feel the effects of the general situation. Very disturbed, I went to see Durand. To all appearances very calm, Durand received me most cordially and told me that he would leave for New York in eight days.

"The deuce!" I replied, "I come too late, I wanted to ask you to come and see my summer's work."

"Never mind! Joseph will go to see you, he can take my place well enough and pick as well as I. He will come out some Sunday by bicycle."

"Of course. Just the same I am sorry you will be gone, I should have liked to show you some figure paintings."

"Never fear, I shall be in New York for just a while. I shall set up my son, the next to the oldest, and return."

So there is hope. Durand will buy my work, I hope, though probably less than last year. But we must be watchful, it is going to be hard to get money. The Paris collectors are going to want to lower our prices.

Joseph Durand told me that he had seen Monet at Giverny. He told me Monet had changed his style and was dividing tones by means of little dots, closely resembling my own work. That doesn't help me any!!

PARIS, OCTOBER 4, 1893

My dear Lucien,

I went to see my good and worthy friend de Bellio. To my stupefaction de Bellio told me, speaking of my last show, that I had gone beyond Monet, that my art was more serious and that I had surpassed Monet's *Poplars*. In all sincerity I don't dare believe him, I feel so puny and mean next to that robust artist!

I saw the pictures cleaned by Portier—the deuce! The large canvas that hung in our lobby is splendid. Degas, who saw it, said it was noble. Another canvas, about 39 x 31 inches, *Hills Above the Railway from Dieppe*, is even more astonishing! All are beautiful.

[PARIS] OCTOBER 5, 1893

My dear Lucien,

Joyant has just left Boussod & Valadon. It seems that Joyant is wealthy in his own right. As Boussod & Valadon wanted to treat him as they treated poor Théo van Gogh, he left him in the lurch and is going, it is said, to set himself up with Manzi. I shall go see him at Manzi's. But I don't trust that schemer Manzi at all. Besides, I don't believe he understands my work. But I have a feeling that I have come to have some importance.

218

My dear Lucien,

I have just received a letter from a gentleman, an American doctor and ophthalmologist, who informs me that he came to ask me for data on color-vision. I was in Paris, and he left for London. He visited Monet, who, it appears, interested him greatly by what he had to say in this regard. He expects to return and I will avail myself, if I can, of his opinion of my eye-trouble. I thought it advisable to give him your address so that you can explain to him your views on optical mixture and ways of mixing colors, etc.

ERAGNY, OCTOBER 10, 1893

My dear Lucien,

We received this morning with your letter of the 7th, your telegram announcing your wife's successful delivery. She had what she desired: a little girl.

I am very annoyed to see that Durand is in no hurry to get you money which you must need now.

Send us news of your wife, let us know if your mother-in-law is with you and how everything is going.

Kiss my grand-daughter and Esther for us all. Remember, there are dangers after giving birth, be careful. Be careful at night!

ERAGNY, OCTOBER 17, 1893

My dear Lucien,

I received your letter of the 13th announcing that your wife and little Ora [1] (how comical a name!) are doing nicely. I hope the little difficulties of the first days will not be prolonged.

Portier came yesterday. He carried two packages of my canvases which he had cleaned. It is amazing! I hung them on the wall of my old studio, they looked extremely well. Some have a clarity and rightness that astonish me. I hope the collectors will hasten to take them—but I have no illusions. I know perfectly well that grey, lusterless painting is not understood.

[1] *In actual fact, the daughter of Lucien and Esther Pissarro was named Orovida.*

The studio is progressing slowly, softly, most quietly. The great bay has finally gotten its glass pane, as well as the other window; the doors are finished, the balcony and stairway are to be set up tomorrow, they tell me. I hope, after Crépin has put a coat of grey paint on the walls and the ceiling has been cleaned, I hope to begin a study from the window, for it is fairylike at this moment, and I am greatly in need of painting.

Dear Esther,

Your sweet letter gave us great satisfaction. We are happy to know that you have completely recovered and that our grand-daughter has only to grow and be pretty. The first days after the delivery are relatively easy, but you have to be careful to avoid all sorts of illnesses later, you must take care of yourself as well as of the baby. You will learn bit by bit to anticipate these indispositions and thus you will begin to appreciate the virtues of homeopathy.

You ask about my eye: it is just the same, Parenteau's treatment has changed nothing. I am using a preparation suggested by de Bellio—up till now the results are nil. I will soon try out Sutter's method, about which Hayet told us.

Kiss our little girl, we send you our affection and our wishes for your good health.

My dear Lucien,

No Durand on the horizon, no one, nothing! Decidedly a trip to Paris is in order! And it is terribly cold! I am very worried.

My dear Lucien,

Unfortunately it is only too true: charlatanism is indispensable to getting oneself noticed. Thus, at this moment, even in Paris, critics of integrity like Geffroy write without compunction articles

on Vogler, who passes now for a great master. I wager that before long he will have an encomium from Mirbeau! It is inevitable. I will probably go to Paris Sunday.

My dear Lucien,

Durand has agreed to advance me some money for the various payments I have to make to the carpenters, masons, etc. I hope Joseph Durand will come to Eragny and take a certain number of canvases.

Gauguin's present show is the admiration of all the men of letters. They are, it appears, completely enthusiastic. The collectors are baffled and perplexed. Various painters, I am told, all find this exotic art too reminiscent of the Kanakians. Only Degas admires, Monet and Renoir find all this simply bad. I saw Gauguin;[1] he told me his theories about art and assured me that the young would find salvation by replenishing themselves at remote and savage sources. I told him that this art did not belong to him, that he was a civilized man and hence it was his function to show us harmonious things. We parted, each unconvinced. Gauguin is certainly not without talent, but how difficult it is for him to find his own way! He is always poaching on someone's ground; now he is pillaging the savages of Oceania.

PARIS, NOVEMBER 27, 1893

My dear Lucien,

Today Miss Cassatt's exhibition opens at Durand-Ruel's. I am going to see it presently.

I just received an invitation to the Brussels exhibition of *La Libre Esthétique*, a continuation of the old group *Les Vingt*. It isn't such a good idea for me to show with them. It would have been more appropriate to invite you, you others, their program

[1] *Gauguin, repatriated from Tahiti, had landed in Marseille on August 30, 1893, with four francs in his pocket. Shortly afterwards he inherited some money from an uncle and this enabled him to take a studio in Paris. In November he exhibited forty canvases and two sculptures at Durand-Ruel's. The show was not a financial success, since Gauguin demanded rather high prices for his paintings. The preface to the catalogue for the exhibition was written by Gauguin's friend, Charles Morice.*

being to show the new art, which, incidentally, seems to me somewhat naive. What do you think?

Everyone to whom I talked about Gauguin's exhibition was furious. De Bellio, among others, thinks it was absolutely bad and senseless! They are all even more outraged than I.

Durand promised to come to see me. I hope things will improve. It seems, from a gentleman I saw at Portier's, that the dealers are transfixed by the bad turn things have taken in America and here. They can't make a penny and seem to regret not having helped us for some ten years, for we are the only ones who, relatively speaking, were bought here and in America. They rue the day and are envious of Durand. Well! If that only meant something, but I am always suspicious!

Lecomte, Fénéon, Luce, Signac *who has made great progress this year*, send you friendly regards.

ERAGNY, DECEMBER 5, 1893

My dear Lucien,

It was a pleasure to get *The Dial*. I find Shannon's two lithographs very beautiful. I say his "two," for the third, with the large Rossetti-like figures, didn't please me, I miss in it the frankness and rich flavor which are the mark of this fine artist when he isn't thinking of the Pre-Raphaelites or rather, of the symbolists. Your woodcut looks very good, much better than the proofs of it I saw.[1]

We are at last on the way to solving our problem: Durand junior came with his friend Mellério and bought 28,600 francs' worth of pictures. As a result of this windfall I will be able to make the final payment for the house, 7,000 francs with the interest and incidental costs, I will give 4,000 francs to Monet and pay for the work that was done here. Not much will be left, but I hope to have a show of my watercolors, pastels and paintings in March, and I should make enough to hold me till the end of the year.

At this moment Miss Cassatt has a very impressive show at Durand-Ruel's. She is really very able!

~~~~~~~~~~~~~~~~~~~~

[1] *See fig. 42.*

I just this minute received a line from Signac about a store which is for rent and in which exhibitions can be held. I am sending you his letter. Write me if you like the idea and let me know what you wish to exhibit; something salable.

On the 15th of December the neo-impressionist shop opens. What works of yours shall I announce? Quickly!

*Dear Master,*

*The arrangement I mentioned to you is now a reality, but contrary to what I told you, there will be no subscription, either in pictures or in money, to cover the costs.*

*Here are the facts: Antoine de la Rochefoucauld is pleased to offer us a completely equipped shop for which he will pay the rent for a permanent exhibition. Those who exhibit at Brebant's will be included, plus La Rochefoucauld and Angrand if the latter is willing.*

*Anarchist grouping: a turn at the regular show-window—new pictures to be exhibited every month—a bulletin-catalogue to be sent every month to the collectors and to the press.*

*Twenty percent on each painting sold will be deducted to pay Moline, who has taken over the "selling" side. From this twenty percent he has to pay the costs of the clerk, lighting, etc. If at the end of the year this twenty percent is not enough to cover even these small expenses, the deficit will be made up by the exhibitors.*

*A purely formal fee (one franc a year?) will be paid by each to give everyone the same rights.*

*I think Georges and Lucien will be happy to take part in this serious and lasting manifestation. . . . As for you, dear Master, you know how you would gladden us by sending us anything at all: drawing, watercolor. How happy we would be to have with us your desired canvases which those belchers, the dealers, didn't want! Whatever you do or decide will have gospel weight with us. Incidentally, La Rochefoucauld will send you word himself of his fine and generous enterprise. I am writing you in advance so that the entries of our dear Pissarros can be ready.*

*Keep secret the matter of our friend's assistance, he wants to appear as just another participant in this enterprise.*

*Accept, dear Master, for yourself and your family my most cordial and sincere regards.*

*Paul Signac*

*Excuse the precipitousness of this letter.—I am also writing to Théo* [van Rysselberghe] *and to Cross. This is a real circular.— Each one of us will contribute every month two or three medium-sized canvases and two or three smaller ones, or drawings, woodcuts, watercolors, lithographs, etchings, etc. I beg you to send me as soon as possible the list of Pissarro entries and their dimensions.*

ERAGNY, DECEMBER 10, 1893

*My dear Lucien,*

I hope you will enter something with Signac, Petitjean; but act as you think best. I am enclosing another plan for a group (decidedly, they are springing up everywhere), that of the *Plume.* As for me, my nest is made, I must remain with the Old; Signac would have liked to win me over, but I renounce.

I am having a show with Durand-Ruel in March, but can anyone count on anything in such an epoch? . . . Doubtless you have read in the newspapers that a bomb was hurled into the Chamber of Deputies [1] . . . the deuce! . . . the poor are refractory.

[ERAGNY] DECEMBER 15, 1893

*My dear Lucien,*

You must know about the reactionary wind which is sweeping the country now. You know Fénéon's Dutch friend, the translator of Ibsen? He is in confinement and is waiting to be taken across the frontier! The poor lad, according to the newspapers, had done nothing! . . . Look out! . . . Hauptmann's play [*Die Weber*] has been forbidden and won't take the boards at the Théâtre de l'Oeuvre—because it is socialistic! This reminds me of a tune known in the days when one named Badinguet prospered! Who the devil says there is something new? This is old, arch-old!

---

[1] *On December 9th the anarchist Vaillant hurled a bomb in the Chamber of Deputies, wounding some fifty people but killing none.*

224

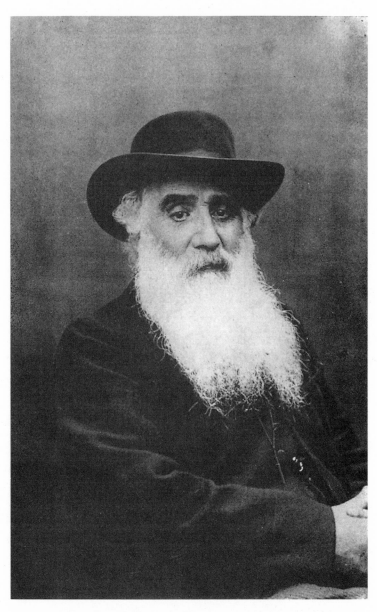

43.—Camille Pissarro, Photograph, about 1895.

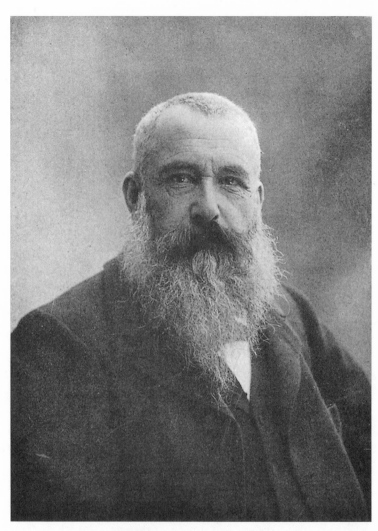

44.—Claude Monet, Photograph.

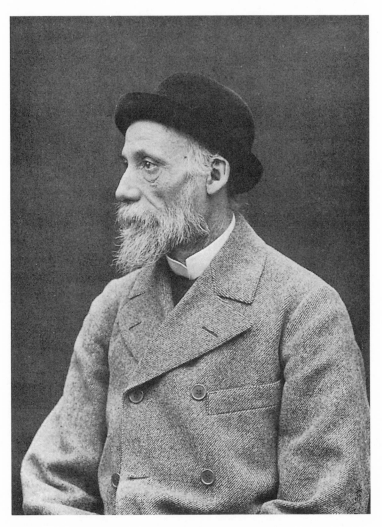

45.—Auguste Renoir, Photograph.

46.—Paul Cézanne. Photograph.

*My dear Lucien,*

I went to see your canvases at Contet's. I find that you have made great progress. Your execution is much more free, your motifs are well taken, the values are right. One effort more and you will no longer be the same! Your backgrounds are luminous; perhaps you are still timid in taking the plunge. But you show, I repeat, even in this regard, real progress. You began your little study in too high tones: it is my belief that one must begin with the exact value of the object one sees. Your trees are very well drawn, perhaps still a bit harsh against the clear backgrounds, but very well done. I am perhaps a little too meddlesome, for your work impressed me as excellent.

PARIS, DECEMBER 23, 1893

*My dear Lucien,*

The *Néos* haven't opened yet. The shop is painted a clear blue, which stains the rue Laffitte. The interior is not ready yet. I would have liked to see how your paintings look in there, for at Contet's you can't view them properly. This will be for my next trip.

At Durand-Ruel's I met Faure,[1] who was enthusiastic about my work and confused me with his long delayed praise. That's being on the rise! . . . Yes, my dear, he considers me a master! the great master! . . . Fortunately I don't let myself become vain, I know from experience what all that is worth.

PARIS [DECEMBER 28, 1893]

*My dear Lucien,*

Yesterday I saw a picture by Guillaumin. It is always the same art, although a little less brutal. With all his talent he falls back on dark tones. It is really unfortunate to deliberately blind oneself! . . . It is true that he says as much of me. But I know where I am going and why; but he, who shouted with us against Jules Dupré and all the obscurantists, turns his back to the sun. His work is darker than ever; of course: the higher his tones, the browner the result.

---

[1] *The actor J. B. Faure was a friend of Manet who had made several portraits of him. Faure owned an important collection, including a number of Manet's works.*

*My dear Lucien,*

Georges and Titi, who have returned from Paris, gave us the details about the show of the *Néos*. . . . The outside of the shop is painted a clear blue with red letters, it is ugly, it is like the entrance to a bazaar, but it seems that nobody finds anything amiss. The day of the opening there was a relatively large crowd; M. Viau was there, he expressed the opinion that you, Georges, Titi and Petitjean were best represented. The dot appears thin and bodiless in this ensemble. It wouldn't be a bad idea for you to show new things there from time to time. Fate favored you and another artist, with him you have the honor of being the first to occupy the show-window.

The press [for etchings] I bought from Delâtre has been installed in the large studio; I am waiting for ink to make some prints. We tried to print with oil color, the effect is astonishing. It gives me the urge to do more etchings.

It is cold here, the wind is icy. I think that you must be enduring the same time at Epping. I have begun four or five large canvases from my window for my exhibition in March.

*My dear Lucien,*

It is some time since I wrote you last, but I have been occupied with so many things. Since I had the press, I decided to make

226

prints of *Baigneuses;* everything went well until I had to stop. The press Delâtre sold me for 300 francs with accessories broke down! The hub of the fly-wheel broke under an ordinary pressure, so I am unable to go on. I wrote him a furious letter.

The studio is marvelous to work in, but everything I began has the same motifs as my paintings of last year. I am trying to find new effects, and I have six or seven canvases representing this effort well advanced.

*My dear Lucien,*

A young man I knew through John Lewis Brown, and who was warmly recommended to me by M. Viau, has opened a small gallery in the rue Laffitte.[1] He shows nothing but pictures of the young. There are some very fine early Gauguins, two beautiful things by Guillaumin, as well as paintings by Sisley, Redon, Raffaëlli, de Groux, of this last a very beautiful work. I spoke to him about you and Georges. When you have something, you must send it to him. I believe this little dealer is the one we have been seeking, he likes only our school of painting or works by artists whose talents have developed along similar lines. He is very enthusiastic and knows his job. He is already beginning to attract the attention of certain collectors who like to poke about.

Guillaumin has a very fine exhibition at Durand's. Seen as a whole, it is astonishing how his work gains; this show ought to help him greatly.

Until next time. Everybody is well at Eragny. Georges and Rodo are here. They went with Luce to pull some lithographs on zinc; the prints are for Marty.

I have just had prints made of two etchings of *Baigneuses;* amazing! you will see it. It is perhaps too naturalistic, these are peasant women—in hearty nakedness! I am afraid it will offend the delicate, but I think it is what I do best, if I don't deceive myself . . . well.

---

[1] *This young man was Ambroise Vollard (fig. 53) who was soon to yield to Pissarro's insistence and go to seek out Paul Cézanne. Vollard presented the first one-man show of Cézanne's work in the fall of 1895.*

*My dear Lucien,*

I will give you the details of what passed between Petitjean and Signac; this is only the beginning of disagreeable discussions among the *Néos,* for Petitjean completely agrees with our view that there is no future in a method as constricted as that of the dot exclusively! About this I am sending you *L'Echo de Paris,* which contains an article by Mirbeau who treats Signac a little roughly but, alas! is only too correct in what he says of his painting.[1]

*My dear Lucien,*

Decidedly I do not understand Signac. After having had a run-in with Petitjean, now there is something else. Besides, he is always the same: a spoiled child. Unable to endure the criticism of Mirbeau's article, he writes me the matchless letter appended below:

*My dear Master,*
*Would it be too much trouble for you to write to Mirbeau that a Signac, in your opinion, resembles a Seurat no more than a Hokusai a Hiroshigé? If, indeed, the reproach of imitativeness with which he seeks to overwhelm me seems to you unjust.*
*The friendship you have always shown me and the compliments you so freely paid me for my recent canvases justify my asking this service of you.*

> *Cordially,*
> *Paul Signac*

I found this request so singular, coming as it does from a beginner, that I became very embarrassed with this good fellow, who is fine enough but much too irascible and much too immodest, considering the poor character of his work. Here is my reply, which I was perhaps wrong to moderate.

---

[1] *Unfortunately it has not been possible to find and quote this important article.*

47.—P. Bonnard: Ambroise Vollard's Gallery, Paris, rue Laffitte. Drawing. (From left to right: Pissarro, Renoir, Vollard, a customer, Bonnard and Degas.)

"My dear Signac,

"Yes, I do indeed object to writing Mirbeau what you ask me to, and for a number of reasons: (1) because my relations with him are no longer friendly, as you know perfectly well, (2) because, for your part, it is improper to dispute the opinion of a critic even when you are convinced you are right. And if you want my frank opinion, which I am glad to have an opportunity to make clear, I find the [neo-impressionist] method itself bad; instead of helping the artist, it paralyzes and freezes him. If I complimented you this year, it is because I found your latest canvases better than those you exhibited with the *Indépendants*, but I am far from believing that you have taken the direction suited to your essentially painter's temperament. If until now I said nothing about this to you, it was because I was sure you would find it disagreeable and, finally, because you may not share my convictions.

"Reflect maturely and consider whether the moment has not come to evolve towards an art close to sensation, freer and more in accord with your nature.

"Though you take it amiss, my dear friend, and I hope you will not, this is my frank and sincere opinion.

"Yours"

I append a copy of the second letter Signac wrote me to tell me that, far from changing, he would continue in the neo-impressionist direction which he approves.—That is all right with me. After all, he is right to do so since he is convinced.

*January 25*

*My dear Master,*

*In asking you to write Mirbeau what I often heard you remark in the old days (with the same technique, a Signac, a Lucien, a Seurat are quite distinct), I had completely forgotten that you were on distant terms with him. I quite understand your not writing him and I beg you to excuse my importunity. Just the same I am convinced that, however poor in fact my method of painting may strike you, you must necessarily regard as unjust this too sweeping indictment of a serious and sincere artist, and that you cannot but believe that ten years of persistent and disinterested effort deserve better treatment.*

*And, candidly, is this method as bad as all that? (I am not referring to the dot). . . . I have never employed it and I never will, for both the word and the thing give me the shudders; what I have in mind is the principle of division, harmony and contrast. I can even now clearly recall your expressions of satisfaction when you stood before my works. Can a thing one has liked so well suddenly appear so odious? It is not I who have changed, dear Master! Since that time, far from having retrogressed, I have been developing in that direction . . . and you yourself this year took occasion to note my development. Your kind words greatly encouraged me to continue, even as your enthusiasm in the old days, when I was a beginner, gave me strength.*

*While I am convinced that we are on the right track, I am even more convinced that we have still a long way to go. There is all the more reason not to be discouraged; on the contrary, it is necessary to persevere and work hard.—Moreover, neither charm of impaste nor the savor of soft tones can tempt me or stay me from my path. For seven years now I have set myself against their easy and enticing promises.*

*I am certain that the definitively "neo-impressionist" technique, when completely disburdened of certain obscure and obstructing elements—give us credit for such research—can alone lead to harmony, light, coloration. . . .*

*Believe, dear Master, that far from taking it amiss, I am very grateful to you for having written me the opinion you have held for some time.*

*It is a mark of confidence of which I am proud and for which I thank you.*

> *Cordially yours,*
> *Paul Signac*

But if I were to continue our correspondence on this matter I should not be able to keep from writing him: "But damn it all, then make something that has life!" He is disgusted with soft tones, impaste; that is likely. I would reply to that: "Take Corot, Courbet, Delacroix, Rembrandt! And then, damn it, paint with—sepia, if you like, but in God's name, make something good! I don't give a fig for the method if the result is poor."

Signac wants me to give him credit for hard work. Faith, I am willing to grant that. But what a flop he's made of it!

Poor Signac! Nobody dares tell him the truth . . . it will be necessary to do so some day. But even before the dot, he hadn't done anything very good, that is clear.

ERAGNY, JANUARY 28, 1894

*My dear Lucien,*

I have sent Théo [van Rysselberghe, in Belgium] the list of prices as you suggested. I upped all my etchings proportionately; you are right, if they are good, I don't see why I shouldn't set my prices as high as Legros'. But I have little chance of selling them, although it is surprising how much artists like my things. Théo paid me not a few compliments for what he saw here, but considering how indifferent are the collectors, I hesitate to believe him.

We shall see about the *Daphnis,*[1] but the nude without a model bothers me as it does you, for I no longer have any hope of getting a model.

I have just made prints of the following: *Peasant Woman Digging* [D.95], *Peasant Woman with Pitchers* [D.85], a small *Portrait of Grandmother* [D.73], *Weeder* [D.72], *The Rue Malpalue* [D.53].[2]

These proofs are much clearer than the ones pulled by that miserable Delâtre; his were soaked too much. If you need *The Rue Malpalue*, it is very beautiful, as is the *Weeder*. For the last number of Marty's portfolio I made a lithograph on stone; I am hoping that he will agree to reserve twelve proofs for me. And at Tailliardat's I had pulled several lithographs on zinc of *Women Struggling,* playing in the water, as in the first proofs [D.159 and 160].

When should I send paintings to van Wisseling? It is absolutely necessary to deal independently of Durand.

ERAGNY, FEBRUARY 11, 1894

*My dear Lucien,*

What you tell me about your woodcut is not new. Every time you tire while working on something, you find it completely dif-

---

[1] *Lucien had suggested to his father that they together illustrate* Daphnis and Chloe. *Pissarro would do the drawings and Lucien would cut them on wood. See fig. 54.*

[2] *These etchings dated from 1883, 1887, 1889 and 1890.*

ferent from what you intended, of course! It is an old story. You must send us a proof so that we can judge it.

The article by Geffroy in *Le Journal* is even harder on Signac than was Mirbeau's, yet it was moderate enough. If something by a writer of talent appears in the newspaper, I'll send it to you. As to telling you anything about the recent events, little prompts me to speak; no, not a word, nothing. As the English say: I shut my box. Besides, I want to take out a regular subscription. *Le Journal*, while it is gossipy, very inconsistent and vulgar, is by its very character forced to publish young and talented writers. The movement is there, and these young writers are to some extent obliged to deal with the true and the beautiful in all manifestations, and there is a little less wickedness than in England where the press is anonymous.

ERAGNY, FEBRUARY 18, 1894

*My dear Lucien,*

I am going to Paris on the twentieth to organize my show. I need at least eight days to prepare for the little event. I have to be prepared in advance for the thousands of difficulties that necessarily come up. Unfortunately in these troubled times people are hardly concerned with art. But the wine is poured, it has to be drunk.

After my exhibition I will probably decide to go elsewhere to paint some pictures, for I have done enough with the motifs here in Bazincourt with its pleasing parish, I have to make a good new series. Where will I go? To Touraine? To England? I don't know, I am afraid to go to Epping, where it seems it is always windy. This is a pity, for from the sketches of Georges and Titi, and your own studies, it would seem the country there has great beauty. You might look around or make inquiries, perhaps you could locate some spot sheltered from winds—which are so bad for me. So if I should decide to make a trip across the Channel, it would be best for you not to come to Paris. If I decide to make a campaign in England, I would be glad to be near you. This will not prevent you from doing good work, I know you fear my influence, but there is such a thing as going too far.

I would have liked you to see the exhibition of a young painter named Maufra, a friend of that good Flournoy from Nantes. The

boy has talent, his work is very synthetic and based on observation of nature, precisely what you strive for in your engravings and what you have so much difficulty realizing in painting; only Maufra is best in his sketches retouched with pastel (between the two of us, it wouldn't be a bad idea for you to do that, as an exercise), but has not yet succeeded very well with painting. But he will get there, his studies justify confidence in him.

Georges and Titi went to Gisors for a walk; hardly any work has been done for several days; they seem to feel the need to do things at random, to walk, to play, to disguise themselves. I suppose youth is claiming its rights. . . . I still do not know what Georges will decide to do. He seems to want to take a little trip to Belgium for the exhibition of *La Libre Esthétique*. I do not know whether he will cling to this project or come with me to London. I still feel that he could make a name for himself in England. You say it is difficult in England: it is difficult anywhere! And it has to be England, for here I am a hindrance to all of you. To succeed in England, you have to be resolute and work hard, but what is so terribly difficult is to take the path appropriate to you and pursue it undeviatingly. Until now, neither Georges nor you have known what to do, now it was furniture, now it was engraving. But the problem is to decide once and for all. I should like to see Georges make up his mind to work *modestly* without taking himself too seriously, and arrange his life simply with what I can give him, while keeping himself in readiness for any opportunity to show his works; to do, in a word, what we old-timers have patiently done for years. One strives in vain. What is necessary is to prepare the ground with truly *felt* works, and one's reputation takes care of itself. There is no better method, everything else is superfluous. Long hair, dandyism, noise, count for nothing; work, observation and sensation are the only real forces.

PARIS, FEBRUARY 23, 1894

*My dear Lucien,*

What bothers me most about these trips to England is coming back; think how short is the time, three months for painting important works, and we must allow for the time lost searching for a suitable location; hardly have you found what you want when you

234

have to think of returning. It is this which bothers me, and especially considering that autumn is the most beautiful season. So a decision must be made on this basis: either I must find some practical way of staying in England long enough to execute a score of important pictures, with new effects, or I must stay in France and content myself with going to the seashore or to Touraine.

If I could spend the fall and winter in England, I might come across some beautiful effects; I could arrange to work from a window in severe weather, not in London or Epping, of course, but in the neighborhood.

Well, well! If we hadn't made the mistake of buying the Eragny Castle, how easy it would have been for all of us to stay in England! . . . I felt it at the time! But this is between the two of us! Some day we'll have to take this up.

You are right, all in all, to follow your feeling when you paint. The truth is that the various manifestations of art do not contradict one another, there is always the same pivot. . . . But from a practical point of view, it is necessary to produce a great many works in order to become skilled.—What you tell me of your modest will is somewhat like what papa Corot used to say to us: *I have only a little flute, but I try to strike the right note.*

PARIS, MARCH 1, 1894

*My dear Lucien,*

Georges went to meet Leboeuf and Nini to stroll along the boulevards which are very lively. People are throwing confetti of all colors and forming prismatic serpentines. It is very jolly.

I have been sad for some time about the death of my old friends. Suffering from bronchitis, lately, I wasn't able to go to see de Bellio's daughter; even Monet, whom I saw, couldn't tell me of what poor de Bellio died. We have just lost still another sincere and devoted friend: Caillebotte died suddenly of cerebral paralysis. And he is one we can really mourn, he was good and generous, and a painter of talent to boot.

*My dear Lucien,*

My show opened today and will close March 21.[1]

I saw your two canvases at Contet's; they are very pretty. At first sight I feel that you are still too close to my work; you should try a different execution and be attentive to the general values. In general your colorations lack something; from the way objects are delimited one would say you practise tone division while first letting your color dry, you are afraid to mix. If I were you I would mix freely, I would not leave so many orange-colored commas. One feels that you are inhibited, but where there is inhibition there is no pleasure. Mix all elements. We must talk of that at greater length.

Tell your wife that I shall of course come to Epping, but that I shall have to work constantly, I have only a few more years to live, and I must not waste my time while I still can see clearly and feel nature intensely, if I am to conclude my life fittingly.

Yes, my dear Lucien, we are going one by one, in Indian file. Our poor friend de Bellio and our comrade Caillebotte are gone. Caillebotte was forty-six, de Bellio sixty-six. I have not yet learned the circumstances of the latter's death. Yes, he was a true friend, and so we are all saddened. I cannot pass La Maison Dorée without a melancholy glance, which seeks him mechanically, despite my knowledge that he is gone. And poor Tanguy, that fine, upright, good man!

I didn't go yesterday to the opening of my show, I was tired and indisposed. Afterwards Durand senior came to my hotel and told me that not a few of the art crowd had been at the exhibition. He asked me for two or three pictures and informed me that several pastels and watercolors had been sold, of those that are for sale. There are few of these, most of them I prefer to keep. The little canvases done in England in 1870 look admirable; they are extremely clear, and while not divisionist in execution, have fine painting quality.

You will see in the neo-impressionist-shop-bazaar a large Cross —it is frightful—unheard of!

---

[1] *Pissarro showed 30 paintings, 23 watercolors, 14 pastels and 4 gouaches. The prices for the paintings ranged from 1,800 to 4,500 francs.*

*My dear Lucien,*

Nothing new in the arts. The bazaar is always very sad!—You would do well to send canvases to Vollard, the little dealer, he is intelligent and an enthusiast. His place compares most favorably with the bazaar, which is so cold, formal, bourgeois.

*My dear Lucien,*

I have reason to be satisfied with my exhibition, from the artistic point of view, of course. My friends were pleased, my figures done in the studio won general favor. Mallarmé told me I am younger than ever, Degas and Monet much admired the same painting, *Potato Harvest in the Setting Sun* [859], Geffroy wrote a splendid article about me, Lecomte sent me a charming letter. As for the financial angle, it may be none too brilliant, but after all these are bad times, and then I may be told nothing . . . nothing. . . . If Durand takes all my work, it will mean the show had some success. In that case I will have cause for satisfaction, let us be modest!

*My dear Lucien,*

I am going to Paris next week. I will probably go to the exhibition of the *Indépendants* which I see has opened. I also expect to take in the Tanguy auction.[1]

The weather is very uncertain for the unhappy art of painting; I am content to triturate indoors. I have done a whole series of printed [lithographic] drawings in romantic style which seemed to me to have a rather amusing side: *Baigneuses*, plenty of them, in all sorts of poses, in all sorts of paradises. Interiors, too, *Peasant Women at Their Toilette*, etc. Such are the motifs I work on when

---

[1] *After Tanguy's death his collection was sold at auction. Very low prices were gotten for his paintings, works by Cézanne, for example, brought from 45 to 215 francs.*

237

I can't go outdoors. It is very amusing because of the black and white values which give the tone for pictures. I have retouched some of them with color—if such lively woodcuts could be made, that would be something; especially in color.

<div align="right">PARIS, APRIL 28, 1894</div>

*My dear Lucien,*

I went to the Champ de Mars the day of the opening and also to the show of the *Indépendants*, which is being held in an annex of the Palais des Arts. As in other years, nothing extraordinary at the Champ de Mars, nothing, that is, besides Whistler and Puvis de Chavannes. Whistler's *Portrait of Montesquiou* is very beautiful, in gesture and rakish elegance, and it has great unity, achieved, it is true, by tricks—à la Velasquez—rather than by the methods proper to painting. Several marines hardly painted, a blue note scarcely drawn, but very artistic, two little portraits of ladies, quite pretty and full of character, the smallest of these being a real beauty.

Your canvases at the *Indépendants* are much better than those at the *Néos*. A little pale, the skies especially, and the impaste is disturbing when looked at closely, but there is great progress in the whole. The canvases are a little less like mine, but there is still some similarity in the ensemble. There is a lack of depth, which I also find in your woodcuts.

General exhibition of Manet at Durand's—which can leave no doubt of the painter's unimpeachable mastery. Soon there will be an exhibition of Monet—the [Rouen] *Cathedral* series [1]—at last!

Our friend Fénéon has just been arrested, it is alleged that he is connected with some criminal organization.—What next?—Isn't this the limit? [2]

Luce told me that he wrote to you recently. He has a good show at the *Indépendants*, his works hang beside yours. There is nothing

---

[1] *See fig. 61.*

[2] *Fénéon, who had been employed editorially at the Ministère de la Guerre, was arrested on April 26 and implicated in the famous trial of thirty anarchists, charged with membership in a criminal organization and with having been in possession of explosive bombs (probably provided by his friend, the terrorist Emile Henry, who had just been executed). After a brilliant and courageous defense, Fénéon, with the other accused, was acquitted on August 12.*

extraordinary in the exhibition; some pretty studies by one Albert André, they have the painter's touch and subtlety.

*My dear Lucien,*

I am mailing you some newspapers so that you can read the account of the anarchist drama unfolding before the public, and also a very sympathetic article on our friend Fénéon by Mirbeau. What an epoch! What terrible events are in store, and what frightful misery!

I shall go to Miss Cassatt's in the afternoon. We are much disturbed by our lack of sales—nothing goes, that is of course the general complaint.

Lately I read an interview with one of the main painters of the Ecole des Beaux-Arts. The subject discussed was Caillebotte's collection.[1] The remarks made were stupid to the point of wonder. . . . Gérôme regards us as pimps! I will try to get the issues and send them to you.

PARIS, MAY 9, 1894

*My dear Lucien,*

I am in Paris for a few days. I just learned that the exhibition of Monet's *Cathedrals* will not be held; I am very vexed by this, I came almost exclusively to see them.

I just went with Durand's son to see Renoir. I will not be able to see the canvases of the Caillebotte estate for a fortnight. The lat-

---

[1] *His fortune had enabled the painter Gustave Caillebotte to help his colleagues of the impressionist movement by buying their works, especially those considered "unsaleable." The important collection that he had accumulated in this way he left to the state, stipulating that it be accepted in its totality. Despite this provision, Renoir, one of the executors of the will, was forced to yield to the objections of the curator of the Luxembourg Museum, and only part of Caillebotte's collection was admitted. But while only a restricted number of works by Pissarro, Cézanne, Degas, Renoir, etc., were accepted, the fact that impressionist works would enter a national museum gave rise to vigorous protest. In April, 1894, the review L'Artiste, attempting by means of a questionnaire to determine the general view, found that the Caillebotte donation was considered "a heap of excrement whose exhibition in a national museum publicly dishonors French art."*

ter's collection has been packed away, and to sort such a quantity of pictures covered with dust is a task for a slave.

As far as I can see, my spring has been a fiasco . . . no way of finishing anything. And I have been working from my window! Miss Cassatt strongly urges me to show my etchings in color with her in New York . . . but I am working on paintings at the moment, I don't want to lose my good mood; and then if I go in for that sort of thing, goodbye to painting in the open which Degas ridicules so wittily.

*My dear Lucien,*

I will go to Paris on Monday; Titi will join me there and I will accompany him to Brussels. I will avail myself of this opportunity, so long awaited, to see the beautiful collections of the Flemish school. I will hardly have time to work there, for I am to stay only until Titi is settled.

Neither Titi nor Georges have done much work here. They think mostly of blowing false notes on a hunting horn and bicycling through the country and other such pranks that hardly advance their knowledge of values and colors.

Georges is very changeable and easily becomes discouraged. . . . At such moments, no efforts! His excuse is that he is waiting for sensations, the old theory of "inspiration." I have not yet been able to convince him that inspiration, or rather sensation, has to be enticed by regular work every day.

The weather is frightful, cold and windy; impossible to work outdoors, so I am working on engravings: etchings in color.

*My dear Lucien,*

I received a line from Théo van Rysselberghe this morning. I at once replied that I would wait until he returned to Brussels before going there. I would like to visit Bruges and perhaps do some canvases there; but I must not think of anything like that this year, I am broke, completely broke. The trip to Brussels your

240

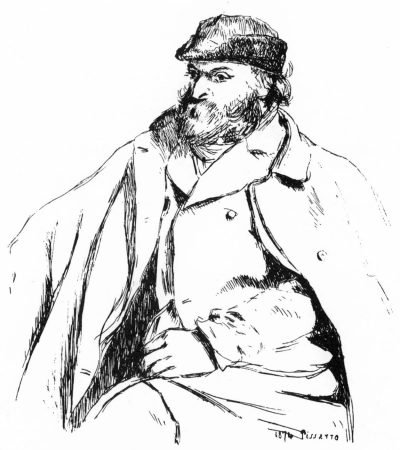

48.—C. Pissarro: Portrait of Paul Cézanne, 1874.

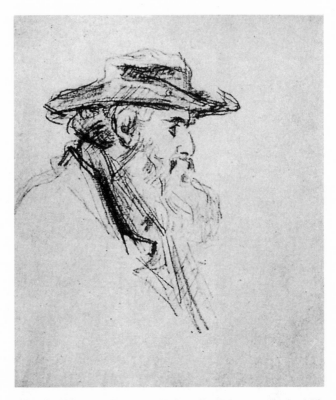

49.—P. Cézanne: Portrait of Camille Pissarro, about 1873.

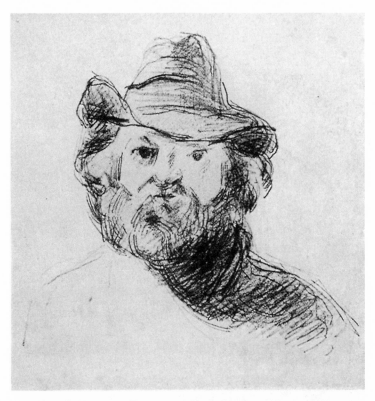

50.—C. Pissarro: Portrait of Paul Cézanne, about 1874.

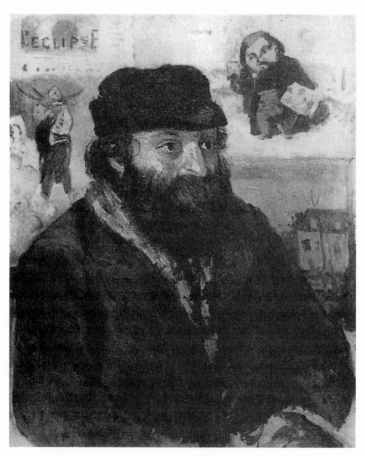

51.—C. Pissarro: Portrait of Paul Cézanne, 1874.

mother contemplates taking will simply empty my purse. And to complete the picture, there is nothing suggesting hope on the horizon: Portier is desperate, Durand is silent and secretive, Boussod simply doesn't exist. . . . The problem is to go on, and despite these hardly encouraging prospects, make works of art full of sensation, wholly uncommercial, satisfactory to both artist and collector; I should really like to see how the symbolists cried up by the young poet Mauclair would deal with such a situation. Mauclair the poet campaigns against me and against Guillaumin; he has a horror of painters who see in art nothing but impaste and cabbages.[1] What would the Gothic artists say, who so loved cabbages and artichokes and knew how to make of them such natural and symbolic ornaments? Words, words . . . and they control everything. Gauguin is behind this. Farceur and trickster!

I think you are right; if one wants to plant roses on a bad soil one has to add the necessary elements to the soil, but that is extremely difficult and the roses will never, I presume, be like those grown in proper soil. I fear that this is a result of our troubled times. We should not despair, however; the age of reason is not entirely here yet. I do hope that the time will come when the love of work will erase the tendency to decry everything, to see only one, the ridiculous side of things, without adding the redeeming character and kindness which, in art, have brought about a Daumier.

ERAGNY, JUNE 18, 1894

*My dear Lucien,*

I leave tomorrow, Tuesday, if time permits, for Paris. I will be there for two or three days at most. Your mother will join us, that is Félix and me, and we will take the train for Brussels. But the truth is, the miserable weather here makes everything uncertain, the season is getting on all the while, and it is necessary to

---

[1] *Camille Mauclair, the successor to Gauguin's friend, Charles Morice, on the* Mercure de France, *published in that review art criticisms of a pretentious character, launching insolent attacks on all the great contemporary painters. He saw in neo-impressionism a trifling technique, referred to Gauguin's art as colonial, spoke of the gangsterism of Lautrec, poured out his scorn for Cézanne, and treated Pissarro with pity. However, when the painters he slandered had died, their greatness established, Mauclair did not scruple to add his voice to the general expressions of admiration.*

come to a decision. We shall see whether the sun is sulky in Brussels, too. I am taking enough equipment to do two or three months' work; it will be necessary to work constantly and to good purpose, and I hope nothing goes awry. I have just enough money to pay our expenses, after that I will be penniless. But I don't see any other alternative.

PARIS, JUNE 23, 1894

*My dear Lucien,*

I believe that in Bruges I should concentrate on watercolors. I will no doubt begin several large canvases in the studio which I will complete in Eragny; I am afraid I can't work properly on canvases of 28 x 23 and 36 x 28 inches while travelling. I would like to make some carefully executed paintings.

At this moment there is a great noise about a Turner which Sydelmeyer wants to sell to the Louvre for two or three hundred thousand francs. The whole thing is a machination of dealers and collectors. So an exhibition of the English school is being held; some superb Reynolds, several very beautiful Gainsboroughs; two Turners belonging to Groult which are quite beautiful, and the Turner they want to "give" to the Louvre, which is not beautiful, far from it!

BRUSSELS, HÔTEL DE SUÈDE, JUNE 26, 1894

*My dear Lucien,*

We arrived in Brussels last night.

I met Théo van Rysselberghe at the station and we expect him this morning. We will probably be here for a week, and Théo will remain for that time, too. He will go with us to Bruges. Brussels and its outskirts seem to me to have character; while on the train we saw some dazzling motifs.

Nothing new except the assassination of President Carnot,[1] an event which cannot fail to complicate things in France. How will

---

[1] *The assassination of the President of the French Republic by an Italian anarchist was to lead to further persecutions of the anarchists.*

242

all this turn out? The poor painters will certainly not be unaffected. Théo has just come in and sends you his regards.

Your mother and Félix are well and the three of us embrace you.

*My dear Lucien,*

We have arranged with Théo to leave Brussels on Friday for Antwerp, but we shall not stay there; the very evening of the day we arrive, we shall make for Ghent, from where we shall set out again for Bruges and take in the country on its outskirts. In this way I can find a suitable spot. We shall see Knocke-sur-mer. When we are settled, I shall let you know the place.

We began several sketches by the canal; it is quite interesting, but we are not settled and so can't do much.

We are all quite well. Your mother went to the woods with Félix, I am waiting here for Vandevelde.

*My dear Lucien,*

I have been back since Monday. On Tuesday your mother left for Brussels; she is returning to France. All I have done so far is make a few watercolors; the country is remarkably beautiful, but for some time Titi has not been too well. He had some trouble with his stomach when we left Paris; leaving Brussels with van Rysselberghe we were as gay and lively as could be, at Antwerp, at Ghent, here and at Knocke one tends to be too active; Titi went bathing with Théo, and this must have aggravated his condition, he came home tired out, with a headache, burning eyes and a cold that worried me no end. What disturbs me most in all this is that Titi is bored here and doesn't want to remain in Belgium. What to do? The problem is to see that he finds something to suit him, but where? It is true that he has some reason for being dissatisfied here, considering his distress, but just the same I fear no good will come of it. I don't think it possible to return to Eragny at the moment.

How can I work?

*My dear Lucien,*

Don't trust this country of Belgium to the extent of mentioning events which disturb everyone, the plain bourgeois and the most ferocious anarchists: the terror of the Panamaites is so great that just to mention the name makes them furious. We received (that is Théo did) a letter from Charpentier giving us news of Luce.[1] Our friends are attending to his wife who had a baby. To cap their misfortunes, she has just been taken back to the hospital with an abscessed breast. I didn't dare write our friend Georges Lecomte, fearing to cause him grief, for truly, no matter how innocent you are, you may cause a lot of trouble to your friends without meaning to. I don't receive the newspapers here, it is impossible to get them, and so I am no longer in touch with events.

Titi is much improved since we came. We have begun to work in the periods between the bad weather. Théo is really wonderful to us and does everything he can to make our stay pleasant.

I have such anxieties about the future that I am afraid my paintings will be affected. Just conceive that the collectors in Paris are so dismayed by events that they won't hear art spoken of now, in America it is even worse, nothing, nothing! . . . Miss Cassatt says it is simply due to the election, and that the situation will be restored when the new group comes in! Which is to say that new pickpockets will replace the old! . . . There's consolation for you! However it is the plain truth.

*My dear Lucien,*

I have been back from our excursion to Zeeland since Friday night. At Middleburg I saw those women's costumes and the charming children of which you spoke with such enthusiasm. They have, in fact, extraordinary aesthetic beauty, I can say that we really have been tipsy with the local color, atmosphere and extremely primitive style of this little corner of Holland. Elisée

---

[1] *Maximilien Luce, who with Fénéon, Signac, Mirbeau, Grave, Elisée Reclus and many others belonged to the group of anarchist intellectuals around Pissarro, had just been arrested.*

Reclus, Théo, Félix and I have spent two enchanting days: we went as far as Westcapelle, the extreme point of the island of Walgrave, so abundantly fertile that it reminds me in a way of the islands surrounding St. Thomas. At Veere I saw motifs for superb landscapes, the butter markets of Middleburg under great trees; what a picture!

I am afraid I shall be forced to remain abroad for some time. Since the last law passed by the French Chamber, it is absolutely impossible for anybody to feel safe. Consider that a concierge is permitted to open your letters, that a mere denunciation can land you across the frontier or in prison and that you are powerless to defend yourself! Our friends have successively left France. Mirbeau, Paul Adam, Bernard Lazare, Steinlen, Hamont were to be arrested, they managed to escape in time; poor Luce was caught, probably someone denounced him. And since I don't trust certain persons in Eragny who dislike us, I shall remain abroad. I wrote to Durand-Ruel to this effect and to ask if he wants me to send him some paintings.

I haven't done badly here, I have seven or eight canvases going.

KNOCKE, NEAR BRUGES, AUGUST 9, 1894

*My dear Lucien,*

I arrive from Brussels with Rodolphe. You ask if I have been as upset; of course, I have had horrible fears lately. I am hardly in a better state than you are, but I make every possible effort to triumph over these afflictions. They are inevitable for whoever is concerned for his family, friends and art! But one must fight bravely.

I made the acquaintance here of some young painters from Munich who are very enthusiastic about the impressionists and who asked me to exhibit in Munich, where I have some supporters and a few collectors. I think I will have to have an exhibition there, here in Brussels there is nothing, nothing can be accomplished in the way of selling. So I may go to Munich. I didn't tell you that Durand wrote he would be delighted to remain on good terms with me, but business has been so disastrously dismal, he will have to lower my prices. So I will try my luck in Munich, I will write you about this at greater length. What disturbs me is the expense of

frames and transportation. All the same I will send some canvases to Durand.

As for my nudes, I am not satisfied; I didn't have all the data I needed, I didn't succeed in rendering the character I had in mind. We shall see if I can find what I want in Brussels.

[KNOCKE, AUGUST, 1894]

*My dear Lucien,*

I am sending you a hundred francs, if you want to come don't delay. I have still two canvases to finish, which will take at least eight days. If you come at once you will find me still here. The four large canvases I finished will have to be dispatched at the earliest possible moment to Durand.

KNOCKE, AUGUST 21, 1894

*My dear Lucien,*

I am happy to be able to inform you that our friend Luce was released Friday; Théo brought the news this morning and let me read your letter.

Your mother writes that something extraordinary has happened: Edline wants to repurchase the house. I wrote your mother to ask a stiff price, and in any case to consider whether, if the deal went through, we should not settle down in the outskirts of London, since the whole family will inevitably be there. I am almost certain that your mother will not consent. In any case we would be able to return to Pontoise and yet have our home with a studio in London, or rather in the outskirts. Thus we could give the little ones a good education. This solution would not alter our situation with regard to the dealers. Here the difficulties are the same as in France, however in Théo and his family we have such devoted friends that I would really hate not to stay. It is a pity!

*My dear Lucien,*

The truth is I don't know when I will return to France. I have finished four large canvases of about 28 x 23 inches; I had my troubles with these, the weather was so abominable; I have three more canvases of about 25 x 21 inches to finish and would like to make up for lost time by starting on several others. It is very hard to do anything good when one's sessions are so often interrupted. It is this, no doubt, which makes me so indecisive and discontented. Moreover, Durand's behavior worries me; I keep on announcing to him that I have a series of paintings, I have not yet received an answer and so I am still in the dark. To make matters worse, I find my studies very poor. Could I return to France safely? I don't know at all. I notice that a number of the militant figures have left. It seems to me that I, who am absolutely of no importance and participate in no actions of any kind, should have nothing to fear; but as you point out, there is always a threat of some sort.

\*    \*    \*

*After meeting Lucien in Brussels, Camille Pissarro decided to re-enter France while Lucien returned to his family in England. Rodolphe went with his father to Eragny, while Félix, who had been joined by Georges, remained with Théo van Rysselberghe at Hemixem near Antwerp. Before leaving Camille Pissarro left some of the paintings he had done in Belgium with Octave Maus, director of* La Libre Esthétique *in Brussels, who thought he could sell them.*

\*    \*    \*

*My dear Lucien,*

I leave at 3:40 for Eragny. Viau is lending me just enough to send Georges and Titi, with just a little left over for the house. I expected Portier to advance me something, too, but he has been away for fifteen days. I have been to Durand's; I saw Durand junior, but I didn't mention my four pictures. I am playing dead,

I am waiting to see what will happen. Business has been terrible this year.

I haven't much news for you, unless in the following there is some justification for hope: Monet has refused to lower the prices of his *Cathedrals*, he is asking fifteen thousand francs for each of them! Durand can't be happy about that. I must be a poor sort indeed for him to kick about my modest prices! I have had no news from Germany and I have not heard from Octave Maus.

<div align="right">ERAGNY, OCTOBER 21, 1894</div>

*My dear Lucien,*

I haven't brilliant news for you—black poverty and not a ray of hope on the horizon. On the contrary, Portier sends back all my canvases and writes me that the collectors don't ask for my work; the American he was expecting arrived sure enough, but what he wanted was a Manet. I met Vollard in Paris, he told me the story of this American who came to Paris to find a beautiful Manet and was willing to pay any price if the painting met his expectations. All the dealers were exhausted from continual searching in every corner for the pearl. Finally this nabob purchased the *Woman With Guitar* from Durand-Ruel for 75,000 francs. Amazement far and wide! . . . In this affair I feel the hand of Faure, Durand and Co.; they have that kind of slyness!

More gossip: all Paris is buzzing about the prices Monet is asking for his *Cathedrals;* Durand would like to buy the series as a whole, but Monet wants fifteen thousand francs for each painting. They quarrel, more gossip. The collectors say Monet is wrong. For example, people want to see the paintings before America gets them. Ah, there is such love of painting in this period! It is discouraging to think of.

Viau wrote me requesting an introduction to Monet, he would like to see his series of *Cathedrals*. I must ask Monet if this is agreeable to him. So I may go to Giverny any day now; I will have to tell him that I still can't pay him, that Durand takes none of my work.

Happily we are all very well, although very sad, too.

I am very glad to see you in such a vigorous frame of mind, my dear Lucien, the situation, undeniably painful, but not irremediable, does not call for despair. For after all, it is because I decided not to give in that I find myself empty-handed; I should only have to take up Durand's last words to me for the war to stop! Didn't he say to me: "If you wish to send some canvases of Eragny to my son, we can come to an agreement, that is, if you lower your prices considerably." I am waiting for some miraculous chance. For the moment my hopes are limited to Miss Cassatt's recommendations to Miss Holloway, whom I knew and who I am sure loves my work, but has not yet gotten anything of mine sold. However she has done much for other impressionist painters. I should also make the acquaintance of Mr. Chase, the well-known collector from New York, etc., etc. But none of this is quickly done. Why don't they come to me of themselves, as to the others? For I have been recommended already and even presented. Someone is barring my way, that is almost sure. Your mother says it is because my ideas don't suit them. But my pictures are not the worse because of my ideas. Yes, I seek here and there for a solution and do not find one, although it seems right near me and easy to grasp.

I hardly count any longer on the Dresden exhibition: this is why: I made M. Morawe these conditions, he was to buy several of my paintings at dealer's prices. I think it would be idiotic to go there and struggle for the sake of a dealer's beautiful eyes; he will get the admission fees while I would receive only platonic praises which are quite unable to allay the pangs of hunger. If he refuses, I will try elsewhere, perhaps in New York. This can't be done recklessly, considering that Durand could do me a lot of harm, Durand is a man who has to be handled.

—Miss Cassatt writes me that she has seen my canvases of Knocke [880–892], she admires them no end, especially *The Mill* [882 or 883]; it is not from this quarter that criticism comes, I know that. There must be an element of nature in my canvases which hurts certain aesthetes. Naturally when I go for the first time to a country that has a distinct character, I have to analyze what I see carefully, I cannot embroider, I cannot give myself over to my fantasy, as in a country I know by heart. Hence the severe and dry quality, which, incidentally, will finally please by its very sincerity. Miss Cassatt tells me I have had much success in Chicago

and that everything I do ought to sell. Now that is past under-standing!

*My dear Lucien,*

I believe this crisis will soon be over, it is not possible to con-tinue the struggle. I came from Durand-Ruel's; I went there with the intention of asking him if he would like to come to an agree-ment. The son Georges (for the father is in New York) said, as he came over to me, "I was just going to write you, Monsieur Pis-sarro!" Thus a graceful introduction to the matter at hand was facilitated. We came to an agreement, and I am writing instruc-tions to Eragny that he be sent a series of Eragny works which, I hope, will be acceptable.

Between the two of us (don't breathe a word at home of what follows), I am not displeased to end this struggle, the situation was becoming untenable. In addition to absolute lack of funds and to concern for your brothers in Belgium, I had to put up with inces-sant arguments at home. You yourself were the cause, innocently, of course, of heated squabbles about the inability of all of you to earn money. In your letter to your mother you took her side, agreeing that it would have been better to have learned a trade. But you also said that you have three trades, but that you pursued them too intelligently and that you are unable—because of your very conscientiousness and zeal for perfection—to profit by them. To do so you would have had to remain a tradesman or a chromatist! Would you have been better off? Your mother says yes.

In your letters to your mother make no allusions to trades. I can say nothing more to you about this tiresome matter, and besides, when the crisis is over, I hope it will be partly settled.

An article has appeared (most timely) by a critic, M. Francis Jourdain, asking with the utmost seriousness how it comes that the "précurseur," the "old painter who never compromised," has not been decorated! I wanted to write him that I didn't care the slight-est bit to be decorated. What would be the good of it?

The check I am sending you is from the money your mother borrowed at Eragny.

*My dear Lucien,*

I dropped in at Durand-Ruel's this morning to discuss terms. The son, Georges Durand, is hesitant about taking my canvases at the reductions I made. Here are the previous prices:

|  |  | I proposed: |
|---|---|---|
| canvas of 36 x 28 inches | 2,500 francs | 2,000 francs |
| canvas of 31 x 25 inches | 2,000 francs | 1,500 francs |
| canvas of 28 x 23 inches | 2,000 francs | 1,000 francs |
| canvas of 25 x 21 inches | 1,500 francs | 1,000 francs |
| canvas of 21 x 18 inches | 1,000 francs | 800 francs |
|  | 9,000 francs | 6,300 francs |

On five canvases I lowered my prices to the tune of 2,700 francs. He hesitates and wants to think it over. Unfortunately I haven't the means to hold out long; however, I was visited in Eragny by an American painter, a woman, a friend of Monet's, who is very enthusiastic about my work. She asked me for paintings to show to Americans, I let her have three canvases. This lady, who has real prestige, introduced me to Mr. Shaw, a great lover of Millet and Corot, who has a very fine collection purchased directly from these two masters—he hates all dealers, especially Durand, and complains, not without reason, that the dealers have assumed the task of governing tastes and of showing only those paintings they think are salable. This Mr. Shaw could be a base of support in a struggle against Durand, but this will take time. I think he may be of use in the future, but I can't wait and I must agree to Durand's reductions. You may be sure that if I were not pressed I would refuse so categorically that he would be forced to reconsider.

For several days now quite a few Americans have gone to Durand's to see my paintings; this development may be attributed to the American colony in Paris. I notice now that Durand is obviously undecided. If I had only several thousand francs, I am almost sure I would get the upper hand without lowering my prices by one centime, for I cannot help noting with astonishment the gap between my sales and my reputation—which is great.

I know perfectly well that my *Peasant Woman* is too pretty, this is nothing new. For it is only by working carefully that I get

251

what I am after. It wouldn't be a bad idea to send it back to me, I will retouch it. I will send you several small figures, but these oil paintings are on the verge of becoming pretty, I rework them incessantly—a very delicate kind of work, which is only possible in moments of great clarity of vision, moments which are blotted out by the cares and vexations of the day. So I am damned suspicious of my work! For more than eight months I have been after a peasant woman of grand stature crossing a brook [900]. How I have worked on it! It won't look right in less than twelve years!

As soon as I have something, I will send it on to you. I have something which I think will be satisfactory, a *Little Peasant Girl Soaking Her Feet* [903], but it will have to lie around [in the studio] for the present; although it is finished, it lacks—well, something! I do think I will get it right, I feel that I will!

ERAGNY, NOVEMBER 30, 1894

*My dear Lucien,*

Your prints are really beautiful although I knew them, they have been a surprise. I hope they will be successful; considering the difficulties that had to be overcome, these works are indeed deserving of praise. I know well the pains you had to take to obtain those faded grey tones; especially since I began to try etchings in color; I made some prints that came out as grey as gouaches, but unfortunately I spoiled so many; and I am dissatisfied with my drawing, which was defective and would have required considerable scratching out to set right the forms. It is too absorbing and not worth the trouble.

I have begun some figures, canvases of about 18 x 15 inches; I shall do a number of these, for these deuced studio paintings seem to go on forever. I still have on the easel my *Peasant Woman Crossing a Brook* [900], which I wanted to send you, but I cannot get it to satisfy me. I began it last winter, I worked like a beaver, and scraped it so much that it was often unrecognizable. I will have to work on it for a while from nature to get it in shape.

Did I write you that Portier, the picture of contrition, informed me in a piteous tone that he sold two small Knocke [canvases], directly after receiving my trunk of paintings which Maus showed

to all his Belgian friends without being able to place any at 1,500 francs. In Paris, I sold a canvas of 21 x 18 inches at that price and one of 25 x 21 inches for 2,000 francs. If other sales are made, I will send you a little more for your publication. At the moment it is difficult, for there are many old debts to be paid here and in Paris.

The boys are settled in Brussels; it costs much less to live there than in London.

*My dear Lucien,*

I am working on a canvas of about 21 x 18 inches, it is of a young peasant girl rising to arrange her hair [864]. It is well advanced, but it will have to lie around in the studio for a while.

Did I tell you that I am sending four or five pictures to Dresden? M. Morawe insisted on having whatever I could send, so I decided to send him for the exhibition he will hold in February the following canvases—although I may make some last minute changes:

My *Knocke Sunset* [888];

*Peasant Woman Soaking Her Feet in a River* [903];

*Cowgirl* [823], which I showed at the exhibition of 1892, which I reworked and which is now superb, I think;

*The Flood*, which belongs to your mother.

We can have a try at exhibiting paintings next year at van Wisseling's [in London]. To do this it would be necessary to repeat what I tried with Thomson, that is, to do several good canvases in London next spring and add to these several figure paintings done in the studio which I will have time to perfect here.

*My dear Lucien,*

I must confess that I find Shannon's nudes—I can see that he has plenty of talent, thank God!—I find his nudes the least bit too studied, too deliberate. How explain this impression other than that my vision is defective? It is probably owing to my having made very few drawings of nudes. Just the same Degas never

253

strikes me that way, Puvis de Chavannes sometimes, in fact, often. What saves the former is a certain ignorance or awkwardness, by which he achieves a real feeling for the nude. I don't know whether this is clear to you.

Would you believe that I lately received a letter from a certain M. Mathias Morhardt asking me on behalf of various admirers of Puvis de Chavannes to be a member of the Committee of art lovers who are holding a banquet in his honor! You know how opposed I am to these ceremonies. Annoyed and embarrassed, all the more so because I admire Puvis de Chavannes, I didn't know how to get out of it; the devil, so much the worse for them, I thought, and I wrote this gentleman frankly that I was very unyielding when it came to any sort of ceremony and that despite my admiration for the artist I would have to ask him to be good enough to call on someone else, although I was not unmindful of the great honor done me. It appears that Rodin is president of the Committee; I will send my subscription just the same.

PARIS, JANUARY 9, 1895

*My dear Lucien,*

Théo [van Rysselberghe] is in Paris with his wife, an exhibition of his work has opened at the *Néos*. The ensemble is what you know: large portraits showing a rare talent for physiognomy but spoiled by the pernicious practice of systematic employment of the dot. Very beautiful drawings of nudes, for instance, very large and with an attractive line, charming pastels full of character. Théo is very gifted; I am afraid he will persist for some time yet in this terrible and cold manner of execution, which has value only if one looks at works exclusively from the point of view of conscientiousness and stubborn toil. It is a great pity, for he would be a rare painter, no doubt of it.

ERAGNY, JANUARY 14, 1895

*My dear Lucien,*

Théo and his wife spent two days here, you can imagine how we raked up paintings, drawings, engravings, discussed various theories, including the theory of the dot. I should really like to see Théo rid himself of these shackles that make his painting cold and inanimate, when he has such real talent as a painter and draftsman. . . . But I am afraid that his friendship for Signac makes him light-headed; it is strange that the technique doesn't bother them! The method, as I told him, is good only for mosaics, and thus there would be no reason to strive for modeling, it would be a purely decorative art, with what beautiful *matière!*

255

Théo thought my etchings very beautiful, the paintings, too, including the nudes. He said something that pleases me particularly, if indeed he really felt it. He said my nudes were completely outside the formula of the schools and had an outdoor and real peasant quality.

On arriving from Paris I found your pretty announcement for *The Queen of the Fishes*.[1] It is delightful and the little woodcut is both charming and in harmony with the letters. Théo found it superb. In short, it is art.

It is very likely that after my Dresden exhibition I will have one in Berlin. M. Stremel, the painter of Knocke-sur-mer, wrote me proposing this.

I should like to send you a canvas or two, but I'm afraid they are not yet ready. I am working on them all the time. I will soon have a large canvas, about 31 x 25 inches, an old work, which you know. It was exhibited at Théo van Gogh's, but was cold and systematic in execution. I recast it and redesigned it from a model; I think it will be satisfactory.

ERAGNY, JANUARY 18, 1895

*My dear Lucien,*

We can continue *Les Travaux des Champs*, as to *Daphnis and Chloe*, I am ready to make the twelve drawings, and if you design a nice fount of type, it will be superb. If I don't often mention the drawings for *Les Travaux des Champs* it is because I have so many things on my mind, many a tiresome problem including the problem of earning money. Consider that at this moment I have about twenty canvases going, studies of very fugitive effects, which I would like to work on at my leisure, nudes which give me no end of trouble (my model having quit without any idea of returning), etchings in color, and with all this, no sales, not to speak of the grave political situation; troubles enough, no? I don't know how I'll manage the nudes for the *Daphnis and Chloe*, they are indis-

---

[1] The Queen of the Fishes, *the first work illustrated and printed by Lucien Pissarro, was not exactly a book, but a kind of album, the pages were printed on just one side and were bound as in Chinese books. The text was written in hand and reproduced by photographic plates. It was a first effort, and by it Lucien gained experience in the craft.*

256

52.—A. Renoir: Portrait of Paul Durand-Ruel, 1910.

53.—P. Cézanne: Portrait of Ambroise Vollard, 1899.

54.—Illustration for *Daphnis and Chloe*. Drawn by Camille and cut on wood by Lucien Pissarro, about 1895.

pensable. Well, we shall see, but it seems difficult to do properly without consulting nature.

The shop on the rue Laffitte is still there but has been completely changed; the *Néos* have broken up. Moline is renting out the shop for small exhibitions. Théo is the last *Néo* to have an exhibition as a member of the group.

I received my colored plates, I had had them steeled. I will send you soon a fine print of my *Little Peasant Girls in the Grass* and a *Market* in black, retouched with tints; I think some excellent things can be made in this way. . . . It has no resemblance to Miss Cassatt, it involves nothing more than retouching with colors, that is all. I have already gotten some fine proofs; it is very difficult to find just the right colors.

The banquet for Puvis de Chavannes took place yesterday.

Brunetière, the Academician, wanted to talk about art and, it seems, talked stupidly; he was hissed! I think I was wise not to attend. Poor Puvis, I am really sorry for him. . . . But what if he really likes that sort of thing?

*My dear Lucien,*

Yesterday I wrote you about drawings for *Daphnis and Chloe;* I have a new idea: why not make the drawings yourself? With your own drawing you can really call attention to your gifts, which are going to get some recognition with *The Queen of the Fishes* and the *Ruth.*[1] It would be very imprudent of you to engrave my drawings. And in my opinion my drawing is not entirely suited for woodcuts. I think it would be a sheer waste, and if successful, I would be the one to benefit—that is not desirable. Well, think it over and see if it isn't better to address yourself boldly to making, as for *The Queen of the Fishes*, a harmonious work, all your own.

It seems that the State has definitely refused to accept the Caillebotte bequest. Now what do you think of that? What a pity Caillebotte didn't provide for its being offered to some foreign country in the event that France refused it. That would have been a real slap in the face.

*My dear Lucien,*

The impressionists, except for Monet and Degas, seem to be losing ground, there is a widespread attitude of indifference that is very disturbing. So if you can get van Wisseling to handle my paintings, that will be all to the good. From all indications my exhibition in Dresden is likely to be another disappointment; I have not heard a word from the dealer, M. Morawe; he has sent me neither an announcement of the opening nor a catalogue. It is wonderful how they mock us! I promised to send these paintings

---

[1] *Lucien was then preparing the* Book of Ruth *and the* Book of Esther, *which, printed in Vale type, was to appear in 1896.*

to Berlin, but I suppose that will be another hoax of the same sort. And into the bargain they may find the paintings horrid! It will be like in Brussels. . . .

Did you receive Geffroy's brochure? He urges the municipality to make an attempt to get the artists, collectors, mayors and advisers to organize neighborhood museums so as to win the workers to things of taste and bring them to abandon their unfortunate penchant for trash. This good Geffroy is right, what is needed is a small scale Kensington Museum in each neighborhood. But I wonder whether this would be enough to educate the poor to a taste for art or love of it! As long as he has the capitalist and wretched wages to contend with, the worker will regard the beautiful with derision. . . . It is the buyers we must educate.

Did I write you that I received a letter from the curator of the Luxembourg Museum asking me to appraise the six paintings [of mine] which were chosen from Caillebotte's collection, but he adds that this is just in case the interested parties should come to agree. What a gang of idiots! I wrote that I would reply when I go to Paris and look at this collection, which I have lost sight of for fifteen years.

Sunday

On the subject of the application of decorative art to industry, more than ever on the order of the day, I want you to know that *La Révue Encyclopédique* has devoted several articles to the question. F. Régamey, among others, makes the judicious observation —we have often said the same—that those who have taken up this venture evince an extraordinary lack of taste. Thus the *Union Centrale des Arts Décoratifs* issues a plan (printed in very meager type on horrible paper ornamented with tail-pieces that have been used for years in all the commercial publications) and warmly enjoins young artists to imitate the English, who try, in all circumstances, to please and not offend the eyes of people of taste (sic!) !!! Régamey concludes with this rather comical outburst: Arbiters of good taste, be watchful! America and England are only waiting for you to slip! Patriotism makes it your duty to—etc., etc. . . . Amazing, no?

Then there is a well documented article by Jean Lahor, on William Morris and the decorative arts in England. This author describes for us the birth of Pre-Raphaelism and the art of Morris.

In a typical passage he says that at chromo-lithography we are as good as, and even better than, the English, and points to Boussod & Valadon! He speaks of Ricketts, and especially of Beardsley who gives promise of artistic greatness; in regard to etchings he mentions Whistler and Seymour Haden, but no French artists. Damn it, this Lahor does not know the etchings of Degas! He says, for instance—it is perfectly true—that there is no lack of men of talent in France, what is lacking is the cohesion to form a tendency. It seems to me that everything that could possibly discourage art tendencies has been done, just think among other instances of the impressionists who would have been able to achieve a real synthesis if the young men had been able to earn a livelihood with some ease. Slogans and patriotic exhortations in concluding. Really, they understand nothing.

<div align="right">PARIS, FEBRUARY 19, 1895</div>

*My dear Lucien,*

I am going to Caillebotte's house at two o'clock to see my pictures and make a selection for the Luxembourg; this morning, at Camondo's,[1] I shall see Monet's *Cathedrals;* he [Camondo] has three of them, he paid 15,000 francs for each;—I have been to Durand's, he was very friendly. I didn't bring up business questions. I am so discouraged by what I am doing and by the indifference the collectors show for my work that I have become much too timid. When I see the paintings of others, my own appear so poor and weak!

<div align="right">PARIS, FEBRUARY 24, 1895</div>

*My dear Lucien,*

I received a letter from Dresden announcing that the exhibition will close in the first week of March: the dealer is no doubt afraid that I won't pay for the frames he had made: the cost, I believe, comes to 400 bucks! And as a result people found my work *inter-*

---

[1] *Count Isaac de Camondo had an important collection of impressionist paintings which he later bequeathed to the Louvre and which today fills several rooms of that museum. Pissarro is represented in this collection by two canvases [540, 867].*

*esting*, he informs me! Small comfort! Just imagine if I had sent thirty pictures and thirty or more pastels and etchings! I was wise to content myself with sending only five canvases. It will be the same story in Berlin. Why should people there be interested in my paintings when even in Paris where I am known, known by everybody, people scorn or don't understand them. Moreover, as a result of this incomprehension I myself am ending up by wondering whether my work isn't poor and empty, without a hint of talent. It is said that money is scarce, but that is only relatively true; doesn't Monet sell his work, and at very high prices, don't Renoir and Degas sell? No, like Sisley, I remain in the rear of the impressionist line.

[PARIS] FEBRUARY 28, 1895

*My dear Lucien,*

I am leaving at eleven o'clock, very morose and bitter, for I have not been able to get even a little money. I am leaving without a cent, it is sad, and the fact is that I am so keyed up for work, for Paris gave me a lift, and I have conceived a whole project for future work. I am awaiting with impatience the trifling sale which Camondo should arrange for me with King Milan. It won't amount to much and God knows if it will come off, although the two things I sent him [a gouache and a pastel] seem to me not so bad.

What you write about the progress of the impressionists abroad is only too true; evidently we were dropped before arriving! But I remark this, a consoling fact, there has been a great and real change. The symbolists here are finished. Gauguin, who is their foremost figure, has just had a serious set-back; his sale was very poor.[1] Without Degas, who purchased several canvases, it would have been still worse. Speaking of Gauguin, I discussed him with Degas lately. Degas made this characteristic remark:

"My dear fellow, I have a certain liking for what he does, although I am not at all blind to his tricks."

"Well," I said, "I, too, know that Gauguin has talent. Didn't I

---

[1] *At the sale organized by Gauguin on February 18, 1895, before his second and final departure for Tahiti, the sum obtained for about fifty paintings hardly exceeded 15,000 francs; the average price for each picture was thus about 346 francs.*

261

tell you so long ago? But don't you grant that he is too much of a trickster?"

Incidentally, this was once Degas' opinion.

Curiously enough, his own pupils are beginning to drop him and returning to good and simple nature. One of them, Séguin, who has just had a show at Le Barc de Boutteville, admitted to me that he had been barking up the wrong tree and that I was completely right. He paid me the greatest compliments for my etchings and figure paintings. Moreover, there is a coterie of young artists who claim to be followers of mine; Agar, Labusquère, etc., who exhibit at Moline's, consider me their leader. I feel—do I deceive myself?—that I am seriously understood by some of the young artists, and it is interesting to note that neither Monet nor Renoir are followed. Their work is counter to Gothic French art.

*My dear Lucien,*

Still in Paris, because I want to attend the funeral of our old comrade Berthe Morisot, who died after an attack of influenza. You can hardly conceive how surprised we all were and how moved, too, by the disappearance of this distinguished woman, who had such a splendid feminine talent and who brought honor to our impressionist group which is vanishing—like all things. Poor Madame Morisot, the public hardly knows her! It is just speculation now that makes reputations and gives one glory, fortune sometimes, but often poverty.

Let us talk about that, about poverty! It is still here, no? I am waiting for the fifteen hundred miserable francs from the King Milan who, I think, is going to find my prices exorbitant. I had to borrow four hundred francs for the boys in Brussels. Your mother is furious because they don't earn any money, and this is understandable. She says it is my fault, that I maintain them in idleness, that they are not working, etc., etc. In short she concludes that we ought to get Rodolphe a place with a banker or a notary so that he can earn money right away. Yes, and then?—Your mother doesn't understand that if I put Rodolphe with a banker or a notary he would give it up altogether one day as a result of not liking the work and not learning anything. A waste of time! What I should

have liked, and what you alone have accomplished, would have been for the boys to learn enough about art to be able to make either books or furniture, chairs, tables, or jewels . . . but damn it, one must have real understanding of art, and that takes a long time to learn and is taught nowhere! However, nothing has been lost, some day I hope to see the boys working in one of the applied arts.

I asked Rodolphe to send you the newspapers in which you will see the letter of Strindberg, the Norwegian dramatist, to Gauguin, and the latter's reply.[1] This author has a poor opinion of the impressionists, he understands no one but Puvis de Chavannes. That's the thing, it is always the Greek, the Renaissance, against the tradition of *French Gothic!* For we are nearer to the French Gothic, especially Degas!

<div align="center">ERAGNY, MARCH 23, 1895</div>

*My dear Lucien,*

Did you know, it is very possible that Durand will start a branch in London? It is absolutely necessary for me to know if he will, for van Wisseling won't dare compete with him in handling impressionists; none of the other dealers did.

I have three etchings in color, I am ready to pull some proofs. I was interrupted by the arrival of—you'll never guess—Francisco Oller,[2] who came here from Puerto Rico to enter a very large painting, more than four yards in size, in the exhibition. You should see how changed he is! It is twenty years since we saw each other. He has changed, aged in every respect, he is shrunken, and I am afraid his painting likewise; he looked at my works with bewilderment, he found them full of light and air. He makes paintings with anecdotal motifs, like the *Negro Flogged* at Tan-

---

[1] *When he was preparing for his final trip to Tahiti and organizing a last auction sale of his works, Gauguin asked Strindberg to write a preface for his catalogue. The latter replied with a long letter in which he justified his refusal to do so, saying: "I cannot understand your art and I cannot like it." Gauguin used this letter as a preface, publishing it in his catalogue with his reply.*

[2] *The painter Francisco Oller y Cestero, born in Puerto Rico in 1833, was one of the group around Pissarro during his first years in Paris. Most of the group came from Cuba and the West Indies, and all spoke Spanish. Oller, the pupil of Courbet and Couture, worked around 1861 in the* Académie Suisse *where he became acquainted with Paul Cézanne. Pissarro often went to the academy to see them.*

guy's. The photograph of his painting seemed very much better to me, but I am afraid it is a bit obvious.

*My dear Lucien,*

I have a canvas on which I have worked from time to time for about a year and a half, a canvas about 18 x 15 inches in size, a great gawky figure of a peasant girl, ugly, she is crossing a brook [900]. She fills almost the whole canvas; there is a cloudy and luminous sky, the trees are green-blue; the execution is uneven, but there is nevertheless a great unity. The picture disgusted me for a long time, but now I rather like it; I now see sometimes many beauties in it and don't dare remove certain little defects lest the ensemble be impaired. I am afraid it is rather terrifying; but I think time will make it a little more *amiable*, if I may so express myself. I also have *Washerwomen* [933], big peasant women tossing their breasts. Oller found them most beautiful; although [the painting] is less complete than the prettier one, I find it not bad; but the washerwomen are perhaps too bare for the English, they are in shirt-sleeves. However, there is enough in the painting so that this feature won't be too prominent.

Things are so bad that I am accepting 500 francs for a canvas about 16 x 13 inches in size, *Young Peasant Girl Standing Nude* [936], a picture I thought highly of. But what can one do, they find 600 francs too high!

*My dear Lucien,*

I am still here, I am waiting for Durand to decide my fate. Thirteen canvases have been deposited at the rue Laffitte, and father and son are now deliberating whether it is wise to buy my work. I am not expecting good news. I hope I will know their decision today.

I don't know when I will return to Eragny. That depends on Durand, for if he doesn't take the whole batch, I shall try Boussod, who may take some.

I have a large lithograph on stone, a *Market* [D.147], going. I am working on it here in Paris. I messed it up with wash, scratched out parts of it, rubbed it with emery paper; I don't know how it will come out, but it was foolish of me to make a *Market*, I should have done some *Bathers*. I have some motifs on metal plates which are very amusing, and I am allowing myself a series on zinc (it is so much more convenient). I will do some in two or three colors, little retouching—nothing to it!—it will be amusing. What a pity there is no demand for my prints, I find this work as interesting as painting, which everybody does, and there are so few who achieve something in engraving. They can be counted.

Impressionist art is still too misunderstood to be able to realize a complete synthesis. . . . I remember that, although I was full of ardor, I didn't conceive, even at forty, the deeper side of the movement we followed instinctively. It was in the air!—In this connection there is an article by Mirbeau on the symbolist movement here, it is entitled *Lilies, Lilies!* I shall send it to Georges and Titi, it will give them food for thought. It has great good sense. Symbolism, here, is finished, done for—at last! Nature, the splendid nature of French Gothic takes the ascendancy.

Georges and Titi should have addressed themselves to doing a little work in industrial art. I pointed out to them that skill of this kind would enable them to earn a livelihood and make them travel around in order to place their works. It would also be a satisfaction to your mother. Unhappily, exhortations and advice are dead letters, the boys depend too much on me. This is bad from two points of view: the practical and the artistic. If you want to succeed some day, you should turn to the movement seeking to relate art to industry and create an impressionist style in this field. There is still time!

This nice fellow Mellério evidently approaches all these ideas only from the surface, but he has good will. He doesn't have a deep enough artistic sense, but what literary man has? Didn't Geffroy in a conversation with me put Willette above Forain, on the basis that Forain follows Degas? He doesn't understand that Willette follows the Ecole des Beaux-Arts! It is enough to make one despair!

Tomorrow I shall see at the exhibition of the *Indépendants* the large painting by Signac, 4 x 5 meters, a *decorative picture*. Lecomte praised it to the skies to me, so did Luce, of course, but if I

am to judge by the picture by Cross that I saw—and Cross follows Signac—it is still not my ideal. It is, however, pleasing enough and the colors are attractive, but the drawing has something of the disorder of official art, there is a lack of values and of personal conception, and there are exaggerations of complementaries around the figures which irritate me.—And then it has the look of a tendency that has become decadent! Yes, yes, it is pretty, as are all unmixed colors, it is a near relation to the chromo! I am so sick of this sort of thing that all my pictures done in my period of systematic divisionism, and even those I painted while making every effort to free myself from the method, disgust me. I feel the effects of that as late as 1894!

*My dear Lucien,*

I finally closed the deal with Durand-Ruel, naturally the terms are not wonderful. It is a great sacrifice, I have given three canvases of 31 x 25, three of 28 x 23, four pictures of 25 x 21, two of 21 x 18 and one canvas of 18 x 15 inches for 10,000 francs. It is disastrous, but there's no doubt it was absolutely necessary for me to accept. I agreed to sell them to Durand in a batch; thus I am not pledged, in case conditions improve, to maintain these prices. It will be just enough to indemnify several creditors. What pains me most is being unable to give Monet anything, he is not going to like that. But the truth is, conditions are much too bad, and I, with Sisley, am treated worse than the others. I rate poorly with the collectors. I don't know why they are so frightened, for really my pictures are not inferior.

*My dear Lucien,*

I am in Rouen with Dario de Rigoyos. I am going to look for a hotel on the quay, for thus I will be able to make some carefully done paintings without too much risk or fatigue. Carrying canvases 36 x 28 inches in size is very difficult now that I am old, and I have no money. I don't know yet when I will come here, per-

haps in the summer, perhaps in the fall. I will arrange that with you if you come, as I trust you will.

Yes, you did tell me that Shannon was doing your portrait. It should be a fine thing. You should have seen the Ingres in the museum, *La Belle Zélie!* and the decorations by Puvis! and the small Corot! That is art!

*My dear Lucien,*

I was delighted to receive the two volumes of *The Queen of the Fishes.* I find them really charming. I am sure that you will be much praised for this. I find only one thing to criticize: the cover is not solid enough and is perhaps a little too delicate for the rest, which, in my eyes, has the great quality of not being pretty.

I will not go to Rouen immediately, I have the time to think about it, and it depends on my financial situation, which is always bad. Monet wrote me recently to ask for a little money. He didn't want to do this; he must need money himself. I sent him 3,000 francs. That's a big hole, and there are still others who have to be paid, and I won't have any paintings to sacrifice until the fall, for now I must count wholly on Durand, and I am glad to have him, even though I lose [so much].

The Berlin exhibition is over, I have had no news; nothing can be expected from this quarter, it is as with the Belgians. Théo and Constantin Meunier visited me recently. I didn't have much to show them.

*My dear Lucien,*

I went to Mrs. Perry's,—she is a young friend of Monet—for tea. There I met quite a few American and Swedish artists, and some Danes more or less interested in art. There was no point in showing your book, which was known and which I heard praised highly. If everybody is as satisfied, it will be wonderful. It is, I think, a small success which promises for the future and which ought to encourage you.

Yesterday at the Champ de Mars I saw a beautiful Puvis de Chavannes which goes to Boston. Among the sculptures some bas-reliefs by Constantin Meunier, which are very beautiful; a fountain in pewter by Charpentier, a *very remarkable* thing, has been bought by Paris: 10,000 bucks! It is really a fine work, he has made great progress, it is less academic. I didn't see anything else to speak of. Oh yes, the Burne-Joneses!!! I don't like his work, I can't swallow it, it is much too sick!

<div align="right">ERAGNY, MAY 11, 1895</div>

*My dear Lucien,*

Monet's exhibition opened yesterday, he is showing twenty *Cathedrals of Rouen!* forty canvases in all. This will be the *great attraction*. It will run till the end of the month.

Théo wrote me that he is coming tomorrow; he will stay for three or four days. What a pity that you won't be here! He is going to begin the portrait of Cocotte. I am concentrating all my efforts on pictures of blossoming spring, I work from my window and also outdoors. We shall see about Rouen when you decide to come.

<div align="right">ERAGNY, MAY 23, 1895</div>

*My dear Lucien,*

Chartres! . . . goodness! didn't I study a guide book for a week to learn the layout of the city? I thought of Rouen because I have been there with Dario, also your mother suggested it, and then I found a hotel on the port. But on further reflection I realized that it is much too expensive. If I want to be at my ease so as to work well and with nothing but that on my mind, I must reckon on spending at least twenty francs a day! The Hôtel de Paris is fifteen francs a day, and five francs for extras. So I would like nothing better than to visit Chartres.—I was also considering Hemixem, three francs a day at the Mosegat, seascape on the Scheldt, a view of Antwerp. But what if Durand again refuses my pictures of this place on the pretext that the color values are not strong enough? I just looked over my studies of Knocke, I find them quite good

and even very interesting in their clarity of colorations and values. Théo has done a pretty pastel portrait of Cocotte, it is a very good likeness. Much better than the horrid dot. Théo told me that Vandevelde has made some furniture that is in the most exquisite taste, a whole ornamented set, this must be more English than Flemish.

I am very glad that the two boys have been to Epping; did you discuss industrial art with them? I think it a good idea to bring the subject up, it will result in their considering the matter. The only thing is that they are not sufficiently versed in many sides of pure art, they have wasted not a little time on romantic symbolism. I am glad to see that it is beginning to dawn on them that nature is our only hope if we are to achieve a real and decorative art.

PARIS, MAY 26, 1895

*My dear Lucien,*

I hope you receive the letter in time to make a trip with the little one. If only you could get here before Monet's show closes; his *Cathedrals* will be scattered everywhere, and these particularly ought to be seen in a group. They have been attacked by the young painters and even by Monet's admirers. I am carried away by their extraordinary deftness. Cézanne, whom I met yesterday at Durand-Ruel's, is in complete agreement with my view that this is the work of a well balanced but impulsive artist who pursues the intangible nuances of effects that are realized by no other painter. Certain painters deny the necessity of this research, personally I find any research legitimate that is felt to such a point.

Bing is opening a gallery; he has an exhibition room where he kept his Japanese collection. It seems he is going to have an employee of the type of Théo van Gogh, it is a friend of Théo van Rysselberghe. The tendency will be to play up the young men, Lautrec, Théo, Signac, etc., etc. It will perhaps be a good place for your books.

*My dear Lucien,*

I arrived in Paris today expecting to see you, but I see from your letter that you will leave too late to see the Monets. This is a great pity, for the *Cathedrals* are being much talked of, and highly praised, too, by Degas, Renoir, myself and others. I would have so liked you to see the whole series in a group, for I find in it the superb unity which I have been seeking for a long time. I can tell you that it pains me deeply not to be able to see the series several times with you. Naturally! I regard it as so important that I came especially to Paris to see it.

\* \* \*

*During the holiday that Lucien, his wife and their little girl spent at Eragny, father and son again discussed the question of their collaboration. Camille Pissarro did not succeed in persuading Lucien to do the drawings for an album of engravings and an illustrated book himself. So it was decided that the father should do the drawings for* Les Travaux des Champs *and the illustrations for* Daphnis and Chloe, *and that Lucien and his wife engrave these on wood. When the young couple left for England, Camille Pissarro was to begin work on the project.*

\* \* \*

*My dear Lucien,*

The house seemed entirely different after your departure; there is nothing like a little child to give one a feeling of life. The Luces are still here. Luce is beginning some studies, his wife is much less sad, she hasn't the time, with all the agitation and excitement, to grieve.

I have just about finished a drawing for *Les Travaux des Champs*, women who have been gathering dead wood returning from the forest.[1] As soon as it is finished I will send it to you.

---

[1] *See fig. 55.*

55.—*Les Travaux des Champs:* Women
Gathering Wood. Drawn by Camille and
cut on wood by Lucien Pissarro, 1895.

*My dear Lucien,*

Luce and his wife left yesterday. He did quite a bit of work here
and finished a fine little group of sketches. His wife was less
stricken by the loss of her baby and seemed calmer than when she
came.

I have done two drawings for *Les Travaux des Champs.* The
last drawing is on old grey paper, rather bleached. I suppose it will
do; it was the sketch, but since I liked it, I didn't do it over on
tracing paper. It is of a *Mower.*

*My dear Lucien,*

What you say about *Daphnis and Chloe* and Ricketts' opinion
does not surprise me in the least. He is absolutely right. I have

271

shown poor judgment in this. It would have been so simple to have Chloe completely nude, and that, by the way, was what I intended to do. But I wanted to do something Greek without making the necessary research. We should have made these at the library or at the Louvre. It is too bad you have already engraved this drawing on wood, otherwise the four drawings could be done over with the costumes changed. But with you away it is not easy.

*My dear Lucien,*

I am working steadily at my figure paintings and I am very fearful that I won't have time to finish them to my satisfaction. Your mother took Cocotte to boarding-school on the seventh of this month. She felt unhappy about leaving the house, and your mother feared that she might become ill, she wept so. We feel better about it now, for this morning we received a letter from her saying that she is not too unhappy and has already made several friends. As you can understand, we feel reassured now, and if your mother can go to see her from time to time—and I too—Cocotte will adjust herself.

I have been able to finish five canvases, 25 x 21 inches, and I am expecting our pessimistic Portier to come any day. As in other years of this epoch, nothing is stirring. I shall simply have to go to Paris to break the run of ill luck.

I find the proofs of Daphnis much superior. I hope Ricketts likes them, I think the others will be much better. I have finished five drawings for *Les Travaux des Champs*. I am now after *Nudes*.

ERAGNY, OCTOBER 16, 1895

*My dear Lucien,*

Have no fear, I will do *The Four Seasons*; I am waiting for you to tell me whether my last drawings are not *too white*, especially the *Reaper*. I am afraid the style of the *Daphnis and Chloe* drawings is a little too monotonous. I dropped the drawings in order to paint, but I will return to them.

56.—P. Gauguin: Jacob wrestling with the Angel, 1889.

57.—Lucien Pissarro: Portrait of Camille
Pissarro.

*My dear Lucien,*

A small sale, oh, it amounts to very little: Portier sold Hayashi my *Bather* for 1,800 francs. And it is a canvas of 28 x 23 inches! I owe Hayashi 700 francs, so very little is left for me.

I wanted to take several pictures the boys did to Paris and try to sell them. Your mother said that I should affix another name to them; this, it seemed to me, is a rather delicate question and difficult to decide. What do you think? I will ask the boys what should be done.[1] The fact is it would be useless to present them under the name *Pissarro,* and if a pseudonym is to be used, it must be maintained from now on, or at least for a long time to come. And as I said to your mother (who called me an egotist, etc.), this should not be done until the boys have had a chance to think about it and given their consent. Don't you agree? It will have to be discussed with them.

And I really want to go to Paris and see what is happening there. Despite a great sweep of work, I am very bored in Eragny. . . . Is it anxiety about money, the fact that the coming winter already makes itself felt, weariness with the same old motifs, or my lack of data for the figure paintings I am doing in the studio? It is partly due to all these things, but what hurts me most is seeing the whole family breaking up, little by little. Cocotte is gone, soon it will be Rodo! Can you see us two old people, alone in this great house all winter?

It is not exactly gay. . . . They say that makes one work. I don't agree. Although I don't like people who annoy you while you work, isolation doesn't give me any eagerness to paint.

*My dear Lucien,*

Met Angrand at Durand's yesterday. Oh, what theories . . . boring and exasperating! I couldn't keep from telling him that it was simply idiotic, that their science was humbug, that the truth was they were not artists, that they had killed their instincts for the sake of a false science, that Seurat, who did indeed have talent

---

[1] *Félix and Georges were then working in England.*

273

and instinct, had destroyed his spontaneity with his cold and dull theory, that Monet achieved more luminosity than they did and that his pictures are much less rotten and boring.

<div align="right">PARIS, NOVEMBER 13, 1895</div>

*My dear Esther,*

At Vollard's there is a very complete exhibition of Cézanne's works. Still lifes of astonishing perfection, and some unfinished works, really extraordinary for their fierceness and character. I don't imagine they will be understood.

Cocotte is in a boarding-school that is pretty good, but in regard to scholarship it is like all other such schools, perhaps a little better because of the students, who are partly English. But the method of instruction is as elsewhere, there is no religious teaching. Cocotte, no matter what her mother says about it, isn't at all dissatisfied there. At the Sainte Catherine they are going to have an evening party (there will be dancing) and they are to perform a comedy. Cocotte is enchanted. I bought her some pretty evening slippers and white gloves. She was so afraid that she would have to wear her large boots. I have taken her for outings several times, I took her to the Louvre and to the Centenary of Lithography at the Trocadéro Museum, etc., etc. Thus I try, little by little, to open her eyes, and without seeming to be aiming at this. At the zoo I called her attention to some beautiful motifs for tapestries, etc. But I beg you, if either one of you write to me, be careful in what you say about Cocotte so as to avoid misunderstandings. . . . Each time mother goes to see her (it is a regular trip) she tells me that Cocotte is so sad, that she wept when they parted . . . perhaps she did. But with me it is the contrary; the last time she was most happy, and so was I. But of course if the mother cries, the girl weeps with her. It is just a lack of sacrifice. I shall try to go there tomorrow.

I am leaving on Friday. I brought the pictures of Jean Roche and G. Manzana [1] to Martin and Commentron.

---

[1] *Georges had chosen the maiden name of Camille Pissarro's mother and signed his paintings Georges Manzana. Félix had chosen the pseudonym Jean Roche.*

*My dear Lucien,*

Yesterday at Portier's I made the acquaintance of the English painter O'Kean,—I don't know whether I am spelling his name correctly. He is very intelligent and greatly admires the impressionists, especially my work. He didn't know me by sight, and he was praising my *Sunset in Knocke,* a canvas of 25 x 21 inches, so highly that I was abashed. . . . He wanted to show me a canvas of his so that I could advise him, which I did scrupulously. His painting, like that of many English artists, is literature, which is not a defect in itself, but does result from a lack of painting content; his work is thin and hard and lacks values. It is, however, intelligent, a little like Chavannes, sentimental and feminine, but as I told him, it is not really painting. . . . Speaking of England, I asked him how it was that we were so little understood in a country that had had such fine painters. England is always late and moves in leaps. This is pretty much our own opinion.

On leaving Portier I had this thought: How rarely do you come across true painters, who know how to balance two tones. I was thinking of Hayet, who looks for noon at midnight, of Gauguin, who, however, has a good eye, of Signac, who also has something, all of them more or less paralyzed by theories. I also thought of Cézanne's show in which there were exquisite things, still lifes of irreproachable perfection, others *much worked on* and yet unfinished, of even greater beauty, landscapes, nudes and heads that are unfinished but yet grandiose, and so *painted,* so supple. . . . Why? Sensation is there!

On the way to Durand-Ruel's, I saw two paintings of Puvis de Chavannes. No, no! That sort of thing is cold and tiresome! A representation of natives of Picardy, and very well composed. But all the same, at bottom the whole thing is an anomaly, it can't be seen as a painting, no, a thousand times no! On a great stone wall it is admirable . . . but it is not painting. I am simply noting my immediate impressions.

Curiously enough, while I was admiring this strange, disconcerting aspect of Cézanne, familiar to me for many years, Renoir arrived. But my enthusiasm was nothing compared to Renoir's. Degas himself is seduced by the charm of this refined savage, Monet, all of us. . . . Are we mistaken? I don't think so. The only

275

ones who are not subject to the charm of Cézanne are precisely those artists or collectors who have shown by their errors that their sensibilities are defective. They properly point out the faults we all see, which leap to the eye, but the charm—that they do not see. As Renoir said so well, these paintings have I do not know what quality like the things of Pompeii, so crude and so admirable! . . . Nothing of the *Académie Julian!* Degas and Monet have bought some marvelous Cézannes, I exchanged a poor sketch of Louveciennes for an admirable small canvas of bathers and one of his self-portraits.

<div align="right">[PARIS] NOVEMBER 22, 1895</div>

*My dear Lucien,*

I am always haggling with Durand who hesitates. I hope he doesn't abandon me. Yesterday he talked to me at length, saying that he would like nothing better than to buy everything I did, but that he wasn't selling my work, that he had four million francs' worth of paintings that cost him tremendous interest.

Mauclair has published an article [on Cézanne] which I am sending you. You will see that he is ill informed like most of those critics who understand nothing. He simply doesn't know that Cézanne was influenced like all the rest of us, which detracts nothing from his qualities. People forget that Cézanne was first influenced by Delacroix, Courbet, Manet and even Legros, like all of us; he was influenced by me at Pontoise, and I by him. You may remember the sallies of Zola and Béliard in this regard. They imagined that artists are the sole inventors of their styles and that to resemble someone else is to be unoriginal. Curiously enough, in Cézanne's show at Vollard's there are certain landscapes of Auvers and Pontoise [painted in 1871–74] that are similar to mine. Naturally, we were always together! But what cannot be denied is that each of us kept the only thing that counts, the unique "sensation"! —This could easily be shown.

*My dear Lucien,*

I am conducting a campaign here against forgers who are peddling fake paintings and gouaches, among others a large gouache by Piette, signed with my name, forged of course, and misspelled. The most interesting thing about this is the price asked: 300 francs for a gouache, 25 x 21 inches; a *Market of Mayence*, not bad, a little monotonous and empty, in no way resembling my style. Of course, the collectors are not fooled.

I have just about finished my large figure paintings. Finished? That is to say I am letting them lie around in the studio until I find, at some moment, the final sensation that will give life to the whole. Alas! while I have not found this last moment I can't do anything further with them! But while waiting for this final sensation I am doing several figures from our Rosa; they are developing with more sureness; I am quite pleased with a canvas of about 25 x 21 inches, *Peasant Girl Selling at the Market*, which is closely related to my figures of 1882–83, with a little more freshness.

Would you believe that Heymann has the cheek to repeat the absurdity that Cézanne was always influenced by Guillaumin? Then how do you expect outsiders to understand anything! This monstrosity was expressed at Vollard's. Vollard was blue. Aren't these babblers amusing? You wouldn't believe how difficult it is for me to make certain collectors, who are friends of the impressionists, understand how precious Cézanne's qualities are. I suppose centuries will pass before these are appreciated. Degas and Renoir are enthusiastic about Cézanne's works. Vollard showed me a drawing of some fruits, which they both wanted to acquire; they drew straws to determine the lucky one. Degas so mad about Cézanne's sketches—what do you think of that!

Didn't I judge rightly in 1861 when Oller and I went to see the curious *provençal* in the *Académie Suisse* where Cézanne's figure drawings were ridiculed by all the important artists, including the famous Jacquet, sunk long since in prettiness, Jacquet whose works bring enormous sums.

Amusing all this; a repetition of the old struggles!

Great emotion among the literary gents over the death of Alexandre Dumas *fils*. An article by Bergerat in *Le Journal* affirming his admiration for the "sole free spirit" of our time. . . . Free?

free? He who wrote that miserable reactionary article in 1870 against Courbet, that admirable painter of the *Demoiselles du Village*, of those two women asleep on the grass under the shade of a willow, of the *Afternoon at Ornans*, which is in the museum at Lille, and of so many other works of the first rank! Come now, there is a terribly reactionary bourgeois side to this man; which of the young literary men, damn it, is going to make this clear? Alexandre, Arsène, hasn't budged yet, neither has Geffroy . . . they have understood nothing of this!

Yesterday Zandomeneghi and I rated Arsène Alexandre roundly in connection with an exhibition of Jeanniot, which I think is very nice but, name of God, without any artistic interest. Poor Arsène, he was so conciliatory. "It is interesting," he said, "there are such nice observations." I admit that I was annoyed to have to compliment Jeanniot, who tries hard enough, but, alas, who cannot free himself from the illustrative style. Now how should one behave in such a situation? be quiet? but when the artist asks your opinion? say to him discreetly: it is good? it would be awful to say: it is worthless. I understand that an artist must be discreet, but a professional critic!

ERAGNY, JANUARY 3, 1896

*My dear Lucien,*

While I was in Paris this last time, I had an opportunity to discuss decorative art with Vandevelde several times. However one may criticize Bing's enterprise, it has a certain value as a point of departure. It is when things are in order that you can best see what is defective. I wish you could have seen the room of Maurice Denis, you can't imagine what it is like: a lugubrious room of a young girl! pieces of furniture that are like graves and everything painted in a dirty yellowish grey! It is an absolute failure! Despite the shortcomings of his collaborators, Vandevelde's pieces clearly have the upper hand, but it must be granted that he has been influenced by the English . . . however, this tendency may certainly change. Condor's boudoir is nice: clear, decorative, silk, some sort of Japanese prints on white silk with a pearl tint, things lightly washed with watercolors, Louis XV ornaments. This isn't new, but its rococo aspect should make it popular. Besnard made the decoration for a rotunda, it is horrible, it is music-hall, it is Julian Academy stuff. And as Vandevelde says: "If Besnard is successful, there is nothing left for us but to pack our bags." And that is likely to happen, for Bing is so proud of it that he has made an agreement with Besnard and with Trolo! If you only could see that one's paintings, really, they are the limit. When one considers the public's love for vulgarity, one feels like giving up in despair. . . .

279

*My dear Lucien,*

I arrived today from Paris. I am going to get down to work as soon as I get my materials, which are being sent from Eragny. I have a splendid view of the harbor. Before leaving Paris I saw our friend Oller, who told me of some extraordinary things that befell him with Cézanne and that indicate that the latter is really unbalanced. It would take too long to tell you. . . . After numerous tokens of affection and southern warmth, Oller was confident that he could follow his friend Cézanne to Aix-en-Provence. It was arranged to meet the next day on the P.L.M. train. "In the third class compartment," said friend Cézanne. So on the next day, Oller was on the platform, straining his eyes, peering everywhere. No sign of Cézanne! The trains pass. Nobody! Finally Oller said to himself, "He has gone, thinking I left already," made a rapid decision, and took the train. Arrived in Lyon, he had 500 francs stolen from his purse at the hotel. Not knowing what to do, he sent a telegram to Cézanne just in case. And Cézanne was, indeed, at home. He had left in a first class compartment! . . . Oller received one of those letters that you have to read to form an idea of what they are like. He forbade him the house, asked if he took him for an imbecile, etc. In short an atrocious letter.[1] This incident is simply a variation of what happened to Renoir. It seems he is furious with all of us:

"Pissarro is an old fool, Monet a cunning fellow, they have nothing in them. . . . I am the only one with temperament, I am the only one who can make a red! . . ."

Aguiard has been present at scenes of this kind; speaking as a doctor, he assured Oller that Cézanne was sick, that the incident couldn't be taken seriously since he was not responsible. Is it not sad and a pity that a man endowed with such a beautiful temperament should have so little balance?

[1] *See* Paul Cézanne, Letters, *London 1941, pp. 195–197.*

*My dear Lucien,*

I made the acquaintance, yesterday, of one of my collectors, a friend of Mirbeau, Monsieur Dépeaux. Monet's brother introduced us. I shall breakfast with them this morning. M. Dépeaux put himself completely at my service, offering me any quarters I want to paint in, even proposing to build me a cabin in his dock yards. But I am too crotchety to accept, I am too afraid of colds. If this were summer it would be perfect. Besides, I will undoubtedly come here again and then I will take advantage of the offer. This collector owns some property in the neighborhood which must be a wonderful place, it is in a forest on the heights from which one can see Rouen in the distance. But I am not thirty years old now, I have to be satisfied with a hotel window. I went to look at the Hôtel d'Angleterre on the harbor, it is admirably located but very expensive: 8 francs a day for a room on the fourth floor. This place is less favorable, but I pay only 5 francs for a nice room on the second floor and another on the third, above the entresol; the view is beautiful.

*My dear Lucien,*

My pictures are advancing. I have eight things going, I am waiting impatiently for snow. Monet's brother assured me that Dépeaux would take some before I finish them. That would suit me fine, the problem is to finish them successfully. One canvas, *View of the Bridge* [950], is about 36 x 28 inches. The theme is the bridge near the Place de la Bourse with effects of rain, crowds of people coming and going, smoke from the boats, quays with cranes, workers in the foreground, and all this in grey colors glistening in the rain. Lecomte found it very fine. I have one of fog with sun, but these effects are infrequent.

What you said in one of your letters is true enough. It is so hard just to maintain oneself when one is old that it is already something to be able to go one's modest way.

Another symbolist has failed miserably! And one whose coming triumph was hailed by Geffroy in *Le Journal*. All the painters

281

worth anything, Puvis, Degas, Renoir, Monet and your humble servant, unanimously term hideous the exhibition held at Durand's of the symbolist named Bonnard. Moreover, the show was a complete fiasco.

You know the sally of Bracquemond: "This deuced Pissarro is not a man but a bowsprit!" But I was right enough!

Lecomte tells me that Cézanne, who is now doing Geffroy's portrait, is running me down to him. Now that's nice! I, who for thirty years defended him with so much energy and conviction! It would take too long to tell the whole story. But it is things like this that give rise to silence and doubts [when my name comes up] . . . bah! Let us work hard and try to make dazzling greys! It will be better than running down the others in turn. . . .

It is imperative for you to have a show in Paris. You are still the only one working in the tradition of good sense. An exhibition by you would be a revelation. If you can come for a few days in April, when I am having my show, you will see what would have to be done.

I ordered some zinc plates to make lithographs of Rouen. I began some sketches of old streets which are being destroyed. . . . I wish you could see the rue St. Romain [D.176–179], it is splendid. I hope it will have a certain interest.

ROUEN, FEBRUARY 26, 1896

*My dear Lucien,*

I sense in your letter a great enthusiasm for your work, that is the main thing, with that one can go a long way. Simultaneously with your letter I received word from the boys. They too seem to be very interested in their studies and to be working hard. All this gives me comfort and the lift necessary to consummate the paintings I had the audacity to undertake here. I have begun no less than a dozen pictures, six canvases of 36 x 28 inches, if you please, of the others one is 21 x 18 inches, one is a sketch which I gave to Monet's son Jean, whom I often see, and five are canvases of 25 x 21 inches. . . .

I have effects of fog and mist, of rain, of the setting sun and of grey weather, motifs of bridges seen from every angle, quays with boats; but what interests me especially is a motif of the iron bridge

282

in the wet, with much traffic, carriages, pedestrians, workers on the quays, boats, smoke, mist in the distance, the whole scene fraught with animation and life. The picture is fairly well advanced. I am waiting for a little rain to put it in order. I hope these pictures won't be too bad, for the moment I see only their defects; at times I have fits of hope that they will be good.

I think I shall stay here until the end of March, for I found a really uncommon motif in a room of the hotel facing north, ice-cold and without a fireplace. Just conceive for yourself : the whole of old Rouen seen from above the roofs, with the Cathedral, St. Ouen's church, and the fantastic roofs, really amazing turrets [973].[1] Can you picture a canvas about 36 x 28 inches in size, filled with old, grey, worm-eaten roofs? It is extraordinary!

<div align="right">ROUEN, MARCH 7, 1896</div>

*My dear Lucien,*

I hope to be able to finish paying for the house this time. I saw M. Dépeaux yesterday evening, he was with his wife. He confirmed the purchase of my *Roofs of Old Rouen* [973] and he retained another canvas of 36 x 28 inches for his brother-in-law, but he didn't speak to me about the price . . . and it didn't occur to me to bring this question up. Would he give me 5,000 francs for each? He bought a *Cathedral* from Monet for 15,000 francs. It seems to me such a price will seem fair enough to him. Mrs. Perry hasn't been able to place a single painting for me so far, really, the Americans can't get used to my painting, which is too sad for them, I recognize that. And even in Paris it is certainly hard though to sell anything, although my pictures are less sad than Carrière's.

I understand that Ricketts and Shannon don't care for Carrière. As for Geffroy, really, he knows nothing about painting, although he once painted himself. Just read in *Le Journal* the article on the Berthe Morisot exhibition, words, the kind of eulogy that appears in all his articles . . . it is true that it is difficult. . . .

My bridge [946] is completed with its effects of wetness, it is quite interesting, I think. I wanted to render the animation of the hive that is the harbor of Rouen. I have a painting of the misty

---

[1] *See figs. 69 and 70.*

Pont Corneille which should be pretty good, a canvas 36 x 28 inches also [962]. But I see them too often to know what they are like.

*My dear Lucien,*

Did I write you that the brother-in-law of M. Dépeaux came to see my pictures, found them superb and was anxious to have one of the best of them. I was timid, I asked for 4,000 francs. He offered 3,000 and I rejected it. He then told me that he had bought a canvas, 28 x 23 inches, from Portier for 1,000 francs.

So there it is. Portier is constantly lowering my prices. Instead of going to Durand who maintains my prices, the buyers go to Portier, and, in short, since there aren't many of them, I gain little by this. So I can assure you I would much prefer to make an agreement with Durand than to run after the collectors. I don't know whether Dépeaux will accept the price I shall set, so much the worse for him if he doesn't, I want to keep the *Roofs of Old Rouen* for myself. I don't want to show it on account of Monet's *Cathedrals*, I am afraid it isn't good enough to stand the inevitable comparison, although it is quite different. You know how much back biting is going on.

I believe I will have finished my campaign by the end of the month. I will spend several days making watercolors and going on excursions to Canteleu, that is, if the weather is promising. For several days now it has been miserably dull.

Until I hear from you. I find ample time to do fifteen pictures, to write to you, to Georges, to Amélie, to the house, to make lithographs, not to speak of the business letters I must write! Surely you can write to me.

I am sending you a letter from Pouget, who is in prison, and on the back you will read your mother's harsh words for me because I am moved by Pouget's misfortune. However, I am only returning to another what Caillebotte did for us when we were in trouble and glad we were to have his help. I don't understand her reproaches. I write to her all the time. She scarcely sends me a word—of reproof!

*My dear Lucien,*

I come from the library. I have been looking at illuminated books. Flemish works of the thirteenth and Gothic French of the fourteenth and fifteenth centuries, admirable books, some in the bindings of the time, and very beautiful. There are manuscripts that would fill you with joy. Do you recall the collection of books and illuminated manuscripts of all schools which we saw in London? I believe nothing comparable can be found anywhere; in Rome there are only a few first rate things.

You will remember that the *Cathedrals* of Monet were all done with veiled effects which gave a certain mysterious charm to the edifice. My *Roofs of Old Rouen* with the Cathedral in the background was done in grey weather and is clearly outlined against the sky; I liked it well enough, it pleased me to see the cathedral firm, grey and clear on a uniform sky in wet weather. Well then, Dépeaux doesn't care for the sky! I think I shall keep the picture for us.

*My dear Lucien,*

At this moment I am packing my canvases without having seen my collector, Dépeaux. I don't understand that fellow. He told me that he wants to see my pictures in frames in order to make up his mind, he promised me some frames which he has in his dining room, it was settled, we were to meet the next day . . . like a fool I waited . . . he didn't show up. Two days passed, the frame-maker of the neighborhood brought me some frames of his own, I apprised my strange collector, made an appointment with him, and I am still waiting. So I am packing up, it's a farce.

*My dear Lucien,*

I am leaving for Eragny this morning to retouch and send off my pictures to Durand. I am very apprehensive, I'm afraid of find-

ing my work inadequate. At Durand's I looked at a series I did recently and which didn't look good to me; I hope that once framed and hung these will have a better effect. I am much concerned about my nudes.

*My dear Lucien,*

I have just sent off my canvases for the exhibition. I will be in Paris on the 10th. The exhibition opens on the 15th. I'm showing twenty-two canvases.[1]

*My dear Lucien,*

Arsène Alexandre came Monday to see my pictures. He found my *Roofs of Old Rouen* [973] very beautiful and was very insistent that I exhibit it. I decided to do so. And what the deuce, it is so different from Monet that I don't think my friends will regard me as spiteful in showing it. The truth is that Cézanne is the only one likely to find fault, and I don't care at all. Each of us does what he can.

*My dear Lucien,*

All my friends say the exhibition is very beautiful. Degas told me that no matter what the "great masters" of the youth, who treat us as dolts, say, we still have the upper hand. From a financial point of view I did the best I could; I much preferred to sell Durand eleven pictures than to wait on the caprice of collectors. I am not cunning enough for transactions of that kind and they bore me. I accepted 14,000 francs for the lot on the condition that Durand would take another series at the beginning of the winter, which

---

[1] *Pissarro actually showed thirty-five pictures, thirteen of which doubtless belonged to Durand-Ruel and various collectors. The preface to the catalogue was written by Arsène Alexandre.*

he promised to do. I am keeping the *Roofs of Old Rouen* for myself; Zandomeneghi, Degas and I consider it the outstanding work. I don't understand how I was able to get this completely grey picture to hold together! Now Camondo wants to have it. He had somebody ask me for it, but without seeming to care about it. Durand, after having spoken to me, received a telephone call asking him not to say anything to me. In short, he wants to get it cheap on the ground that he will offer it to the Luxembourg!— *After his death!*

"Let's see, if Camondo offered you 4,000, that's all right with you isn't it? That's reasonable enough," Durand said to me.

"Goodness no! The Luxembourg doesn't tempt me at all, I won't sell for less than a good price. . . ."

So that's the situation. I expect to ask 10,000 or keep it. Dépeaux could have had it for 4,000, he hesitated. He won't get it.

Finally I am happy about the moral effect of the exhibition. I showed only one *Bather*, which was well liked. Miss Cassatt complimented me on it. I was wrong to exhibit it this year, since it was not the chief attraction.

I am going to see Fénéon. The yap of *La Revue Blanche* seems hostile to me,[1] it is the organ of the new generation. Lately they gave a banquet for Gustave Kahn; they sent me a card which I received afterwards when I was working in Rouen. But banquets for men of genius don't suit me at all!

My dear friend Arsène [Alexandre] came to see my pictures at Eragny. Unfortunately I couldn't refuse to let him write a preface to my catalogue, although I always find these pieces useless and banal. Alas, you should read this morsel! And what is most comical is that he is so pleased with it! Well, I have always been too agreeable. . . .

PARIS, APRIL 25, 1896

*My dear Lucien,*

I saw Lecomte this morning, we discussed the article Geffroy wrote about my show; he finds a certain hesitancy, not unpraiseworthy, in my Rouen series. This notion is also developed in the

---

[1] *All the symbolist writers and artists, among the latter notably Paul Gauguin, Pierre Bonnard, Edouard Vuillard, Félix Vallotton, etc., were grouped around the brothers Nathanson and Félix Fénéon on* La Revue Blanche.

other journals whose inexperienced critics haven't the guts to come forward with their own ideas. If I were to find fault, I should on the contrary object to the too great audacity shown in attempting such a thing and to the fact that the paintings have too much verve, the *Roofs of Old Rouen* excepted.

On the other hand I have had great success with the artists, so much so that I am even somewhat disturbed. Contet, who knows my painting, believes I changed my technique! Useless to assure him he is mistaken, he will not give an inch. . . . And do you know the reason for this? It is simply because I eliminated from my palette the intermediary whites that gave me trouble. I left only one white at the beginning and another at the end [of the row of colors on the palette], and then I added half an essence of turpentine to mineral essence, thus I am completely liberated from neo-impressionism!

On Thursday I went to the *Indépendants*. The Signacs, my dear, are really abominable; he has a portrait of his wife that is frightful from every point of view; he has now gotten rid of planes, values and drawing. The works of Cross are of the same order, Luce is certainly less sick, but he too has the gangrene. I didn't know how to make him understand that what I saw at his place is completely false . . . some scenes of Belgium, burning factories, night, moonlight, chimneys and landscapes . . . they are strong blue, and lumpish. It is true they were done in the studio, and you know how long it takes to get the effects you want when working indoors. His drawings, though, are good.

There is an exhibition of Carrière at Bing's. He [Carrière] has had highly laudatory articles from Geffroy. I didn't go to the show, for I long ago became acquainted with the formula of this "master"! The show is not a great artistic success, people are beginning to see that he is a little too vague and of too little variety.

PARIS, APRIL 26, 1896

*My dear Lucien,*

Vollard spoke to me about exhibiting color engravings.[1] This simply annoys me, for I have only a few things, three in all, to

---

[1] *Vollard had begun to take particular interest in the graphic arts. In 1895 he published a Portfolio of lithographs by Bonnard, and in 1896 a Portfolio by Redon. In 1896 and 1897 respectively, he published Albums of Painter-Engravers, each con-*

288

58.—Lucien Pissarro: Portrait of Camille Pissarro etching in his Studio, about 1895.

59.—C. Pissarro: L'Hermitage
à Pontoise, 1873.

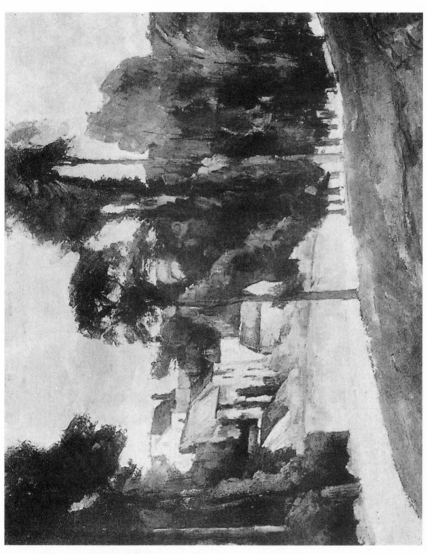

60.—P. Cézanne: L'Hermitage
à Pontoise, about 1873.

61.—C. Monet: The Cathedral of Rouen, 1893.

62.—Photograph of the same Subject.

show. But does he mean business? I really don't know. Vollard, of this you can be sure, doesn't bother with anything he can't sell; reputation! The rest means nothing to him!

*My dear Lucien,*

I went to Bing's yesterday to see the Carrière show. It is worse than ever, as sad and dull as could be. That is the general opinion —really, Geffroy has no judgment!

At Durand's there is a decided change in my favor as a result of the great success of my show. Degas, from what I hear, seems to have spoken up for me. Sunday, I met Jacques Emile Blanche, who told me that he had talked with Degas about my *Rouens* and trees, and Degas, he said, praised them to the skies. You can imagine how gratified I am by this after my long and patient efforts.

ERAGNY, MAY 2, 1896

*My dear Lucien,*

Vollard is surely an idiot! I told him that he knew nothing about Ricketts' gifts and that Beardsley had no talent, but here's the rub, he is in with people who have reputations, *he doesn't give a damn about the others.* He wants names, and he doesn't realize that Ricketts is better known than the other.

Geffroy is looking for ways of being unfriendly, I sense his hostility. He must be angry because his friend Carrière was such a flop at Bing's, and doubtless he knows that all the impressionists, from Degas to Guillaumin, unanimously find this art weak and sentimental. Since he doesn't dare say anything against the impressionists favored by the press, he tries to lay the blame on me. . . . You will remember how we argued about Willette and Forain at Georges Lecomte's wedding.

taining prints of various artists, chosen more or less indiscriminately. For reasons which he makes clear in his correspondence, Camille Pissarro was not represented in these Albums. The second one contained engravings by his son Lucien and by Shannon, as well as by Bonnard, Cézanne, Cross, Fantin-Latour, Guillaumin, Lautrec, etc.

*My dear Lucien,*

One thing I greatly regret; it is that despite all the pains you take you never succeed in being ready at the right moment. Which reminds me that this faculty was one of my strong points. It has enormous value.

I wrote Monet that Durand-Ruel has five thousand francs for him. He wrote me a very cordial letter, saying that he had heard wonderful things about my show and that he was coming to see it. Saturday was the last day and he didn't appear; the beautiful weather probably kept him in Giverny.

I am thinking about going to see whether I can paint in Canteleu. . . . I will go any day now with Rodolphe, along the Seine, from Rouen to Caudebec, which I have heard is very beautiful. After this past winter's exertions, I lack the stimulus to work, Eragny simply doesn't give me the lift I need. Is it that I am getting too old? I have such a passionate desire to see a new environment, but I am detained by heaps of things.

ERAGNY, JUNE 22, 1896

*My dear Lucien,*

I received word from Vollard to the effect that his exhibition [of prints] is a great success. He wants to know the prices I ask for my prints in color. He would like to know whether my prints were retouched with gouache, and by hand; everybody asks him about this. Now what do you make of that? Strange! He would like to know if any printer can pull the proofs and how many can be made. I replied that I would only sell my prints when I had a whole group of them, and that furthermore I made engravings just for my own amusement and that I didn't care to sell them.

I am sorry I didn't see Vollard's exhibition, I should like to have seen the new productions.

*My dear Lucien,*

Hardly had I begun to work from nature when I was forced to leave off and go to see Parenteau. The probable cause is the east wind, which rose the least bit yesterday.

*My dear Lucien,*

I am enclosing a letter which I just received from Lepère. Read it carefully, you will see that he wants to attempt to resurrect the woodcut. This effort may not succeed, but the fact that it was conceived means something and shows that there is much interest in the graphic arts, so long abandoned in France.[1] I think Lepère is very attentive to the movement which is crystallizing bit by bit, and since he has some influence, there is no point in discouraging him by refusing. You need to show your work here; it is well, I think, to have the support of those who may be useful in due course. It is true that Lepère is associated with people who are compromising in so far as real art is concerned, but one may hope that the inevitable purge will take place all by itself, as happened with the impressionists, who, to put it briefly, were not tainted.

Vollard is just leaving, his show has been successful. Shannon has had a very great triumph. The fact is that his lithographs are first rate; your woodcuts and mine, it seems, were very successful. Vollard asked me my prices. He said there were a number of collectors who wanted them. I told him again that in due time I would make a portfolio of them.

Vollard also asked me whether you would do a book by Verlaine for him.[2] He intends to write to you about this himself when the time comes, but this blessed Vollard is so *fluttery*, one doesn't know what to believe. He has so many projects that he can hardly carry out everything he has in mind!

[1] *At the end of the 19th century a renaissance of the graphic arts began in France and in England. William Morris and his followers did for the movement in their country, what Gauguin and his friends, as well as Lautrec and Lepère did across the Channel. Lepère founded the review* Image, *which, during the year of its existence, devoted itself especially to the woodcut and to which Lucien Pissarro contributed.*

[2] *It was not Lucien Pissarro, but Bonnard, who finally illustrated Verlaine's* Parallèlement *for Vollard.*

*My dear Lucien,*

I am sending you the Vollard catalogue. There are good things and atrocities. Shannon's things were well placed and were successful, yours were not so favorably placed yet were successful also.

Vollard told me that he would have sold several Shannons if the prices asked had not been so high. Here they must get masterpieces for nothing!

Vollard commissioned me to do a lithograph in color, a large plate, he would like a *Market*, he asked me what I would charge. I told him I would have to consider the matter. This blessed Vollard has grandiose ambitions, he wants to launch himself as a dealer in prints. All the dealers, Sagot, Dumont, etc., are waging a bitter war against him for he is upsetting their petty trade. He has talked a lot about books for you to do, but he is a real moth, I am afraid his fate will be the taper's flame! In any event, there is no point in suffering disillusionment!

Met Raffaëlli yesterday, and he told me with great enthusiasm about his trip to America. An immense people, grandiose, full of the future! he said; about Monet's success he had this to say: Monet alone is recognized in America, enthusiasm for him has reached such a point that Raffaëlli actually heard a lady say: "Monet is so great that all the other painters ought to paint Monets (sic)." I thought this was a gag, he assured me it had actually happened, that the remark was meant literally.

*My dear Lucien,*

What annoys me is being unable to work outdoors; I am making gouaches and bathers here, and for lack of a model I am posing myself!

As to Vollard, I can't follow him. He has so much imagination that he forgets his proposals. When I return, I will ask him what he thinks of the proposal he made about Verlaine!

Did I tell you that the color print Vollard wants me to do is to be a lithograph? I should have preferred to do it in black and white, but it seems that color is the fashion.

*My dear Lucien,*

I went to see Vollard. We argued about the price of my lithograph in color; I had all I could do to get him to stick to the point. You won't believe what he proposed! Really, they think they can milk us! Drudge, work, they say, and we, we shall take it upon ourselves to make the money! Arguing that Fantin-Latour sells his lithographs (the plates) at 100 francs, he proposed to give me 500 francs for one hundred prints, the plate to be erased afterwards. Naturally I didn't accept. He said then: "All right, let's try this. Pull one hundred proofs at your own expense, give them to me to sell at a commission. . . ." If he thinks I'll agree to that, he is mistaken. I will make the plate and then consider what to do.

Vollard told me that Vannier is the one who owns the rights to certain of Verlaine's works, that he obtained them for a crust of bread. Vannier wants 500 francs for the rights, what gall! You can't do anything with Vollard, no more than with Bing, Sagot and *tutti quanti,* unless you are willing to be fleeced.

I told Vollard he ought to make Degas a proposition for his lithographs—no danger!

*My dear Lucien,*

I am preparing to go to Rouen, providing, that is, that Durand-Ruel grants me the necessary funds. I am very anxious to know whether he will want to take the four pictures of Eragny, three of which seem to me better than the Rouen paintings. It is true that the motifs are of green trees and that the general tone is rather grave and restrained, and the collectors don't like anything with a grave note.

Gutbier, whom I asked to return my engravings, sold two of them: *The Hovel* [D.20] and *The Stone Bridge.* He asked me for new ones. I sold *The Hovel* for 100 francs, the other for 75 francs. Vollard was nettled, he who found 150 francs for a print in color too dear! He persists in asking me to make a deal with him. But what would be the point? I am sure he has no collectors; but perhaps I shall send him some small gouaches.

293

*My dear Lucien,*

Vollard is going to have a press for lithographs in his place, rue Laffitte. This Creole is amazing; he wheels from one thing to another with startling ease. Poor Vollard! I told him that he was venturing into a field that one has to understand thoroughly, that prints don't sell, the dealers don't know much about them and depend solely on tricks, like posters, color prints, etc. . . . He has been tormenting me lately to let him handle a few of my gouaches or lithographs. The day before yesterday I showed him three things I was going to have matted, he didn't even look at them, he left me standing there to show me a Cézanne and didn't think about my things again. So it will be a long time before I take the trouble to show him anything. This young fellow is really too flighty.

*My dear Lucien,*

Your mother insists that I should not give you 300 francs per month. She must have spoken of this to you. For a long time now she has been arguing about this with me. I try to reconcile all parties but I don't succeed very well. All I can tell you at the moment is that you can be sure I will help you if conditions are not too bad.

I am writing you hastily, your mother may come to Paris today. I shall not discuss this question of money with her, it would accomplish absolutely nothing and advance us not a step. She doesn't realize the difficulties of a beginner in art, nor does she understand that one can find a place in this field if one has the will to do so. And I have listened and shall continue to listen only to what my own experience counsels. You have to get in a good position to succeed in your field and, as you say, we have to prevent that other profit from what you have taken so many pains to establish. So, for my part, I will do my utmost to send you the 300 francs without speaking about it. I insist on this, it is to avoid wearisome discussions with your mother. I will send you the money some other way, this will depend on the circumstance, but in any case I shall send it. I am forewarning you, that is all. It is disagreeable to be

underhanded, but damn it, it's no go otherwise!—This is the only way to avoid arguments!

Your mother is afraid that I am helping you too much and thus depriving your brothers, but this is not so; when their turn comes, I expect you to be more secure and I will do for them what I am doing for you three; it's not much, but I do the best I can.

If things don't improve we'll have to get along somehow, that's all. . . . Durand-Ruel fears there will be a terrific crash in this blessed America: this matter of the free coinage of money.[1] If the president elected is in favor of this, we shall have our hands full.

<div align="center">

HÔTEL D'ANGLETERRE, COURS BOIËLDIEU
ROUEN, SEPTEMBER 8, 1896

</div>

*My dear Lucien,*

I am in Rouen. From my hotel window I have a different view of the harbor than from that of the Hôtel de Paris. I am letting my view of the landscape resolve itself. Sensations don't come all at once—I shall stroll a bit first.

<div align="center">

ROUEN, SEPTEMBER 20, 1896

</div>

*My dear Lucien,*

You are completely right to say that the masses feel no need for art and take no interest in it, but this, I think, is as true in England as elsewhere. Money is everything. . . . My boy, we must take the times for what they are and keep ourselves in check, that is the best we can do. We old ones have gone through all that, we remember the contempt those idiots showed for us when we tried to solve our problems. So if by chance you find someone who wants to exploit you, you can consider yourself damned lucky, unless you happen to be as shrewd as the dealers!

---

[1] *W. J. Bryan, Democratic candidate for the presidency, advocated the free and unlimited coinage of silver. The Republican party, whose candidate was William McKinley, opposed this measure.*

*My dear Lucien,*

The new movement Ricketts ironically urges you to support seems to me absurd, at least for you, since this neo-catholic movement dovetails with the reactionary turn of the upper bourgeoisie, which is fearful of the rising anarchist philosophy. Damn it, neo-catholicism may be in style for a bit, but since real belief is necessary for it to succeed, the chances are that it won't get very far, everybody can't be as sick as Huysmans is, his talent notwithstanding . . . no, des Esseintes cannot be our standard-bearer . . . return to nature, healthy and beautiful. No, I hope the movement will not succeed. So much the worse for it if it does. In any case it must be combatted! I am sending you an issue of *La Société Nouvelle*, read the article on the *Semitic God and the Aryan God*, it is the last of a series, you will see that scientists clearly foresee a march in a new direction which will be neither neo-Christian nor Jewish.

We are on the right track, be faithful to your sensations.

*My dear Lucien,*

I received your books yesterday.[1] They are really splendid, they are in exquisite taste.

What you said last time about Ricketts' views on the future of neo-catholicism keeps running through my mind. You are right in believing that if this movement succeeds, we—or rather you, the young generation—would be severely threatened. It is true that it could not last, it is philosophically outside the ideas of our time, and then there is the question of the genius of those who favor this art. What reassures me is the knowledge that to create this movement, belief is indispensable . . . and this is not likely; to believe one has to do more than read the book of a man with a bad stomach (Huysmans)!

I am working like a nigger! I am working on ten pictures at once . . . every kind of effect. I have a motif which should be the despair of poor Mourey: just conceive the new section of Saint

---

[1] *Lucien had just published the* Book of Ruth *and the* Book of Esther.

Sauveur right opposite my window, with the Gare d'Orléans always new and shining, and a mass of chimneys from the gigantic to the diminutive with all their smoke. In the foreground, boats on the water, to the left of the station, the workers' quarters which extend along the quays up to the iron bridge, the bridge Boiëldieu, you should see all this in the morning when the light is misty and delicate. Well now, that fool Mourey is a vulgarian to think that such a scene is banal and commonplace. It is as beautiful as Venice, my dear, it has an extraordinary character and is really beautiful! It is art; if I consult my sensations, I find that there is not only this motif, there are marvels on every side. . . . I would rather start from a real scene like this than begin with hypocritical sentiments. . . .

I have been drawing that little statuette I mentioned to you; when I have tracing paper I will send you a copy. It is nature to the life and not religious, no more so than much of the Gothic and Renaissance works. I am anxious to go and do a corner of La Cour de la Maîtrise in the Cathedral, which they are going to tear down. I want to do a splendid etching!

While looking for paints this morning I ran into Anquetin. He told me that he hadn't done any work, that all he had been doing was riding horses, that he simply had to use his energy in this way, that painting bored him! Doubtless he wanted to pull my leg. . . . Besides it's fashionable now to play the fool!

ROUEN, OCTOBER 8, 1896

*My dear Lucien,*

Mirbeau began last Sunday a series of articles on the Symbolist-Catholic-Primitives. . . . Although perhaps he isn't too well-informed, he will say a few good things, and then I feel that at bottom he is defending our ideas, the idea of beauty based on nature. . . . The sensation of art is well off; he gives a drubbing to Maurice Denis and Mourey, a good smack to Le Barc de Boutteville, a fillip to Monier de la Sizerai, to Camille Mauclair, the one who attacked my painting on the ground I liked nothing but cabbages, which isn't enough. He [Mirbeau] reviews the prostituted religious art— and there is more to come. So much the better!

I'm really sorry that I am no longer in touch with him, but I

297

will try to let him know through Monet that I am very pleased [with his article]. This is the only way of defeating this reactionary movement which, I believe, is absolutely in contradiction to the real tendency of our modern philosophy. Reaction is trying to take over, but it is too late, people no longer believe in the authority of God, religion, government, etc. . . .

*My dear Lucien,*

I am sending you a package of newspapers in which I marked Mirbeau's article on neo-Christian art entitled: *Botticelli Objects.* There is also in *Le Gaulois* an article by Mirbeau, which should be read. I believe that these articles with all their faults represent the correct position and that here we have a nucleus of people who are not losing their perspective. And for a long time now I have been afraid that Ricketts and maybe even Shannon might lose theirs!

*My dear Lucien,*

I agree with you that Burne-Jones has made excellent illustrations, but bad, very bad paintings. If I had to be influenced, I should prefer to be influenced by the authentic French Gothics, whom I have here under my eyes all the time. It is amazing how natural they are despite their decorativeness, and they are free from the sentimentality and affectation of the modern artists who call themselves their pupils. . . . But Degas is much closer to French Gothic. And Rembrandt is closer to the Gothic than these people. . . . I am at the moment looking at quite a large photograph of the *Woman Bathing*, and its character is so much closer to the Gothic. . . . And it is even ornamental, my dear! Do you know what you lack? Confidence in yourself. . . . If you could see the things that I find here, in Rouen, you would understand what I mean.

Well, never mind, Mirbeau says foolish things, mixes things up, but at bottom he is right to pounce on those who, on the pretext of achieving a style, distort nature, draw badly and don't dispose of

298

values properly. . . . Shannon has admirable gifts, but let him beware of the pretty, of sentimentality, of anglicized Grecianism, and let him make good pictures with adequate values and without tricks; let him depend on vital sensation like the Gothics, Degas and some of the impressionists. You will perhaps think me a little severe to say *some* of the impressionists—but I think I am correct.

ROUEN, NOVEMBER 6, 1896

*My dear Lucien,*

Yesterday evening I received your letter and also the very beautiful engraving for *L'Image;* [1] it is truly superb and truly ours. It makes me think of the things we once tried to do, Monet in his large canvases and I myself in the big picture I was working on in 1868–1869, the one in which you posed with poor Minette in our garden at Louveciennes.[2] Your engraving is not all like Shannon's, it is very good, and I like its clear aspect. There are one or two lines in the dresses that could have been more supple, and there is a buckle that seems somewhat exaggerated. This is perhaps because the shadow was not introduced in the way you desired. The girl about to mount the staircase also has one harsh trait; but it doesn't amount to much . . . the ornamentation is beautiful.

McKinley is elected! So Durand just wrote me a very friendly letter in his own hand—*Quès aco?*

ROUEN, NOVEMBER 11, 1896 [3]

*My dear Lucien,*

I am leaving tomorrow morning by express for Paris. I must go and have my eye cauterized by Parenteau, it is again inflamed. I just dispatched to Eragny fifteen pictures, in which I tried to represent the movement, the life, the atmosphere of the harbor thronged with smoking ships, bridges, chimneys, sections of the city in the fog and mist, under the setting sun, etc. . . . I think that what I have done is bolder than what I did last year. I had the luck

---

[1] *See fig. 63.*

[2] *A reference to Monet's first* plein air *painting:* Femmes au jardin, *now in the Louvre. The whereabouts of Pissarro's picture are unknown; it seems to have been lost.*

[3] *See fig. 64.*

to have boats with rose-colored, golden-yellow and black masts. One picture is colored like a Japanese print; that won't please the neo-catholics. . . . But at least I painted what I saw and felt; perhaps I am deceiving myself for the motifs are fleeting, they don't last more than one, two, three days. . . .

*My dear Lucien,*

The boys are leaving England Tuesday evening. They want to go to Barcelona. I would ask nothing better, only I gave them to understand that I have positive information to the effect that the recent victories of the Cubans and the last presidential election in the United States have given the Spanish Republicans a marked impetus, so that there will no doubt soon be a big uprising in the peninsula and that Barcelona will be one of the principal seats of the rebellion; obviously, foreigners are likely to get into trouble. They can do as they please.

*My dear Lucien,*

If you remain in England, you will be associated rightly or wrongly, with English art. You say that's not so bad! Yes, indeed, but you must side with the art that best suits your temperament. It seems to me that your place is here. The sole end I have in view in speaking of this is to influence you to make the best decision. On the other hand, you are right to say that people are skinflints here; you are telling me! Official art murders us, and our collectors bluster in vain, for all their fuming they are at bottom conventional; on the other hand, some instinct thrusts them towards pantheist art. . . .

I have spoken to Georges and Félix. There is a misunderstanding underlying your disagreement, which I have done my best to dissipate. Georges does not like Ricketts' work at all and accuses him of borrowing constantly from the great masters. And between the two of us, let me say it is only too obvious. You will tell me that it is done in a manner based on principle with purpose aforethought.

300

63.—Lucien Pissarro: Roses d'Antan. Woodcut, published in
*L'Image* in 1896.

Yes, but we belong to another school. If we were to borrow hands
or feet from Dürer, I think the result would not be satisfactory.
Carry Ricketts' reasoning further and the drawings of Degas are
nothing. . . . We impressionists have precisely the opposite attitude.
And note this, we have an altogether different concept of what it
means to be inspired by the ancients. We ask nothing better than
to be classics, but we want to achieve that in terms of our own
experience: how different that is!

ERAGNY, NOVEMBER 28, 1896

*My dear Lucien,*

Every time I noticed some defect in your work, I spoke of it to
you, and I shall do so again. I believe I told you that from the point
of view of our experience of art I much prefer *The Queen of the*

Rouen
Hôtel d'Angleterre        11 nov. 96

Mon cher Lucien

Je pars demain matin
par le train rapide pour
Paris il faut que j'aille me faire
cautériser l'oeil par Parenteau,
car voila que cela y est.

J'ai expédié à l'instant
pour Éragny 15 Tableaux où
j'ai tâché de donner une idée
du mouvement, de la vie, de
l'atmosphère du port si peu=
=plé de bateaux fumant, des
ponts, des cheminées, des quartiers
de la ville dans la brume, le
brouillard, soleil couchant-
etc . . . . . Je crois que ce que
j'ai fait est plus hardi que
l'année dernière, j'ai eu la
chance d'avoir des bateaux

302

avec des mats roses, jaunes d'or,
noir, il y en a un qui est. 
coloré comme une gravure ja=
=ponaise, c'est ce qui ne plaira
pas aux néo-catholiques....
enfin j'ai fait ce que j'ai vu et
senti..... Il est possible que je
me fiche dedans, car ces motifs
ne posent pas longtemps, une,
deux, trois, jours ·······
à Paris donc et à bientôt
de vos nouvelles.
Je verrai sans doute Fénéon.
Destrée etc·······

je vous embrasse
Tous les trois
Ton père aff
C. Pissarro.

64.—Facsimile of Camille Pissarro's letter dated Rouen, November 11, 1896.

*Fishes,* not because the engravings are in color, but because of the whole conception of the book. I also told you what I thought of your last engraving and I urged you to devote yourself resolutely to our art, meaning the art of the impressionists, who have nothing in common with the others. I fear only that you are yielding not to religious or mystical art, but to *sentimental* art. As I see it, mistakenly perhaps, the Pre-Raphaelites were somewhat sentimental and their descendants are much more so. . . . Sensation, yes, sentiment, too, damn it!

Yes, you are right, you must stick to your rough Eragny style, and I am glad Ricketts noticed that while you are not a decorator, your work is decorative. . . . But does Ricketts begin to understand that there is something besides the Greeks?

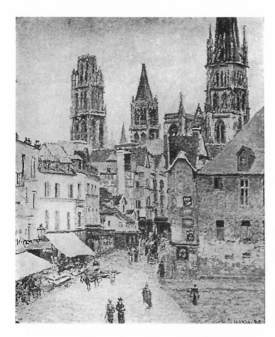

65.—C. Pissarro: La rue de l'Epicerie à Rouen, 1898.

66.—Photograph of the same Subject.

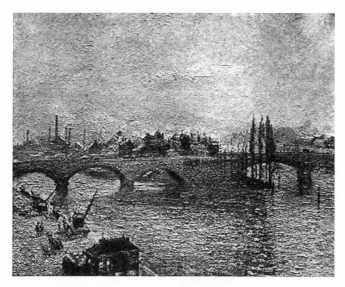

67.—C. Pissarro: Le Pont Corneille à Rouen, 1896.

68.—Photograph of the same Subject.

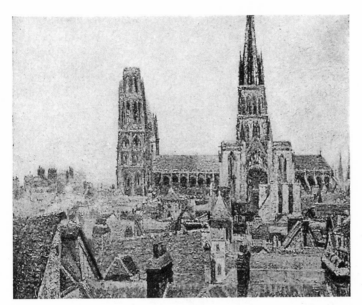

69.—C. Pissarro: The Roofs of Old Rouen, 1896.

70.—Photograph of the same Subject.

71.—L'Avenue de l'Opéra, Paris, 1896.

72.—Photograph of the same Subject.

*My dear Lucien,*

The day before yesterday we heard from the boys. They have left Saint-Sebastian, which is unlivable because of the continual storms that prevail in those parts for much of the winter. At first they had elected to go to Madrid, suddenly they changed their minds and went to Barcelona, which for quite some time they had dreamed of visiting. Unhappily they didn't have a chance to enjoy the visit. They had hardly arrived when they had a brush with the police, who doubtless had been spying on them, watching them making sketches in the harbor, near the fortifications, anywhere and everywhere without precautions! At about three o'clock in the morning the police came to their room with a search-warrant, ransacked their trunks, taking with them letters, newspapers, etc. . . . Luckily for them an artillery captain with whom they had become acquainted, a man with a fondness for painting and painters, kept the police from arresting them and advised them to take the nine o'clock train for Perpignan that very morning, which they did! Now they are in Perpignan and will soon be on their way to England, which they should never have left. . . . The whole trip has been a failure! My advice to look for a place in England where the climate is mild and there is no fog as in London was, after all, the best solution, and it would have been more economical, too. . . .

*My dear Lucien,*

We are going through a miserable period. I fear every minute to get bad news from Durand-Ruel, and there is no escape, not a ray of hope anywhere. Durand-Ruel rejected the gouaches he had ordered from me, not because he didn't care for them, but because the clients he had expected vanished. They have changed their minds as a result of the advice of German dealers. . . . Thus I have worked a whole month for nothing. I feel very discouraged, for there is not another dealer who wants to handle anything. . . .

*My dear Lucien,*

I am going back to Eragny tomorrow morning. During my stay here I was able to do six small canvases, which should defray the month's expenses, the pictures are of effects of snow on the rue Saint-Lazare and the rue d'Amsterdam [981–985].

I heard from the boys, who arrived safely in London.

The Vever auction took place on Monday and Tuesday. The outcome was excellent for Monet who had a dozen things, five or six that were first rate, one canvas brought 21,000 francs, a Degas brought 10,000 francs, a Sisley 2,500 francs, a very poor Lebourg the same sum, 2,500 francs. I had two things not too good, 900 francs! There were fifteen Sisleys which ranged from 1,500 to 2,000 francs, twenty-five Lebourgs, all poor stuff, really bad, these got high bids, it is past understanding! And you should have seen how poor they looked next to the others! It was unlucky for me, for the auction made a big noise; it brought Lebourg success like that! They tell me it was Manzi who bid for the Lebourgs. Good for him but sad for art! . . . A Daubigny brought 72,000 francs!— it was a small canvas of about 25 x 21 inches . . . . An admirable Corot, a marvelous landscape which simply obliterated the Daubigny, brought only 7,000 francs. Did you ever hear of such a thing? Really, sincere and beautiful works are not liked. A fairly large Puvis brought only 22,000 francs.

*My dear Lucien,*

I am returning to Paris again on the tenth, to do a series of the boulevard des Italiens. Last time I did several small canvases—about 13 x 10 inches—of the rue Saint-Lazare, effects of rain, snow, etc., with which Durand was very pleased. A series of paintings of the boulevards seems to him a good idea, and it will be interesting to overcome the difficulties. I engaged a large room at the Grand Hôtel de Russie, 1 rue Drouot, from which I can see the whole sweep of boulevards almost as far as the Porte Saint-Denis, anyway as far as the boulevard Bonne Nouvelle. If you decide to come to Paris, I have two beds in my room.

HÔTEL DE RUSSIE
PARIS, FEBRUARY 13, 1897

*My dear Lucien,*

I have unpacked and am stretching some large canvases [986–1000]. I am going to get one or two ready to paint the crowd on Shrove-Tuesday. I don't know if I can manage it, I am very much afraid the serpentines will hamper me no end; at this moment I have some beautiful effects of rain,—very beautiful.

PARIS, FEBRUARY 18, 1897

*My dear Lucien,*

Did I tell you that the Luxembourg Museum, the annex, has opened? A crowd formed around the impressionist paintings [Caillebotte's bequest] and made a terrific racket. . . . The room is narrow, of a poor sort, badly lighted, the frames are miserable, and the pictures are stupidly hung. . . . I saw a critic, Monsieur Jourdain, (Francis), who was highly indignant. . . . He swore that it was done deliberately out of cowardice and hypocrisy; and indeed this good fellow who was so irritated against the administration, who was infuriated because we are not decorated, and who struts around with a big ribbon of the Legion of Honor in his buttonhole and seems to be so proud of it, well now, didn't this

same Francis Jourdain write a spiteful idiotic article against Renoir during his wonderful exhibition last year, treating him like a weakling? . . . that's how they all are. On this score, someone told me—but I don't believe any of it—and strictly in confidence,—that Mirbeau has aspirations to the *Académie*. . . . That's pretty stiff! What's the good of clamoring against it all one's life just to cringe in the end? It's like those Freemasons who attack the priest and wind up by calling the priest to their deathbed! What a comedy! No, I can't believe that of Mirbeau! They say his wife is behind it! Just a farce!

PARIS, MARCH 5, 1897

*My dear Lucien,*

Your book must be finished and in Vallette's hands and you must be working on your survey of printing and the art of the book.[1] Have you received the prospectus of the review Mellério is going to edit: *L'Estampe?* On the cover are the masters of engraving, among them Lepère, Steinlen, Vierge, Gustave Doré, and for the etching, Bracquemond, Legros, Rops. It will sell for six francs a year. I haven't much faith in Mellério's ideas, he's a timid one.

I have a number of things going.[2] At Shrove-Tuesday I painted the boulevards with the crowd and the march of the Boeuf-Gras, with effects of sun on the serpentines and the trees, the crowd in the shadow [995–997]. Probably you won't see this series, just as you didn't the last Rouen paintings, the latter have gone to New York and this new group will go to join the others. Durand-Ruel is organizing an exhibition of my Rouen paintings in New York.

PARIS, MARCH 10, 1897

*My dear Lucien,*

In connection with the Caillebotte collection at the Luxembourg we can be satisfied with the quality of the works: Renoir has his *Bal au Moulin de la Galette*, which is a masterpiece; Degas has

---

[1] *Reference to a little book,* De la Typographie et de William Morris, *which Lucien was going to publish in collaboration with Charles Ricketts.*
[2] *See fig. 81.*

some very beautiful things; Monet has his *Railway Station;* Sisley's things are perhaps not his most careful works, but they are interesting enough. I have two of the best things I did in 1877, as good as those in your mother's collection.[1] Only they're hung stupidly and very vilely framed, that's all. The young artists and some of the good collectors have paid me the highest compliments. But then there's the struggle, the fight against us by those of the *Ecole des Beaux-Arts*—they don't understand anything about it; nothing surprising in this, they don't know anything. Real painters and people who can understand them are very scarce. Haven't had time to go there but Degas told me about it. I do think that while the collection is not complete it is a very good one and that the Renoir is admirable. I'm sending you some newspapers. *L'Eclair* publishes an interview with Gérôme (the *Institut* has protested to the Minister of Fine Arts), he takes Renoir to task and says he should not be confused with Renouard, for the latter can draw and has talent! The limit! . . . A reply in *Le Temps*, in which Gérôme is soundly rated. This idiot has made himself ridiculous and the *Institut* also. Which is all right with us. The truth is they are angry and we are right. At least, so I am convinced. But you may be sure that all this will do us a lot of good, this protest has been a sensation and things won't stop there.

You tell me that you are beginning to realize that you must shift for yourself and not depend on Ricketts, but that's obvious! I will advance you money to move. I must tell you since we are on the subject of money, that I am changing my will and that Tessier is handling it. He tells me that, in order to prevent any litigation, I must make or rather keep an account for each child to whom I send money, so that if necessary a reckoning can be made and so that there will be no jealousy. As I want to spare you annoyance, I am doing it; and then he advises me to send him some savings so that there will be a fund in reserve. I will do my utmost in this regard, it won't be easy, I will have to redouble my efforts. However, I will send you what you need to move.

---

[1] *Among the pictures in the Caillebotte collection finally accepted by the state were seven canvases by Camille Pissarro [175, 364, 384, 387, 416, 493, 537].*

*My dear Lucien,*

I was present at the Goncourt auction, which took place at the Hôtel Drouot. Their prints were sold at absurd prices, 200 to 300 francs for very dry and very ordinary modern prints; better things at 5 or 10 francs can be gotten at the dealers. Goncourt didn't know very much. Hayashi, whom I saw, and Théo van Rysselberghe were both flabbergasted! Everyone was taken in!

*My dear Lucien,*

I met Lepère at Durand-Ruel's yesterday. He's quite satisfied with the sale of *L'Image*. Lepère assured me that you would be successful in France, that the English movement is waking up the sleepy heads and that there will certainly be a serious revival. Lepère says that you ought to assist this movement with your talent and experience. It is a question, I say this in confidence, of not allowing the vulgarizers to take the lead. But that's the difficulty : whether you are in England or here, the movement will be just the same and you would benefit less by remaining in London; on the other hand, Ricketts will watch you working in London not without some apprehension. . . . You'll end up by quarreling, that would be bad. Forewarned is forearmed!

The discussion over the impressionists [on account of the Caillebotte bequest] is making the round of the press, each puts in his more or less sensible opinion, only Mirbeau, Geffroy and Arsène Alexandre have kept a prudent silence, at least until now. Duret, whom I saw last night, assured me that I was very well represented, the least good things are those by Sisley and Monet and these were quite good. Durand-Ruel is delighted and the other dealers are furious!

*My dear Lucien,*

Your book arrived. Very beautiful, very polished, the first page with the ornament of Salomé, the typography, etc., has the stamp

of a master. What matter if they cry that it is English, Morris-like, Gothic?—it is art. . . . The cover is charming, it is a beautiful book!

*My dear Lucien,*

My pictures are progressing, but certain effects are holding me back. In two months I have set fourteen paintings on my easel and developed all of them; I even have fifteen—and you know, they have been thoroughly pondered. . . . I only work for two hours in the morning and two hours in the evening—and even less, sometimes.

*My dear Lucien,*

I know that Mellério is preparing a work on engraving, no doubt he will also discuss typography.[1] Here, when something is taken up, everybody wants to participate in it. At the moment prints are the exclusive interest here, it is a mania, the young artists no longer do anything else. Note that Bracquemond doesn't know about what you are doing, and here his word is law. . . . I only half trust his judgment, for, as you know, he is dogmatic, cold and inconsistent; you have seen in Mellério's review what the latter thinks of Bracquemond, Vierge, Lepère, etc. . . . Here is a disquieting symptom, light must be shed. I have already begun with Mellério on our encounters at Vollard's exhibitions.

I have almost finished my work here, one or two more sessions of sun and I shall have. Unfortunately the sun hides obstinately.

---

1 *André Mellério's book* La lithographie originale en couleurs *appeared in 1898, illustrated by Bonnard. It is chiefly devoted to the works of Lautrec, Bonnard, Chéret, Steinlen, etc., as well as to Vollard's publications.*

*My dear Lucien,*

I am packing my things and sending my sixteen canvases to Eragny. I shall repair to the Hôtel Garnier, which is much less expensive. I am going to look for a place to work this fall, somewhere near the quays, perhaps near the Luxembourg Garden.

*My dear Lucien,*

I have already pointed out to Mellério how reactionary is his position, and at the symbolists' exhibition at Vollard's, I made him aware of certain absurdities. I took him to task severely on the question of etchings and of Bracquemond, whom he considers outstanding, ignoring Whistler, Degas, Mérion. . . . About my work, I surprised him very much when I told him I had made more than 100 plates. . . .

"You are not *au courant*, my dear," I said to him.

I read in the catalogue of de Goncourt a preface by Bracquemond on prints! a monumental piece of stupidity about the Japanese. . . . He speaks of values, he, who only makes details!

It is amazing how the attack of the members of the *Institut* [against the Caillebotte bequest] has served our cause. This momentum will take us far if we know how to hold fast about art. . . . Your mother expressed the wish to sell the paintings in her collection. That would be most unwise for me, particularly now; all the small dealers are after me, they don't stop making offers, they want me to leave work with them and sometimes they even want to buy. If they happened to find out that your mother wanted to sell, they would be at our heels!

*My dear Lucien,*

I am settled here again. Without delay I set to work outdoors. The country is magnificent, the apple trees are heavy with blossom,

the field is superb with green. The weather is somewhat variable, little storms interrupt me, but the temperature is very mild.

We all hope you will decide to spend the summer here. I am counting a great deal on your coming. I hope you will be able to see my series of *Boulevards* [986–1000] at Durand-Ruel's. I am just retouching them and I won't delay sending them to Durand.

Did I tell you that I have been to the Luxembourg? I am quite satisfied with my pictures, I think I am very well represented. They are presented, for example, as only officials could conceive of, in a passageway, and the pictures are crowded one next to the other. This won't surprise you, experience has taught us to be prepared for bad taste in French museums!

\* \* \*

*In the spring of 1887, Lucien contracted a serious illness in London. His father went to join him in England and then returned with Lucien, his wife and their child, to Eragny, where the young artist recovered. During his stay in London, Camille Pissarro painted several landscapes in Bedford Park [1005–1008]. The correspondence between father and son was continued again after Lucien, still weak, returned to London. His brothers Georges and Félix were then also in England, where Félix in turn fell seriously ill. Madame Pissarro immediately came over to tend him.*

\* \* \*

ERAGNY, OCTOBER 23, 1897

*My dear Lucien,*

I received Esther's card announcing that you all arrived in good order.

I hope that now you are back in your own circle, you will be able to set to work. You must give proof of will-power; it is also a question of habit. With a little courage you will succeed.

*My dear Lucien,*

I sent Esther a little box with a pair of scissors that she had left here. Along with these I sent a pair of spectacles, which I found shining in the sun under the seat of the large walnut tree; I saw them while I was making a study. Soon I hope we shall find, little by little, everything Esther lost in field and garden.

Are you going to begin to do a little work? I think it would be well for you to set to it, you have to organize your time so as to be able to be outdoors early in the morning and set to work at will.

P.S. Esther should find the shoe in question in her basket, she had left it in the basement; it is a pity that all the things she sows can scarcely take root and blossom!

*My dear Esther,*

I am delighted to hear that Lucien is really well. I should like to see him take up again his former habits of work, write his letters himself, draw, in a word, little by little busy himself with the affairs of life; he really must do this.

Did I let you know that I had received a letter from a review in Munich asking my permission to reproduce a picture "A House in the Country," [227] which was recently bought by the Berlin National Gallery. Surprise! Thus, my pictures sell!

*My dear Lucien,*

I am sending you a batch of newspapers that will bring you up to date on the Dreyfus case, which is so agitating public opinion. You will realize that the man may well be innocent, at any rate, there are honorable people in high positions who assert that he is innocent. The new brochure of Bernard Lazare, which has just appeared, proves that the document the General gave the press is a forgery. Lazare's contention is supported by twelve scientists of different nationalities. Isn't it dreadful?

*My dear Lucien,*

I received a letter Saturday from Doctor MacNish in reply to the one I wrote him asking his opinion about our going to London. He says that for the present neither your mother nor I need go away, that Titi is relatively past the crisis; but your mother had already gone—on Thursday night. I would have gone too, but I'm afraid of complications with my eye.

<div align="right">

ERAGNY, [NOVEMBER 26, 1897]

</div>

*My dear Lucien,*

I have had no news of you except from Georges, who told me that your mother has been to see you and found you improved. I am so anguished about you, I would be happy to learn that you are beginning to busy yourself with some little projects. It is a great consolation to be occupied with something; it is, incidentally, what I force myself to do here, I try to work.

Georges writes me that Titi is not too bad. Here we are all quite well, the children are very kind and have taken over their mother's duties handsomely.

<div align="right">

PARIS, 111 RUE SAINT-LAZARE
DECEMBER 15, 1897

</div>

*My dear Lucien,*

I received your letter and Esther's. I can't tell you how glad I am to see that you have been able to brave the disastrous news of the death of our poor Titi, whom we loved so much, our hope, our pride. We were afraid to inform you and didn't know how to conceal our great grief from you, but in such fatal circumstances we have to be resigned and think of those who are around us. To give way to discouragement would be terribly dangerous, and we must surmount what we could not prevent. In our misfortune I was able to see how well Georges rose to the occasion, he evidenced great strength of character, for he kept your mother from making herself ill. Well, my dear Lucien, let us work, that will dress our

wounds. I wish you strength, I want you to wrap yourself up, so to speak, in art; this will not keep us from remembering that fine, gentle, subtle and delicate artist, from loving him always.

Mirbeau has written a remarkable piece about our poor child.

Unhappily, as a result of this wretched wet weather, my eye has again become inflamed, not much, it is true, but I had to go again to Parenteau to have it cauterized, it is better now, but I have to keep going to him. . . .

I forgot to mention that I found a room in the Grand Hôtel du Louvre with a superb view of the Avenue de l'Opéra and the corner of the Place du Palais Royal! It is very beautiful to paint! Perhaps it is not aesthetic, but I am delighted to be able to paint these Paris streets that people have come to call ugly, but which are so silvery, so luminous and vital. They are so different from the boulevards. This is completely modern! I show in April.

<div align="right">PARIS, DECEMBER 21, 1897</div>

*My dear Lucien,*

I am leaving tomorrow for Eragny. I hope you are all well; as for myself, I'm quite all right, my eye is completely healed.

I am hoping to return on about the 5th of January to the Grand Hôtel du Louvre, where I shall begin work for my exhibition. This will cost a lot, but Durand-Ruel seems to be encouraging me to do it. I am well disposed for work and after having looked at the motifs carefully, I think I will accomplish my purpose.

Embrace my little Kiddie for me, we wish her a Merry Christmas, though for us the holiday will be so sad!

ERAGNY, JANUARY 3, 1898

*My dear Lucien,*

This is just a line to let you know that I am going to Paris on Wednesday, January 5, to the Hôtel du Louvre, 172 rue de Rivoli. I will write you at greater length from Paris.

I have chosen a little thing by Titi for you, I shall frame it and send it to you. I am keeping the last things he did, they are quite remarkable; if you only could see these framed, they are very beautiful and have exquisite finesse; he was an artist!

HÔTEL DU LOUVRE
PARIS, JANUARY 6, 1898

*My dear Lucien,*

I unpacked yesterday. I have two big rooms with large windows from which I can see the Avenue de l'Opéra. The motif is very beautiful, a real painter's motif [1018–1032].[1] I have already begun two canvases of about 36 x 28 inches.

I hope nothing will keep me from my work. I left Eragny very disturbed about your mother's condition; while she has just recovered from the grippe, what really worries me is that she appears to be completely discouraged and in a state of nervous exasperation such as I have never seen her in before. She weeps for our poor Titi night and day, that is understandable, but what is less so is

---
[1] *See figs. 71-74.*

her belief that we are all indifferent, that none of us thinks of our poor little one. Because I do my best not to awaken our grief, your mother regards me as a bad father lacking in sensibility and without affection for the poor boy. Everybody doesn't feel the same way, Georges and I live with Titi by arranging his drawings and pictures, and we feel his absence when we see what a subtle artist he was. Your mother's exasperation is, of course, the result of her grief and of overworking herself in London tending our son. I have done my best to persuade her to rest, but she resists all advice. If I gave way to discouragement, what would become of us?

PARIS, JANUARY 13, 1898

*My dear Esther,*

The Dreyfus case is causing many horrible things to be said here. I shall send you *L'Aurore*, in which there are the very fine pieces of Clemenceau and Zola. Today Zola accuses the General Staff. Ajalbert has published a very courageous article in *Les Droits de l'Homme*, but the bulk of the public is against Dreyfus, despite the bad faith shown in the Esterhazy affair. I heard Guillaumin say that if Dreyfus had been shot at once, people would have been spared all this commotion! He is not the only one of this opinion! At Durand-Ruel's, everyone took this view except for the door-man, and I heard many others speak that way too. Alas for a people so great in '93 and '48! The Third Empire has indeed been pernicious in its effects.

PARIS, JANUARY 15, 1898

*My dear Lucien,*

I will find out the addresses. You really want to send your book to everybody? Some, despite their reputations, are very indifferent. I am very distrustful, I am always afraid of seeming a little too insistent to certain people. There are, however, our friends who will be delighted to receive your book. You should send me two copies, one for M. Pereira and one for Viau. Huysmans, Puvis de Chavannes? Do you think they would be interested? Out of courtesy, perhaps? Degas? Perhaps. I think that Monet, who has

always been so kind to us, and even Mirbeau, would be much more appropriate. Paul Alexis? Good Lord!—he is a fine fellow, but heavens, he is blind!

*My dear Lucien,*

I repeat that you should not worry, the anti-semitic ruffians are much less noisy and aggressive since the beating they received at Tivoli Vauxhall, where they had organized an anti-semitic demonstration. No, it is becoming clear now that what we are threatened with is a clerical dictatorship, a union of the generals with the sprayers of holy water. Will this succeed? I think not. Indignation against the General Staff seems to be growing here in the provinces, the socialists are active, it is possible that the clouds will lift. But will the review of the trial take place? No one knows. I hope it will not interfere with my work, for I am in high fettle.

I realize that you want to send your book to as many as possible. Here are the addresses:

G. Geffroy, 133 rue de Belleville
André Mellério, 11 rue Portalis
Arsène Alexandre, 20 rue Gérando
Ajalbert, 55 rue de la Faisanderie

I will find out the other addresses.

I will send you some newspapers. You will see in *Les Droits de l'Homme* an article by Ajalbert, revealing what *Degas, the ferocious anti-semite*, thinks. . . . Your book will be ill received in that quarter!

PARIS, JANUARY 23, 1898

*My dear Esther,*

Didn't you receive my letter? I mentioned that I am painting the Avenue de l'Opéra and a bit of the Place du Théâtre Français, it is a splendid motif and my canvas is progressing nicely.

Yesterday I saw at Joyant's an album of reproductions of Degas' drawings published by Manzi. It is superb! It is here that one can see what a real master Degas is; his drawings are more beautiful

than Ingres', and, damn it, he is modern! One doesn't feel that element of official art which offends me even in Watts!

*My dear Lucien,*

You are right not to permit yourself to be too upset by the hue and cry about the Dreyfus case. For the present, these are little brawls, but behind this case a second *May 17* is being prepared, a clerical *coup d'état* and a *coup d'état* by the army. The question still to be determined is how the elections will go. Unfortunately the masses haven't the least understanding of what is going on; they assume a social struggle is being waged against Capital without asking themselves who will be defeated—they dislike the Jewish bankers, and rightly, but they have a weakness for the Catholic bankers, which is idiotic.

I am sending you several addresses:
Puvis de Chavannes, 89 Avenue de Villiers
Huysmans, 11 rue de Sèvres
I shall send you other names.

The little picture of Félix will be sent Monday or Tuesday. You will hang it, won't you? We have hung one in our dining room, it is charming and looks so well beside the other paintings; but these were his last sketches. Poor boy, what a subtle and delicate gift he had. His memory never leaves me. What a dreadful separation!

*My dear Lucien,*

Things are beginning to calm down around here; at least, the demonstrators are keeping quiet. The trial of Zola is awaited impatiently; he will evidently be found guilty, for everybody declares that the government is in the right and that Zola should have minded his own business. . . . There speaks prejudice, you see, but one cannot with impunity conceal the truth, sooner or later it will out.

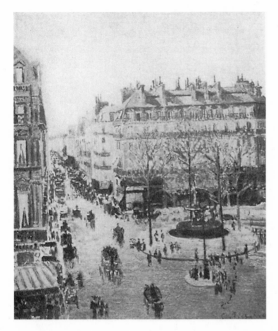

73.—C. Pissarro: La rue
Saint-Honoré, Paris, 1896.

74.—Photograph of
the same Subject.

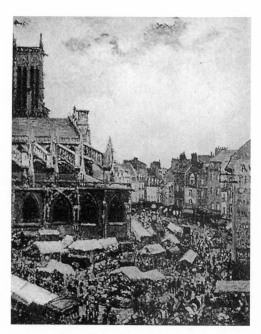

75.—C. Pissarro: Le
Marché Saint-Jacques à
Dieppe, 1901.

76.—Photograph of
the same Subject.

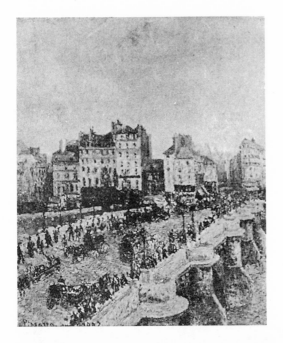

77.—C. Pissarro: Le
Pont Neuf, Paris,
1902.

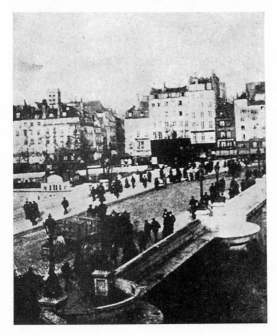

78.—Photograph of
the same Subject.
taken by the Artist's
son Rodolphe in
1902.

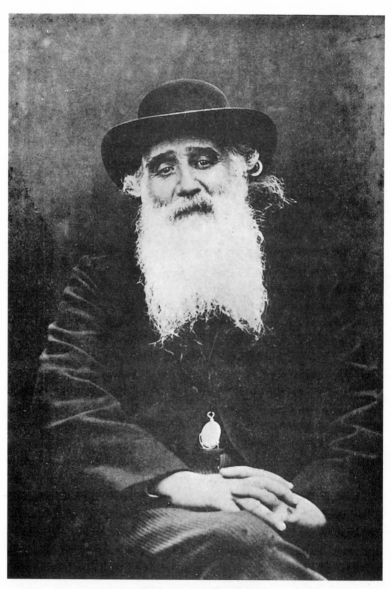

79.—Camille Pissarro, Photograph, about 1895.

*My dear Lucien,*

The newspapers report that Huysmans has definitely entered the religious fold. *So keep your book for someone else.* Another invalid! I ran into Blanche, he has become religious and anti-semitic! All cracked. He seeks to revive what was so well done when it was believed in, but today this has no use for anyone; yes, it has, it has value for deceiving poor simpletons!

We shall see many others like them, all those who have turned up their noses at our age and who have nothing inside!

<div align="right">PARIS, FEBRUARY 10, 1898</div>

*My dear Lucien,*

I had positive news about Huysmans; you see, I know the head clerk at the Librairie Stock, a man who used to go with us to the café La Nouvelle Athènes. I learned from him that Huysmans had been at Stock's recently, had inquired about me and asked the clerk to send me his greetings. It seems that the story of his having taken religious orders is completely false, Huysmans said this repeatedly, he had allowed the newspapers to spread the story, he didn't say a word in denial, thinking that this would be good advertising. . . . The clerk assured me that he had not changed, except that he had found an interesting mine to exploit. . . . It was a canon who announced that he had taken orders, believing that this was so. What a comedy of the times!

Send him your book, he will be delighted with it. As for Degas, he is so peppery, don't send it to him, he is even apt to return it.

Things have hardly improved. You can read the account of Zola's trial in the *Daily News*. It is favorable to Zola, since it was written by Duret. You will notice that all the witnesses for the prosecution were unwilling to answer the questions of Zola's attorney; nevertheless, the truth emerges, breaks through. Zola will be condemned just the same, the mob is against him, he will be condemned even against the evidence! No, the people want a tyrant, they unanimously assert the infallibility of the army. Poor France! Who could have imagined this nation, after so many revolutions, enslaved by the clergy like Spain! The slope is slippery.

And now I see that you are right to stay in England, where you can expect a little more justice and common sense. Here I fear the end has come. There will be nothing left but the symbolists. Can you see art represented by Schuffenecker? . . .

*My dear Lucien,*

Don't worry any more about the Zola case. No new anti-semitic outbursts. Anti-semitism is now condemned even in the Chamber of Deputies: it is propagated only by immature idiots who do not even shout any longer. The government is mighty sick of the whole affair, but does not know how to dispose of it; people are beginning to reflect. Grave, whom I saw yesterday, says it is all over, it will be hushed up soon like the Panama Canal scandal!

I am working very hard, I have finished six canvases and am on four more, I am not wasting my time. I counted to some extent on the Carnival, but the weather is frightful, it is hailing. You see a fancy carriage in the middle of the empty avenue, its oc-cupants benumbed and of pitiful mien.

*My dear Lucien,*

I went to the Legros exhibition at Bing's. Very important. For me his etchings are much superior to his paintings, although to this superiority Rembrandt here and there lends a hand! Loving Rembrandt as I do, I find his imitators too far beneath him. No, really, these works are much too labored, dull, rather black in tone, and even the motifs of conical huts are too imitative. What's the good of looking to the past and never at nature, so beautiful, so luminous, so full of novelty? Always in the path of the old masters, who surely should not go unheeded because we venerate them! It seems to me that the better course is to follow their example by seeking with our own senses elements in our own environment. I am talking nonsense, perhaps, in saying this, but I stick to my guns. I have seen some Courbet landscapes recently. They are far superior and really Courbet's. And take Cézanne, his expressiveness

didn't come from his not being himself. What's the good of un-wearyingly repeating everything that has been done so well? And Manet? And Degas, who constantly pushes ahead, finding expressiveness in everything around us? They don't show weakness! In fact it makes me sad to see a man as well endowed as his colleagues failing because of a theory! Such, my dear Lucien, are quite frankly the thoughts that came to me as I looked at the work of Legros. I did not feel the whiplash of originality.

George Moore has come to Paris, he should come to see me, but I haven't caught sight of him. Durand-Ruel told me that George Moore had been asked by a friend to buy impressionist paintings, to the amount of 3,000 francs. He would like to get a Manet, impossible, 12,000 francs, a Degas, 20,000 francs, etc. He will probably have to content himself with some unfledged Academicians. He has not come to see me. Why?

PARIS, MARCH 23, 1898

*My dear Lucien,*

Anquetin is having an exhibition—just drawings—at Hessel's, rue Laffitte. Another one who rummages in the portfolios of the masters; it is Michelangelo he robs, brazenly yet slavishly, and very clumsily. It seems that he is delighted when this is perceived. Whoever the influence, Manet, Renoir, etc. . . . it is always impotence. That's the example of Legros! About Shannon I think as you do that he lacks progressive ideas in art, but this is not precisely what I have most in mind: the real question is *personality*, *individuality*. Nobody would think of denying the strongly marked individuality of a Rembrandt, or even of a Manet, who comes from Goya but brings an entirely different vision, a very specific and modern consciousness, which Goya could not have envisaged. That Corot comes from Lorrain and reflects him is evident, but it is also clear to what degree he transformed what he took, in this lies all his genius; his figures are as modern as you please. In short, it is only here [in France] that artists are faithful to the tradition of the masters, *without robbing them.*

*My dear Lucien,*

Signac has gone to London for about a week's stay. *Strictly in confidence, so don't be indiscreet:* Lecomte has informed me that a book is to appear on neo-impressionism from Delacroix to Signac. The author is Signac.[1]

This seems to be a secret, so don't breathe a word. The author reviews all the painters and winds up with the appearance of the dot. . . . How much better it is for a painter to make a good picture; literature is for literary men and painting for painters, as the saying goes!

PARIS, APRIL 11, 1898

*My dear Lucien,*

Floury gave me your two volumes. He is quite satisfied, and he told me that he had purchased the lot. Yes, it will get around, but let me give you a bit of advice: protect your instinct, your individual taste. I am very happy to hear that you have begun to work with ornamented types of fount.

I have finished my work here [1018–1032]. Durand-Ruel is taking everything.

PARIS, APRIL 26, 1898

*My dear Lucien,*

I am going to try to leave Paris on Thursday. I sent twelve canvases to Durand-Ruel this morning, I am keeping three for us.

ERAGNY, MAY 2, 1898

*My dear Lucien,*

I am completely happy to be able to breathe the air here and to see green pastures and flowers. I have set to work so as not to lose the habit. . . .

---

[1] *Signac published in* La Revue Blanche *a book entitled* De Delacroix au Néo-impressionnisme, *in which he tried to show that neo-impressionism was the logical heir to and consummation of the art of Delacroix.*

*My dear Lucien,*

In regard to Rodolphe, the best thing would be for the two of you to arrange matters when you are together. I would certainly like to see the two of you in sympathetic agreement. I, who am without bias, see clearly that there is little concordance, very simply because of the *general* ideas tenaciously held to by both sides. If only you could discuss theories and forget your opposite views once the discussion closed! But ideas bite in so deeply that what is an incident of little importance becomes a cause of conflict. It is so foolish to attach importance to these discussions. Good Lord, let each one have his own notions! This is my constant plea. How many times haven't I been in disagreement with you, Esther, Ricketts and others! This doesn't prevent me from seeing things differently when the affairs of daily life are in question. It seems to me that all of us are not built the same.

The interesting thing to remark is that Rodolphe has a lot of good sense, considering his youth. In art he has the same ideas that I have and that you held years ago at Eragny; it is only experience that he lacks. The fear of being involved with a theory which he thinks is false and sentimental makes him resist. . . . Knowing the underlying problem and what is in the boy's mind, it should be easy enough for you to encourage him to follow his own bent and avoid anything that might deflect him. I express myself badly, no doubt, what I mean is that you should leave him free to go his inevitable way.

My *Avenue de l'Opéra* series is hanging at Durand-Ruel's. I have a large room devoted just to my things. There are twelve *Avenues*, seven or eight *Avenues and Boulevards,* besides studies of Eragny, all of which I am well satisfied with. In addition there is *Blossoming Spring,* on which I worked for two consecutive years, and which, I think, is the best thing I ever did. Durand-Ruel is well satisfied. In the neighboring rooms there is a group of admirable Renoirs, another room has some superb Monets, a room is devoted to Sisley, and the last small room to Puvis de Chavannes. So the gallery is filled with impressionist works. My *Avenues* are so clear that they would not suffer alongside the paintings of Puvis.

*My dear Lucien,*

I am going to pack my trunks and go to Mâcon.[1] This trip doesn't mean anything to me, I have so many projected paintings to realize that displacing myself is just upsetting to me. No question about it, one makes progress only when painting what one knows thoroughly, and hence I have even played with the idea of going to Pontoise to repaint many of the motifs I studied in time past.

My exhibition is a decided success, practically no one but Arsène Alexandre, who attacked it in *Le Figaro,* was unfavorable. . . .

*My dear Lucien,*

I am sending two paintings to America, to the exhibition in Pittsburgh, I was invited by the director, a charming man. He also invited me to be a member of this year's jury, with traveling expenses paid both ways, and for the best hotels, by the Pittsburgh Museum. I would stay for fifteen days. Naturally I declined, out of principle.

*My dear Lucien,*

I will spend one or two days in Dijon to visit the museum. I probably won't spend more than a week at Mâcon. These places are very beautiful, but I won't work there, I am afraid to stay for very long on account of my eye. I will probably return to Rouen.

The village is very picturesque, it is a pity it is so far off. I did several poor watercolors at Troyes, Châtillon and Grancey, but I am beginning to make some better ones now.

---

[1] *Mme. Pissarro wanted to visit with her husband the village Grancey-sur-Ourc near Mâcon, where she was born.*

80.—C. Pissarro: St. Urbain's Church at Troyes. Sketch from the artist's notebook, 1898.

*My dear Lucien,*

Lyon is a great and beautiful city, at times you think you are in Paris. The quays of the Saône are really beautiful; but the city is not picturesque, although there are indeed fine avenues and lovely sights. For instance, there is a fine museum with completely beautiful decorations by Puvis de Chavannes; his famous *Sacred Wood* makes a superb effect in the monumental stairway resembling the one in Rouen. In the museum there are superb primitives, works by Tintoretto, Veronese, there is a Greco, there are things by Claude Lorrain, etc. . . . A beautiful portrait by Chenavard. I am going back today to see the famous cartoons of Chenavard [for the decorative paintings in the Panthéon]; in fact it is the museum which interests me most. Mâcon and Châtillon-sur-Seine would have been better as far as painting is concerned, although there ought to be some beautiful motifs on the outskirts of Lyon. It is the houses that are displeasing to me, they are commonplace and without character, the houses in Paris are superb by comparison; here they are as alike as the double sixes in dominoes.

327

*My dear Lucien,*

I received your letter simultaneously with Rodolphe's card announcing his arrival in London. In regard to what you say in your letter, I am sorely perplexed as to how to advise you. Looking at the problem in the light of my experience, I see so many contradictions. Most often, restraint, instead of guarding one from harm, precipitates one into it. It is practically impossible to keep a young man from going where his passions lead him. Often the accident of an unlucky meeting is enough for ruin to follow. Do you imagine that education, the example of others, prevents anything? Just observe what happens in all societies, here as in other countries, the young are all the same; I recently had an opportunity to observe the extraordinary results of free education and of authoritarian education. You know as well as I what follows from the training given in the seminaries and what follows from that given in the English universities. One produces sodomists, the other, rakes. Which is to be preferred? The first is against nature, yet protects one from the accidents of which you speak, the other leaves one to the mercy of an unlucky encounter. . . . That is the truth of the matter, we have only one weapon, our own judgment. When I recall that as a young man I found myself free, absolutely free, left to my own resources in a foreign land, and when I consider that I had the luck never to fall into misfortune, I ask myself what counsel I could give? All I can suggest is judgment and a wise suspiciousness . . . and yet—I am waiting for news from Rodolphe the grumbler. . . .

Nota: the author of this letter had a powerful anodyne: Art!!

*My dear Lucien,*

I received your letter this morning, I am very happy that Rodo and you are on such good terms and that he has decided to stay with you.

For a long time now I have been casting about for some way to put five hundred francs aside to buy the press for you, but I haven't

been able to. Since I can't always work at Eragny, I am forced to go to places where I can find attractive and interesting motifs, and this is expensive, very expensive. Fortunately I am still able to work. Yesterday I discovered an excellent place, where I hope to paint the rue de l'Epicerie and even the market, a really interesting one, which is held there every Friday [1036–1038].[1] Unfortunately there was thunder and rain today. I shall put aside whatever I can and send you money for the press as soon as possible.

I do not doubt that Morris' books are as beautiful as Gothic art, but it must not be forgotten that the Gothic artists were *inventors* and that we have to perform, not better, which is impossible, but differently and following our own bent. The results will not be immediately evident. Yes, you are right, it is not necessary to be Gothic, but are you doing everything possible not to be? With this in view you would have to disregard friend Ricketts, who is of course a charming man, but who from the point of view of *art* seems to stray from the true direction, which is the return to *nature*. For we have to approach nature sincerely, with our own modern sensibilities; imitation or invention is something else again. We have today a general concept inherited from our great modern painters, hence we have a tradition of modern art, and I am for following this tradition while we inflect it in terms of our individual points of view. Look at Degas, Manet, Monet, who are close to us, and at our elders, David, Ingres, Delacroix, Courbet, Corot, the great Corot, did they leave us nothing? Observe that it is a grave error to believe that all mediums of art are not closely tied to their time. Well, then, is this the path of Ricketts? No. It has been my view for a long time that it is not a question of pretty *Italian elegance*, but of using our eyes a bit and disregarding what is in style. Reflect in all sincerity. . . .

ROUEN, SEPTEMBER 9, 1898

*My dear Lucien,*

Just a line to let you know that I just wrote Durand-Ruel to send you five hundred francs to buy the *printing press*.

---

[1] *See figs. 65 and 66.*

*My dear Lucien,*

I shall leave in three or four days for Eragny. I am waiting for some money from Durand-Ruel in order to leave Rouen; it seems he has to be pressed. I shall have to come to a decision when I arrive in Paris in a few days. This is what I expect to do: take advantage of the fact that there is an exhibition of Rembrandt in Amsterdam, go there for the show and at the same time see if there isn't something to paint. This summer I received several letters from M. Meier-Graefe, begging me repeatedly to send some pictures to M. Uterwijk, saying that he had collectors for my works; the most practical thing would be to go and see for myself. I have also had offers from Berlin. So I shall go and see what the situation is.

Durand-Ruel strongly urged me to take this trip, he encourages me to go there to work when the fancy takes me, it is what I intend to do. I will have an opportunity to go to The Hague and see M. Uterwijk and above all try to effect some sales more profitable than those to Durand-Ruel, who has given me the same prices for ten years. . . . It is true that he takes all my work, but on the other hand, he has too much power over me.

*My dear Lucien,*

We have been back from Holland since Sunday night. Zandomeneghi made the trip with us. These eight days in Holland could not be surpassed, we were favored with magnificent weather. What superb landscapes and beautiful pictures we saw! The Rembrandt show was comprised of some forty or so works of the first order, and the museum of Amsterdam is very interesting. One really has to spend several months in Holland just to see the museums; what do eight days amount to? I can hardly remember all the masterpieces I saw. I hope to go back some day.

I shall return to Eragny. I expect Georges today. He has taken a studio in Montmartre with Rodolphe. Thus we shall be all alone at Eragny; I don't know how we'll manage.

*My dear Lucien,*

I haven't had time to write about what I felt when I looked at the admirable works of Rembrandt. The thought that struck me after I had seen not only the Rembrandts, but the works of Franz Hals, Vermeer and so many other great artists, was that we modern painters, we are unassailably correct to seek where they did not or rather to feel differently from the way they did, since different we are, and their works are so definitely of their time that it would be absurd to follow them. And then, as I have so often said, I am suspicious of those adroit painters who know how to make pastiches of the old masters. I have not for these artful ones as much respect as I have for painters who, incapable of masterpieces, yet look with their own eyes. But how can I describe Rembrandt's portraits to you? The paintings by Hals, and the *View of Delft* by Vermeer, are masterpieces akin to the works of the impressionists. I returned from Holland more persuaded than ever to love Monet, Degas, Renoir, Sisley. . . .

Amsterdam is an admirable city, full of movement and of the unexpected; I hope to return in June. The hotels seem to be located by the best sites, along canals bordered by trees or near the port. I have seen marvelous things to paint, aspects full of freshness, effects of bland or misty clarity which our ancestors never attempted to transcribe. Happy are the artists who look at nature and love it!

*My dear Lucien,*

You ask me why I bring my pictures to Paris. Very simply, not to have to leave them here while we stay in Paris, for I am very much afraid of the effect on the canvases of the winter wetness. I have selected my best things, some forty odd pictures. The family will spend the winter in Paris, we are looking for an apartment; we shall stay until April or May and return to Eragny for the summer.

I haven't found anything yet which your mother approves. She has been in Paris since yesterday to look for a place. I still don't know whether I'll have to look for a separate studio; you realize of course how inconvenient it would be to attempt anything at all

at home. If I find something to paint along the quays, I will try to get a place there. As for living near the quays, no, it is too far from the railroad. Moreover, once my pictures are finished I wouldn't have to live there. Not a very neat solution! But all I know is that after January I will have to do a good series of things that will interest Durand-Ruel, otherwise I'll be penniless. . . . I hope, if my health holds out and nothing comes up to deflect me, to go to Holland for a truly beautiful series.

<div align="right">
HÔTEL DU LOUVRE<br>
PARIS, NOVEMBER 19, 1898
</div>

*My dear Lucien,*

You need not worry about my safety here. For the moment we have to deal with nothing more than a few Catholic ruffians from the Latin Quarter favored by the government. They shout: Down with the Jews! but all they do is shout. The healthy majority has come to its senses and understands that the object of the shouting is to overturn the Republic, or rather to make the Jesuits absolute rulers. I believe and hope that in the end free men will have the upper hand. Yesterday, at about five o'clock, while on my way to Durand-Ruel, I found myself in the middle of a gang of young scamps seconded by ruffians. They shouted: Death to the Jews! Down with Zola! I calmly passed through them and reached the rue Laffitte. . . . They had not even taken me for a Jew. . . . Protests against the verdict in the Zola case abound everywhere. All the intellectuals protest, and there are the socialists who organize meetings; the day before yesterday the socialists and the anarchists made a terrible row against the meeting of Rochefort and the Jesuits. Who could have imagined such behavior from Rochefort? The idiot, he lost his bearings this time. France is really sick, will she recover? We shall see after Zola's trial. I wrote him a few lines to express my whole-hearted admiration. Yesterday I received a card from Mirbeau asking me to sign the protest with Monet and various others. Despite the grave turn of affairs in Paris, despite all these anxieties, I must work at my window as if nothing has happened. Let us hope it will end happily.

*My dear Lucien,*

We have engaged an apartment at 204 rue de Rivoli, facing the Tuileries, with a superb view of the Park, the Louvre to the left, in the background the houses on the quays behind the trees, to the right the Dôme des Invalides, the steeples of Ste. Clotilde behind the solid mass of chestnut trees. It is very beautiful. I shall paint a fine series [1097–1110, 1123–1136].

The deuce! here is still another potential artist. . . . Kiddie shows skill in drawing, it was written that she would. Her drawings are already full of sentiment, elegance, waywardness.

*My dear Lucien,*

Coming here I found the frontispiece of your book. You ask what I think of your woodcut: considering the kind of aesthetic idea in which the drawing is conceived, I have nothing to say, since everything I would object to has been done on purpose. Thus the only thing I can judge is the line, which seems up to the level of what you have already published, and the execution of the actual cutting seems excellent to me. Esther has acquitted herself admirably. I think it will go well with Ricketts' lettering.

At this moment I am having an exhibition at Pittsburgh, in the United States, and a show of my works is to open in Moscow. Durand-Ruel exhibited our work in November in Berlin and Munich. I have had no reports from these various exhibitions; we serve the purposes of the dealers, we are left without even the satisfaction of knowing whether we have had some success.

204 RUE DE RIVOLI
PARIS, JANUARY 22, 1899

*My dear Lucien,*

We have at last moved in and unpacked and I am hard at work. I have the Jardin des Tuileries facing me and to the left the Place du Carrousel and the Louvre, it is very beautiful. Until now I have only been able to begin effects of grey and rainy days, for since our arrival we have had miserable weather with winds that could unhorn bulls. They sweep across this great open space and make a deafening racket.

Just now we are having an exhibition of Boudin, who died recently. Fine and skillful work. The small early canvases are pretty; there is more delicacy than strength.

Sisley, I hear, is seriously ill.[1] He is a great and beautiful artist, in my opinion he is a master equal to the greatest. I have seen works of his of rare amplitude and beauty, among others an *Inundation* [in the Camondo collection], which is a masterpiece.

About the drawing you are beginning: I think you ought to keep working on it. You must understand that adroitness is not indispensable. Didn't Renoir paint ravishing pictures with his left hand when he broke his right arm? Yes, it will come to you.

The Dreyfus case is not progressing too quickly, but it is not going too badly either. The Chamber of Deputies voted against the reactionaries by big majorities several times in a row; the latter will certainly have a hard time going against the current. The anti-

---

[1] *Sisley was to die at Moret-sur-Loing on January 29, 1899, in complete destitution.*

334

semites and Esterhazyites are already beginning to be ridiculous, and that is always fatal!

*My dear Lucien,*

I am drudging away, although I have had to discontinue work at times on account of the heavy mists. I have fourteen canvases on the easel, of which twelve are finished. The motifs of the Carrousel and the Jardin des Tuileries please everybody, but so far I have had nothing but effects of fog. I am awaiting the thrust of the leaves and flowers so as to get more varied effects.

As for financial matters, I am quite content, if not in view of the money I have actually obtained, then at least in consideration of the way the future looks and of the position in which I am now vis-à-vis of Durand-Ruel. A syndicate has been formed (always!) of Georges Petit, who seems to be a big dealer, Montaignac and the Bernheims, father and son, who have undertaken to push my work. They have just bought some thirty odd pictures of mine from Durand-Ruel and several collectors for an exhibition which will open on the 25th of this month. It seems they have already sold half of this just purchased collection. And now, as an immediate consequence, Durand has to be very kind to me. I have just refused to sell to the syndicate; I hope that now Durand will permit me to raise my prices.

PARIS, APRIL 12, 1899

*My dear Lucien,*

I have done much work on my *Tuileries* series. I shall have an important canvas, *The Garden of the Tuileries on a Winter Afternoon,* for an auction the proceeds of which are to go to Sisley's children. It is a canvas of about 36 x 28 inches; there will also be a Monet and an important Renoir. It is expected to be a sensational sale.

Durand-Ruel has opened an important exhibition; a whole room of Corot, one of Sisley, one of Monet, one of Renoir, and a room of my work.[1] It seems to be a great attraction. . . .

[1] *Pissarro was represented by thirty-six canvases executed between 1870 and 1898.*

*My dear Lucien,*

I sent Durand-Ruel eleven of my *Tuileries* canvases, I am keeping three of them.

Right now Durand-Ruel is holding a splendid exhibition of Jongkind, three rooms are devoted to him. After this there will be a show of Puvis de Chavannes.

George Moore was in Paris recently, he bought one of my drawings from Portier and sent me his book on art [*Modern Painting*]. I didn't run into him.

There are quite a few of my pictures that have been sold lately at public auctions. Since my prices are going up, the collectors are putting on sale a quantity of small canvases which come from God knows where!

*My dear Lucien,*

I went to Arques. It is true that there are any number of Englishmen there, but this doesn't bother me too much, and then, wherever the English are there are always accommodations; no, it isn't that, but the fact that the country doesn't suit me; it is too panoramic, while I am in search of nooks and corners. . . . I have found nothing better than we have here, that is to say, from Pontoise to Rouen. Caudebec is really not very beautiful and the winds are as lusty as in Dieppe.

*My dear Lucien,*

You ask whether I have made my decision for the season. Yes indeed: I am not budging from here, I have been harnessed to my work since June, I have begun some motifs in the field, some with figures. I have reason, I think, to congratulate myself on these things. I think they will be interesting. Later on I will probably continue my work at Gisors where I haven't painted for years, it will be a novelty!

It is very beautiful for the layman, but for the poor painter the weather has been extraordinarily changeable!

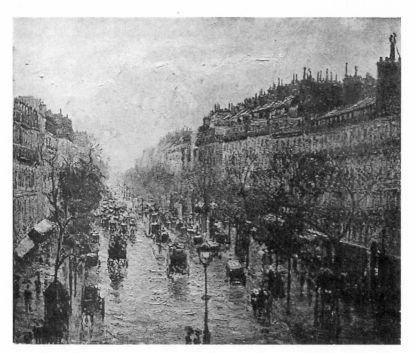

81.—C. Pissarro: Le Boulevard Montmartre, Paris, 1897.

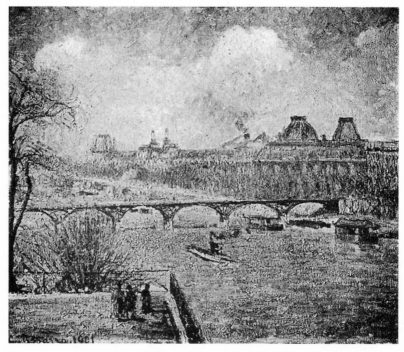

82.— C. Pissarro: La Seine et le Louvre, Paris, 1901.

83.—C. Pissarro: La Place du Vert Galant (Pont Neuf), Paris, 1902.

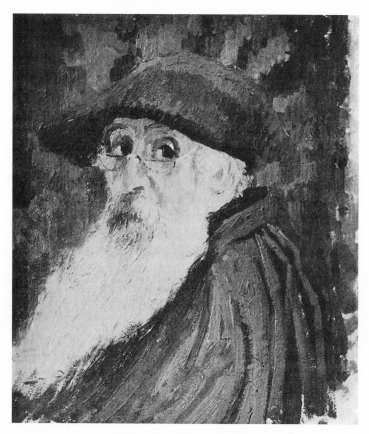

84.—C. Pissarro: Selfportrait, about 1900.

85.—Lucien Pissarro: Girl with Geese. Woodcut, 1899.

*My dear Lucien,*

Having finished my summer's work I am considering a little trip to Varengeville, near Dieppe, in order to vary my motifs somewhat.

*My dear Lucien,*

I received the two volumes in perfect condition.[1] It is very well done and all to your honor. The ornamented page is without question the most beautiful you have ever made, it is full of style, very

---

[1] *Jules Laforgue: Moralités Légendaires, 2 volumes, published by Lucien Pissarro.*

decorative and sufficiently like nature to go well with the type of fount; the gold blends admirably with the light greenish-grey tone, the drawing of the figures is charming, the lettering is firmly drawn, the geese are very beautiful; I am delighted with the woodcut of the geese.[1]

I think you have well developed your own style and I am certain that all you will do will attract much attention. I am very glad you are devoting yourself to engraving, I am sure you will succeed.

PARIS, NOVEMBER 24, 1899

*My dear Lucien,*

Your little proof, enclosed in your last letter with the two prints of *Daphnis and Chloe*, is very charming, very delicate, and sound in its naïveté. If you take my advice, you will not publish the two cuts of *Daphnis and Chloe*. They are dark, heavy, and seem at once too complicated and banal, they would not go well with your lettering. I apprised Vollard of the exhibition of your books, for he has a shop which is soon to be transformed. It is as ever on the rue Laffitte, the same spot. I expect to speak of it to Floury and I shall tell you what he thinks of it. . . . If only nothing comes along to upset things here! For there is much talk of expelling the Jews, which would be the last straw!

PARIS, DECEMBER 1, 1899

*My dear Lucien,*

I should like nothing better than to rework the *Daphnis and Chloe* for you, but I am completely occupied with painting from my window, and for the moment it would be difficult to try anything else. Tell me if it is urgent. Why don't you attempt it yourself? You have the qualities necessary to succeed in this style, your drawing is so appropriate for the book. . . . Well, I'll see if I can.

---

[1] *See fig. 85.*

338

*My dear Lucien,*

Here they don't look at a book as a totality, even the young artists who try to do good work haven't learned this. Thus, yesterday Vollard showed me a galley for a volume of Verlaine with a sixteenth-seventeenth century type. It was illustrated by Bonnard (a young artist), the drawings are rendered very freely by the [lithographic] process. . . . To my objections Vollard replied: "But this is seventeenth century typography." I saw a book done by William Morris, which I found repellent. . . . That's the situation here. Denis (the painter) is going to do *Daphnis and Chloe* with woodcuts. He will certainly make some pretty cuts but the ensemble will undoubtedly be poor.

I think you should stick to your idea of making your own fount of type. But what I particularly advise is to avoid too elongated figures in the drawings for your cuts, such figures ring false. One can be simple, natural and yet very expressive! I think more can be learned from French works, from the Lenain brothers, even from Chardin, than from the Italian school, over-subtle and too graceful. Besides, Italian art is not in accord with your temperament. You need a cunning hand, like Whistler and others. Whistler always seems to be dancing on a thread, while creating with much talent Spanish-Italian works. But he has no profundity.

*My dear Lucien,*

I found an apartment on the Pont Neuf [28 Place Dauphine]. It has a very fine view.[1] I am going to move in July. This should not influence your trip here, I am simply afraid of failing once again to avail myself of a picturesque part of Paris.

Be of good courage, and until next time! Try to come before June. The *Exposition Universelle* hasn't made much progress; anyway it will be a monstrosity—bazaar, music-hall—well, that's the taste of the day!

*My dear Lucien,*

We, that is to say, the impressionists, have a room at the centenary exhibition, and it seems that we are very well represented. Durand-Ruel finally decided to occupy himself with it. The Bernheims told me yesterday that it is very fine and that it will be sensational; our room comes after the one devoted to the school of 1830. There will even be some Cézannes; the latter, by the way, is very much in vogue, it is extraordinary! Yesterday I learned that five of my pictures have been bought for Berlin. The present price of the Sisleys is between 6,000 and 10,000 francs, of the Cézannes from 5,000 to 6,000, the Monets from 6,000 to 10,000, even the Lépines are getting high prices!

*My dear Lucien,*

Decidedly, we no longer understand each other. What you tell me about the modern movement, commercialism, etc., has no relation to our conception of art, here at least. You know perfectly well that just as William Morris had some influence on commercial art in England, so here the real artists who seek have had and will have some effect on it. That we cannot prevent stupid vulgarization,

---

[1] *See figs. 77, 78, 82 and 83.*

86.—Lucien Pissarro: La Belle au Bois dormant. Woodcut, about 1900.

even such things as the making of chromos for grocers from figures of Corot . . . is absolutely true. Yes, I know perfectly well that the Greek and the primitive are reactions against commercialism. But right there lies the error. Commercialism can vulgarize these as easily as any other style, hence it's useless. Wouldn't it be better to soak yourself in nature? I don't hold the view that we have been fooling ourselves and ought rightly to worship the steam engine with the great majority. No, a thousand times no! We are here to show the way! According to you salvation lies with the primitives, the Italians. According to me this is incorrect. Salvation lies in nature, now more than ever.

Let us pursue what we believe is good, soon it will be evident who is right. In short, money is an empty thing; let us earn some since we have to, but without departing from our roles!

341

*My dear Lucien,*

The day before yesterday I visited the [English Section of the] Centenary exhibition. There are hardly more than two good things, the portrait of Shannon, a pure Watts, very skillfully done, in fact overdone and lacking in blood. Shannon is not the color of a cooked Hindu. No, my dear, there is no point in repainting the old masters however skillfully you do it, even Watts, even Whistler, especially Whistler, adroit as he is, fails alongside of Manet and Renoir, lacking inspiration. There is the same monotonous repetition, one feels the process behind it. The Ingres are marvelous, Delacroix is poorly represented with very few things, there is a fresco by Chassériau which is admirable and shows us where Puvis de Chavannes got his inspiration; it is like the work of Watts in simplicity of tone but the style is much superior. Also by Chassériau a superb portrait, something entirely different. I saw an *Odalisque*, rather, a nude woman and a head, by someone named Trulat of Dijon, of whom little has been said, it is admirable; he must have been a pupil or school fellow of Géricault or Delacroix. He was born at Dijon in 1824 and died in the same city in 1848. You will find it interesting.

*My dear Lucien,*

Your early woodcuts in color had a personal savor which distinguishes them from those you did since under the Italian influence of Ricketts. Whatever the reason, this is the fact. And it is incontestable that art in England is generally under this influence, and I do not know if I am right, but looking at the English exhibition I felt that the works lacked life, as do all things which are wanting in personal intuition.

*My dear Lucien,*

I am fairly well satisfied with the prices that my paintings brought at recent auctions; my canvases have gone up a good deal,

as I wrote you: one picture brought 8,400 or 8,500 francs; at another auction one canvas got 5,000 francs and recently the prices have been around 7,000, 6,000 and 5,000. The pictures, dating from 1874 to 1880, were in very good condition and looked very fine. They were of motifs of Pontoise, trees, slopes, a corner of the public garden with figures. All these paintings are very luminous and rich. This is pretty good, I hope the collectors will ask me for some.

<div align="right">GRAND HÔTEL DE BERNEVAL<br>BERNEVAL, JULY 11, 1900</div>

*My dear Lucien,*

Here I am at Berneval, a pretty little watering place an hour's drive from Dieppe. For the present I am staying at the hotel. The place is smaller than Varengeville, but it is a real nest surrounded by trees and slopes and with a pretty beach. If we take a place here, you will have to come and spend several days with us. I hope to be able to start working as soon as I get my paints and canvases [1143–1149].

<div align="right">BERNEVAL, JULY 12, 1900</div>

*My dear Lucien,*

Ricketts spoke to you about Chassériau, but you give me the impression that you listen only to him. I wrote you a very detailed letter about the frescoes in the *Cour des Comptes*. I once showed you works by Chassériau, and he has done very beautiful things; I have known his name for a long time, for the Chassériaus were merchants in St. Thomas; your grandfather knew them, they did business together. He just escaped being forgotten, for his principal work, the frescoes, were only lately saved from ruin. Imagine these frescoes subject to the rain and wind for twenty years in the ruins of the *Cour des Comptes!*

<div align="center">343</div>

*My dear Lucien,*

I am sending you the three types of drawings with the sketches which could serve you for the cutting if need be. I have done my best in all the bustle of finishing paintings, unpacking and checking up on my pictures. . . . Well, see if these will do; I don't send them to you as perfect drawings for the cut, but it seems to me there might be a way to use them.

*My dear Lucien,*

It is true I haven't written you for a long time. We are so disorganized and upset by the holidays, and I have done not a little work since I have had such beautiful effects; in addition I have been busy with my show, or rather the show that Durand-Ruel is expecting to hold of my works. The opening is about the 10th or 15th of this month.

*My dear Lucien,*

Today my show opens at Durand-Ruel's: forty-two canvases. The paintings of Eragny seem to me better than those of Paris and of Rouen.[1]

*My dear Lucien,*

My exhibition has had some small *succès d'estime*, but people don't seem to be terribly enthusiastic.

---

[1] *This exhibition was composed exclusively of paintings done between 1898 and 1900.*

*My dear Lucien,*

I have had the grippe once more and trouble with my eye too! I am almost over this, I am beginning to work again, but for more than two weeks I have not gone outdoors.

I have finished so to speak, my Winter series: four canvases of 36 x 28 inches, five of 31 x 25 inches, two gouaches, five canvases of 21 x 18 inches which are almost finished [1155–1181]. . . . As you see I haven't wasted my time thanks to my regular hours of work. I will begin my Spring series in April, maybe even in March!

CAEN, JUNE 19, 1901

*My dear Lucien,*

Not wishing to return to Berneval this year, for I am not very interested in the place either for painting or for anything else, I calculated that I could find a more suitable place elsewhere. I have just gone through several watering places with Rodolphe who had been staying at Dieppe. We went to Rouen to take the train to Trouville, which, as you may imagine, I found horrible. En route from Rouen to Trouville we got the idea of stopping at Lisieux, which you praised so highly; and really the city seemed very interesting to us, with its old streets and churches. After Trouville, we saw Villers-sur-mer, which seemed to us even uglier than Trouville. . . . Atrocious chalets and an insignificant countryside. Well, I thought that Caen would be worth looking at. It is a very interesting city with superb churches, old houses and curious streets, but it is also being buried under enormous modern houses.

We expect to go back tomorrow or the day after. In all this traveling I have found nothing suitable.

HÔTEL DU COMMERCE
DIEPPE, JULY 26, 1901

*My dear Lucien,*

I received your book, *Un Coeur simple,* which I found excellent. I got it when I returned to Paris to have my eye treated, which, as a result of the great heat, became inflamed; but it's not serious.

I am staying here in a small hotel room across from the church

of St. Jacques and the market [1]; I have already started several canvases of effects of rain, which I dared begin as I thought that, after the tropical heat which was bestowed on us, rain could not fail to fall, to the great despair of the merchants in the neighborhood [1193–1200].

Your mother, Cocotte, Rodo and Paul, have moved into a large chalet at Berneval. They have a pony and carriage at their disposal. What a pity that you can't stay there too! I was hoping that you would come at the end of the season and stay until winter. You are right, it is only after November that people busy themselves with art in Paris, in London you can't know what's going on.

*     *     *

*During the summer of 1901 Lucien spent several weeks with his father in France and then returned to London.*

*     *     *

ERAGNY, OCTOBER 12, 1901

*My dear Lucien,*

Since your departure I have finished four fairly large canvases.

I am as embarrassed as you about giving Sam the information he wants concerning the painter Lucientes y Goya. The English art critics are really amazing: Goya is an extraordinary personality and is worthy of a serious and careful analysis. It is the paintings of these modern artists that must be seen and studied; this takes time and trips. History today is written so hastily and is more a question of stylishness than anything else! That isn't serious.

PARIS, DECEMBER 31, 1901

*My dear Lucien,*

I too think that it is not in the drawing that we must look for the defect [of the woodcuts for *Les Travaux des Champs*], it is, as you said, in the way of treating each colored plate and in the way of engraving. If we were together, I am sure that we would hit upon the right way. We will have to work together this summer at Dieppe or elsewhere.

~~~~~~~~~~~~~~~~~~

[1] *See figs. 75 and 76.*

28 PLACE DAUPHINE
PARIS, JANUARY 4, 1902

My dear Lucien,

My eye bothers me constantly. The slightest change of weather induces an inflammation. Thus, yesterday my eye was perfect, and this morning it is congested again; it will have to be cauterized. The inflammation has become chronic.

PARIS, MARCH 28, 1902

My dear Lucien,

I will send you next week Duret's book on Manet; he is quite proud of it, but he does feel that it is lacking in something, that it is not the last word. He would like to make a second edition (the first edition of 600 copies is already exhausted). The book sells for 25 francs, with a number of reproductions. For the second edition he would like to use only woodcuts for the reproductions. Every time I see him he begs me to speak to you about this, he constantly asks me if you would be willing to undertake this, for he is a great admirer of your books. I think that if you write him about this matter, you would have to explain carefully your methods of work. I don't see how you could reproduce paintings by Manet or others.

My dear Lucien,

It is not lack of desire that keeps me from going to London to see you, this would be a great pleasure indeed, but it is absolutely necessary that I set up my easel outdoors after a winter of claustration; moreover I have to furnish Durand-Ruel and the Bernheims with some paintings. It is of the utmost importance that you come and spend some time with us, if only to keep in mental touch with us.

DIEPPE, JULY 11, 1902

My dear Lucien,

Well, here I am in Dieppe at the Hôtel du Commerce. I have rented a room on the second floor under the arcades of the fish-market. This is my studio. I have a first-rate motif, indeed I have several. It is really a pity that you can't come to Dieppe this year, but perhaps you will be able to escape for a little while. I believe your mother will come any day now with Cocotte and Paul to spend the 14th of July. In any case, there would be room for you, since I have two rooms.

There aren't many people here but the place will fill up later. The beautiful weather is attracting visitors, the English are the first to come as tourists and excursionists. However, the coronation, to which I am completely indifferent, may keep them at home. For all that, they are interesting, they never despair, they have found a way of glorifying their part in an infamous war in which they have not shown any brilliance except through their money.[1]

DIEPPE, AUGUST 11, 1902

My dear Lucien,

I am very happy to learn that you are going to begin to print with your own types of fount. You didn't show me your complete

[1] *A reference to the Boer War.*

alphabet, I only saw a few letters, but I hope that on the whole they have as much distinctiveness as those of the Vale Press.

I am working hard and for good reason, deals are tough, as the peasants say. Last year the Bernheims wrote me many pressing and friendly letters, this year not a word.

My motifs are very beautiful: the fishmarket, the inner harbor, the Duquesne basin, in the rain, in the sun, in the smoke, etc., etc. [1241–1258]. . . .

And our publication, *Les Travaux des Champs*???

DIEPPE, AUGUST 15, 1902

My dear Lucien,

You can get your alphabet made. I have swung a little deal which will bring me exactly the necessary money, 2,500 francs. Dr. Julius Elias, an art critic from Berlin, and very enthusiastic, wanted absolutely to buy something of mine. I will have this money towards the beginning of October or November; if you need it sooner, let me know. I would of course prefer giving it to you at that date, for my credit with Durand-Ruel is almost exhausted.

ERAGNY, OCTOBER 3, 1902

My dear Lucien,

You have heard that Zola is dead. It is a terrible loss to France! And coming after the Dreyfus case, it is, as you can see, a grave event. I sent my condolences to his widow, but I do not believe, considering my age, that I can attend the funeral. I would not dare follow the procession . . . and then I have just arrived from Dieppe with my trunks full of canvases to be retouched and which I have to bring to Paris.

ERAGNY, OCTOBER 20, 1902

My dear Lucien,

This morning I received your volume of Ronsard [*Choix de Sonnets*]. It seems to me that this time you have surpassed yourself.

350

87.—*Les Travaux des Champs:* Girl with Cows. Drawn by Camille and cut on the wood by Lucien Pissarro, about 1902.

The whole thing is simply superb, the cover is charming and discreet in tone, the engraving is ample and very appropriate to the ornamentation and to the characters, and the ensemble is decorative, in very good taste and without affectation. I hope your collectors will see it; as soon as I have an opportunity, I will be glad to show it around.

The letters engraved by Esther are of great delicacy and admirable workmanship.

ERAGNY, NOVEMBER 4, 1902

My dear Lucien,

I am very concerned about the attitude Durand-Ruel and the Bernheims have taken. I certainly don't intend to let them cheat me, but I have so many expenses that it will be hard for all of us.

Clearly Durand needs me, otherwise he wouldn't be so roundabout in his relentless attempt to quarter me. Nor can I count on the collectors either; I have some hope about Germany, where it seems I am well known, but on the other hand, I know that I have to contend with Durand-Ruel's enemies, who have done everything they could to depreciate the value of my work by offering my canvases at low prices. As before certain big Paris dealers sold pictures at a loss in order to control the market and ruin Durand-Ruel. In short, I have to bore myself with these matters instead of looking solely to my art.

PARIS, NOVEMBER 26, 1902

My dear Lucien,

What you write me about Ricketts' work doesn't surprise me. The general rule that is followed nowadays is to look for a style in the works of one's predecessors without asking oneself what nature could provide. Thus inevitably, he turns about like those squirrels in their cage, without suspecting that there is a spring, a summer, an autumn, a winter, air, the light, harmonies, admirable and infinite subtleties in nature, and that the problem is to pay close heed to these. It is true that he is not a painter, but a literary man who has a story to tell; that isn't very interesting, and the fact is that this has been very well done already—there is little value in playing the same note all the time.

We have just received a letter from Rodo [who is with Georges in Martigues]. It seems that he is working a good deal, he tells me that they go around with a pupil of Cormon; this youth is extraordinary, he makes many studies from nature using the methods taught in the schools. In this way he is able to cover endless quantities of canvas without taking into account the air or the light, and he paints everything a uniform brown! And that in the south! When he has made enough sketches in this way, he addresses himself to his painting, for the official Salon, a canvas of more than six feet, after having established his motif by means of photographs! Marvelous, what! He will get a medal for this and will be hailed as a great painter. . . .

Durand-Ruel and the Bernheims show no signs of life. I am waiting to see what will happen.

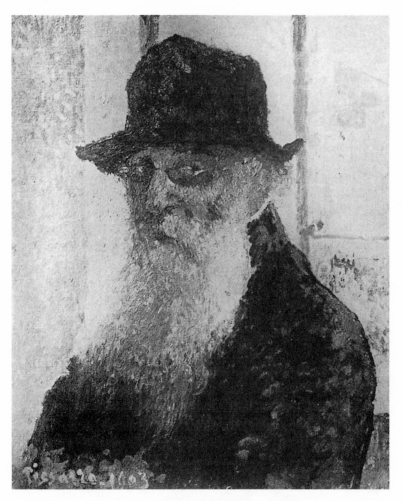

88.—C. Pissarro: Selfportrait, 1903.

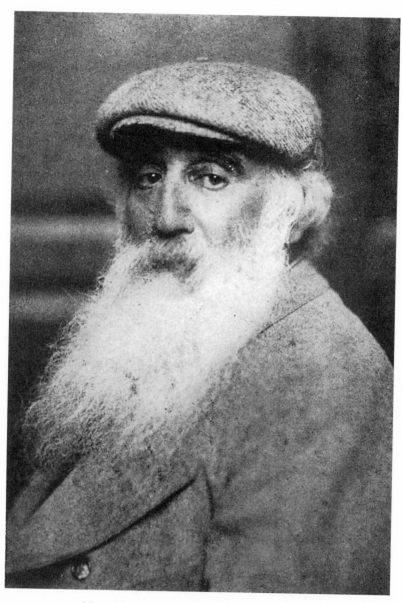

89.—Camille Pissarro in 1897, Photograph.

My dear Lucien,

You will observe that this year I have had to limit my expenses as much as possible in order to hold out and keep fighting, and I am warning you that it is most likely that it will be necessary to diminish your allowance. You should now be able to lighten my burden a little with your own work. The few cents I have put aside will be absorbed by my expenses.

28 PLACE DAUPHINE
PARIS, JANUARY 24, 1903

My dear Lucien,

Durand-Ruel and Bernheim had refused to take my pictures at the prices I proposed, and since a new dealer who had come to see me wanted to buy some of my paintings I seized my chance and sold the whole batch for a good sum. What motivated me especially was that here was an opportunity to escape from Durand-Ruel, who not only had a monopoly of my work by which he profited, but even forced his prices on me under the pretext that my works couldn't be sold.

This won't prevent me from selling to him later on, but I believe it was necessary to indicate in some way, even if it involved some sacrifice, that I wanted to be free. This is a big experiment, but it was necessary to try it. It will provoke Durand-Ruel; so much the better!

PARIS, FEBRUARY 26, 1903

My dear Lucien,

I have just dispatched my things to the exhibition of the "Secession" in Berlin, although M. Cassirer has not yet come to see me as he promised. I sent my work just the same. I belong to the Society; if I could build up connections apart from Durand-Ruel, I would feel more at ease. Perhaps I should go to Berlin to attend the opening either with you or with Georges. I would be only too glad to do so!

My dear Lucien,

I am doing at present a series of canvases from the Hôtel du Quai Voltaire: the Pont Royal and the Pont du Carrousel, and also the sweep of the Quai Malaquais with the *Institut de France* in the background and, to the left, the banks of the Seine; superb motifs of light [1287–1296].

On April 2 the Exhibition of Impressionists opens at Bernheims'. All the pictures shown will have been borrowed from collectors.

My dear Lucien,

I shall not go to Germany, the weather is too unfavorable, and then I doubt whether I would be able to sell anything. As for going to London, that wouldn't be very practical either. If possible I will visit London next year.

My dear Lucien,

This Mr. Dewhurst [1] understands nothing of the impressionist movement, he sees only a mode of execution and he confuses the names of the artists, he considers Jongkind inferior to Boudin, so much the worse for him! He says that before going to London [in 1870] we [Monet and Pissarro] had no conception of light.

[1] *Wynford Dewhurst was then preparing a work which appeared in 1904 under the title:* Impressionist Painting, Its Genesis and Development. *Pissarro himself supplied the author with certain data, and one of his letters, in which he tells of his stay in England in 1870, is quoted by Dewhurst:* "In 1870 I found myself in London with Monet, and we met Daubigny and Bonvin. Monet and I were very enthusiastic over the London landscapes. Monet worked in the parks, whilst I, living at lower Norwood, at that time a charming suburb, studied the effects of fog, snow and springtime. We worked from Nature and later on Monet painted in London some superb studies of mist. We also visited the museums. The watercolors and paintings of Turner and of Constable, the canvases of Old Crome, have certainly had influence upon us. We admired Gainsborough, Lawrence, Reynolds, etc., but we were struck chiefly by the landscape-painters, who shared more in our aim with regard to 'plein air,' light, and fugitive effects. . . ."

The fact is we have studies which prove the contrary. He omits the influence which Claude Lorrain, Corot, the whole eighteenth century and Chardin especially exerted on us. But what he has no suspicion of, is that Turner and Constable, while they taught us something, showed us in their works that they had no understanding of the *analysis of shadow*, which in Turner's painting is simply used as an effect, a mere absence of light. As far as tone division is concerned, Turner proved the value of this as a method, among methods, although he did not apply it correctly and naturally; besides we derived from the eighteenth century. It seems to me that Turner, too, looked at the works of Claude Lorrain, and if I am not mistaken one of Turner's paintings, *Sunset*, hangs next to one of Claude! [1] Symbolic, isn't it? Mr. Dewhurst has his nerve.

<div align="right">ERAGNY, JUNE 17, 1905</div>

My dear Lucien,

I still don't know where I shall go to paint. These last weeks the weather has been so bad that I couldn't look for a place. However I did make several gouaches which I have promised the Bernheims as payment for what I owe them. We have arranged that they will try to boost those of my pictures which are sold at auction, and I will supply them with gouaches. I have to do this in order to counteract the process by which my paintings sold at auction are being priced at 1,000 instead of 5,000 or 6,000 francs! So you see my fortunes are at lowest ebb. In short, I will have to be tight-fisted until there is a new development, and I will have to find motifs so as to be able to take advantage of any opportunity that presents itself. As soon as the weather improves I will look for a place.

<div align="right">ERAGNY, JUNE 30, 1905</div>

My dear Esther,

Lucien is right to turn every once and a while to nature, this should be done regularly every year, otherwise he would never make any progress. Renewal is indispensable, and three weeks is little time for that, he really needs two or three months!

[1] *At Turner's request, one of his landscapes was hung next to a landscape of Claude Lorrain in the National Gallery in London.*

My dear Lucien,

I have been here since Saturday; if the weather is good I will probably go with your mother to Honfleur.

We have made the rounds—by carriage—with one of my collectors, Monsieur Vandevelde, toured the city and its outskirts, and gone through Sainte-Adresse. It is really very beautiful, but I hardly think I could find a place with a window from which I could work. Perhaps I will find what I want at Honfleur. If I decide to stay there you could come and join me.

I should like nothing better than to have you working by my side. As I see it you would not suffer by our working together, neither you, Rodo, nor anyone. For generally one only finds one's own direction after having worked for a great many years. Of course, one can find one's style without this, but then one has to look at the masters, as we all have done.

LE HÂVRE, JULY 10, 1903

My dear Lucien,

Honfleur is a pretty little town, completely flooded by villas, which are everywhere along the coast, alas! But the harbor is very interesting, there are hotels which are quite accessible, that is, charge no more than seven or eight francs a day. We slept at the famous Hôtel Saint Siméon, at which all the painters since 1830 have stayed. Formerly it was a farmhouse, with apple trees in the green fields and a view of the sea; Boudin, Corot, Daubigny, Monet, Jongkind stayed there, but nothing remains of those glorious days. These idiotic new proprietors have put the place in "good order." It is horribly painted up and polished, there are rectilinear gravel paths, one can get a view of the sea only from the dining halls, from the room windows you can't even get a glimpse of the sea now, in short, it is arranged to suit the taste of the English ladies who abound. It is heartbreaking! So I returned to the Hôtel Continental; I really don't know how to organize things for my work. In my view, our field at Eragny is a marvel in comparison with what I see here. As soon as I have achieved what I came to do,

357

I shall return to Eragny to paint some trees. Unfortunately, everything works at cross-purposes this year. Since things were so bad I was compelled to do a series which I thought would please my collectors: the Jetty at Le Hâvre, of which the people of the town are proud; and really it has character.

* * *

Lucien came to see his father at Le Hâvre and then went to Eragny before returning to England; Camille Pissarro remained at Le Hâvre to complete his series on the Jetty [1298–1315].

* * *

LE HÂVRE, AUGUST 29, 1903

My dear Lucien,

Now that you are back in London you must have examined your studies and compared them with those you made before. I hope you noted the difference. In the short letter you wrote me you were very sparing of details about Eragny. You seem to have seen only the watercolors in my portfolios, and these don't deserve the compliments you paid me. I could even say that I discontinued to do some, for I find that I did not achieve the effects I aimed at. Too infected by chance!

LE HÂVRE, SEPTEMBER 8, 1903

My dear Lucien,

I too received an invitation to that Exhibition [in Berlin], but I have little information about it, except that I know the names of several members of the committee, among others the director of the Berlin Museum, and the German painter Liebermann who defended us so well in Berlin. I have no luck in exhibitions: in Berlin, at the show of the "Secession," the three figure paintings I showed were not sold; at Mâcon I had a whole series—nothing was sold; at Dieppe I showed some Views of the Pont Royal in Paris—nothing was sold; at Beauvais I exhibited my *Apple Trees in Bloom*—

nothing. What do I get for all the trouble of sending my works, running risks, regilding old, ruined frames, for the cost of packing and insuring the parcels? Isn't it idiotic? It is not worth the trouble, and what is most provoking is to see what is actually bought! Petitjean, who arrived from Mâcon, wrote me that the painter who had most success there was the worst mediocrity and without any reputation. This doesn't surprise me; it is not so easy to understand how to look at pictures. It will probably be the same story in London, if not still worse, for they really don't care for anything in painting except a brilliant brush stroke!

<div align="center">LE HÂVRE, SEPTEMBER 22, 1903</div>

My dear Lucien,

I intend to leave towards the 26th of this month. I sold two pictures to the Museum [1310, 1315] and two to collectors. I am waiting for other collectors, but I am hardly besieged by demands! I see that we are far from being understood—quite far—even by our friends.

90.—Lucien Pissarro: Portrait of Camille Pissarro. Woodcut.

On his return from Le Hâvre, Camille Pissarro prepared to move into a new apartment, where he expected to paint views from the window. He caught a cold while supervising the moving men who packed his paintings. An abscess of the prostate, which his homeopathic physician tried to cure without an operation, resulted in blood poisoning.

Lucien, his sister and his brothers, except for Georges, came immediately to the bedside of their father, then seventy-three years old. Camille Pissarro's suffering was not prolonged. He died peacefully on November 12, 1903.

In April 1904, Paul Durand-Ruel organized a large exhibition of the works of Camille Pissarro. This exhibition contained one hundred and thirty-two canvases, gouaches, drawings and engravings, executed between 1864 and 1903. The preface to the catalogue was written by Octave Mirbeau. The prices of the paintings ranged from 10,000 to 20,000 francs.

FINIS

INDEX

Académie Française, 203, 308
Académie Julian, 276, 279
Académie Suisse, 53, 263, 277
Adam, P., 180, 181, 245
Agar, 262
Aguiard, 280
Aix-en-Provence, 280
Ajalbert, 84, 95, 181, 318, 319
Alexandre, A., 183, 278, 286, 287, 310, 319, 326
Alexis, P., 85, 120, 121, 319
America, 65, 66, 72, 76, 89, 125, 127, 128, 154, 159, 177, 222, 244, 248, 259, 292, 295, 326
Amsterdam, 330, 331
André, A., 239
Andrei, 196
Angrand, 77, 156, 223, 273
Anquetin, 112, 136, 156, 169, 171, 188, 297, 323
Antwerp, 243, 247, 268
Arosa, 168, 192
"Art dans les Deux Mondes, L'," 142, 149, 150, 154, 155, 163, 180
"Art Moderne, L'," 31, 81
Asnières, 93, 106
Aurier, A., 163, 180
"Aurore, L'," 318
Auvers-sur-Oise, 57, 100, 117, 121, 137, 139, 167, 276
Avery, 124, 177

Barcelona, 299, 305
Bartholomé, 142
Bastien-Lepage, 35, 53
Baude, 148
Bazincourt, 76, 86, 192, 233
Bazire, 129
Beardsley, 260, 289
Beauvais, 194, 197, 358

Belgium, 153, 181, 232, 234, 243, 244, 247, 250, 288
Béliard, 276
Bellio, de, 26, 91, 99, 106, 118, 119, 129, 156, 161, 170, 218, 220, 222, 235, 236
Bénézit, 148, 154, 177
Bensusan, 52
Bérard, 73
Bérenger, 211
Bergerat, 172, 277
Berlin, 45, 256, 259, 261, 267, 314, 330, 333, 340, 350, 354, 358
Berlioz, 26, 50
Bernard, Emile, 156, 165, 167, 170, 188
Berneval, 343, 346, 347
Bernheim-Jeune, 171, 189, 192, 335, 340, 349, 350, 351, 352, 354, 355, 356
Besnard, A., 90, 91, 108, 279
Beugnet, 67, 68
Bing, 206, 269, 279, 288, 289, 293, 322
Birmingham, 185
Bismarck, 92, 93
Bizet, 26
Blanche, J.-E., 289, 321
Bonington, 46
Bonnard, 104, 188, 229, 282, 287, 288, 289, 291, 311, 339
Bonvin, 355
"Book of Ruth," see: *"Ruth, Book of,"*
Boston, 33, 268
Boudin, 72, 334, 355, 357
Bourget, 73
Boussod & Valadon, 115, 123, 126, 127, 128, 131, 137, 143, 154, 155, 161, 172, 174, 188, 189, 190, 208, 218, 241, 260, 264
Bracquemond, 30, 71, 76, 94, 95, 96, 97, 98, 109, 115, 127, 150, 152, 282, 308, 311, 312
Brown, J. L., 58, 81, 82, 83, 106, 108, 211
Bruges, 240, 242, 243

361

Brunetière, 258
Brussels, 81, 83, 86, 98, 100, 101, 102, 154, 221, 240, 241, 242, 243, 245, 246, 247, 253, 259
Buhot, 143, 150
Burne-Jones, 268, 298
Burty, 28, 73
Busnach, 103

Caen, 346
Caillebotte, 32, 63, 64, 71, 75, 235, 236, 239, 258, 260, 284, 307, 308, 309, 310, 312
Caldecotte, 49
Camondo, de, 260, 261, 287, 334
Canteleu, 43, 201, 202, 284, 290
Carabin, 172
Caran d'Ache, 82
Carnot, 242
Carolus-Duran, 53, 199
Carrière, 189, 283, 288, 289
Caseburne, 80, 91
Cassatt, 45, 64, 71, 75, 76, 146, 148, 157, 158, 159, 160, 164, 165, 170, 175, 178, 179, 181, 186, 192, 204, 221, 222, 239, 240, 244, 249, 257, 287
Cassirer, 354
Caudebec, 290, 336
Caze, R., 68
Cazin, 106
Cézanne, 58, 59, 63, 68, 106, 121, 165, 167, 186, 227, 237, 239, 241, 263, 269, 274, 275, 276, 277, 280, 282, 286, 289, 294, 322, 340
Champ de Mars, Exhibition at the, 169, 172, 198, 238, 268
Champfleury, 57
Chardin, 339, 356
Charpentier, 244, 268
Chartres, 268
Chase, 249
Chassériau, 342, 343
Châtillon-sur-Seine, 177, 326, 327
"Chat Noir," 82
Chaumont-en-Vexin, 178
Chenavard, 327
Chène, 214, 215, 217
Chéramy, 183, 192
Chéret, 311
Chevreul, 64, 99
Chicago, 215, 249
Chocquet, 106
Clapisson, 80
Claude Lorrain, 143, 323, 327, 356
Clauzet, 65, 67, 84, 94, 96
Clemenceau, 36, 318
Clouet, 56
Cluzel, 66, 129, 135
Cocotte, see: Pissarro, Jeanne
Compiègne, 54, 55, 57, 58
Condor, 279
Constable, 355, 356

Contet, 68, 114, 225, 236, 288
Cormon, 352
Corot, 25, 56, 144, 177, 183, 212, 231, 235, 251, 267, 306, 323, 329, 335, 342, 356, 357
Courbet, 105, 177, 231, 263, 276, 278, 322, 329
Couture, T., 263
Crane, 149, 179
"Cri du Peuple," 120, 121, 125
Cross, H. E., 77, 224, 236, 266, 288, 289
Cuba, 263

Damps, Les, 187, 202, 203
Dante, 193
"Daphnis and Chloe," 232, 256, 257, 258, 270, 271, 272, 338, 339
Dario de Rigoyos, 266, 268
Daubigny, 56, 61, 146, 306, 355, 357
Daumier, 35, 50, 52, 56, 57, 124, 241
David, L., 329
Degas, 21, 23, 28, 30, 31, 35, 39, 40, 45, 46, 57, 63, 64, 69, 71, 72, 74, 75, 76, 81, 83, 90, 95, 97, 98, 103, 104, 108, 125, 127, 130, 142, 144, 146, 149, 153, 160, 161, 162, 163, 164, 165, 168, 170, 175, 177, 179, 183, 203, 204, 216, 218, 221, 229, 237, 239, 240, 253, 258, 260, 261, 262, 263, 265, 270, 275, 276, 277, 282, 286, 287, 289, 293, 298, 299, 301, 306, 308, 309, 312, 318, 319, 321, 323, 329, 331
Delacroix, 25, 26, 32, 39, 50, 52, 106, 111, 144, 177, 183, 230, 276, 324, 329, 342
Delâtre, 28, 133, 226, 227, 232
Denis, M., 279, 297, 339
Denmark, 76
Dépeaux, 281, 283, 284, 285, 287
Desclozeau, 111
Deudon, 73
Deville, 43, 201
Dewhurst, 355, 356
"Dial, The," 138, 146, 152, 157, 161, 216, 217, 222
Dieppe, 336, 337, 343, 346, 349, 350, 358
Dijon, 326, 342
Doré, G., 308
Dowdeswell, 178
Dresden, 256, 258, 260
Dreyfus, 314, 318, 320, 334, 350
"Droits de l'Homme, Les," 318, 319
Dubois-Pillet, 82, 83, 92, 99, 101, 103, 139, 153
Dumas, A., 277
Dumas, 78, 81, 85, 103
Dumont, 143, 148, 292
Dupré, 84, 225
Duran, Carolus, see: Carolus-Duran
Durand-Ruel, Ch., 72, 131
Durand-Ruel, J., 72, 190, 193, 194, 208, 217, 218, 221, 222, 239, 247

Durand-Ruel, P., 23, 24, 27, 28, 30, 32, 33, 36, 37, 42, 43, 44, 54, 58, 59, 60, 61, 63, 64, 65, 66, 67, 68, 69, 70, 71, 72, 75, 76, 77, 78, 79, 80, 81, 84, 86, 87, 89, 91, 94, 98, 100, 101, 102, 116, 123, 124, 125, 126, 127, 128, 129, 130, 131, 132, 138, 140, 141, 142, 144, 145, 148, 149, 150, 152, 157, 158, 159, 160, 161, 162, 163, 164, 165, 166, 168, 171, 172, 174, 178, 180, 181, 183, 184, 188, 189, 190, 192, 193, 194, 198, 199, 201, 202, 204, 205, 206, 207, 208, 209, 212, 214, 215, 217, 218, 219, 220, 221, 222, 224, 227, 232, 236, 238, 241, 245, 247, 248, 249, 250, 251, 260, 263, 266, 267, 268, 269, 273, 275, 276, 282, 284, 285, 286, 289, 290, 293, 295, 299, 306, 307, 308, 310, 313, 316, 318, 323, 324, 325, 329, 330, 332, 333, 335, 336, 340, 345, 349, 350, 351, 352, 354, 360
Dürer, 301
Duret, 24, 25, 26, 28, 29, 30, 31, 32, 34, 50, 73, 103, 162, 164, 207, 208, 310, 321, 348

"Echo de Paris," 155, 170, 178, 228
"Eclair, L'," 155, 183
Ecouen, 34
Egypt, 54, 181
Eiffel Tower, 137
Elias, J., 350
England, 27, 35, 37, 38, 40, 55, 137, 140, 157, 178, 185, 205, 233, 234, 235, 236, 247, 259, 270, 273, 275, 291, 295, 300, 305, 310, 313, 322, 340, 342, 355, 358
Enot, 98
Epping, 95, 212, 215, 226, 233, 235, 236, 269
Eragny, 55, 58, 59, 71, 91, 98, 117, 125, 137, 138, 143, 146, 157, 158, 162, 176, 182, 184, 188, 189, 190, 192, 194, 199, 200, 201, 203, 209, 211, 215, 221, 227, 235, 242, 243, 245, 247, 249, 250, 251, 264, 270, 273, 280, 285, 287, 290, 293, 299, 304, 306, 312, 313, 316, 317, 325, 329, 330, 331, 345, 357, 358
"Estampe, L'," 308

"Fagerolles," 73, 112
Fantin-Latour, 51, 289, 293
Faure, 225, 248
Fécamp, 48
Fénéon, 64, 81, 83, 85, 93, 95, 96, 110, 111, 112, 113, 114, 126, 127, 134, 136, 137, 156, 169, 181, 182, 222, 224, 238, 239, 244, 287
"Figaro, Le," 29, 36, 45, 105, 113, 172, 174, 199, 326
Flaubert, 68
Flournoy, 324, 338
Forain, 55, 57, 64, 72, 76, 265, 289
Fouquier, 174

Fourcault, 150
France, 35, 38, 40, 52, 55, 66, 76, 80, 89, 137, 150, 151, 162, 185, 235, 242, 243, 245, 246, 247, 291, 310, 321, 323, 332, 347, 350
"France, La," 47
"France Nouvelle, La," 196

Gachet, Dr., 137
Gainsborough, 242, 355
Gallimard, 168, 171, 172, 173, 174
Gauguin, Abbé, 195, 197, 201, 209
Gauguin, P., 25, 31, 35, 36, 44, 45, 47, 48, 52, 54, 57, 64, 70, 74, 76, 77, 81, 82, 83, 95, 96, 97, 111, 112, 145, 153, 154, 156, 163, 164, 165, 167, 168, 170, 171, 172, 174, 179, 188, 221, 222, 227, 241, 261, 263, 275, 287, 291
Gausson, 188
Gavarni, 50
Geffroy, G., 148, 162, 164, 187, 220, 233, 237, 259, 265, 278, 281, 282, 283, 287, 288, 289, 310, 319
Géricault, 183, 342
Germany, 66, 248, 352, 355
Gérôme, 239, 309
Gervex, 35, 73
Ghent, 243
"Gil Blas," 68
Giotto, 96
Gisors, 55, 56, 58, 62, 88, 200, 212, 234, 336
Giverny, 200, 218, 248, 290
Gladstone, 36, 54
Glasgow, 191
Gogh, Théo van, 115, 116, 118, 119, 120, 121, 122, 123, 124, 125, 126, 127, 128, 130, 131, 135, 136, 137, 139, 141, 143, 148, 149, 155, 162, 163, 165, 168, 192, 218, 256, 269
Gogh, Vincent van, 137, 139, 153, 154, 170, 188, 191
Goncourt Brothers, 187, 310, 312
Gonse, 28
Gosset, 71
Goujon, 62
Goupil, 45, 46, 78, 115, 143
Goya, 323, 347
Grancey-sur-Ourcq, 326
Grave, J., 195, 210, 244, 322
Gray, John, 137
Greco, El, 327
Greenaway, K., 49
Greuze, 110
Groux, H. de, 227
Guillaumin, 25, 42, 63, 65, 66, 68, 70, 71, 72, 73, 75, 76, 77, 82, 84, 96, 99, 100, 111, 112, 121, 153, 191, 225, 227, 241, 277, 289, 318
Guillemet, 56, 61, 68, 73, 75
Guingasse, see: Pissarro, Paul-Emile
Gutbier, 293

363

Haden, Seymour, 143, 150, 360
Hague, The, 73, 130, 330
Hals, 331
Hamerton, 150, 151
Hauptmann, G., 224
Hâvre, Le, 358, 360
Hayashi, 162, 273, 310
Hayet, L., 136, 145, 220, 275
Hemixem, 247, 268
Henry, Charles, 178
Heymann, 60, 67, 70, 71, 80, 91, 92, 95, 101, 102, 104, 109, 114, 277
Hiroshigé, 201, 207, 228
Hochedé, 108, 162
Hokusai, 228
Holbein, 37, 38, 40, 56
Holland, 73, 80, 109, 130, 139, 244, 320, 331, 332
Holloway, 249
"*Hommes d'Aujourd'hui, Les*," 165, 167
Honfleur, 357
Huysmans, J. K., 31, 73, 111, 115, 269, 318, 320, 321

Ibsen, 224
"*Image, L'*," 291, 299, 301, 310
"*Indépendants*," see: "*Independent Artists*"
"*Independent Artists*," 77, 83, 92, 104, 108, 114, 125, 136, 139, 153, 155, 156, 161, 169, 171, 237, 238, 265, 288
Ingres, 30, 50, 177, 183, 267, 320, 329, 342
"*Intransigeant, L'*," 29, 32, 129
Isaacson, Alfred, 22, 36, 49, 50
Isaacson, Alice, 22, 52, 137, 167
Isaacson, Amélie, 22, 110, 284
Isaacson, Esther, 22, 38, 52, 53, 62, 137, 167, 206
Isaacson, Phineas, 22
Isle-Adam, 49, 57

Jacque, 28
Jacques, Ch., 143, 146, 150, 177
Jacques, E., 32, 148
Jacquet, 277
Japanese prints, 28, 39, 158, 206, 207, 208, 269, 279, 300, 312
Jeanniot, 162, 278
Jongkind, 39, 56, 184, 187, 336, 355, 357
Jourdain, F., 307, 308
"*Journal, Le*," 233, 277, 281, 283
Joyant, 143, 188, 189, 190, 191, 197, 198, 199, 203, 218, 319

Kahn, Gustave, 81, 84, 85, 90, 91, 92, 104, 105, 136, 145, 149, 150, 180, 181, 182, 183, 287
Keene, C., 35, 56
Kennedy, 176, 177
Kensington Museum, 22, 37, 259
Keppel, 177
Kew, 201, 203

Knobloch, M., 181, 182
Knocke-sur-mer, 243, 249, 252, 256, 268
Knoedler, 78, 79
Kropotkin, 195

Labusquère, 262
Laforgue, Jules, 189, 337
Lagny, 184
Lahor, J., 259, 260
Latouche, 68
Lautrec, see: Toulouse-Lautrec, de
Lawrence, 355
Lazare, Bernard, 245, 314
Le Barc de Boutteville, 188, 199, 204, 262, 297
Lebourg, 102, 306
Lèbre, 89, 90, 92, 96
Lecomte, Georges, 166, 194, 222, 237, 244, 265, 281, 282, 287, 289, 324
Legrand, 78, 79
Legros, 34, 35, 39, 142, 143, 150, 177, 232, 276, 308, 322, 323
Le Hâvre, see: *Hâvre, Le*
Leloir, 130
Lemmen, 182
Lenain Brothers, 339
Leonardo, 143, 193
Lepage, see: Bastien-Lepage
Lepère, 140, 148, 291, 308, 311
Lepic, 71
Lépine, 340
Les Damps, see: *Damps, Les*
"*Libre Esthétique, La*," 221, 234, 247
Liebermann, Max, 358
Lille, 278
Lisieux, 346
London, 24, 26, 27, 28, 29, 31, 32, 34, 39, 40, 43, 46, 47, 50, 58, 81, 137, 139, 140, 143, 146, 150, 152, 153, 170, 171, 174, 178, 182, 184, 188, 191, 192, 194, 197, 198, 199, 200, 209, 210, 212, 219, 246, 253, 263, 285, 305, 306, 310, 313, 315, 318, 324, 328, 347, 349, 355, 358, 359
Lorrain, C., see: Claude Lorrain
Louveciennes, 168, 276, 299
Louvre, 156, 170, 242, 260, 272, 274, 299, 334
Luce, M., 137, 145, 165, 166, 169, 172, 182, 188, 201, 204, 208, 222, 227, 238, 245, 246, 265, 270, 271, 288
Luxembourg Museum, 153, 169, 183, 239, 259, 260, 264, 287, 307, 308, 313
Lyon, 204, 280, 327

McKinley, 295, 299
Macon, 326, 327, 259, 360
Madrid, 305
Maeterlinck, 182, 187, 190
Maison Doré, La, 75, 236
Mallarmé, 73
Manet, Edouard, 24, 25, 29, 39, 50, 51, 54, 72, 166, 170, 183, 195, 208, 225, 238, 248, 276, 323, 329, 342, 348

364

Manet, Eugène, 71, 73, 74, 195
Manet, Mme Eugène, see: Morisot, B.
Mantz, P., 156
Manzana, 274, see also: Pissarro, Georges
Manzi, 59, 204, 218, 306, 319
Martigues, 352
Martinet, 85, 90
Martinique, 170
Marty, 208, 227, 232
Mauclair, 241, 276, 297
Maufra, 233, 234
Maupassant, de, 50, 73, 155
Maus, Octave, 81, 247, 248, 252
Maxwell, 64
Meaux, 33, 34
Meier-Graefe, 330
Meissonier, 150
Mellério, 193, 222, 265, 308, 311, 312, 319
Menzel, 45, 46
"*Mercure de France*," 163, 241
Méryon, 312
Meunier, C., 101, 267, 268
Meyer, Salvador, 123, 165, 187, 188, 192, 205, 208
Michel, Louise, 39
Michelangelo, 101, 323
Middleburg, 244, 245
Milan, King, 261, 262
Mill, J. S., 50
Millet, 25, 72, 105, 109, 110, 111, 119, 146, 177, 251
Mirbeau, 104, 115, 137, 145, 148, 166, 170, 178, 182, 183, 184, 186, 187, 189, 190, 199, 202, 203, 206, 209, 210, 221, 228, 230, 233, 239, 244, 245, 246, 265, 281, 297, 298, 308, 310, 316, 319, 332, 360
Moline, 223, 257, 262
Monet, 23, 24, 25, 26, 27, 31, 32, 39, 43, 45, 46, 62, 63, 64, 65, 66, 68, 69, 72, 75, 77, 80, 83, 84, 90, 92, 93, 95, 99, 101, 104, 105, 107, 108, 109, 111, 114, 121, 126, 127, 128, 129, 131, 137, 142, 153, 154, 155, 159, 161, 162, 163, 165, 166, 167, 168, 171, 173, 183, 188, 190, 200, 201, 202, 203, 206, 207, 215, 218, 219, 221, 222, 235, 237, 238, 248, 251, 258, 261, 262, 266, 267, 268, 269, 270, 274, 275, 276, 280, 281, 282, 283, 284, 285, 286, 290, 292, 298, 299, 306, 309, 310, 318, 325, 329, 331, 332, 335, 340, 355, 357
Monier de la Sizerai, 297
Montaignac, 154, 155, 335
Monticelli, 191
Moore, G., 73, 323, 336
Morawe, 249, 253, 258
Morel, 43, 44, 56
Morice, Charles, 221, 241
Morisot, B., 64, 69, 70, 71, 72, 75, 76, 104, 108, 110, 170, 175, 178, 262, 283
Morris, William, 138, 259, 291, 308, 311, 329, 340

Moscow, 333
Mourey, 296, 297
Munich, 245, 314, 333
Murer, E. and M., 42, 94, 117, 118, 119, 120, 121, 143

Nantes, 233
Nathanson, 281
National Gallery, London, 22, 40
Nelaton, 116, 117
New York, 72, 76, 77, 78, 79, 80, 89, 116, 124, 125, 131, 140, 143, 164, 165, 168, 179, 189, 208, 217, 218, 240, 249, 250, 308
Nini, 38, 50, 235
Nittis, de, 56, 71
Nouvelle Athènes, Café de la, 82, 321
Nunès, 69, 70, 101, 122, 200

Ollendorf, 104
Oller, F., 263, 264, 277, 280
"*Ordre de la Rose-Croix*," 193
Orovida, see: Pissarro, Orovida
Osny, 24, 25, 31, 34, 76
Outamaro, 206

Paganini, 183
Paillard, 172, 188
"*Panel Society*," 170, 175, 178
Parenteau, Dr., 144, 165, 167, 209, 210, 220, 291, 299, 316
Paris, 23, 24, 27, 28, 29, 31, 32, 34, 36, 41, 42, 45, 58, 59, 65, 69, 79, 80, 82, 86, 89, 93, 96, 98, 99, 100, 101, 103, 104, 109, 116, 117, 118, 119, 120, 122, 126, 130, 137, 138, 141, 142, 143, 148, 149, 154, 155, 160, 164, 165, 172, 180, 181, 182, 185, 186, 191, 195, 197, 200, 201, 206, 216, 218, 219, 220, 221, 226, 229, 233, 237, 239, 240, 241, 243, 244, 248, 251, 253, 255, 256, 259, 261, 263, 265, 268, 270, 272, 273, 279, 280, 282, 283, 286, 294, 299, 307, 316, 317, 323, 324, 327, 330, 331, 332, 340, 345, 346, 347, 350, 352, 358
Paulin, 65, 66, 67, 68, 70, 72, 93, 98, 102, 104
"*Peintres-Graveurs, Les*," 138, 146, 152, 154, 157, 158, 160
Péladan, Sàr, 193
"*Père Peinard, Le*," 195
Perpignan, 305
Perry, Mrs., 267, 283
Petit, Georges, 28, 54, 60, 75, 80, 83, 95, 99, 102, 103, 104, 106, 108, 109, 113, 114, 115, 116, 335
Petites Dalles, Les, 48
Petitjean, 224, 226, 228, 359
Piette, 277
Pillet, 82, 83, 90, 93, 94, 95
Pissarro, Esther, née Bensusan (Mrs. Lucien Pissarro), 176, 201, 202, 219, 220, 236, 270, 313, 314, 315, 319, 325, 333, 351, 356

365

Pissarro, Félix (Titi), 48, 78, 142, 143, 176, 177, 185, 189, 195, 197, 206, 209, 214, 215, 216, 226, 233, 234, 240, 241, 243, 244, 245, 247, 253, 262, 263, 265, 269, 273, 282, 300, 304, 306, 313, 315, 316, 317, 318, 320

Pissarro, Georges, 143, 146, 176, 182, 187, 206, 209, 210, 212, 215, 216, 223, 226, 227, 233, 234, 235, 240, 247, 250, 253, 262, 263, 265, 269, 273, 282, 284, 300, 304, 306, 313, 315, 318, 330, 352, 354, 360

Pissarro, Jeanne (Cocotte), 117, 136, 185, 186, 268, 269, 272, 273, 274, 347, 349, 360

Pissarro, Julie, née Vellay (Mme Camille Pissarro), 21, 26, 79, 81, 93, 100, 107, 116, 117, 118, 123, 129, 134, 135, 137, 141, 142, 143, 167, 182, 185, 186, 188, 189, 196, 199, 200, 201, 207, 212, 213, 216, 243, 246, 249, 250, 253, 262, 268, 272, 273, 274, 284, 294, 295, 309, 312, 313, 315, 317, 318, 326, 347, 349, 357

Pissarro, Ludovic Rodolphe, 138, 185, 214, 227, 245, 247, 262, 263, 273, 290, 325, 328, 330, 346, 347, 352, 357, 360

Pissarro, Orovida (Kiddie), 219, 220, 270, 313, 316, 333

Pissarro, Paul Emile (Guingasse), 185, 186, 347, 349, 360

Pittsburgh, 326, 333

"Plume, La," 224

Poissy, 206, 207

Pont-Aven, 97

Pontoise, 25, 29, 30, 34, 88, 115, 117, 124, 167, 184, 246, 276, 326, 336, 343

"Portfolio, The," 150, 151

Portier, 55, 67, 68, 70, 71, 72, 77, 80, 94, 95, 98, 102, 103, 104, 114, 115, 123, 124, 125, 149, 160, 161, 162, 165, 183, 186, 197, 199, 201, 203, 204, 212, 218, 219, 222, 241, 247, 248, 252, 272, 273, 275, 284, 336

Pozier, H., 110, 111, 136, 215

Pouget, 166, 195, 284

Poussin, 143

Pre-Raphaelites, 179, 185, 222, 259, 304

Proudhon, 49, 179

Proust, A., 29, 50

Puerto-Rico, 263

Puvis de Chavannes, 90, 104, 172, 198, 204, 238, 254, 257, 258, 263, 267, 268, 275, 282, 306, 318, 320, 325, 327, 336, 342

"Queen of the Fishes, The," 95, 258, 267, 301

Raffaëlli, 87, 106, 173, 227, 292

Réclus, E., 244, 245

Redon, O., 64, 76, 77, 165, 227, 288

Régamey, 259

Regnault, H., 96

Régnier, de, 136

Reid, 191

Rembrandt, 143, 150, 177, 231, 298, 322, 323, 330, 331

Renoir, 23, 25, 26, 27, 28, 31, 42, 43, 45, 46, 55, 63, 64, 65, 66, 68, 72, 75, 77, 80, 83, 89, 95, 99, 101, 104, 105, 107, 108, 109, 111, 114, 120, 121, 126, 127, 129, 132, 142, 166, 180, 181, 190, 198, 199, 207, 221, 229, 239, 261, 262, 270, 275, 276, 277, 280, 282, 308, 309, 323, 325, 331, 334, 335, 342

Renouard, 125, 309

"Revue Blanche," 287, 324

"Revue Encyclopédique," 259

"Revue Illustrée," 78, 82, 85

"Revue Indépendante," 85, 111, 115, 127

Reynolds, 242, 355

Ricketts, 137, 138, 146, 149, 152, 157, 260, 271, 272, 283, 289, 296, 298, 300, 301, 304, 308, 309, 310, 325, 329, 333, 342, 343, 352

Robertson, 91, 98

Robida, 57

Roche, J., 274, see also: Pissarro, Félix

Rochefort, 83, 332

Rochefoucault, A. de la, 223

Rodin, 108, 142, 173, 186, 187, 202, 207, 254

Rodo, see: Pissarro, Ludovic Rodolphe

Rome, 285

Ronsard, 350

Rood, N. O., 64

Rops, F., 308

Rose-Croix, see: Ordre de la Rose-Croix

Rossetti, 222

Rotterdam, 37

Rouart, 71, 76

Rouen, 40, 41, 42, 43, 44, 45, 46, 48, 52, 57, 61, 62, 65, 76, 130, 133, 134, 201, 202, 238, 266, 267, 268, 280, 281, 282, 283, 284, 286, 287, 288, 289, 293, 295, 298, 303, 308, 326, 327, 330, 336, 345, 346

Roujon, 186, 209

Russia, 58

"Ruth, Book of," 258, 296

Rysselberghe, van, 101, 156, 224, 232, 240, 242, 243, 244, 245, 246, 247, 255, 256, 257, 267, 268, 269, 310

St. Thomas, 245, 343

Ste. Adresse, 357

Sagot, 292, 293

Salmon, 28

Sargent, J. S., 183, 184

Schuffenecker, 74, 76, 111, 112, 188, 322

"Secession" (Berlin), 354, 358

Séguin, 262

Sérusier, 188

Seurat, 63, 64, 66, 70, 72, 73, 74, 76, 77, 81, 82, 83, 84, 85, 90, 93, 94, 96, 98, 99, 100, 101, 102, 103, 110, 112, 114, 120, 126, 129, 130, 132, 136, 142, 153, 155, 156, 158, 165, 168, 169, 181, 182, 228, 230, 273
Shakespeare, 26
Shannon, 138, 149, 150, 157, 213, 222, 253, 267, 283, 289, 291, 292, 298, 299, 323, 342
Signac, 63, 64, 66, 70, 72, 73, 74, 76, 77, 81, 82, 83, 85, 90, 92, 93, 98, 99, 100, 101, 103, 104, 105, 110, 112, 114, 125, 126, 129, 135, 136, 153, 156, 158, 165, 169, 175, 181, 182, 188, 204, 222, 223, 224, 228, 230, 231, 233, 244, 255, 265, 266, 269, 275, 288, 324
Sisley, 23, 31, 33, 45, 64, 65, 66, 68, 72, 75, 98, 99, 101, 104, 105, 108, 109, 110, 111, 114, 121, 126, 129, 142, 153, 155, 162, 163, 166, 172, 188, 227, 261, 266, 306, 309, 310, 325, 331, 334, 335, 340
Slade School (London), 34
Société des Artistes Indépendants, see: "Independent Artists"
Société des Peintres-Graveurs, see: "Peintres-Graveurs, Les"
Steinlen, 245, 308, 310
Stremel, 256
Strindberg, 263
Suéton, 215
Swinburne, 155
Switzerland, 212

Tahiti, 156, 170, 172, 221, 261, 263
Tailliardat, 138, 232
Tanguy, *père*, 59, 100, 172, 204, 236, 237, 263, 264
Tassaert, 25, 183
"*Temps, Le*," 309
Thomson, 198, 253
Thureau-Dangin, 207
Tillot, 76
Tintoretto, 327
Titi, see: Pissarro, Félix
Toché, 96
Toulouse-Lautrec, de, 136, 143, 188, 199, 208, 241, 269, 289, 291, 311
Touraine, 195, 233
"*Travaux des Champs, Les*," 85, 130, 131, 138, 144, 147, 203, 256, 270, 271, 272, 347, 350, 351
Trocadéro, 274
Trolo, 279
Trouville, 346
Troyes, 177, 326, 327

Trublot, see: Alexis, P.
Trulat, 342
Tual, 118, 119
Turner, 22, 39, 132, 144, 242, 355, 356

Uterwijk, 330

Vallette, 308
Vallotton, 211, 287
Valmondois, 57
Vandevelde, 243
Varengeville, 337, 342
Veere, 245
Velasquez, 238
Vellay, 54
Venice, 297
Verhaeren, 101
Verlaine, 49, 172, 173, 291, 292, 293, 339
Vermeer, 331
Veronese, 327
Versailles, 34
Vever, 214, 306
Viau, Dr., 226, 227, 247, 248, 318
"*Vie Moderne, La*," 55, 89, 101
Vierge, D., 308, 311
Vignon, 44, 76
Villers-sur-mer, 346
"*Vingt, Les*," 81, 83, 98, 99, 100, 101, 102, 139, 153, 154, 221
Vogler, 221
"*Vogue, La*," 81, 84, 85, 89, 90, 91, 92, 96
Vollard, 227, 229, 237, 248, 274, 276, 288, 289, 290, 291, 292, 294, 311, 312, 338, 339
Vuillard, 287

Walgrave, 245
Watteau, 162
Watts, 320, 342
Westcapelle, 245
Whistler, 22, 23, 27, 28, 56, 72, 104, 106, 108, 110, 132, 138, 143, 195, 198, 208, 238, 260, 312, 339, 342
Willette, 265, 289
Willumsen, 156
Wisseling, van, 232, 253, 258, 263
Wolff, Albert, 29, 45, 96, 108, 113

Zandomeneghi, 71, 76, 82, 84, 142, 160, 162, 168, 170, 213, 278, 287, 330
Zeeland, 244
Ziem, 144
Zola, 25, 38, 43, 49, 54, 68, 73, 75, 103, 167, 197, 207, 276, 318, 320, 321, 322, 332, 350